ARTRE

Y (Place Blanche)

TROUVE

MUSIC-HA

Graf

RETRO PARIS

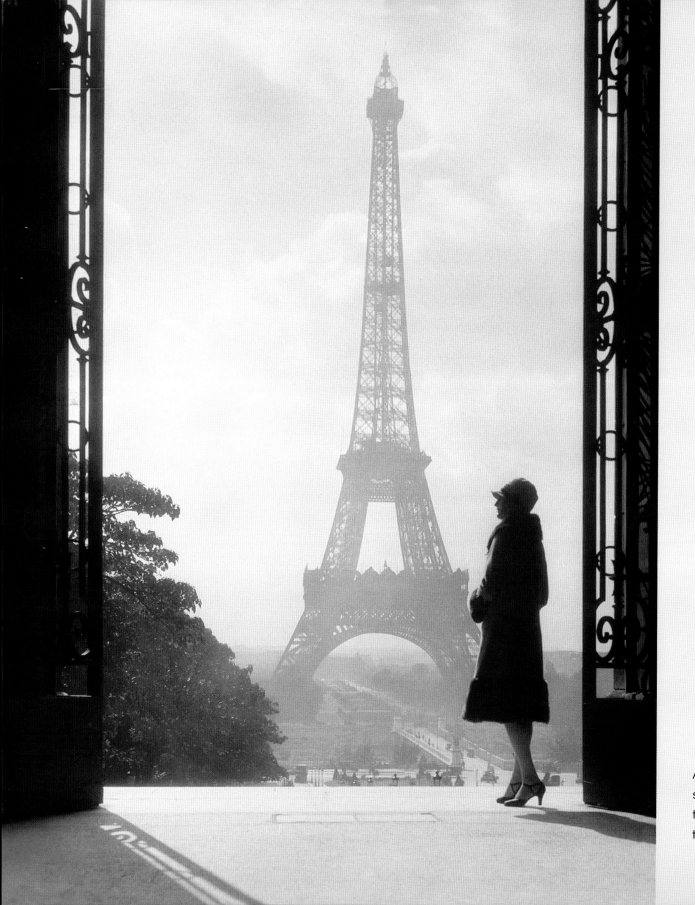

An evocative view of a silhouetted woman standing in the Trocadero looking toward the Eiffel Tower, (c.1920s).

Retro PARIS

Gary Chapman

in association with the
Mary Evans Picture Library

First published in 2015 by New Holland Publishers Pty Ltd
London • Sydney • Auckland

The Chandlery Unit 009 50 Westminster Bridge Road London SE1 7QY United Kingdom
1/66 Gibbes Street Chatswood NSW 2067 Australia
5/39 Woodside Ave Northcote, Auckland 0627

www.newhollandpublishers.com

A record of this book is held at the British Library and the National Library of Australia.

ISBN 9781742577555

Managing Director: Fiona Schultz
Publisher: Alan Whiticker
Project Editor: Susie Stevens
Designer: Andrew Davies
Production Director: Olga Dementiev
Printer: Toppan Leefung Printing Limited

10 9 8 7 6 5 4 3 2 1

Keep up with New Holland Publishers on Facebook
www.facebook.com/NewHollandPublisher

CONTENTS

INTRODUCTION

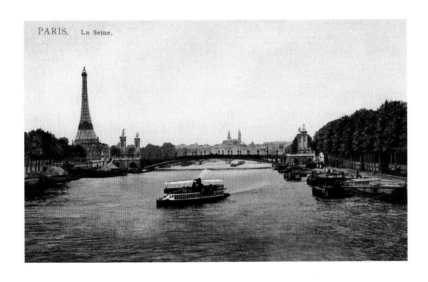

Looking down the River Seine with the Eiffel Tower on the left (c. early 1900s).

Paris has changed little in the 20th century partly because it did not suffer the devastating damage that London endured during World War II. The grand transformation orchestrated by Baron Haussman for Napoleon III in the mid-19th Century, with the removal of much of the medieval city and the implementation of a geometric grid of avenues and boulevards, still pervades the city today. Paris became the most magnificent city in Europe and the streets, the monuments and the landscape have retained its quintessential distinctiveness, charm and allure. You can almost feel and savour the flow of time at each place you visit, and each place tells its own unique story.

Paris is often referred to as La Ville-Lumière (The City of Light) and there is much debate about the meaning of this much-quoted phrase. The accepted explanation is that the reign of Louis XV was regarded as the age of enlightenment as Paris became a crossroads where new ideas and creativity were tested and evolved. As such, Paris was thought to be an 'enlightened' place and established itself as the European centre of education, learning, philosophy, scientific reason and the arts.

Perhaps adding to this, Paris was one of the first cities to adopt street lighting in the 19th century with gas lamps on the Champs-Élysées in 1829 and electric lights for the Great Exhibition of 1889. When many other cities in Europe were still dark, Paris banished the night and everything became illuminated, including the Eiffel Tower, bridges, parks, public places and shops. The city shone and glowed with life. Needless to say, the bright lights of Paris have also become synonymous with its exuberant night-life and somewhat licentious, 'naughty' image.

In the midst of the Belle Époque, with art nouveau as the predominant style, Paris capitalised on its multi-layered image as the City of Light, with the Universal Exhibition in 1900. Designed to celebrate the achievements of the past century and look forward to the new one, it was a vast showcase of the achievements and lifestyle of various countries besides France. The exhibition was visited by 50 million people and heralded the dawn of a

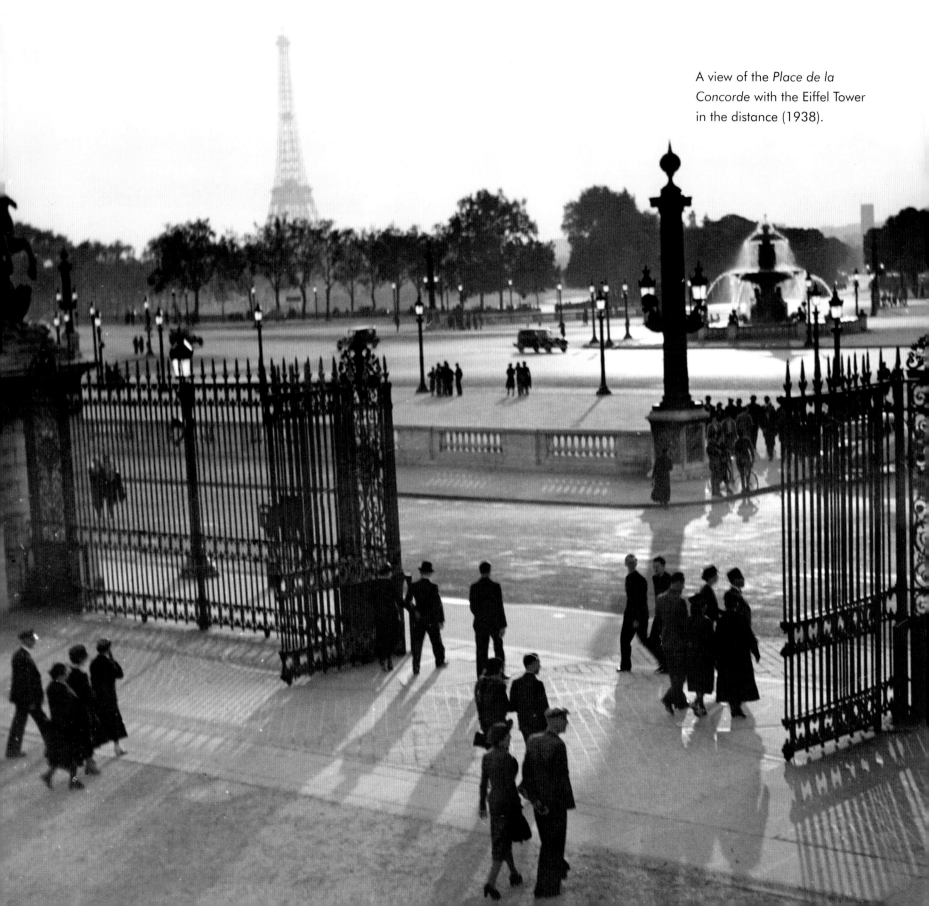

A view of the *Place de la Concorde* with the Eiffel Tower in the distance (1938).

new age and the beginning of modern urban life as the new conveniences of lifts, central heating, the motor car, cinema, the telephone, the gramophone and aeroplanes became more commonplace.

The 1900 exhibition was followed by the birth of new art forms such as Fauvism, Cubism and Futurism and the arrival of Sergei Diaghilev's sensational Ballets Russes, all of which had a huge influence on Parisian life and culture. The advent of the dance, the Tango was also a momentous event and, from 1910, inaugurated the world-wide ballroom dancing craze and the growth of cabaret, both as a place and an activity.

From 1915, World War I (also known as the Great War) disrupted everything and for nearly five years a bleak hiatus enveloped the city. However, of significance, was America's intervention in the war and the arrival of troops in August 1917. Black soldiers brought with them Jazz, which began not only the Parisian love of jazz music, but also Parisian's love of black culture in general. Following the arrival of the legendary James Reese Europe and Louis Mitchell and others, local musicians rose to the fore along with violinist, Stéphane Grappelli and the Gypsy guitarist, Django Reinhardt. They formed one of the first all-string jazz bands called the Quintette

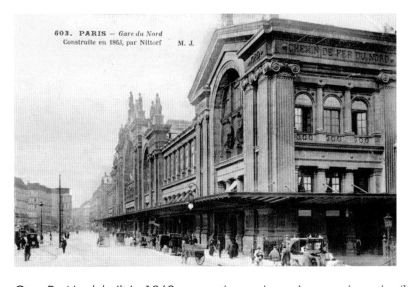

Gare Du Nord, built in 1863 by Nitorf.

du Hot Club de France in 1934. In later years, the American, Sidney Bechet became one of the most idolised jazz musicians. Needless to say, jazz became synonymous with Paris and Paris with jazz – a love affair that endures to this day.

After the Great War, Americans, in particular, flocked to Paris because of its openness, its favourable exchange rate, not to mention the fact that they did not have any prohibition on drinking alcohol as was the case in the United States at the time. They could live well on very little money and many led completely self-indulgent lives enjoying all the benefits of a more permissive and carefree society where Champagne flowed freely.

Between the wars, Paris was the undisputed international capital of pleasure and extravagance and the cultural and artistic centre of Europe. As the new angular modernistic style of art deco took hold, Paris became the centre of the avant-garde encompassing all the visual arts. Many innovative and progressive artists flourished in this environment, epitomised in particular, by the work of Matisse, Pablo Picasso, Marcel Duchamp, Jean Cocteau and Man Ray, an American visual artist who made Paris his home. As the city fragmented into the two artistic hubs of Montmartre and Montparnasse, Paris blossomed into a global tourist attraction. People flocked to enjoy its unique atmosphere and its diverse attractions of art, café society, jazz, night life, dancing, cabaret, wine, cuisine, couture, theatre, music hall and, of course, its beautiful women.

The extravagance of the revues at the Folies Bergère, Casino de Paris and the Moulin Rouge became an ideal that was exported all over Europe and the rest of the world. At the same time, beside the time honoured resorts in Montmartre such as Le Rat Mort and Abbaye de Thélème, there was an explosion of new 'dancings' and nightclubs such as Le Perroquet in the Casino de Paris, and Le Boeuf Sur Le Toit to match the proliferation of the distinctive Parisian cafés like the hugely popular Les Deux Magots, Café de Flore and Café du Dome. It was once said that to become a fashionable 'dancing' place, it had to be small, crowded and difficult to dance. Many emerged one season and disappeared the next.

Haute couture, long a Parisian institution, reached even more dazzling heights following the glittering creativity of Paul Poiret, Worth, Paquin and others. New designers became de rigueur including the British born Lucile and Edward Molyneaux along with French designers such as Coco Chanel and Jean Patou. Paris became the envy of the world and a showcase for the glamour and style. Designers were relentlessly copied everywhere. Perhaps the only challenge that Paris faced was from the emerging brilliance of Hollywood designers as fashion in moving pictures began to set the latest fashion trends.

Besides the radical advancement in the arts and entertainment, Paris also became an intellectual hub most noticeable for its literary aspirations led primarily by Gertrude Stein who hosted weekly discussion salons in her atelier in the Rue de Fleurus. Stein coined the phrase 'the lost generation' to describe the American writers who flocked to Paris including F. Scott Fitzgerald, Ernest Hemmingway and the journalist Janet Flanner. All gravitated around, what was to become another celebrated Parisian landmark, Shakespeare and Company, a bookshop and small press owned by Sylvia Beach.

Paris was the place of tolerance where diversity was clebrated and free expression of sexual orientation, colour of skin and background was embraced. Parisians maintained an open fascination with black culture – black was beautiful and fashionable. This was highlighted by the successful staging of black revues such as *La Revue Nègre* (1925) that introduced young African Americans, Josephine Baker and Florence Mills at the Café des Ambassadeurs (1926). Both women swiftly became the toast of Paris. Equally, the Bal Negre became a showcase for open multi-racial dancing. One cannot forget that Paris had its own home-grown stars to compete with the imported American talent and luminaries such as Gaby Deslys, the incomparable Mistinguett and the legendary Maurice Chevalier.

For ordinary Parisians, living and working in the city, alongside the bright lights, the extravagances of the rich and the deluge of foreign visitors, life simply went on. Factory workers, government bureaucrats, waiters, dancers, musicians, street vendors, shopkeepers, business people, cleaners, labourers, drivers and policemen all worked relentlessly behind the scenes in time-honoured fashion.

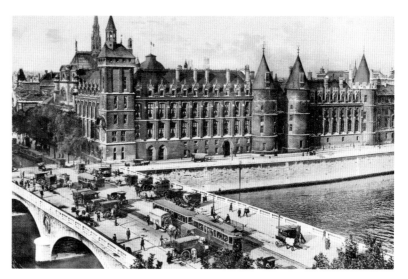

La Conciergerie, with the Pont au Change in the foreground teaming with traffic, (c. early 1900s).

Of course, many big luxury brands flourished as they catered for the new rich elite. Car manufacturers, Renault and Andre Citreon (who gave the masses the 5CV, France's first popular car), Coty (perfume), Cartier, (jewellery), Dubonnet (aperitif), Louis Vuitton (travel goods) and the department stores of Bon Marche, Printemps and Galeries Lafayette all prospered.

The freneticism of the Jazz Age was followed by the occupation of Paris by the Germans during World War II, 1940–1944. Despite the humiliation and the austerity of rationing, the deportation of Jews and the execution of dissidents, Paris continued its artistic, literary and theatrical life. Thankfully Paris was spared destruction. Liberation by the Americans was a jubilant occasion, with Charles de Gaulle, who had led the Free French Forces from exile in London, taking power in the interim government. Whilst enduring the bleakness of the early 1940s and the Cold War with the USSR that followed, Paris couture flourished once again. Christian Dior's New Look of

1947 revolutionised fashion, redefined Paris couture and ushered in a new era. This paved the way for Yves Saint Laurent, regarded as one of the greatest names in fashion history. At the same time, great efforts were placed on regeneration and new building projects introduced new landmarks most notably the Centre Pompidou (1977) and the Pyramid at Le Louvre (1989).

Despite many ups and downs, including the Algerian crisis in 1950s and the student riots in 1968, Paris has maintained its visibility as a European treasure and although perhaps its allure as a cultural melting pot waned after World War II it has reinvented itself by placing huge emphasis on its cultural and architectural heritage, almost as a living museum. It is still highly regarded for the excellence of its cuisine, art and couture, all of which have continued to make it a beacon to visitors. Even today Paris remains the most popular tourist attraction in the world with over 32 million visitors in 2013. It is not difficult to understand why.

Significantly it is also thought to be the most romantic city in the world and Paris continues to flourish as a magnet for lovers despite the many clichés. Simply put, as a rendezvous for love, Paris has it all. It is easy to seduce the senses and lapse into complete indulgence from the comfort of its elegant hotels, world-class dining and candlelit suppers. There are many idyllic daytime activities to enjoy such as a cruise on the Seine, a show at Le Lido or the Moulin Rouge to see the infamous can-can, watching the sunset from one of the many iconic vantage points such as the Eiffel Tower, a tour of its many glorious museums, a walk through the parks and open spaces such as the Place de Vogues or the Jardin de Luxembourg. And, finally of course, there is nothing better than to have breakfast, lunch or just sip coffee, hot chocolate or a little aperitif and wile away the day watching everyday life in one of its many cafés. Paris has it all.

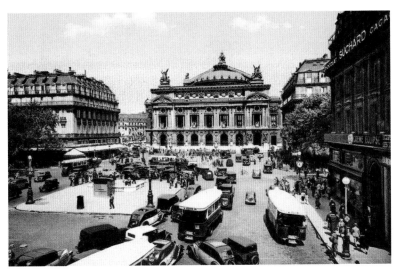

Place de l'Opéra: the hub of Paris, therefore of France, therefore of the world, (c. early 1900s).

Retro Paris seeks to bring together a collection of photographs and a range of other images documenting the world of 20th century Paris, through the Belle Époque, the frenetic Jazz age, two world wars, the swinging sixties and beyond.

It draws on the vast archive of images from the Mary Evans Picture Library. The library's founders, Mary and Hilary Evans, were erstwhile Francophiles and owned a flat in Paris where they spent many holidays collecting material to add to their ever-expanding collection.

Founded and based in Blackheath in South East London, the library has preserved our past in pictures since the library started in 1964. It has accumulated a wealth of visual photographs and illustrations depicting the minutiae of everyday life – what people wore, what they ate, what amused them and what shocked them. This rich visual treasure trove is supplemented and enhanced by a fascinating variety of ephemera – magazine covers, scraps, cigarette cards, advertisements, theatre programmes, music sheets, tickets, documents and cartoons.

Anyone who loves Paris will see much that will excite, inform and delight from the famous Parisian monuments, the celebrated personalities, everyday life, the many artistic movements, the many highs and lows including the Nazi occupation, the glamour of Parisian couture and its sparkling night life all of which present a nostalgic romp through 20th century Paris to show the alluring beauty of the world's most romantic city.

ICONIC PARIS

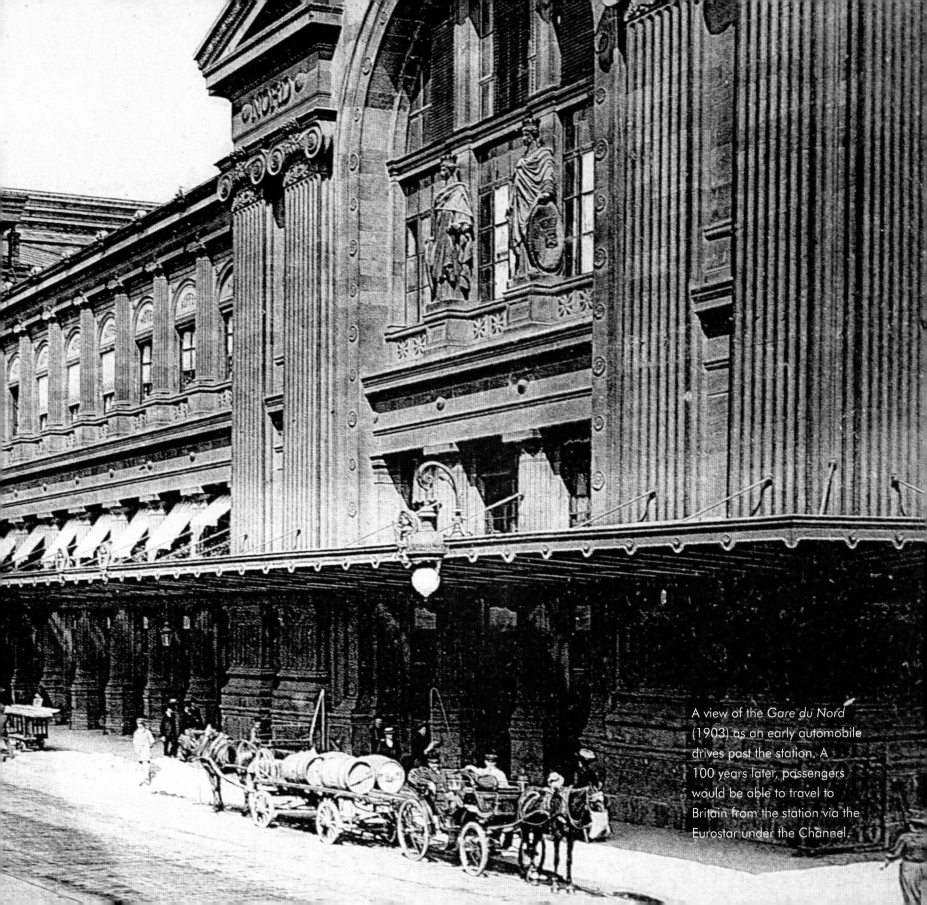

A view of the *Gare du Nord* (1903) as an early automobile drives past the station. A 100 years later, passengers would be able to travel to Britain from the station via the Eurostar under the Channel.

Arriving in Paris is always a magical experience. The excitement of the place is palpable and often it is difficult to decide what to do first. Usually visitors converge into the grand capital of France via one of its landmark rail stations such as the Gare de Nord, now made famous because of Eurostar. They then disperse via the Métro or taxi to their apartments or hotels.

It is helpful that Paris is divided into twenty districts (*arrondissement*). The central district is followed by others that spiral outwards in a clock-wise direction and most of the iconic attractions can be found in one of the central eight arrondissement.

First time visitors should remember that, like so many cities, Paris is best seen on foot. Taking on the role of the time honoured *flaneur*, someone who strolls through a city observing its history and atmosphere at first hand, is ideal. It is the perfect way to observe the famous landmarks that Paris has to offer – and there are many. Of course you can supplement your energetic perambulations by using the buses, taxis, the Métro and the fine bateaux mouche on the Seine, all of which should feature in any Parisian experience.

But where do you start? Clara E. Laughlin in the book, So You're Going to Paris (1924) offers the best advice that the Place de la Concorde is the perfect orientation point to view the central heart of Paris and explore many of its key monuments. Stand with your back to the Arc de Triomphe, near the entrance to the Avenue des Champs-Élysées, and look east toward the Jardin des Tuileries and Le Louvre, south to the Seine and North toward the Rue Royale and the Madeleine. This is where the guillotine stood in the period 1793–94 and where Marie Antoinette met her final fate. It is also often the finale of any ceremonial parade down the Champs-Élysées.

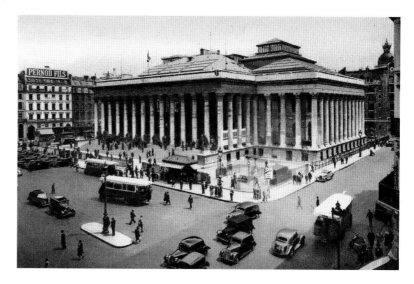

The Bourse, Paris 1920.

From here you can walk in either direction. Going north takes you along the Rue Royale where you can take a peek at the infamous art nouveau restaurant of Maxim's. At the end, in a commanding position, is the Roman Catholic Church of the Madeleine. Travelling via the Boulevard des Capucines, past the Olympia music hall, brings you to the Place de l'Opéra and the spectacular Opéra Garnier. From here you can make your away north to visit the grand department stores of Galeries Lafayette and Printemps on the Boulevard Haussmann before moving back, with a digression to inspect the art deco splendour of the Folies Bergère. Return to the Place de Concorde via the Bibliotechique Nationale, past the Palais Royal and along the Rue Saint-Honore.

Walking east along the Avenue des Champs-Élysées you can visit the Grand Palais and Petit Palais built for the Universal Exhibition of 1900, explore the smart shops, stop at the famous Le Lido music hall and emerge at last before the Arc de Triomphe. From here follow the Avenue d'Iena to the Palais de Chaillot, (formerly the Trocadero) a neo-classical building constructed for the world fair, Exposition Internationale des Arts et des Techniques appliqués à la vie moderne, in 1937. Cross the Pont d'Iena to the Eiffel Tower, perhaps the most well known of all Parisian landmarks. After having a rest in the delightful expanse of the Parc du Champs de Mars, pass the École Militaire and head north via the Avenue de Ségur to the Dôme des Invalides, a monument in the Parisian landscape not to be missed. Here is Napoleon I's tomb and the emblem of the Hôtel National des

Invalides, a group of monuments and museums relating to the military history of France.

Venturing south across the Pont de la Concorde, visit the grand Musée d'Orsay once a pivotal railway station and now a superbly appointed museum. Follow the Boulevard Saint Germain to the church and square of Saint-Germain-des-Prés and stop at the café Les Deux Magots or Café de Flore before returning via the narrow Rue de Bonaparte and the river. Turning east, walk along the Rue de Rivoli, take in the glorious space of the Jardin de Tuileries and the irresistible majesty of Le Louvre. Then visit the Île de la Cité finding the hidden medieval church of Sainte-Chapelle. With its magnificent stained glass windows, it is regarded as one of the historic treasures of Paris. Close by is the majestic cathedral of Notre-Dame de Paris, a Gothic masterpiece completed in 1330 after 170 years of construction.

Back along the south (left) bank, La Rive Gauche, you will find the bouquinistes or the second hand book-sellers, to complete the tour. Of course, there must be various trips to explore the other areas of Paris. A visit to Montmartre, for example is essential. On the summit of the butte Montmartre, the highest point of the city,

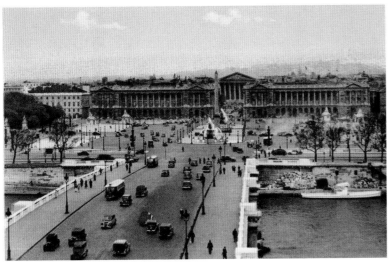

A view of the expansive Place de la Concorde from the Pont de la Concorde, the bridge that leads to it over the River Seine, (c.1920).

is the elegant and imposing church of Sacré Cœur, ideally reached by the funicular or cable railway. Stop at the Place du Tertre, famous for its artists and cafés before exploring the Place Pigalle, once the centre for nightclubs and 'dancings' in the Jazz age and of course, the infamous Moulin Rouge. But don't forget the poignancy of the Montmartre cemetery, the final resting place of so many treasured and famous souls including Alexandre Dumas, Sacha Guitry and Nijinsky.

On the left bank, visit the Latin Quarter full of cafés and jazz clubs, the Panthéon and the Sorbonne, seat of the University of Paris before a wander through the luxuriously appointed Jardin du Luxembourg. Then onto Montparnasse to savour the delights of the Café Le Dôme and the restaurant La Coupole that opened in 1927 and is now celebrated for its seafood.

The districts in the west side of Paris are equally attractive. The area of Les Halles was once the busy central market for fresh food that was demolished in 1971. It is now a modern shopping mall, mainly underground and a central hub of the rail network. At street level, one finds extensive green space. Beyond the Centre Pompidou are the narrow streets of the revamped Marais, often described as the most fascinating area of Paris. Revived in the 1960s with the influx of the gay community, it now has some of the city's hottest bars and restaurants. As such, it is now chic and fashionable with its narrow streets, cafés, shops and artisans. Finally, there is the glorious Place des Vosges and the historic Place de la Bastille.

Don't forget a general walk along the river on both sides underneath the bridges, a boat ride along the River Seine, a trip to the Bois de Boulogne, a large public park located along the western edge of the 16th arrondissement, a visit to Versailles and a weekend excursion to Porte de Clignancourt in the north of Paris for the biggest antique market in the world. This is just a taste of the highlights, as Paris offers an extensive menu of things to do and see from parks, museums, art galleries, restaurants, music halls, nightclubs, restaurants, shops, not to mention just simply watching everyday life at one of its thousands of cafés.

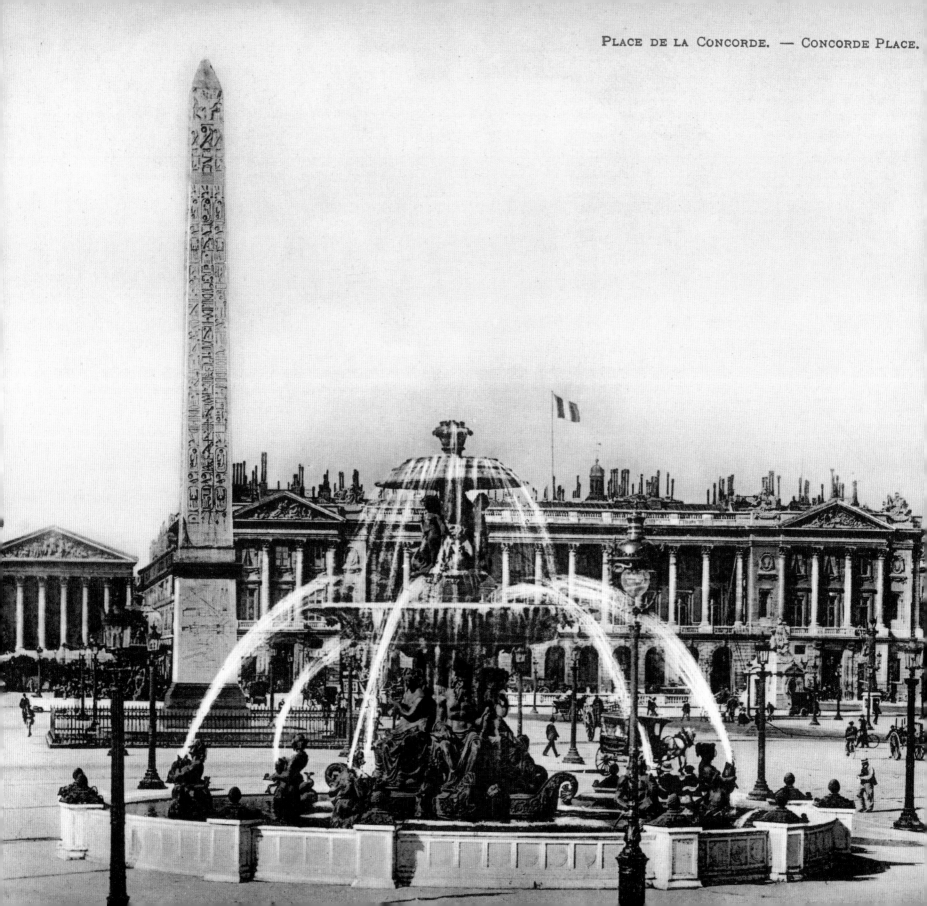

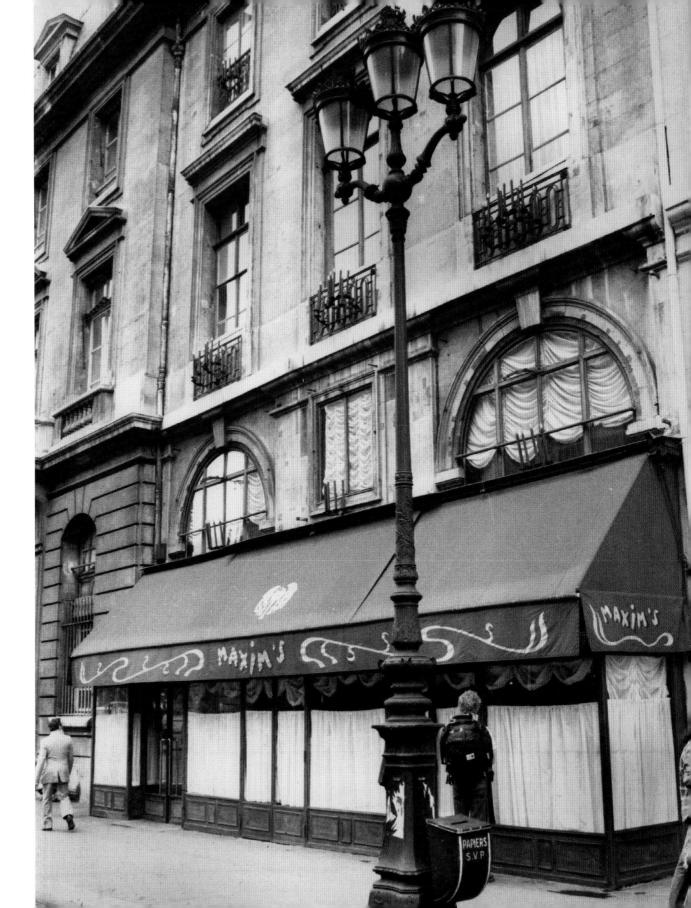

LEFT: Place de la Concorde with the fountain in the foreground and obelisk from the temple of Ramses II in Thebes, (c.1905).

RIGHT: Maxim's restaurant on the Rue Royale, (1979).

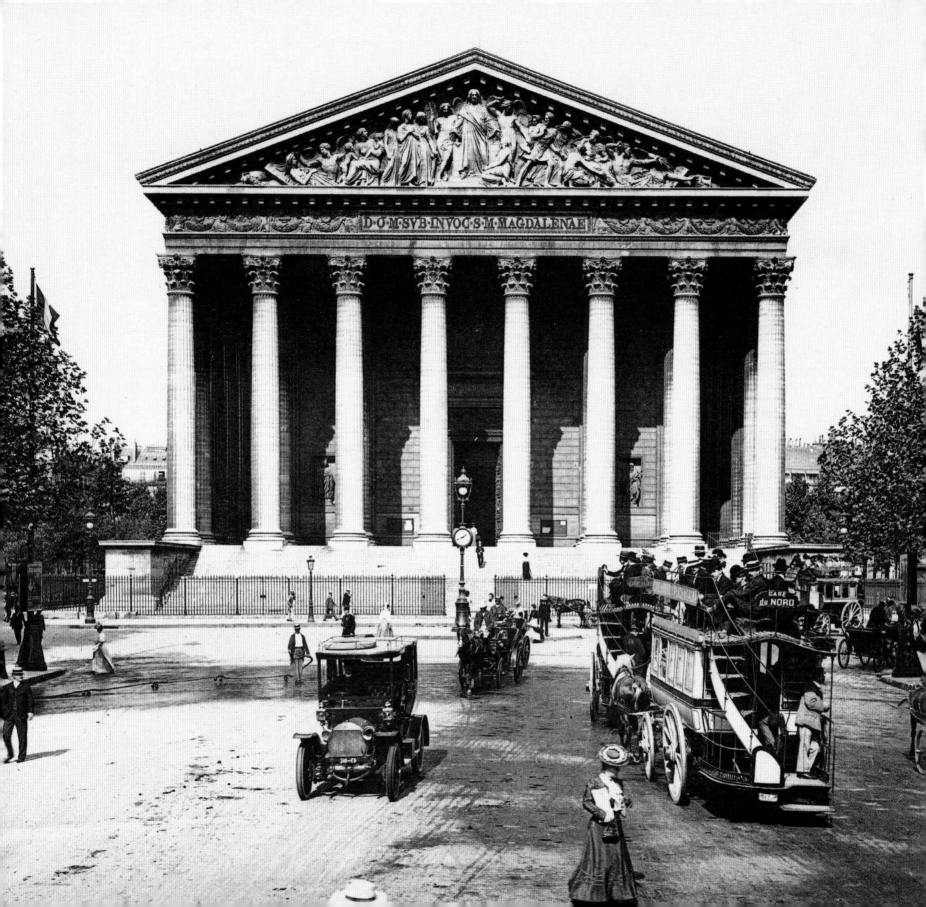

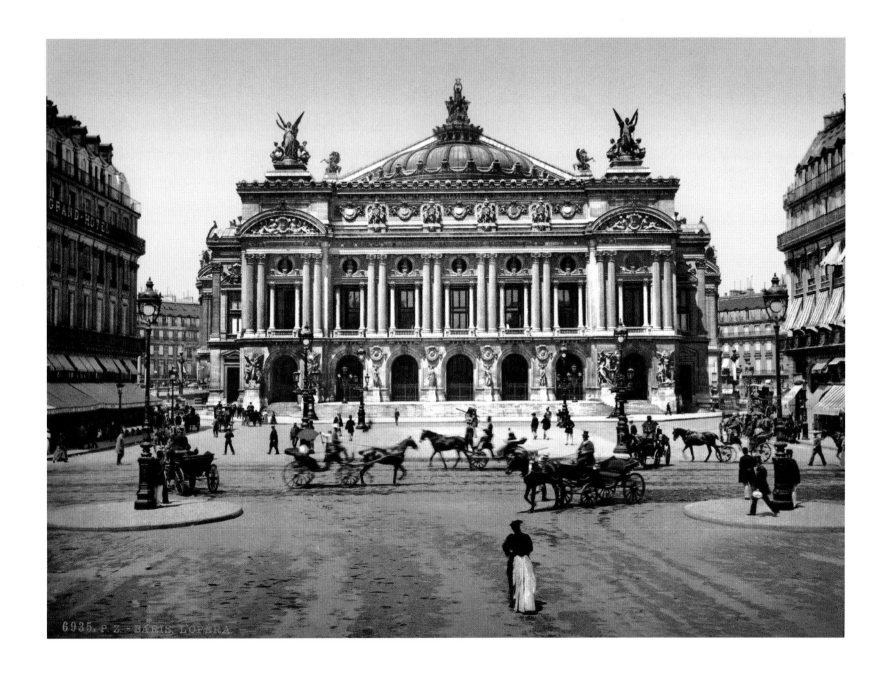

6935. P.Z. - PARIS. L'OPERA.

LEFT: The classical facade of the Madeleine church dedicated to Mary Magdalene. The original church was never completed and Napoleon built this monument in the neo-classical style as a memorial to his army. It was later converted to the church we see today, (1904).

ABOVE: The spectacular Opera House or Opéra Garnier in the last decade of the 19th century. Designed by Charles Garnier, it housed the Paris Opera from 1875–1990, (c.1890s).

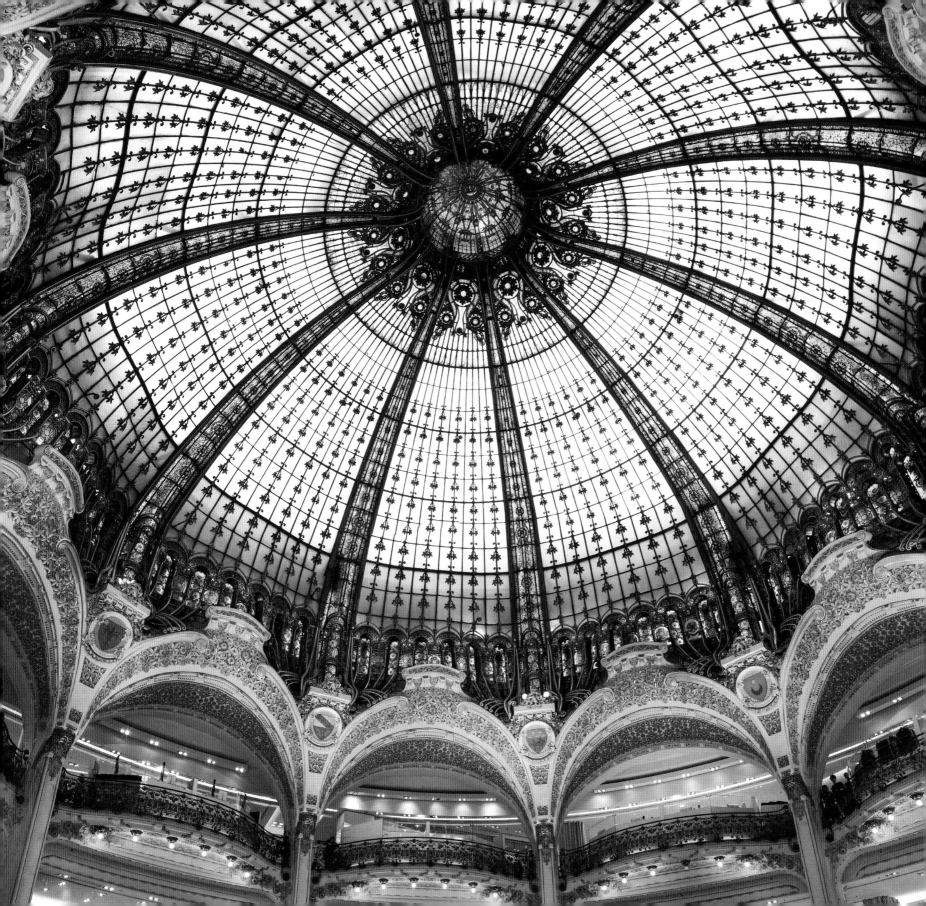

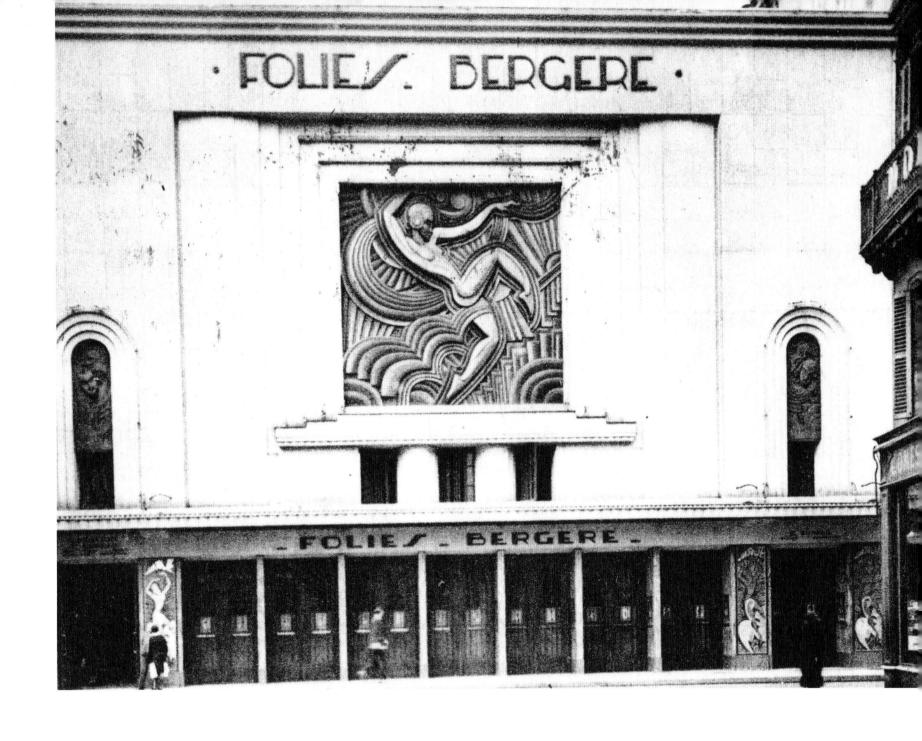

LEFT: An interior view of Galeries Lafayette, the most famous of Parisian department stores on the Boulevard Haussmann. The ten-storey building, opened in 1912, is crowned with a magnificent iron and glass dome.

ABOVE: The exterior of the Folies Bergère, one of the most popular music halls in Paris and home to some of the most spectacular revues in history, (c.1920s).

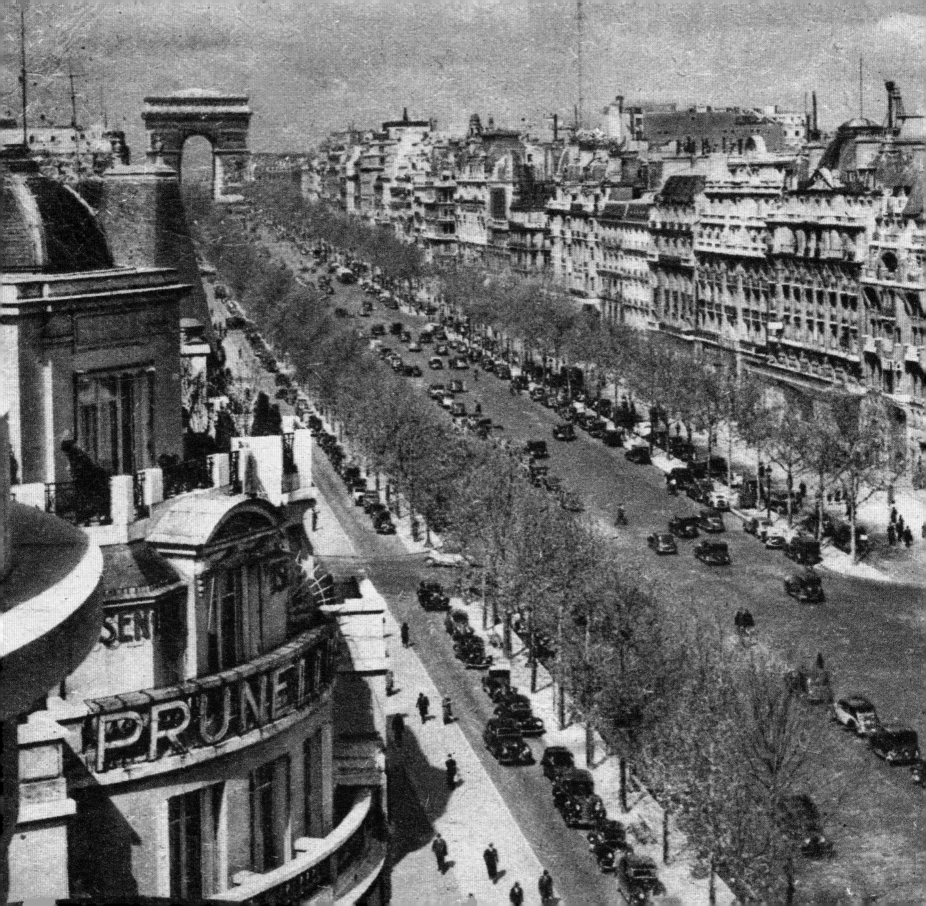

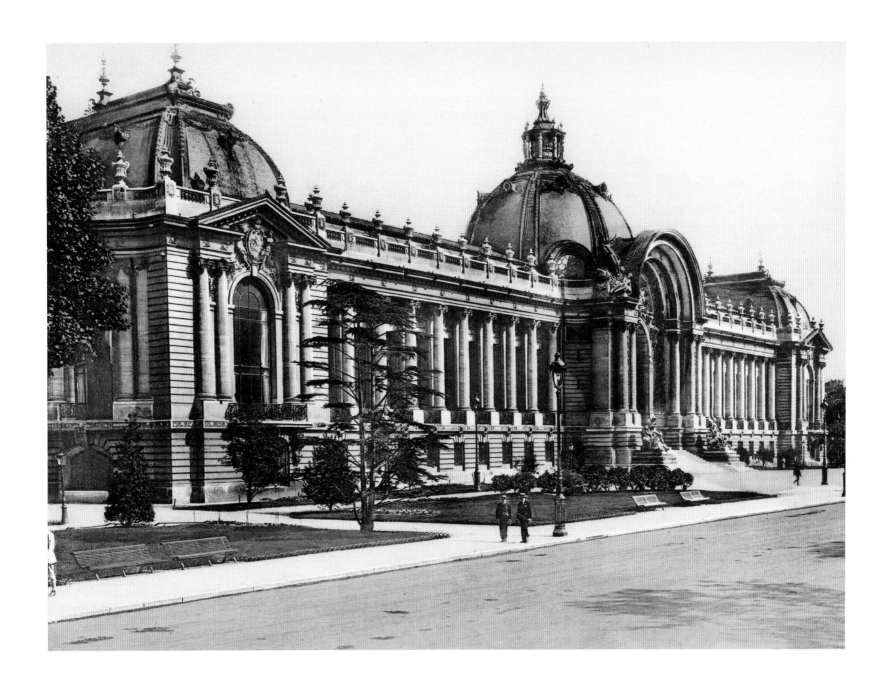

LEFT: The Champs-Élysées soon after World War II, (c.1946).

ABOVE: Le Petit Palais built for the Universal Exhibition in 1900. Designed by Charles Girault in the *beaux-arts* style, it now houses the museum of fine arts, (c.1905).

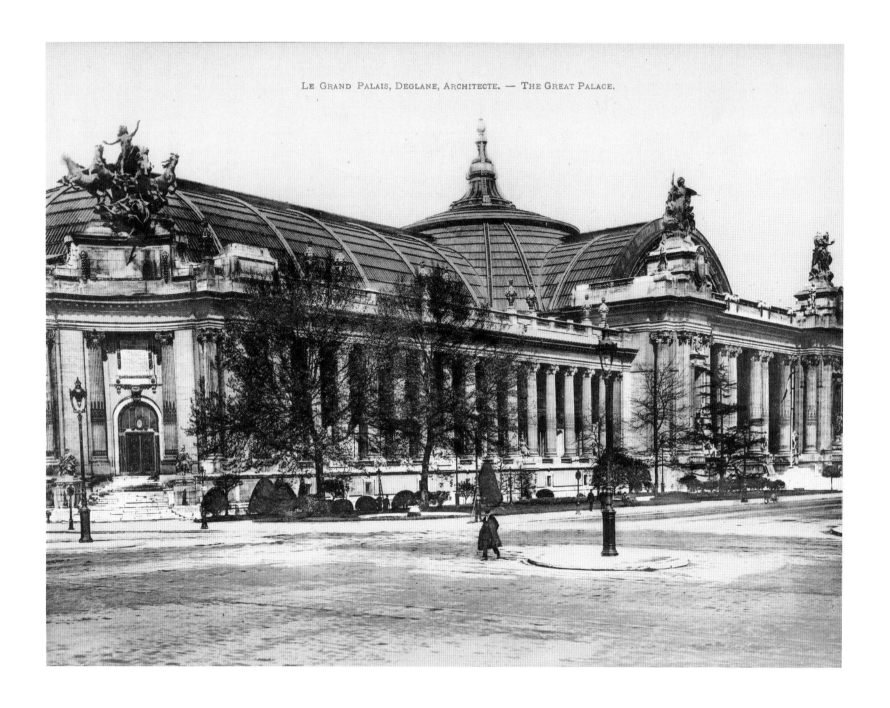

ABOVE: The Grand Palais built for the Universal Exhibition in 1900. Designed by a group of four architects in the *beaux-arts* style, it now has a variety of function areas for exhibitions and fashion shows, (c.1905).

RIGHT: The Arc de Triomphe is situated in the middle of the Place Charles de Gaulle (originally Place de L'Étoile). Built to honour those who fought in the revolution and the Napoleonic wars, it has become one of the most famous of Parisian monuments, (c.1908).

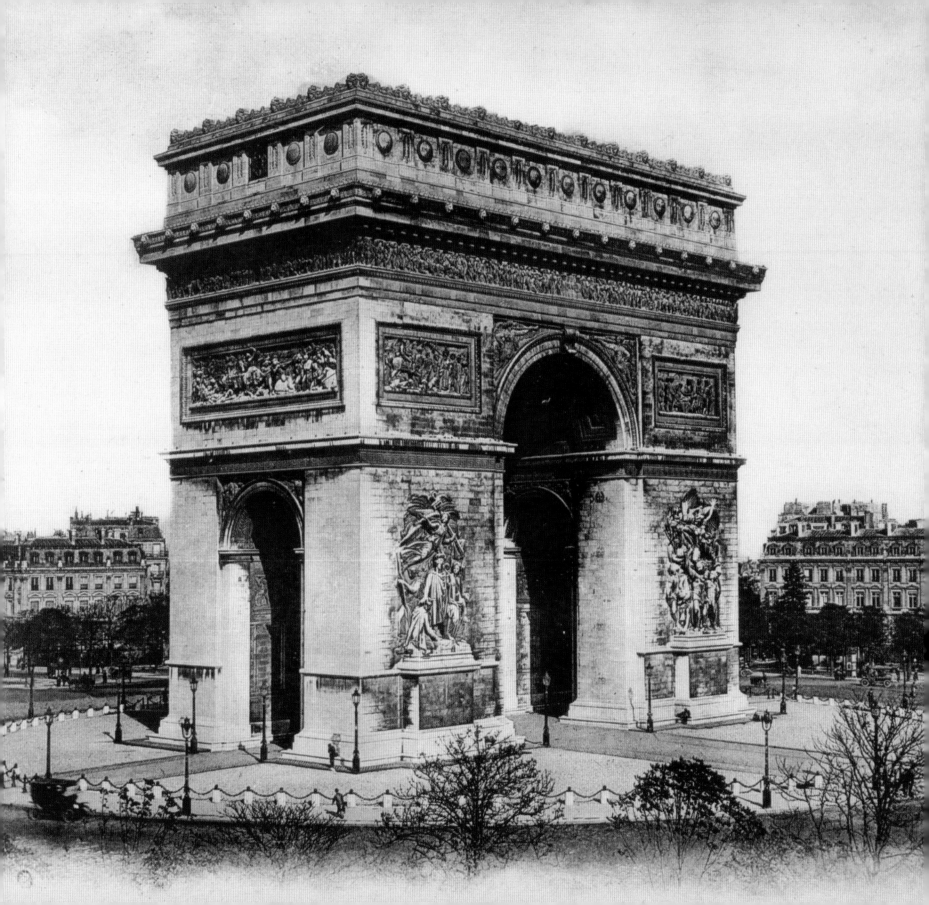

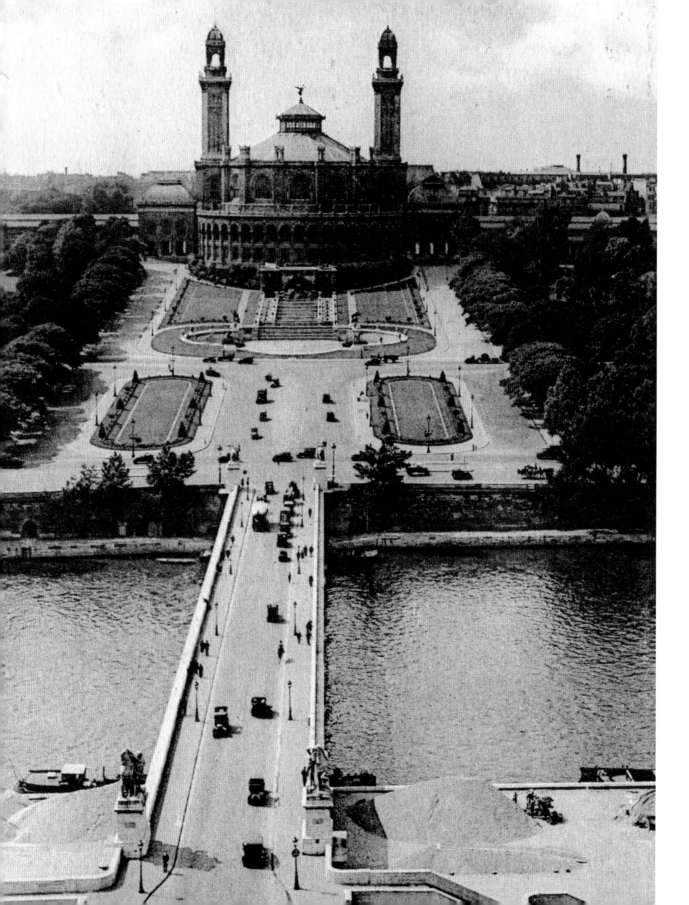

LEFT: A view of the Palais du Trocadéro, gardens and the Pont d'Iena in the 16th arrondissement, (1931). Designed by architects Davioud and Bourdais for the World Fair in 1878, it features Moorish and Byzantine elements.

RIGHT: The Palais du Trocadéro was demolished for the 1937 World Fair and replaced by the Palais de Chaillot. This view was taken from the Eiffel Tower in 1954. Below the *Palais* is the first headquarters of the UN (1946–1951). The latter was later removed and the area reverted to gardens.

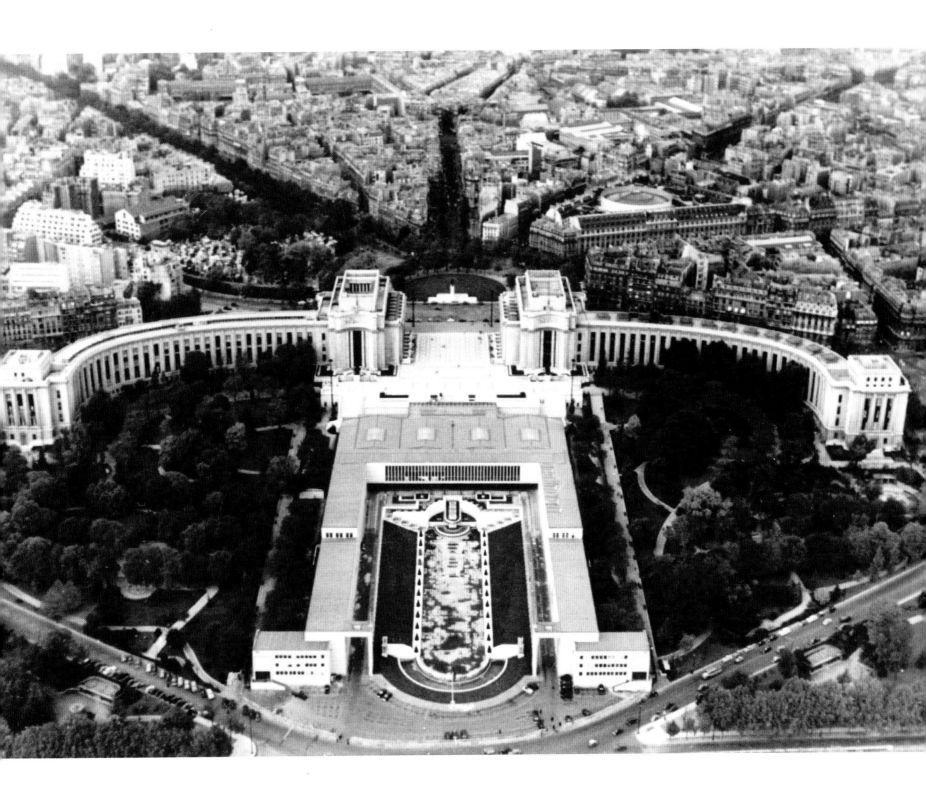

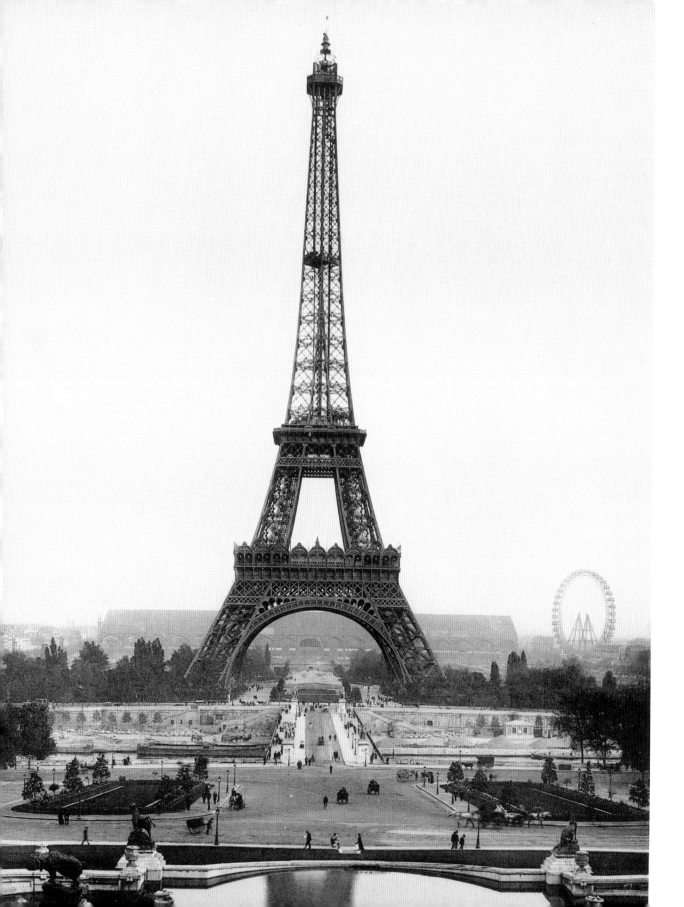

LEFT: The Eiffel Tower built for the occasion of the *Exposition Universelle* of 1889. The world far was staged during the 100th anniversary of the French Revolution. This photo was taken at the time of the 1900 Exhibition.

RIGHT: A view of Paris and the River Seine from the Eiffel Tower, (c.1960s).

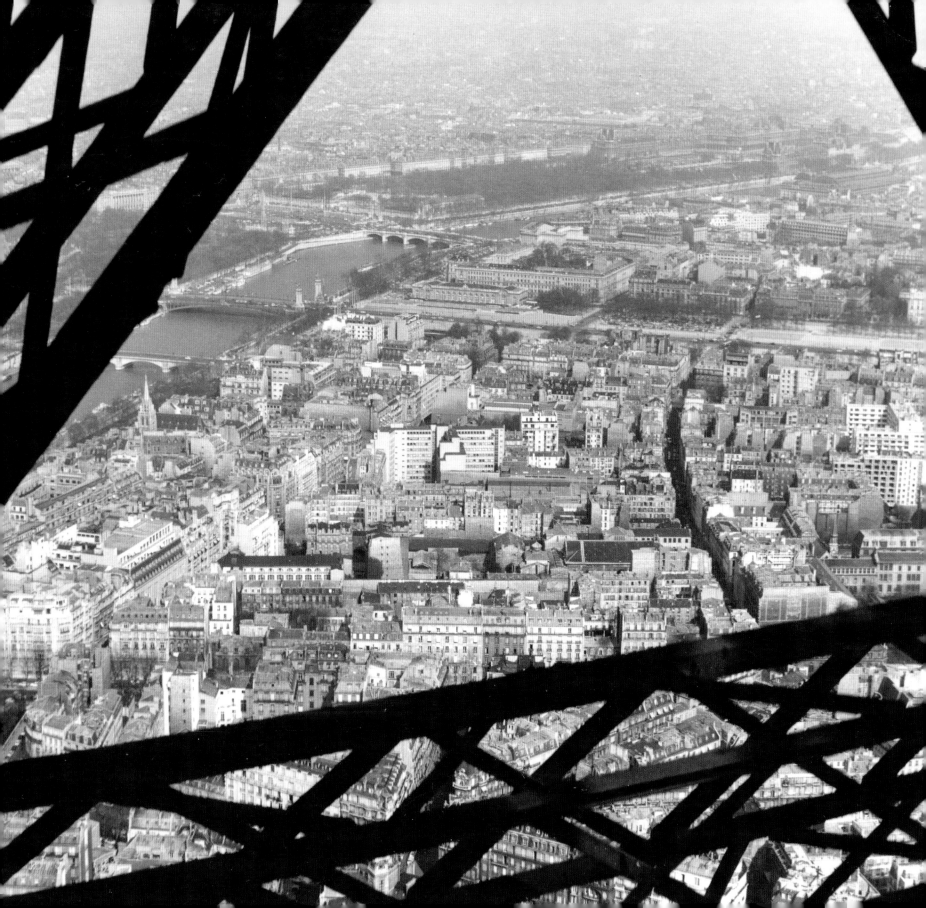

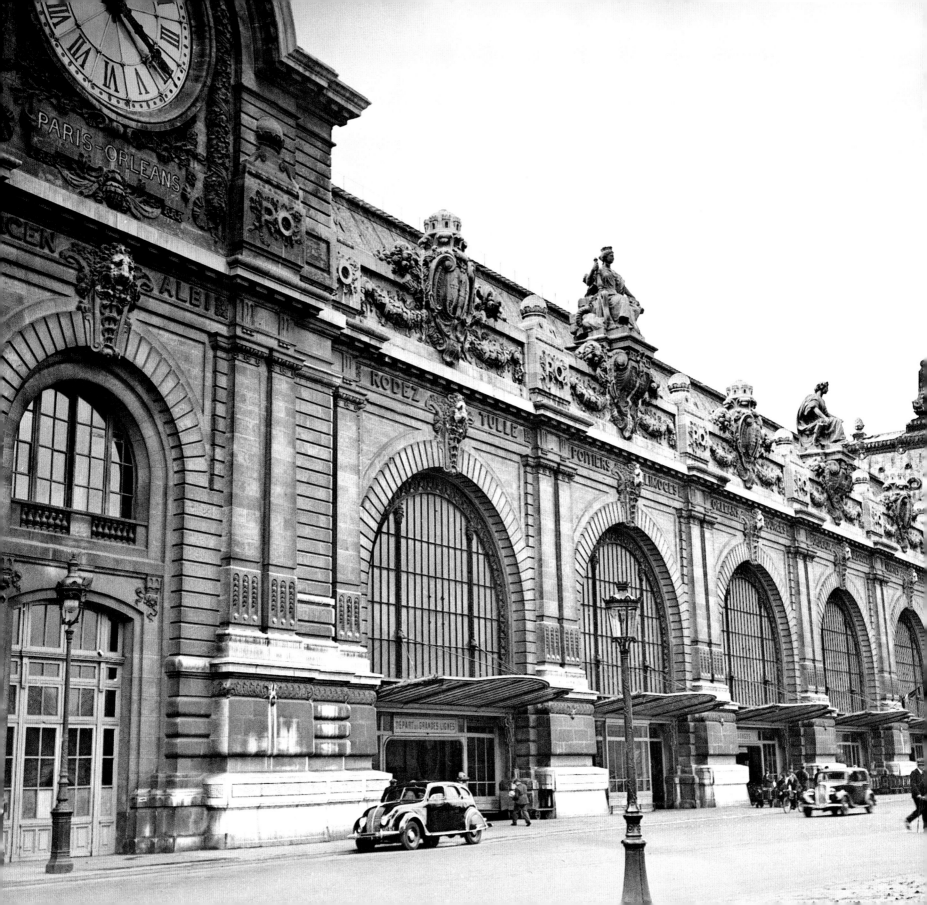

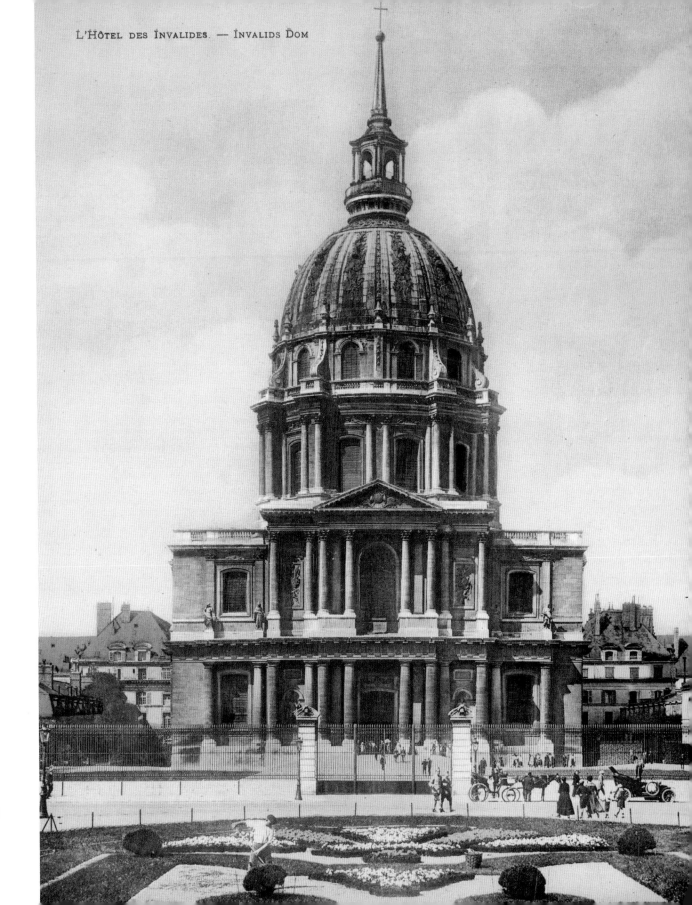

L'HÔTEL DES INVALIDES. — INVALIDS DOM

LEFT: The train station Gare d'Orsay was built opposite Le Louvre in 1900. Abandoned from 1961, the station was transformed into the Musée d'Orsay between 1977, when the decision was made, and 1986 when it was finally completed, (1935).

RIGHT: Dôme des Invalides, part of the complex known as Hôtel National des Invalides founded in 1671 by Louis XIV and now, housing the tomb of Napoleon, (c.1905).

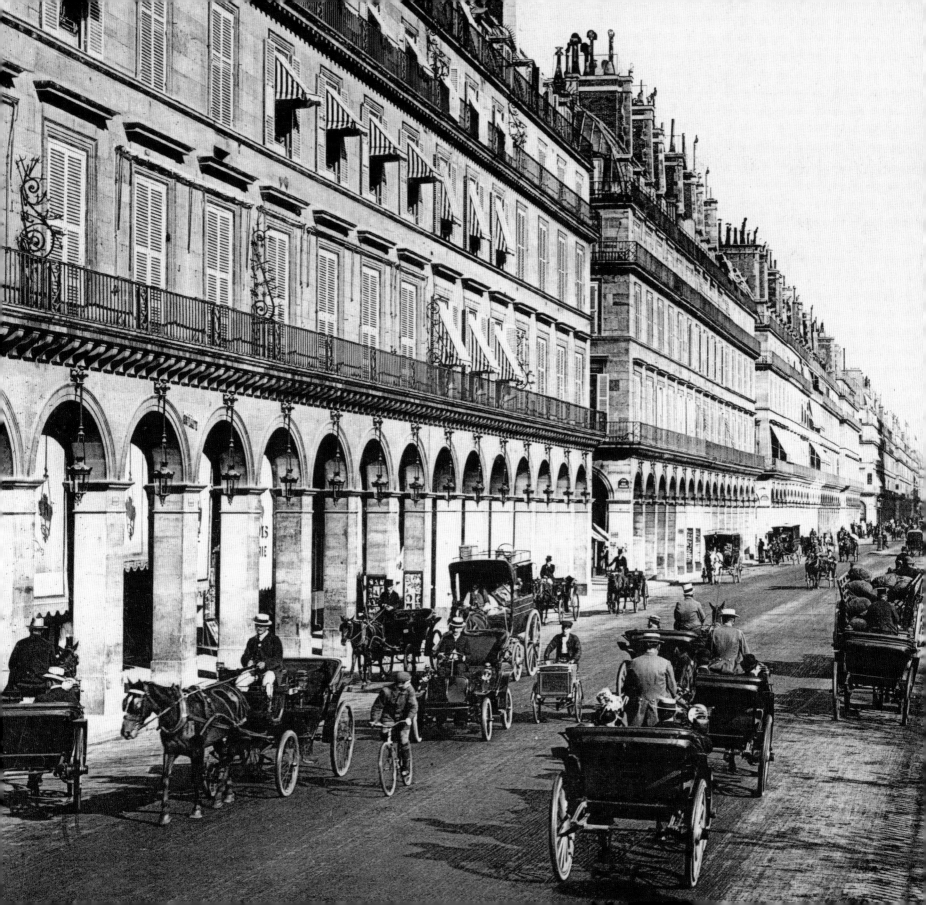

LEFT: The Rue de Rivoli, (1904).

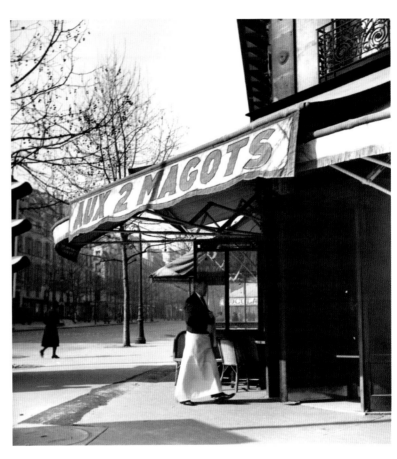

ABOVE: The famous café Les Deux Magots in Saint-Germain-des-Prés, a favoured rendezvous of many intellectuals, artists and musicians, (1943).

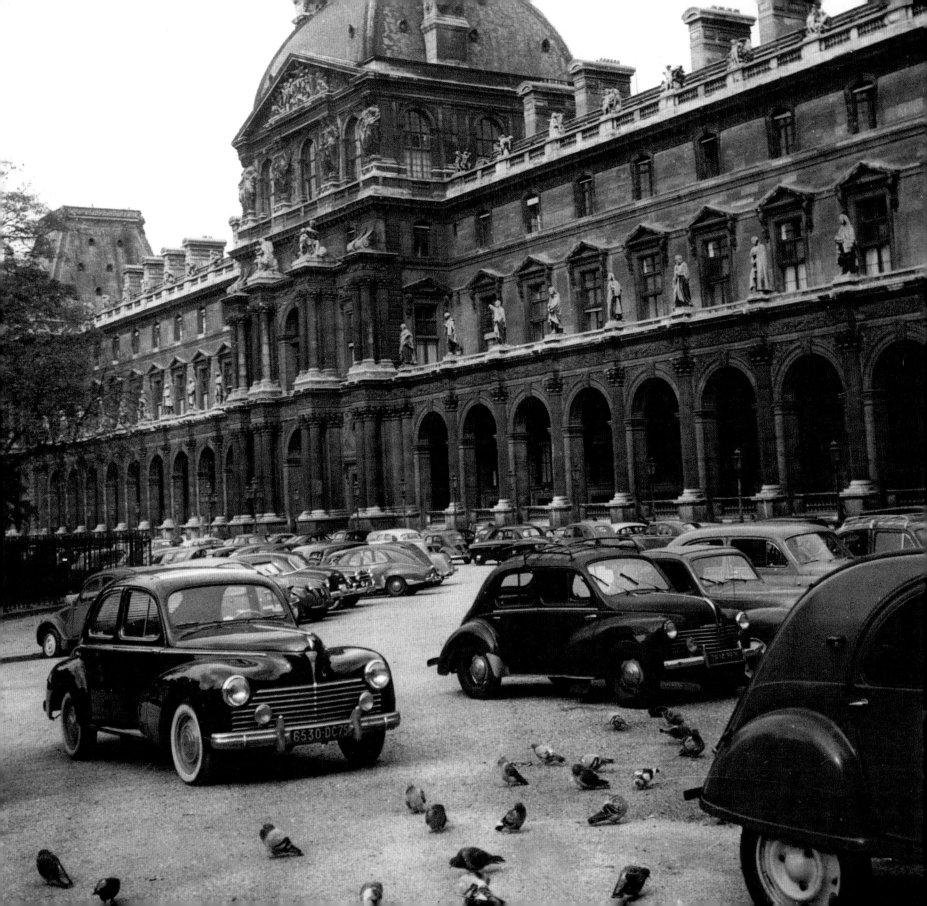

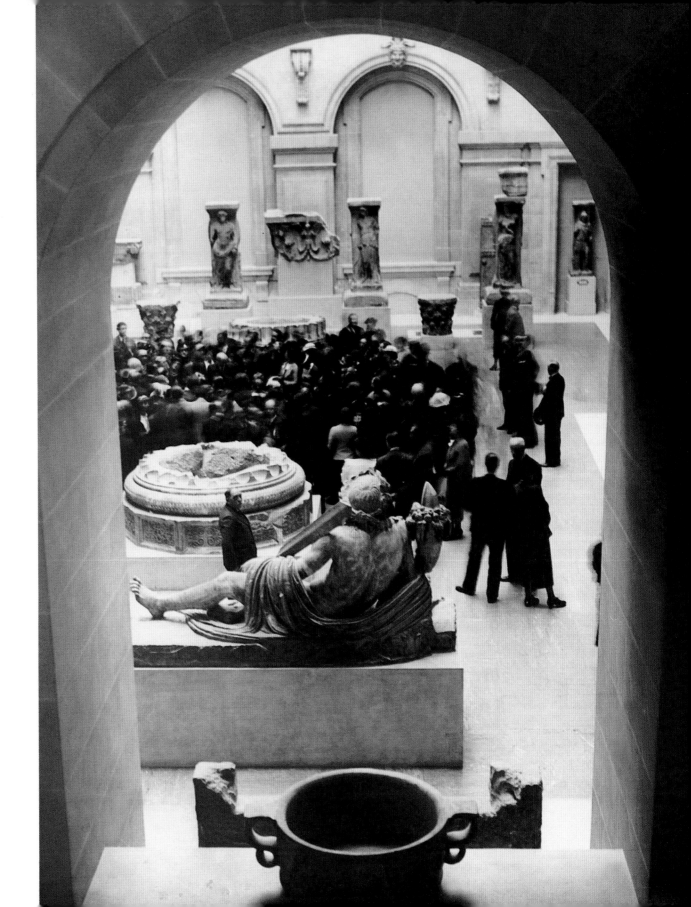

LEFT: Le Louvre museum in 1954. Originally the royal palace, it is now one of the world's most famous museums.

RIGHT: Museum visitors in Le Louvre observing the antique sculptures, (1936).

ABOVE: Typical ambience
of Paris in the Rue de Seine,
(1958).

RIGHT: A view of the Île de
la Cité with the River Seine
flowing on either side with the
Pont Neuf (bridge) joining the
right and left banks and the
Notre-Dame in the distance,
(1904).

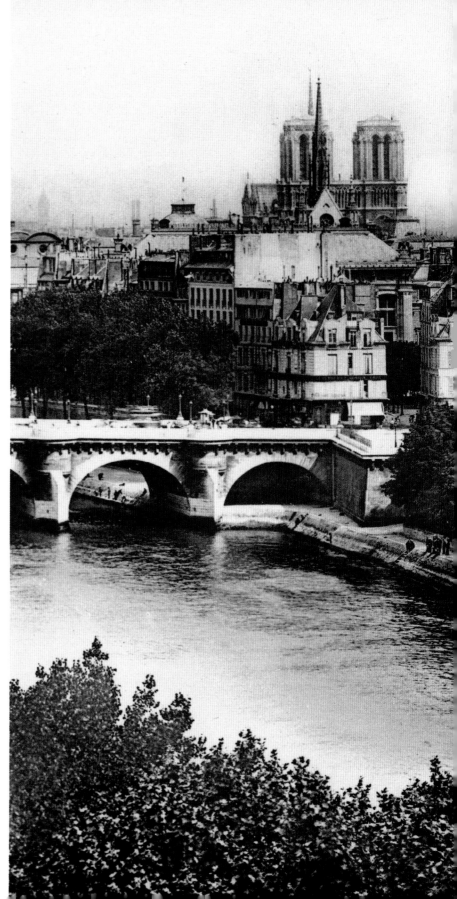

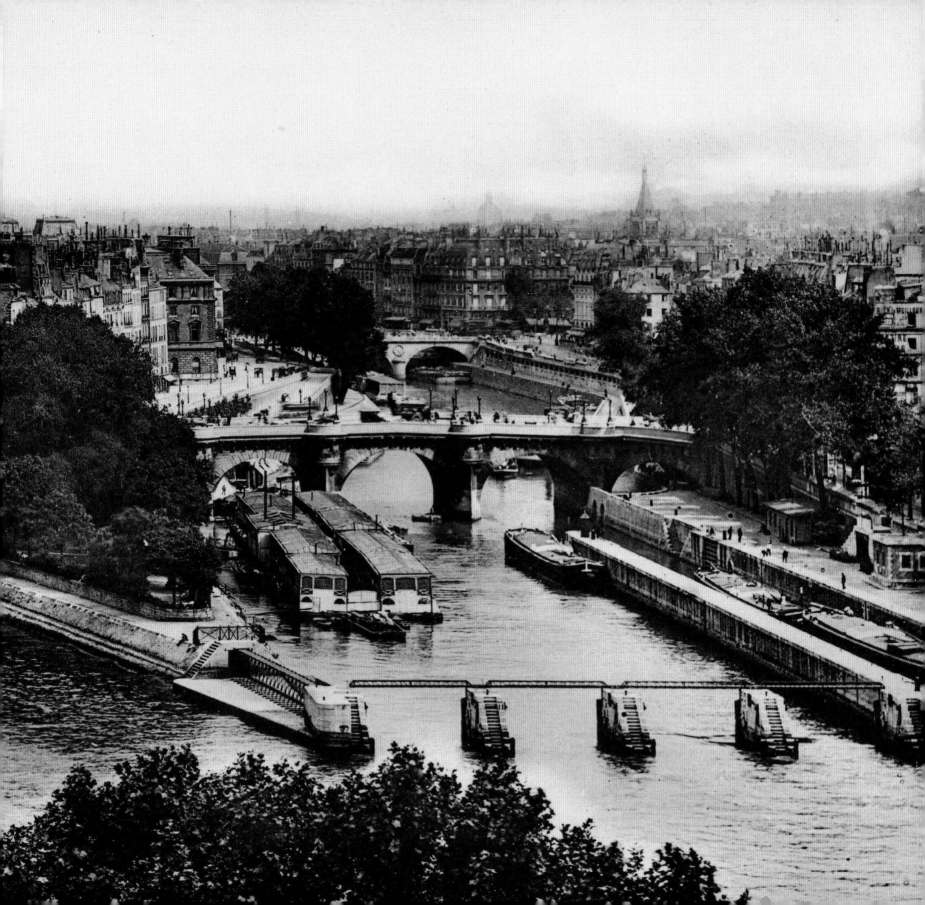

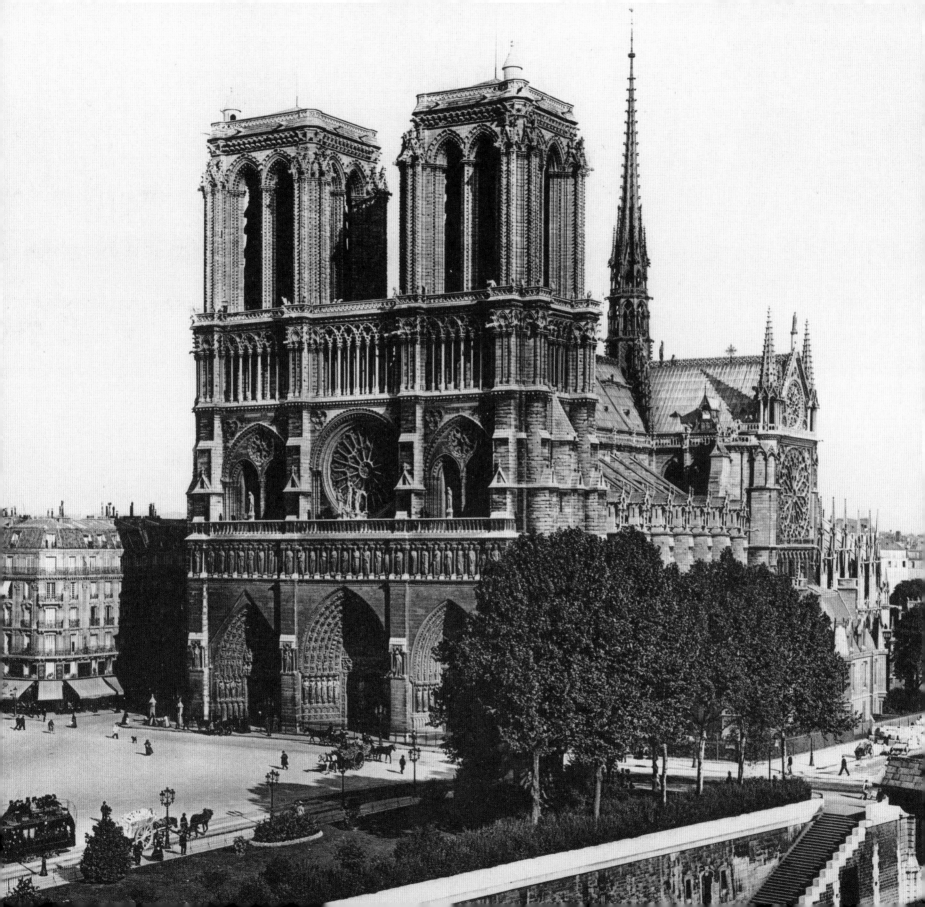

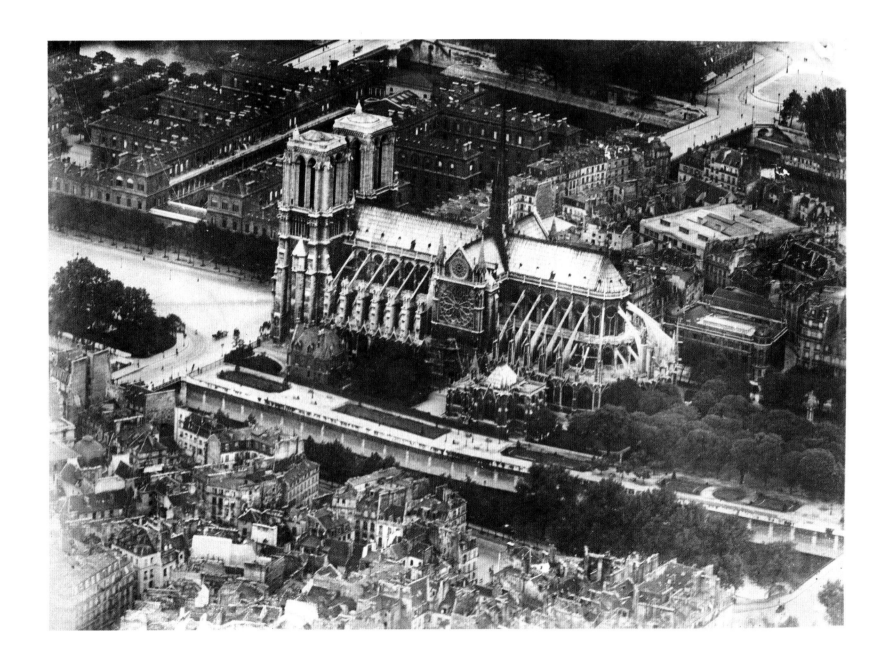

LEFT: An exterior view of Notre-Dame: the construction of this
gothic masterpiece, the cradle of Paris and the religious centre of
the city, began in 1163 and was completed in 1272, (c.1900).

ABOVE: Notre-Dame cathedral as
seen from the air, (c.1930s).

BELOW: The *bouquinistes* whose stalls form a permanent book and print market lining the Quai de la Tournelle on the banks of the River Seine, (c.1930s).

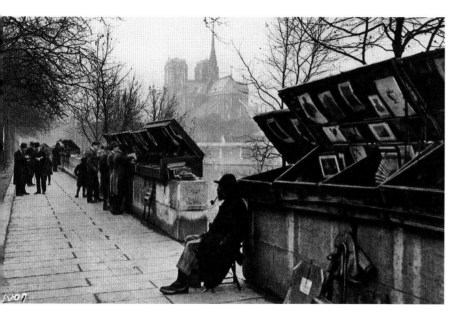

RIGHT: The Sacré Cœur stands high on the butte Montmartre, but you don't have to walk up the hill; there's a funicular (cable railway) to carry you to the top, (c.1904).

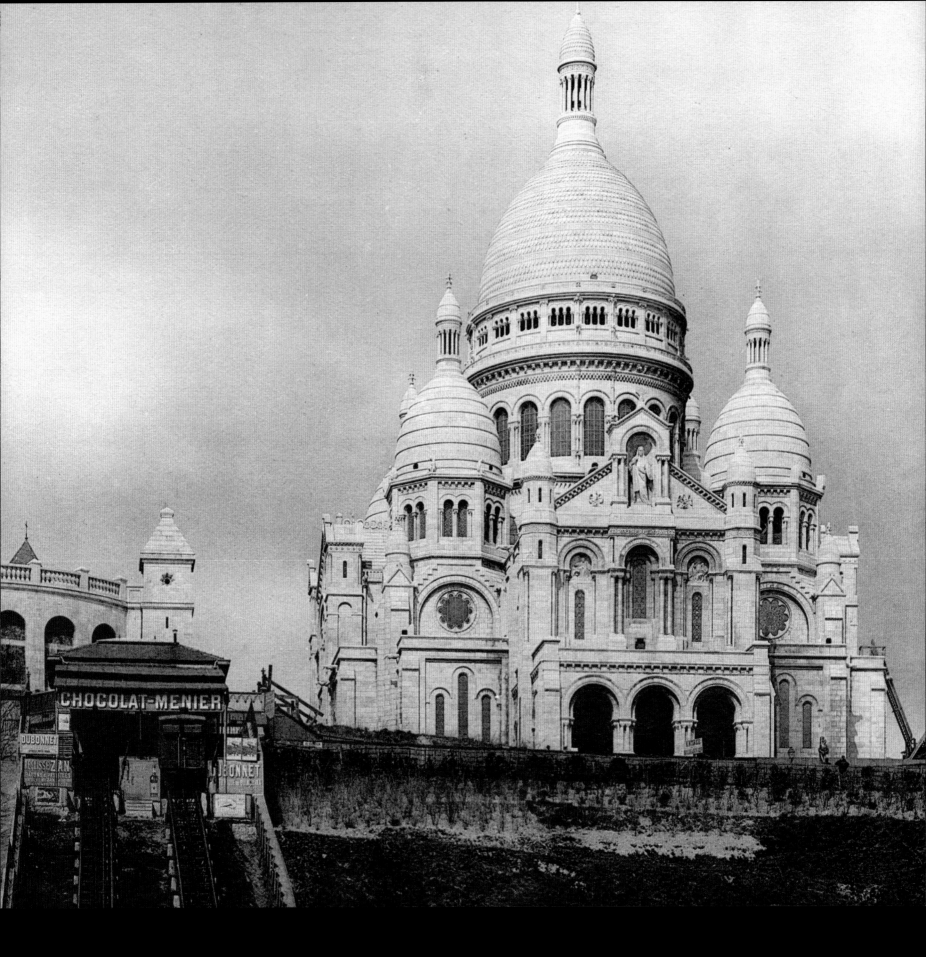

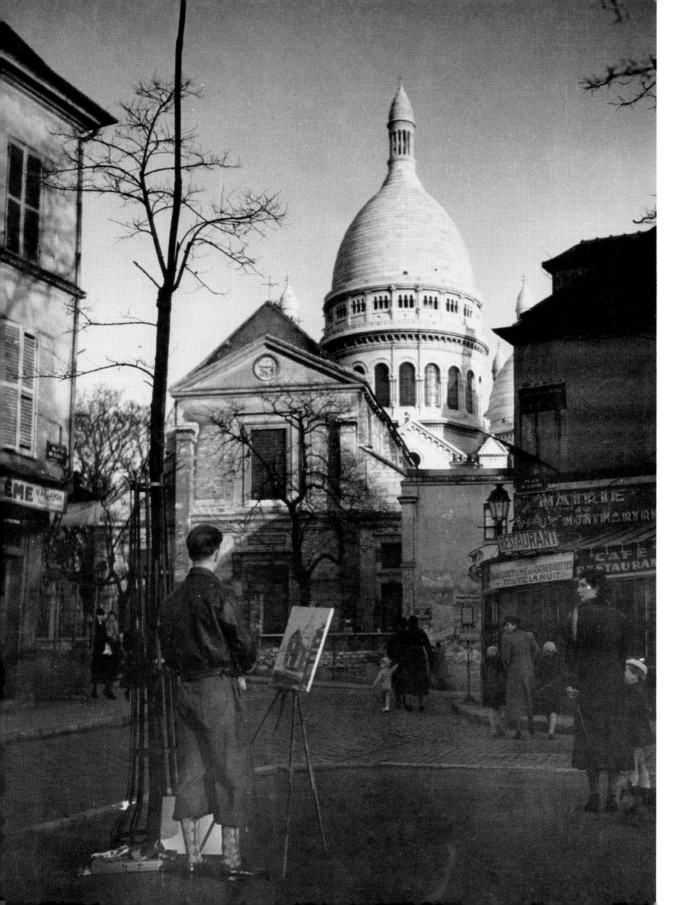

LEFT: An artist paints the Sacré Cœur and St Peter's Church in Montmartre, (c.1950).

RIGHT: A street market in Montmartre showing various paintings on sale, (1970).

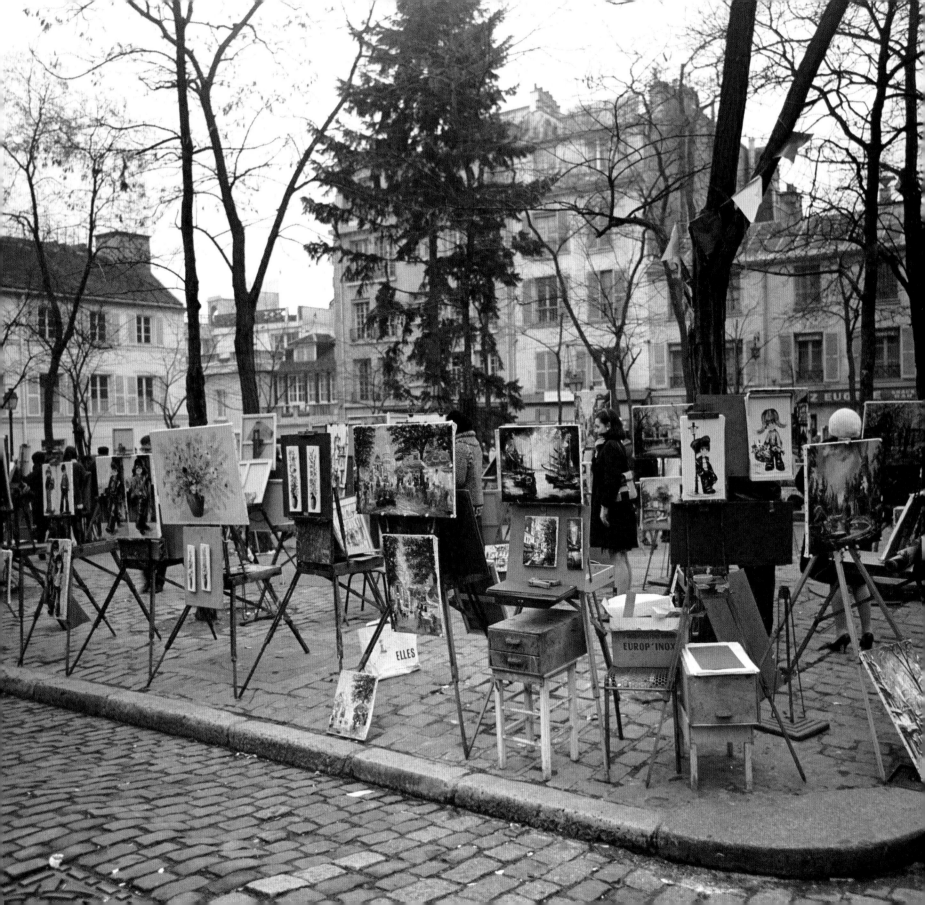

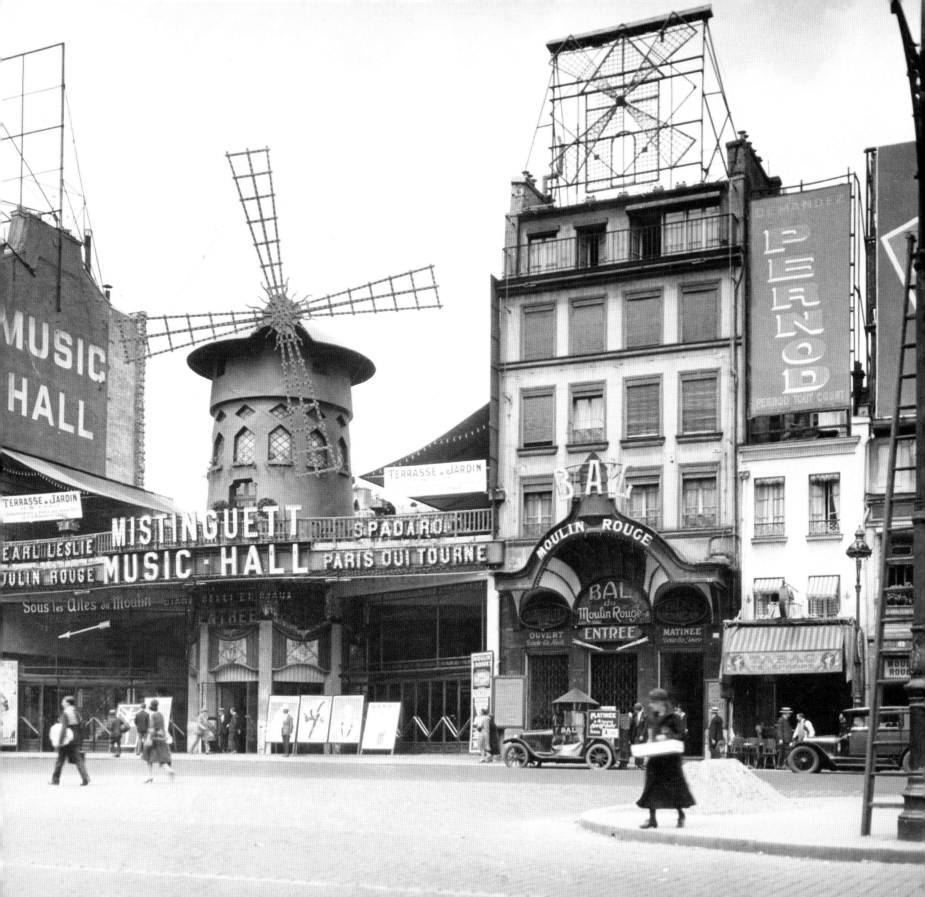

LEFT: The exterior of the famous music hall, the Moulin Rouge in the Boulevard de Clichy, Montmartre. At the time this photograph was taken, the famous Parisian entertainer Mistinguett was appearing in the show *Paris Qui Tourne,* (1929).

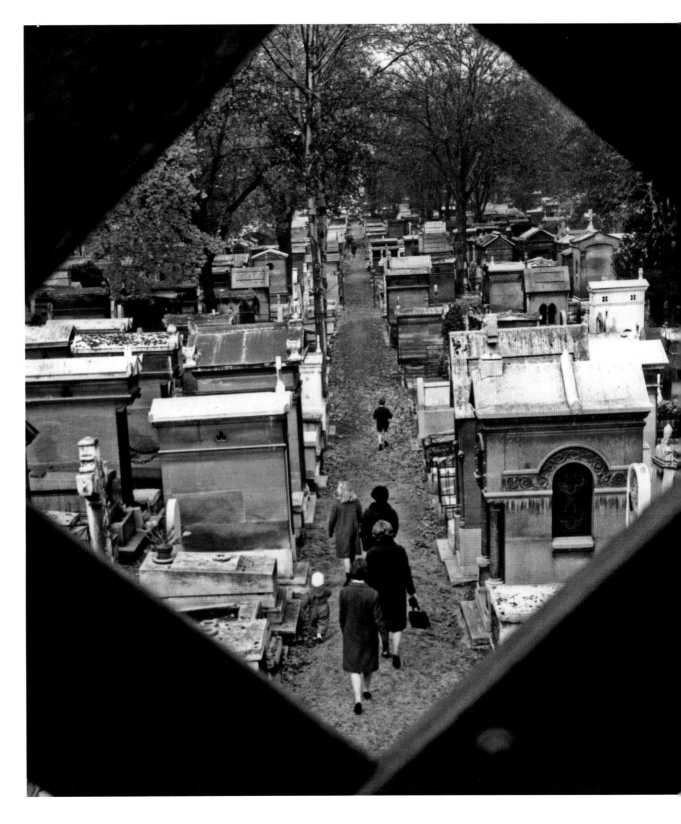

RIGHT: A quiet retreat, the Montmartre cemetery was established during the revolution and is the last resting place of many well-known artistic and literary figures, (1964).

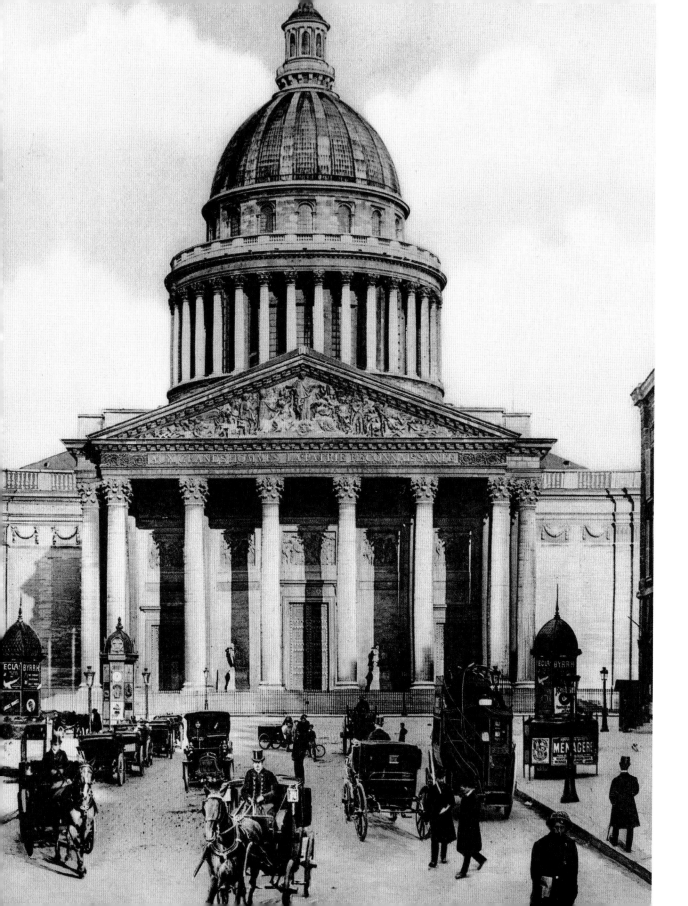

LEFT: The Panthéon seen from the Rue Soufflot, (1904). Looking over the Latin Quarter, the Pantheon was originally built as an abbey of Sainte-Genevieve from 1764 to 1790. It became a national memorial and burial site.

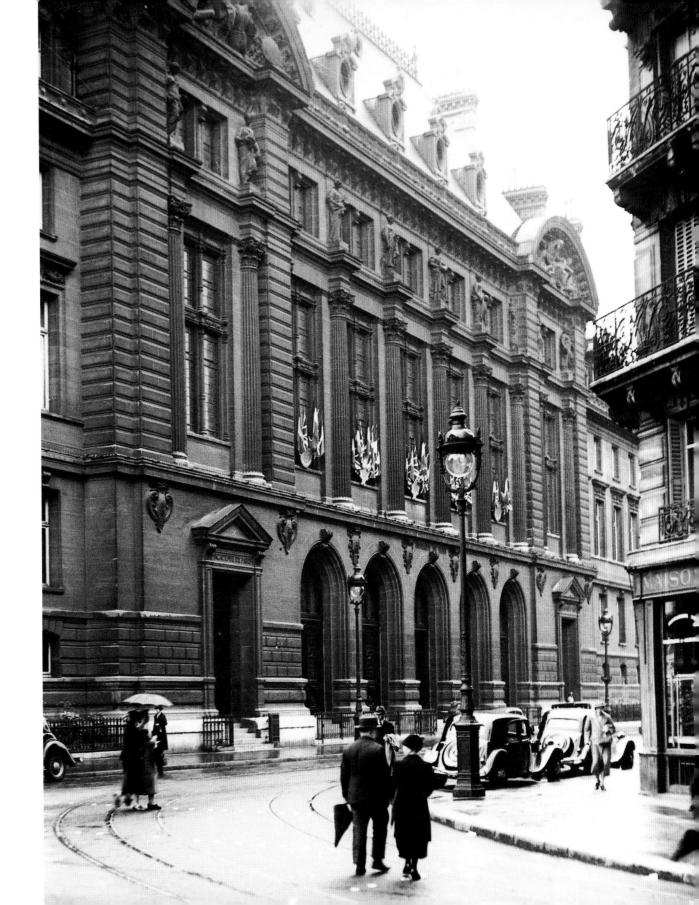

RIGHT: The Sorbonne university in the Latin Quarter is the centre of Parisian learning, (1938). It was the epicentre of the 1968 student riots.

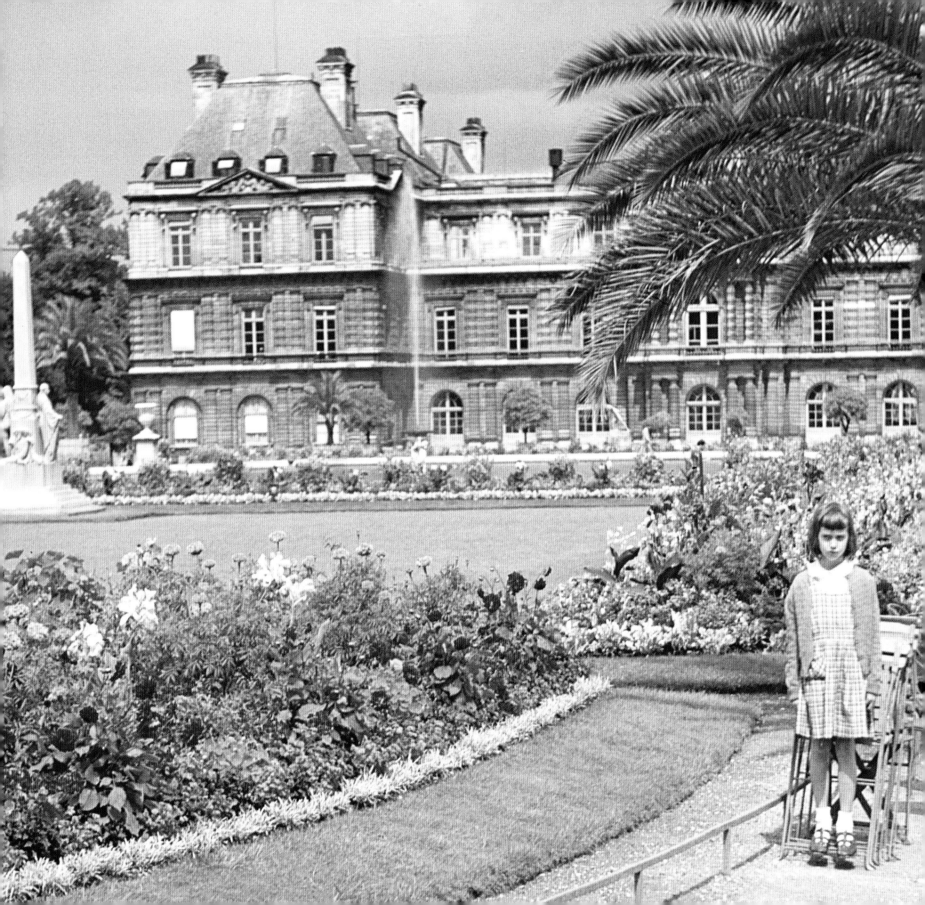

LEFT: A welcome relief from the crowded streets is the Luxembourg Gardens, Jardin du Luxembourg, (1951). Dotted around the most beautiful flower beds are many statues and several fountains including the romantic Baroque *Fontaine Medicis*.

BELOW: Café Le Dome in Montparnasse opened in 1898 and became renowned as an intellectual and artistic meeting place, (c.1935).

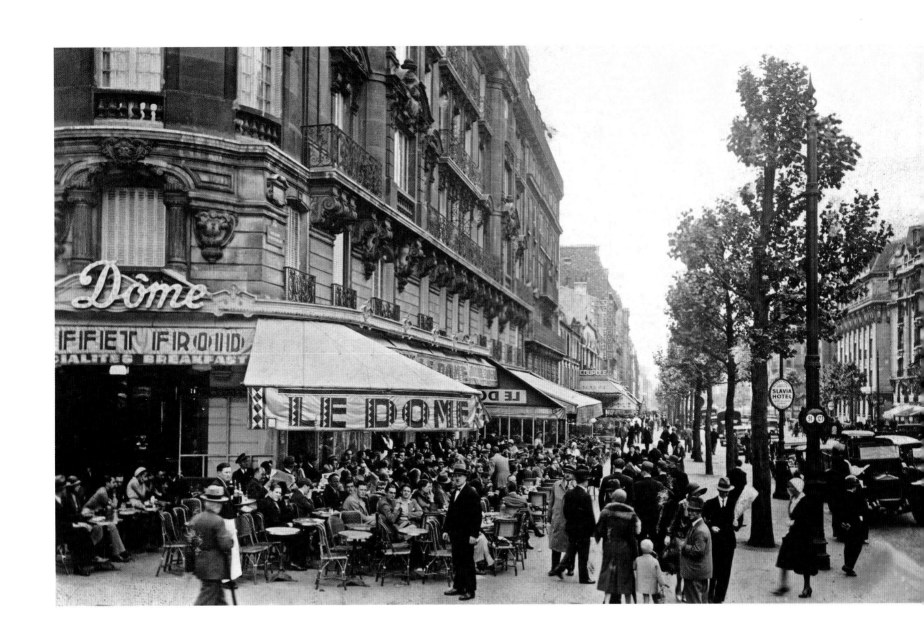

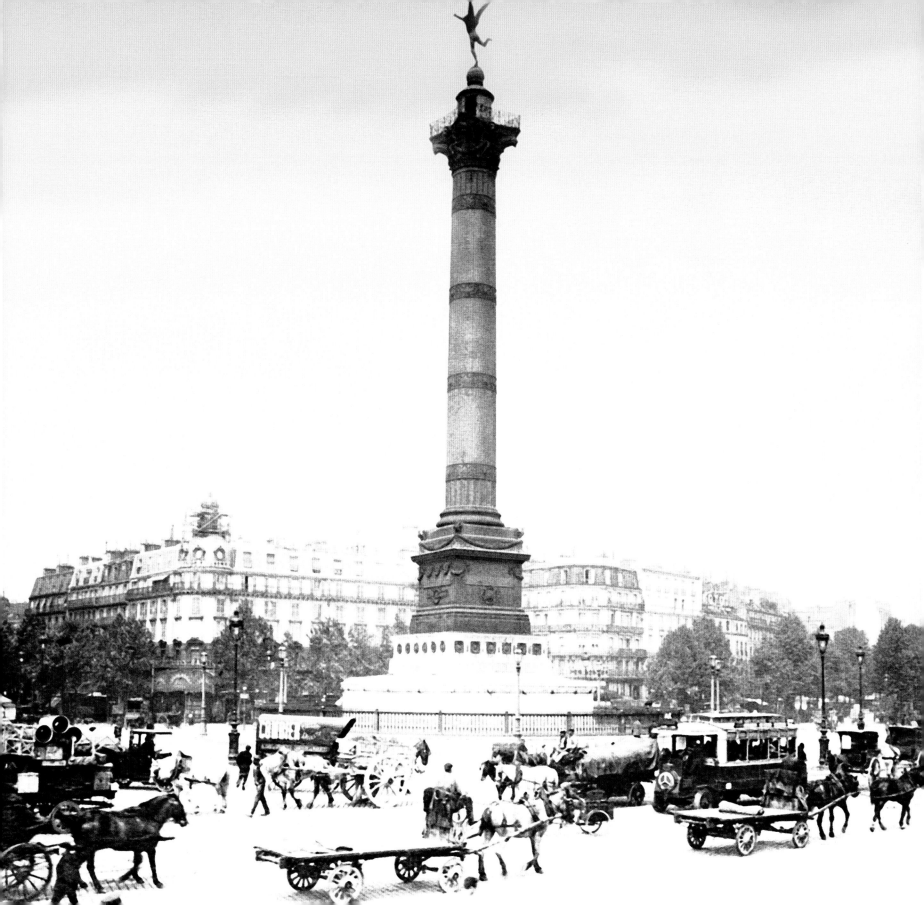

LEFT: Automobiles, carriages and horse carts on the Place de la Bastille, (1914). In the middle of the square is the column Colonne de Juillet, which was built in the years 1833–1840 in memory of the victims of the July Revolution of 1830. This was the site of the original Bastille prison that was destroyed during the revolution of 1789–1790. Today north east of the Place de la Bastille is filled with bars, cafés and restaurants.

No 21
DIMANCHE
24 mai
1931

40 centimes.

Le Petit Echo de la Mode

LE GRAND HEBDOMADAIRE FÉMININ
1, rue Gazan, PARIS (XIVᵉ).

LIIIᵉ ANNÉE
32 pages
(dont 16 en grand format)

SUR LA SEINE

Z 4524. ROBE en reps de laine. Forme légèrement blousée sur jupe plate dans le haut avec trousse de côtés sur les côtés. Mét.: 3 m. en 140.
Z 4525. COSTUME pour 5 à 7 ans. Blouse avec empiècement piqué devant et dans le dos. Culotte droite en serge bleu marine. Métrage: blouse, 1 m. 25 en 80 ; culotte, 0 m. 55 en 140.
Z 4526. ROBE en granité de laine. Corsage découpé en gilet sur guimpe. Jupe plate aux hanches formant dans le bas un volant à gros plis creux. Petit chapeau en feutre d'été. Métrage: 3 m. 75 en 140.

Exceptionellement, pendant 8 jours seulement, les patrons de cette page seront établis sur papier fort, sur mesures, au prix de 6 francs chacun.
A partir du 2 juin, ces patrons rentreront dans la catégorie des patrons sur mesures ordinaires : robes, 10 francs ; costume garçonnet, 8 francs.

Dans ce numéro commence un grand roman inédit : UN ÉTRANGE MARIAGE, par CONCORDIA MERREL. (Traduit par E. de Saint-Segond.)

RIGHT: The perfect way to see Paris: a sightseeing tour on a bateau mouche along the River Seine, (1931).

49

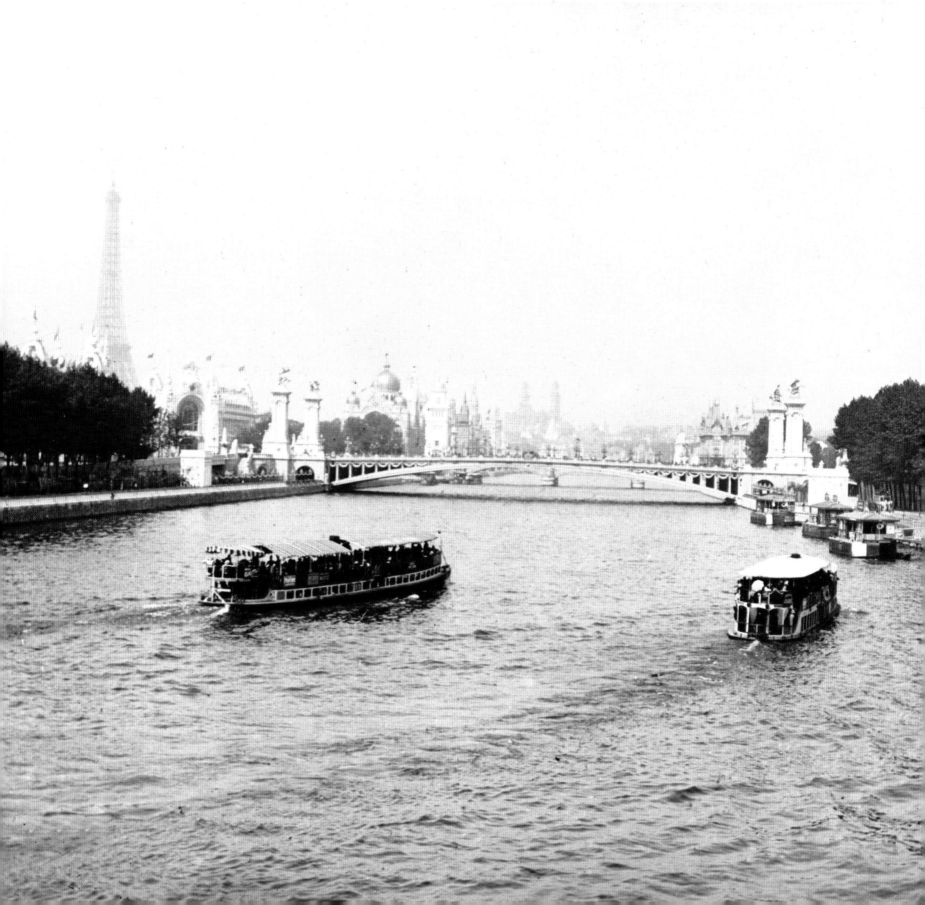

LEFT: Steam boats on the River Seine during the Universal Exhibition of 1900.

BELOW: A view of the Versailles Palace, the home of Louis XIV, the Sun King and now a major tourist destination famous for its spectacular interior and world famous gardens, (1949).

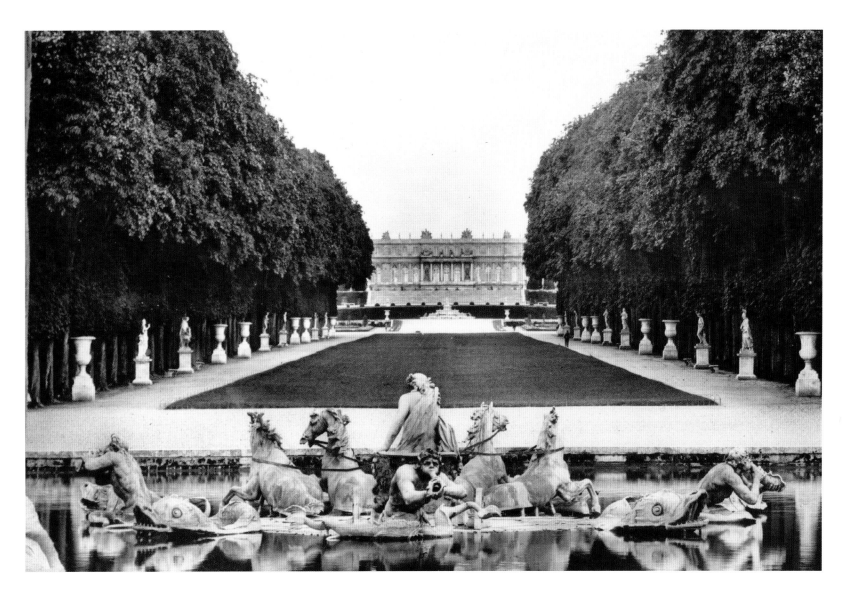

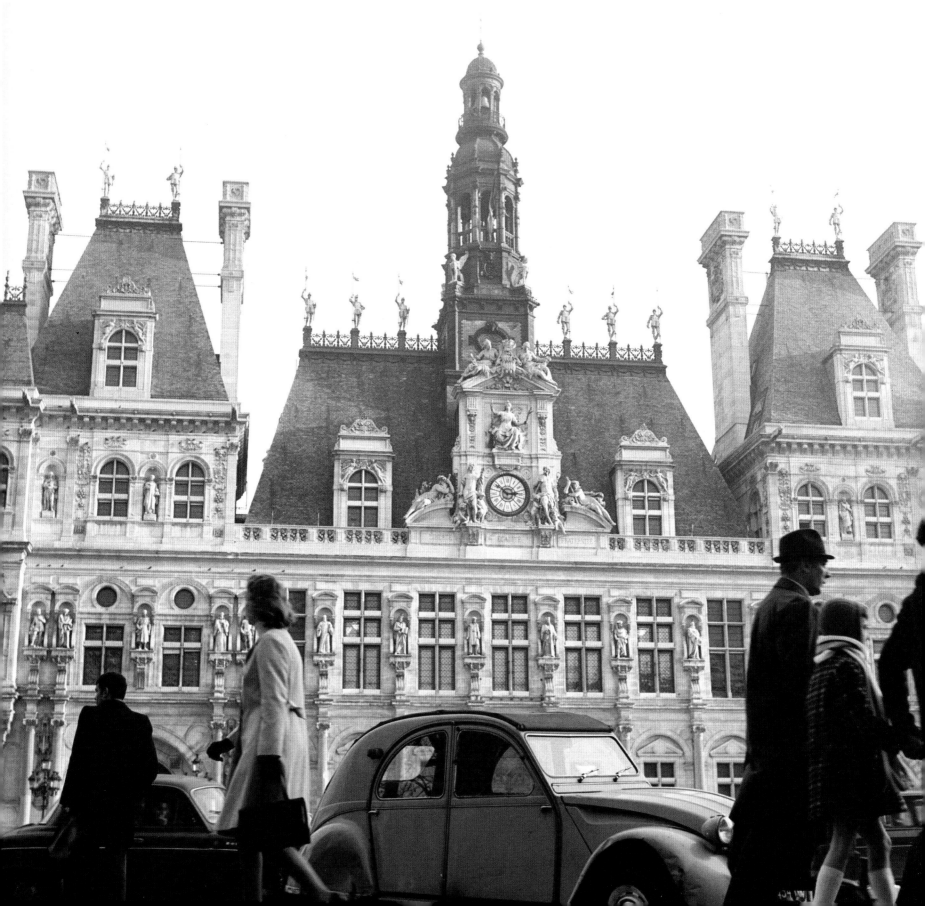

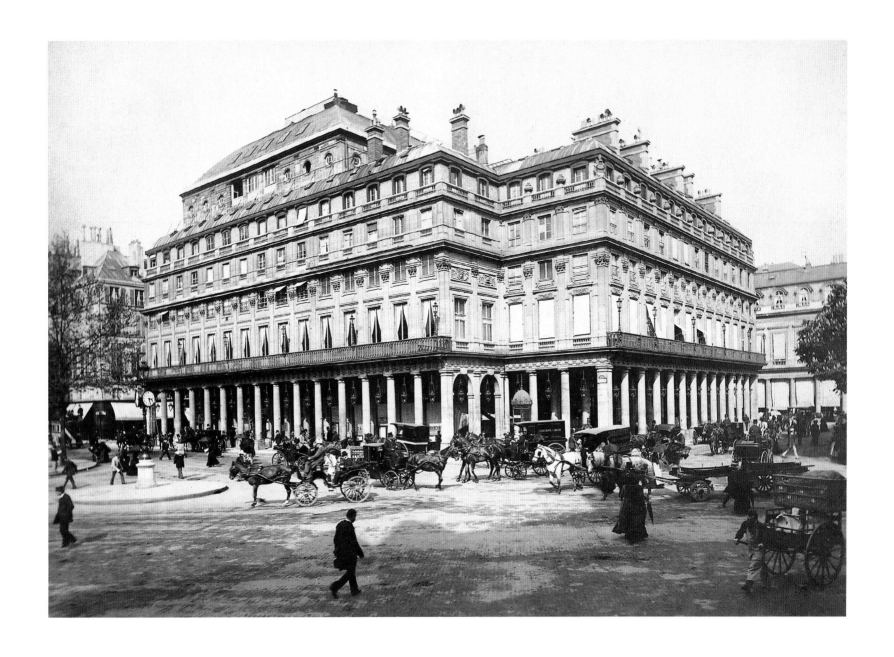

LEFT: A view of the Hôtel de Ville or city hall (1970). The building was constructed in the second half of the 19th century in Renaissance Revival style after the city hall was destroyed during the Paris Commune, an insurrection against the French government in 1871.

ABOVE: Established in 1680, France's national theatre, La Comédie-Française, (1909).

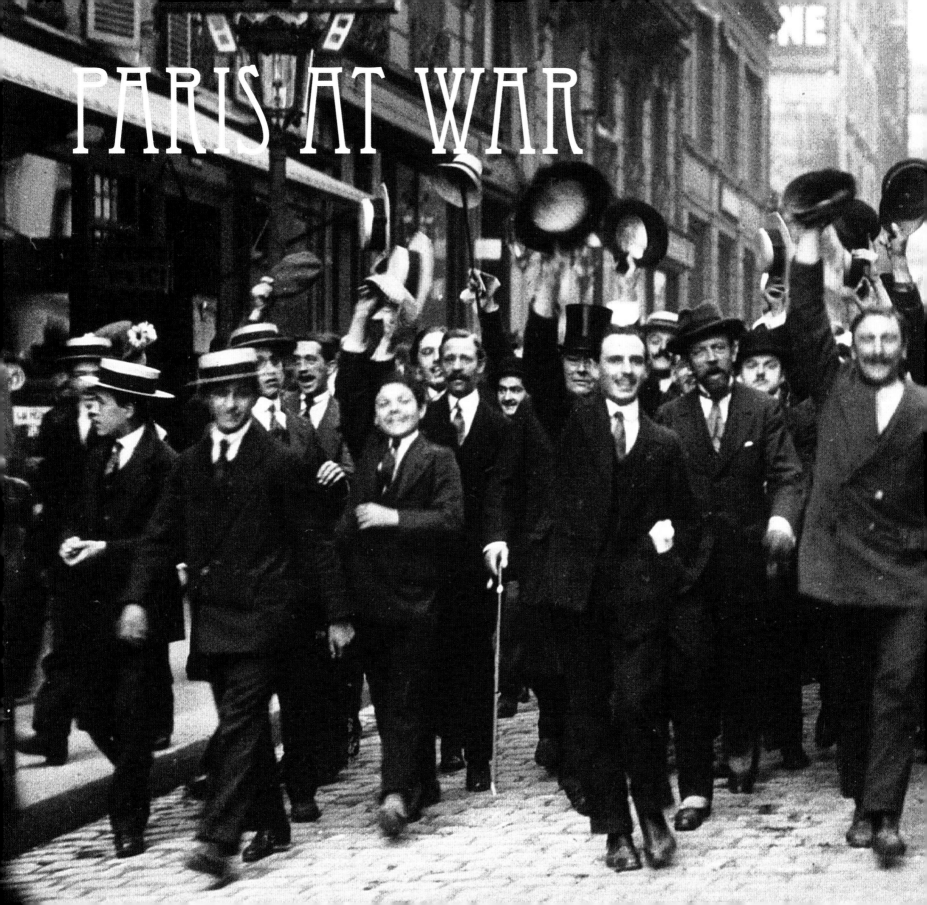

PARIS AT WAR

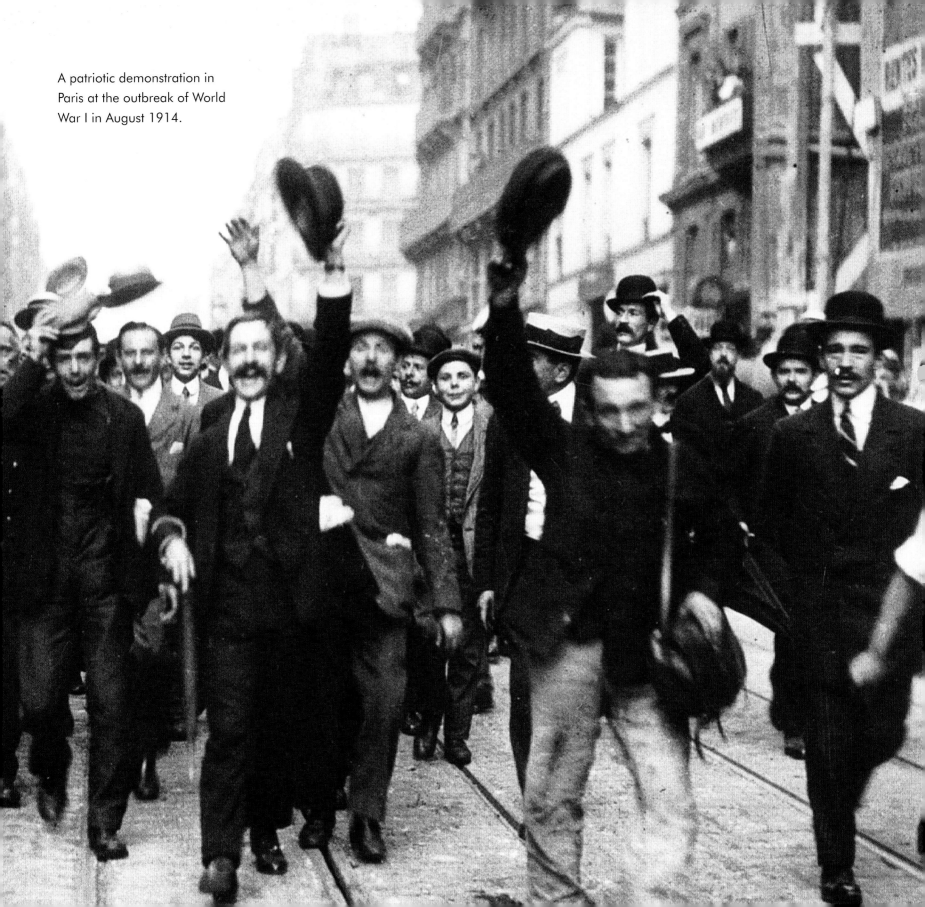

A patriotic demonstration in Paris at the outbreak of World War I in August 1914.

The assassination of Archduke Ferdinand in Sarajevo was the catalyst that propelled Europe in to a state of war. In August 1914 Germany declared war on Russia and then on France. Patriotic demonstrations preceded the mobilisation of troops who then departed for the front. It was the end of the momentous Belle Epoque era. Paris braced itself as Germany's first major offensive to capture the city began. Avoiding the French fortifications, the Germans marched west through neutral Belgium and then headed south into France.

The French, thinking this was a diversion, attacked Germany through Alsace and Lorraine and at the Battle of the Frontiers on 2 August 1914. A staggering 27,000 French soldiers were killed. The Germans were confident that they could destroy the French army defending Paris. But exhausted and ahead of their supply lines, they came to a halt 30 miles outside Paris and were distinctly vulnerable.

The French Army Commander-in-Chief, Joseph Joffre advised the government to relocate to Bordeaux and many great works of art and valuables from Le Louvre were transported to Toulouse. Joffre then ordered a counter offensive that was to become known as the Battle of the Marne in early September 1914. Aided by Britain and soldiers from her colonies, they attacked the exposed German flank and taking them by surprise, halted the advance but with the loss of 263,000 allied casualties.

As part of this operation, Joffre, with the aid of Joseph Gallieni, the Military Commander of Paris, needed to get reinforcements to Marne and so requisitioned buses and, most famously, about 600 Paris taxicabs, using them to carry 6,000 troops to the front. More than anything, this act symbolised French unity and solidarity, even if on their return, some of the taxi drivers read their meters and billed the military.

French morale soared as Paris was saved but thereafter the war settled into a stalemate along trench lines stretching across Western Europe. The government came back to Paris and life returned to relative normality as the theatres and cafés also reopened. Throughout the war Paris was sporadically bombed, first by Zeppelins and then toward the end of the

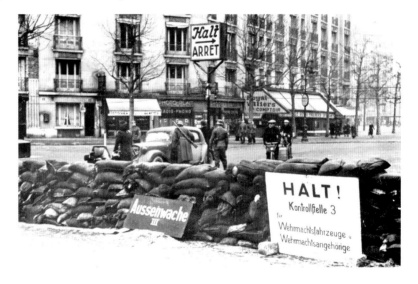

A street scene of Paris under German occupation – here is a checkpoint guarded by German armed force vehicles and personnel, (1941).

war as part of another German offensive, by long range guns generically called Big Bertha. The latter killed or wounded over 1,000 people. On 29 March 1918, for example, one shell struck the Saint-Gervais church, killing 88 people.

When America officially entered the war in April 1917, a new phase began. Two months later in June, American troops (called Doughboys) arrived in Paris under General John Pershing and half of Paris came out to greet them. The Americans subsequently played a pivotal part in the defeat of Germany and finally an armistice was declared on 11 November 1918. Hundreds of thousands of Parisians filled the Champs-Élysées on 17 November to celebrate and Paris emerged from the war relatively unscathed. At the time it was estimated that there were over two million American troops in Europe.

Huge crowds welcomed President Woodrow Wilson for the Paris peace conference but it took six months of negotiations before the final Treaty of Versailles was signed on 28 June 1919, followed by a victory parade by the Allied armies on 14 July 1919. However, Paris did not escape capture in the next war. Following Hitler's invasion of Poland in September 1939, France declared war on Germany. Most Americans and other foreign nationals

left the country, children were evacuated to the country and bomb shelters were constructed. Little happened for the first eight months and the French called it the *drole de guerre* (funny kind of war) as both sides watched each other and waited for something to happen. And, in the meantime, it did give Parisians the time to protect the city's major monuments and treasures.

Finally, on 10 May 1940, as French forces waited in the fortifications of the Maginot Line, the Germans invaded France, outmanoeuvring the French defences. Paris was flooded with refugees and a mass civilian exodus began fleeing to the south, the government included. The Luftwaffe initiated air raids and the Germans marched into Paris on 14 June 1940. Marshal Philippe Pétain capitulated and was forced to sign an armistice in the same railway carriage used when Germany surrendered in 1918.

As Adolf Hitler arrived in Paris on 24 June and visited the tourist sites and Napoleon's tomb, France was divided into the occupied north and a supposed free zone centre in Vichy under the control of a collaborationist government led by Pétain (which was fully under German control by late 1942). Charles de Gaulle formed a government, *Forces françaises libres* (Free French forces), in exile in Britain.

Paris clocks were set to Berlin time and German street signs were put up everywhere. A resistance movement was difficult to mobilise as the Germans had such a tight grip on the capital. But dissent did occur despite harsh retaliation from the Nazis. The round up of over 12,000 Jews in the Vélodrome d'Hiver in July 1942 including 4,051 children and 5,082 women and the execution of hostages was shocking. Eventually, the different factions of the Resistance were united in May 1943.

In April 1944 the allies bombed Paris. As they advanced toward the city, strikes organised by the resistance disrupted the railways and public services and on 19 August the resistance ordered a general uprising. Finally, the city was liberated on 24 August 1944.

The Americans and General de Gaulle and other resistance leaders were welcomed with considerable jubilation. Hitler had ordered the destruction of the city but the German commander Dietrich Von Choltitz had refused and Paris was spared. The celebrations were marred by much recrimination and the punishment of those who collaborated with the Germans. The wounds of the war ran deep.

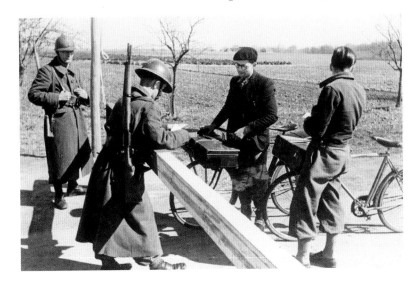

French positions along the demarcation line to Vichy. After the occupation of Paris, a border was formed along the so-called demarcation line between occupied France and the unoccupied area in the south. French soldiers check the papers of some Frenchmen who want to cross the border, (c.1940s).

LEFT: Following the outbreak of war in 1914 and the French Government's move to Bordeaux, many people left Paris. This illustration shows Parisians leaving for England from the Gare du Nord, (1914).

RIGHT: Anti-aircraft search lights over Paris, (1914). The Parisians feared airborne attacks from the Germans and therefore used searchlights to identify German planes early.

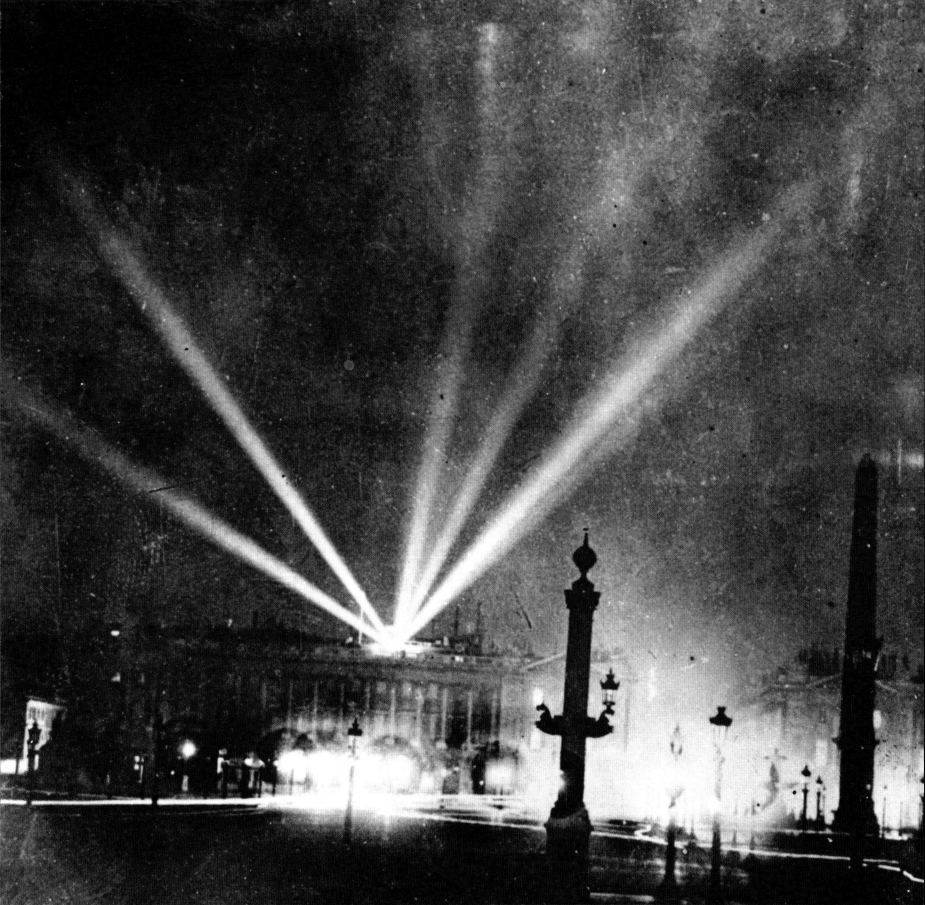

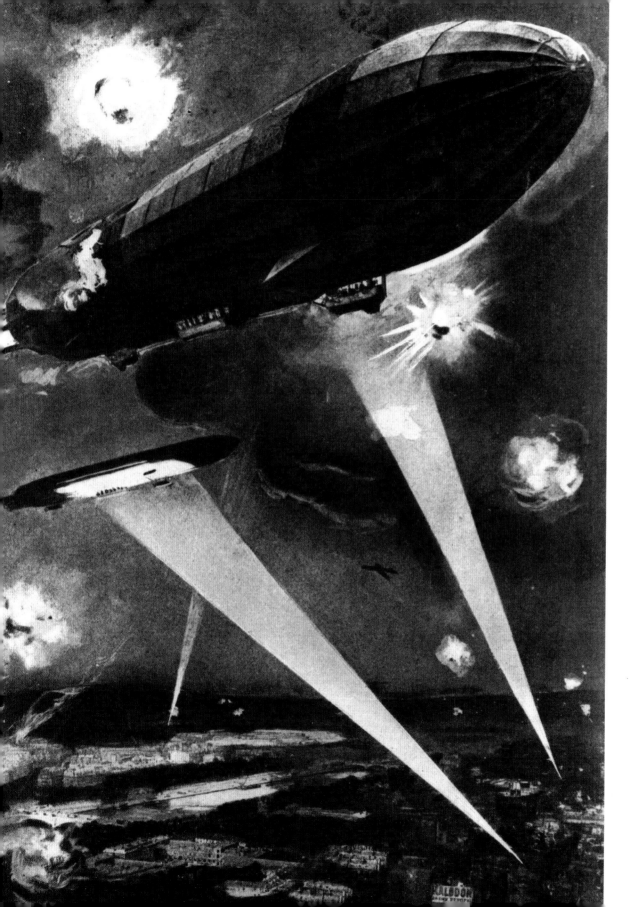

BELOW: A sketch showing Voisin aircraft defending Paris from the air, (1915).

LEFT: An illustration depicting German zeppelins dominating the sky in an air raid at night over Paris, (1915). Searchlights beam from the city below, marking the zeppelins. The city defends itself by trying to gun down the attackers using ground-based artillery. Quick-firing explosions light up the sky and surround the enemy.

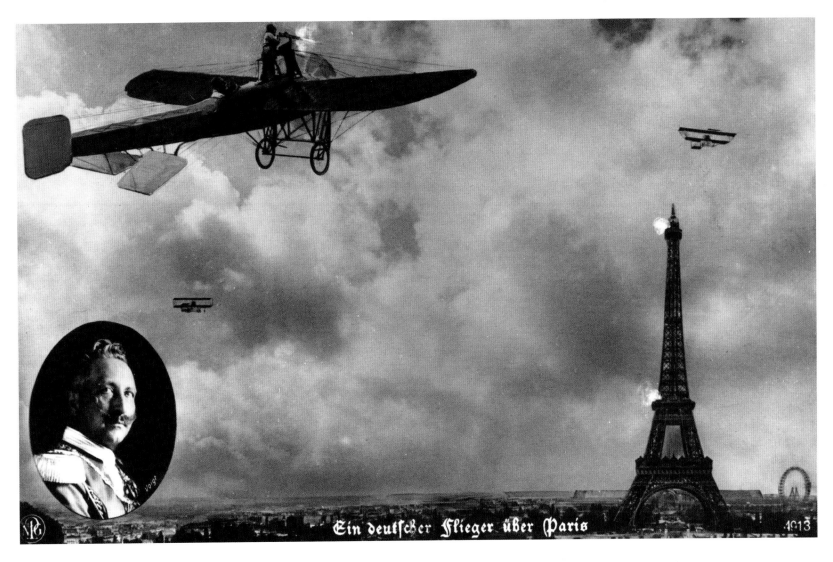

Ein deutscher Flieger über Paris

ABOVE: A propaganda postcard showing German planes flying over Paris and the Eiffel Tower during World War I, (c.1917). Inset is a portrait of Kaiser Wilhelm II, (c.1917).

RIGHT: French civilians in the Jardin du Luxembourg watch the skies for German air raiders, (c.1916).

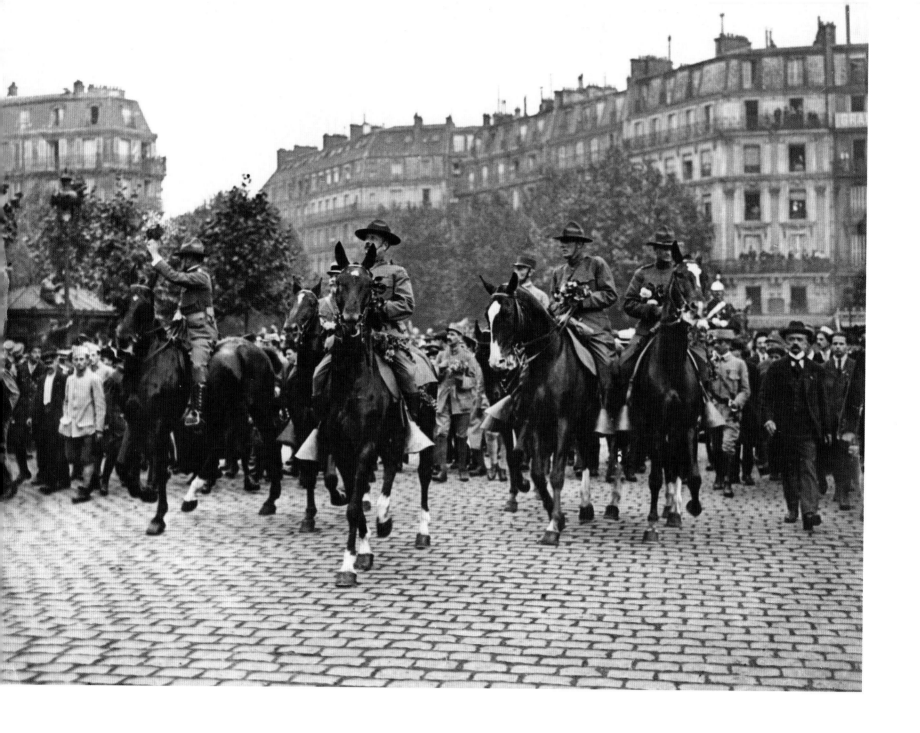

ABOVE: American officers riding through Paris on horseback during World War I. Some of them are holding bouquets of flowers. Perhaps this was taken during their first arrival in the city, hence the flowers, (c.1917).

RIGHT: The portal of Notre-Dame cathedral in Paris was protected against German artillery fire. A long-range cannon enabled the direct artillery bombardment of Paris in the spring of 1918, making it necessary to protect many buildings, (c.1918).

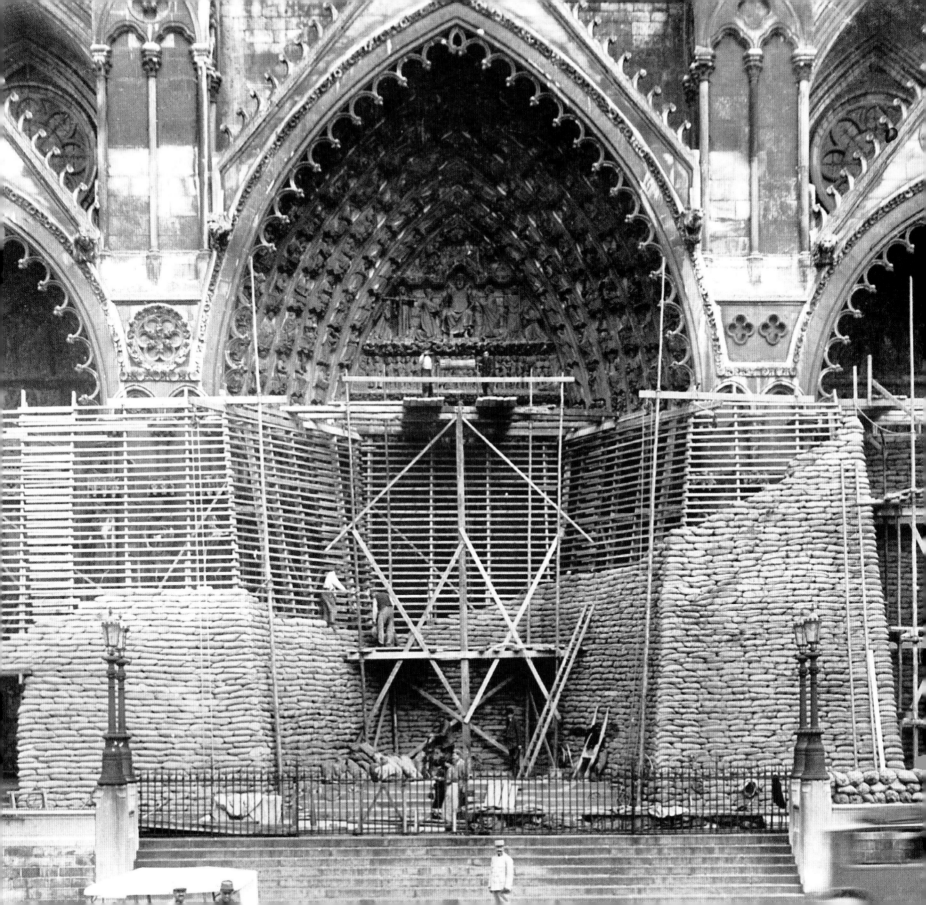

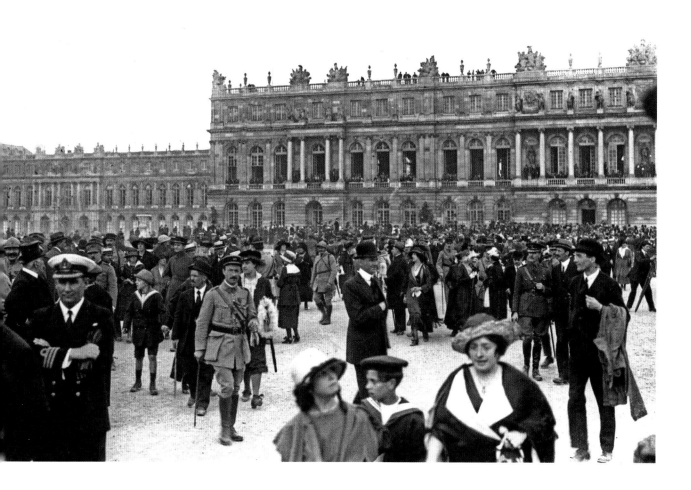

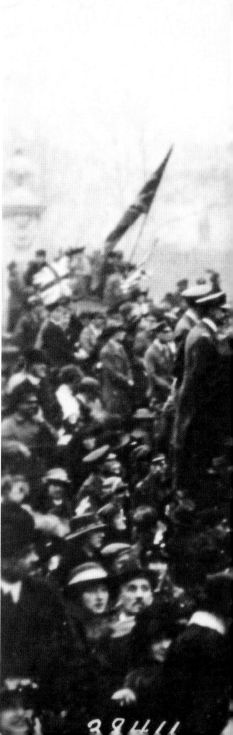

ABOVE: A large crowd waiting in front of the Palace of Versailles during the signature of the Peace Treaty on 28 June 1919.

RIGHT: A scene of jubilation on the streets of Paris on Armistice Day, 11 November 1918, the official end of World War I.

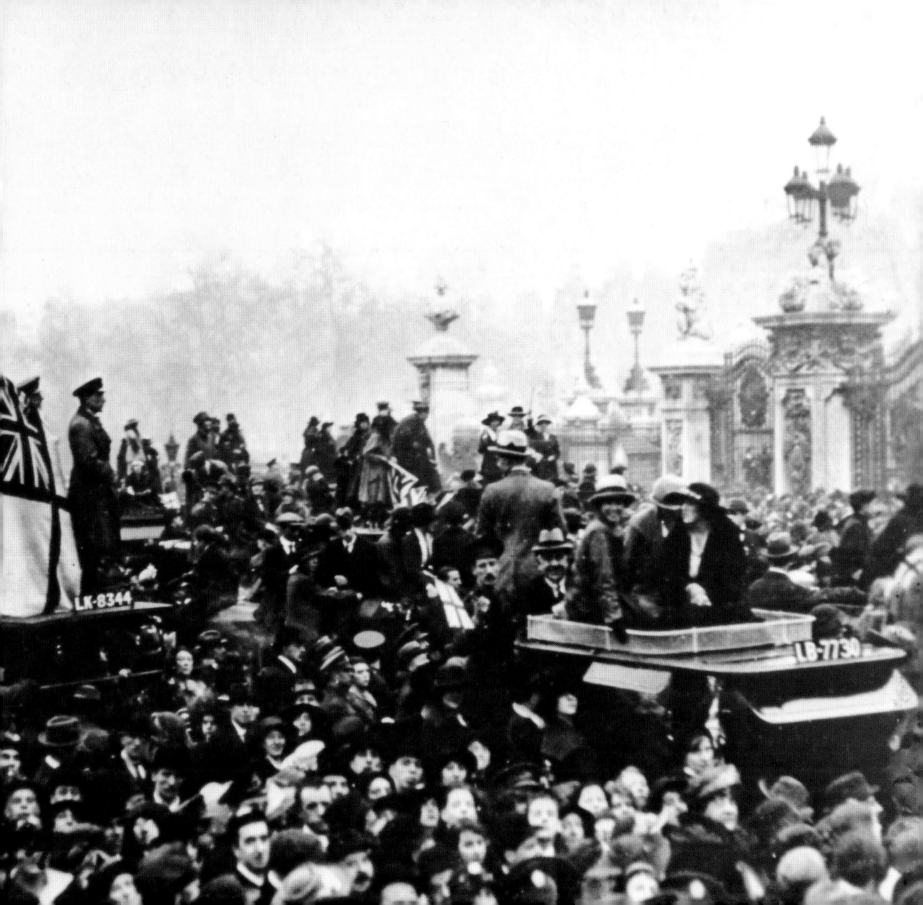

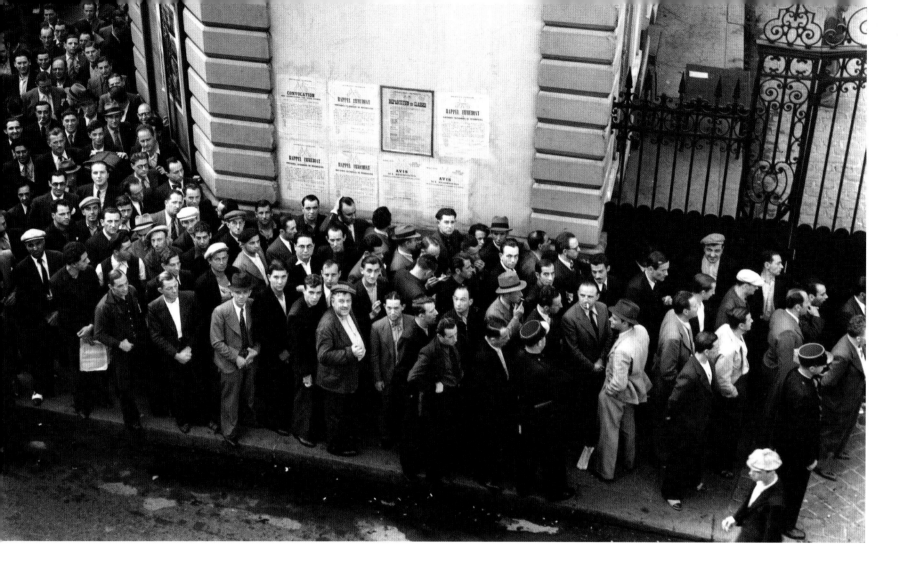

ABOVE: With the declaration of war in September 1939, the mobilisation of men in Paris began. The image shows the queue of men waiting to enlist on the Rue Saint-Dominique (c.1939).

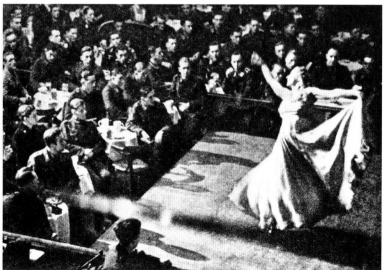

LEFT: German soldiers enjoy themselves at a Parisian nightclub during World War II (c.1940s).

RIGHT: The evacuation of Paris, 2 September 1939, at the barrier of the Gare de Lyon train station at the beginning of the World War II.

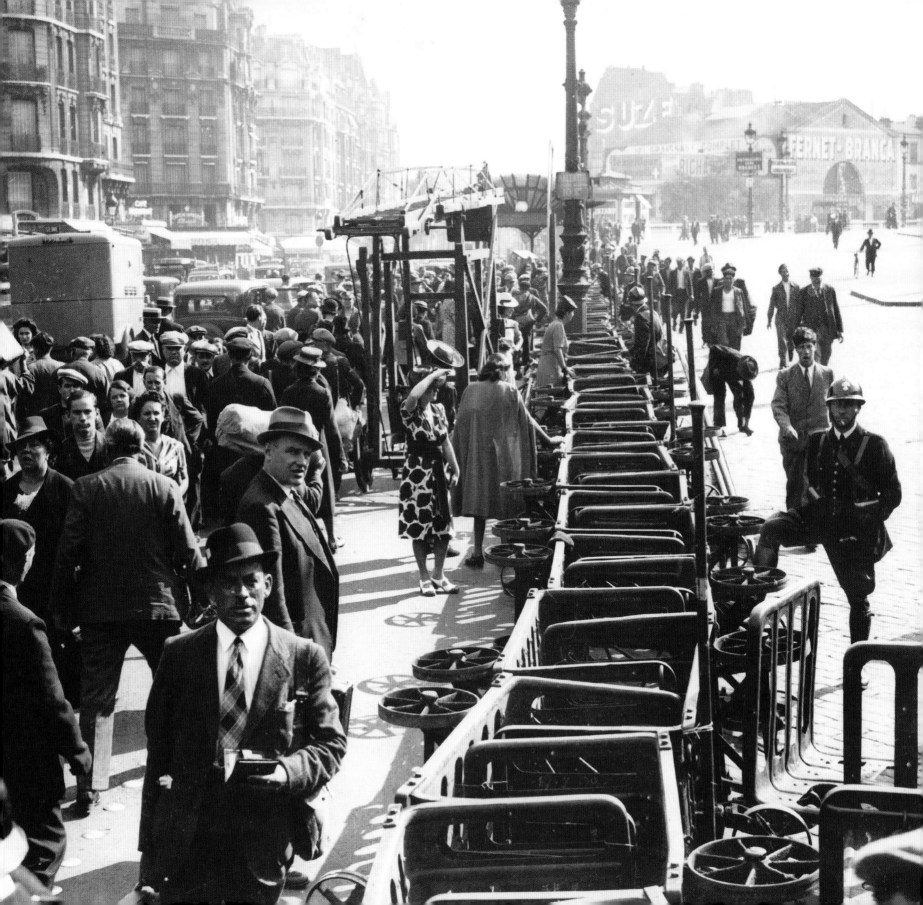

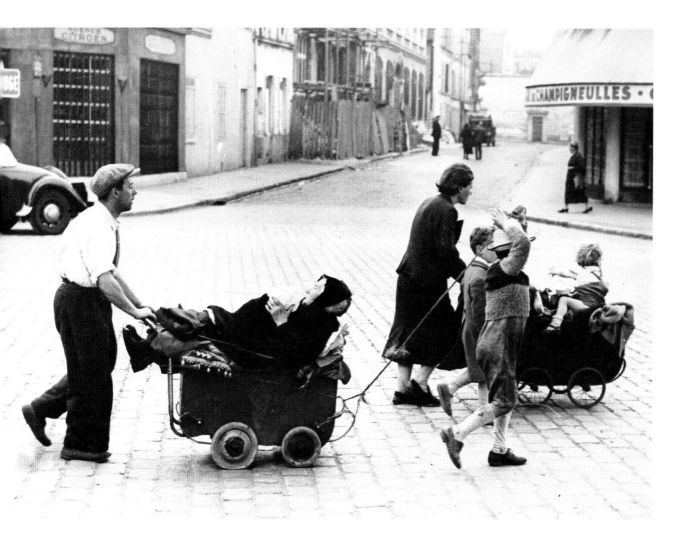

ABOVE: As the evacuation of Paris proceeds, many Parisians leave the city for safer havens. Here a poor family is using all possible means of transport to leave, wheeling their grandmother in a pram, (c.1939).

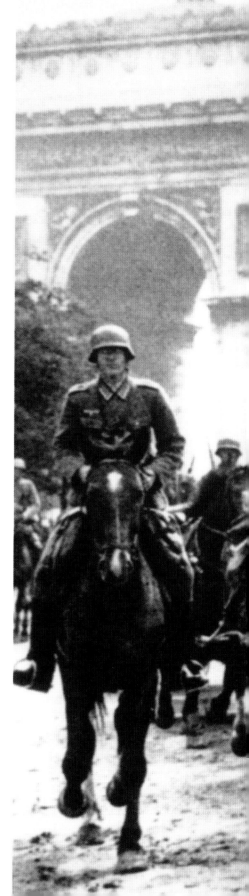

RIGHT: The Germans enter Paris, passing the *Arc de Triomphe* on 14 June 1940. They met no resistance as French troops had withdrawn to avoid the destruction of Paris and General Hering, the military governor, declared the capital to be an open city.

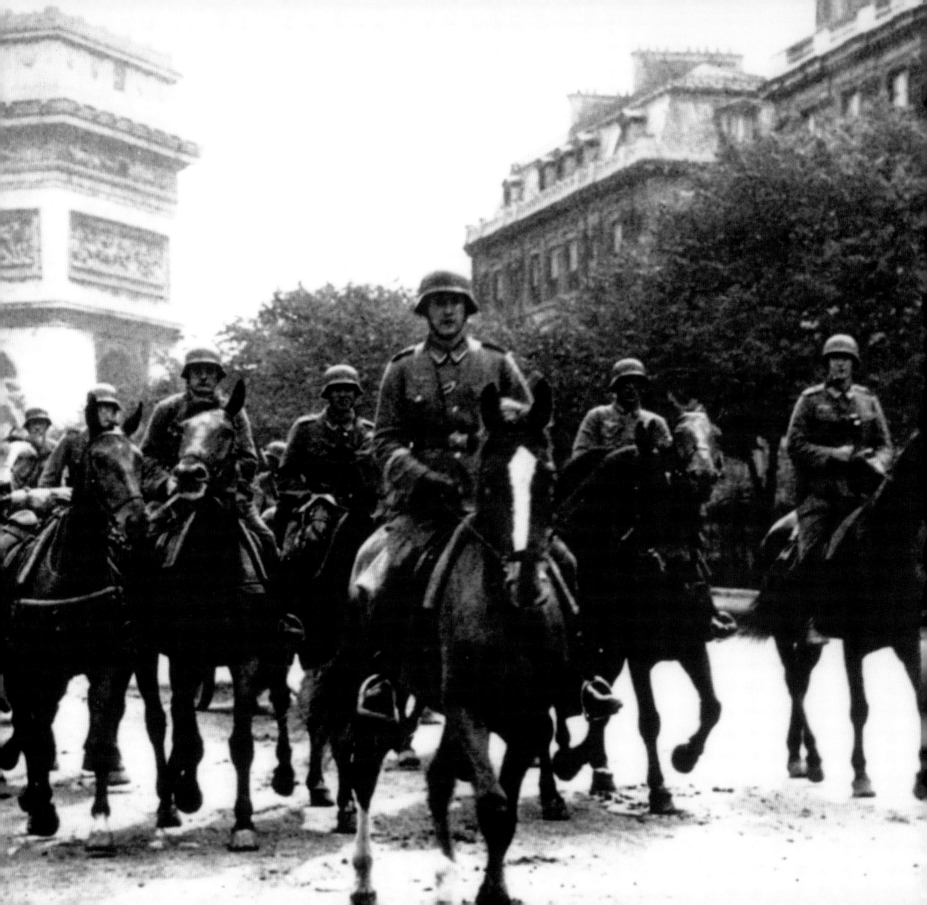

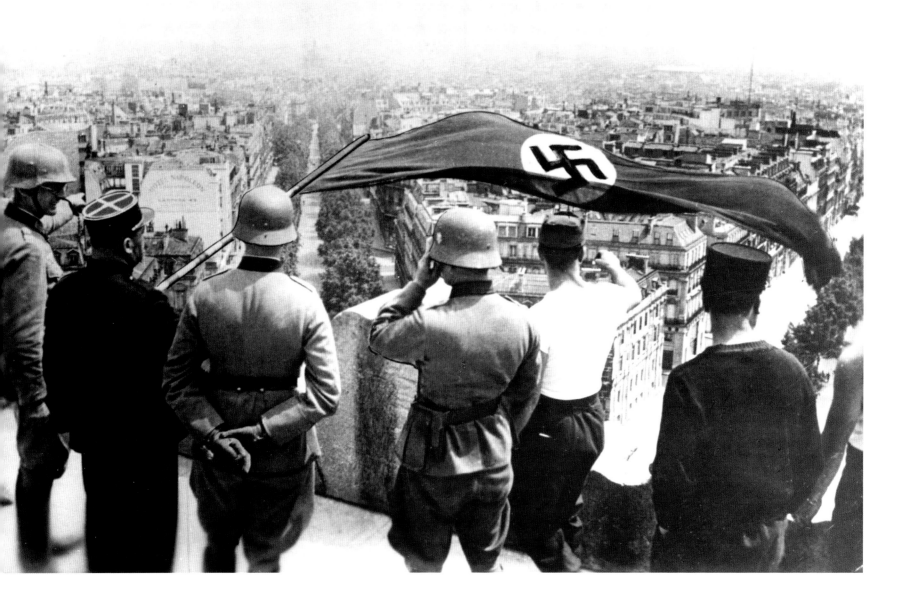

ABOVE: The German occupation of Paris in June 1940. The German flag is flying from the Arc de Triomphe.

RIGHT: At the start of the German occupation, families consult a list of prisoners of war displayed on shop window, 28 June 1940.

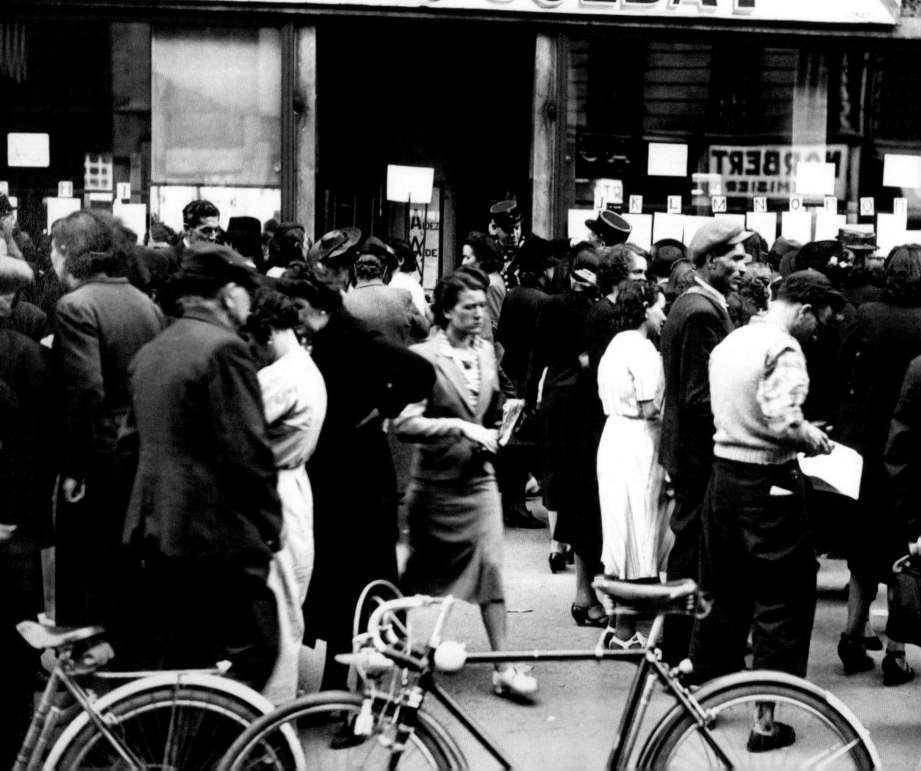

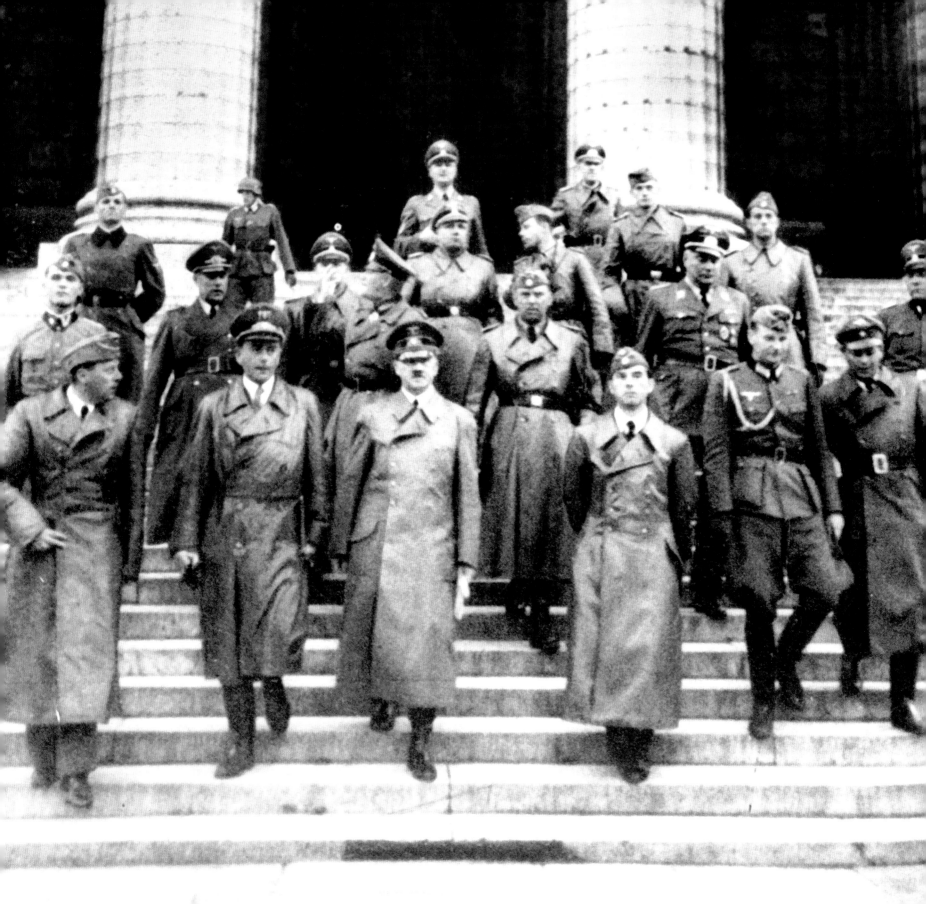

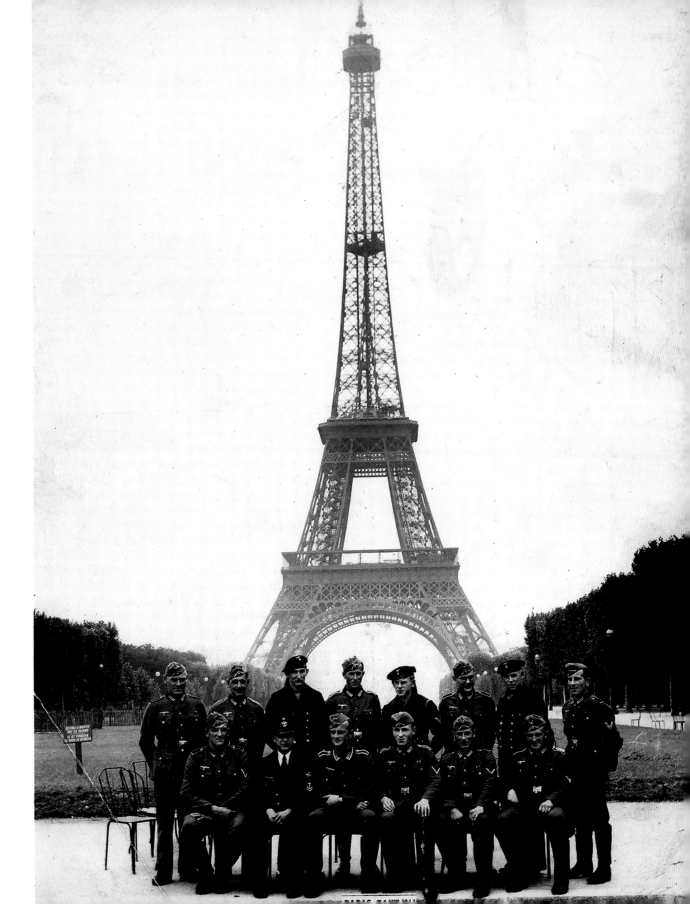

LEFT: Adolf Hitler arrives in Paris on 23 June 1940 and tours the city. Here he leaves the Madeleine church.

RIGHT: A group of German soldiers in front of the Eiffel Tower, (1941).

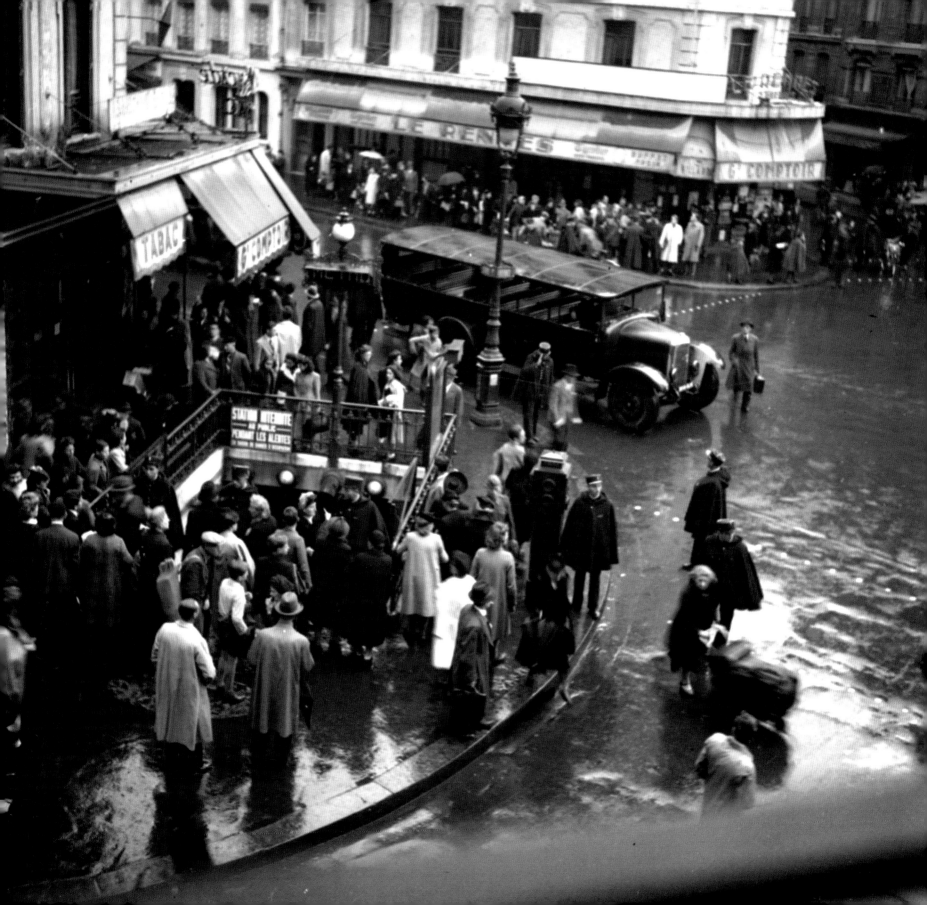

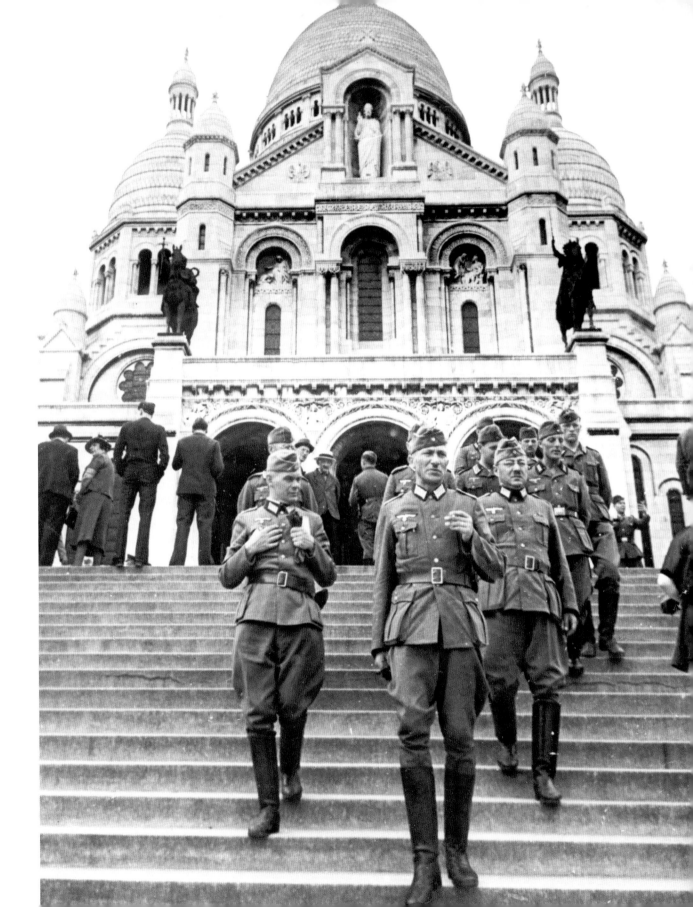

LEFT: Identity control at the entrance of the Métro in Paris during World War II, (c.1940s).

RIGHT: German soldiers in Paris, visiting the church of Sacré Cœur in Montmartre, (c.1942).

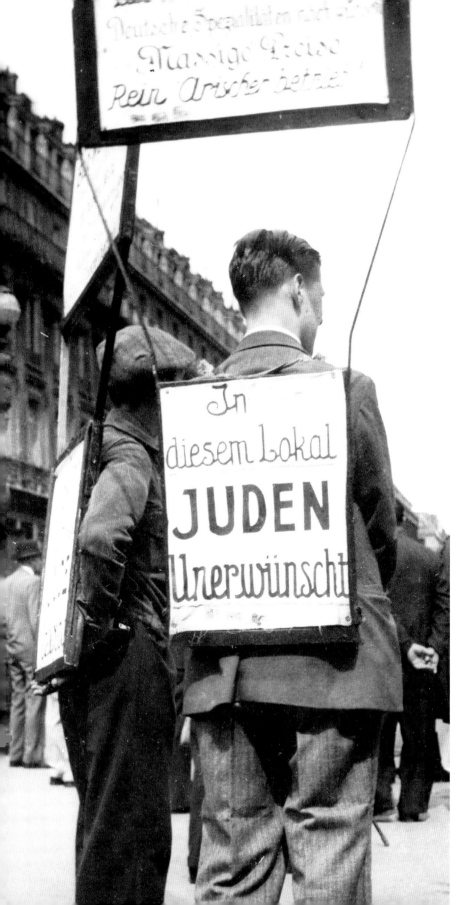

LEFT: A man carrying a sandwich board sign for a restaurant in Paris during World War II that forbids Jews from the premises, (c.1940s).

RIGHT: A market scene in occupied France during 1941 showing a delivery of foodstuffs. Parisians watch as sacks and hampers of potatoes and other vegetables are opened up in the street.

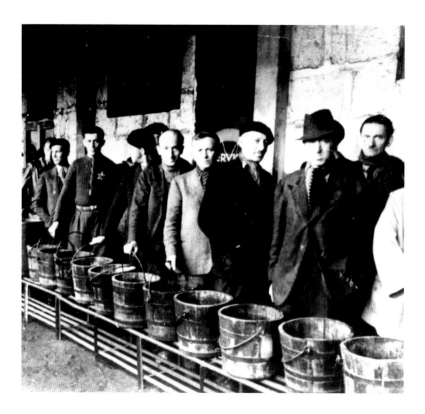

ABOVE: Jewish men interned at the camp of Drancy near Paris. The camp was requisitioned by the German Army on 14 June 1940. At first it was used for prisoners of war before becoming a concentration camp on 20 August 1941.

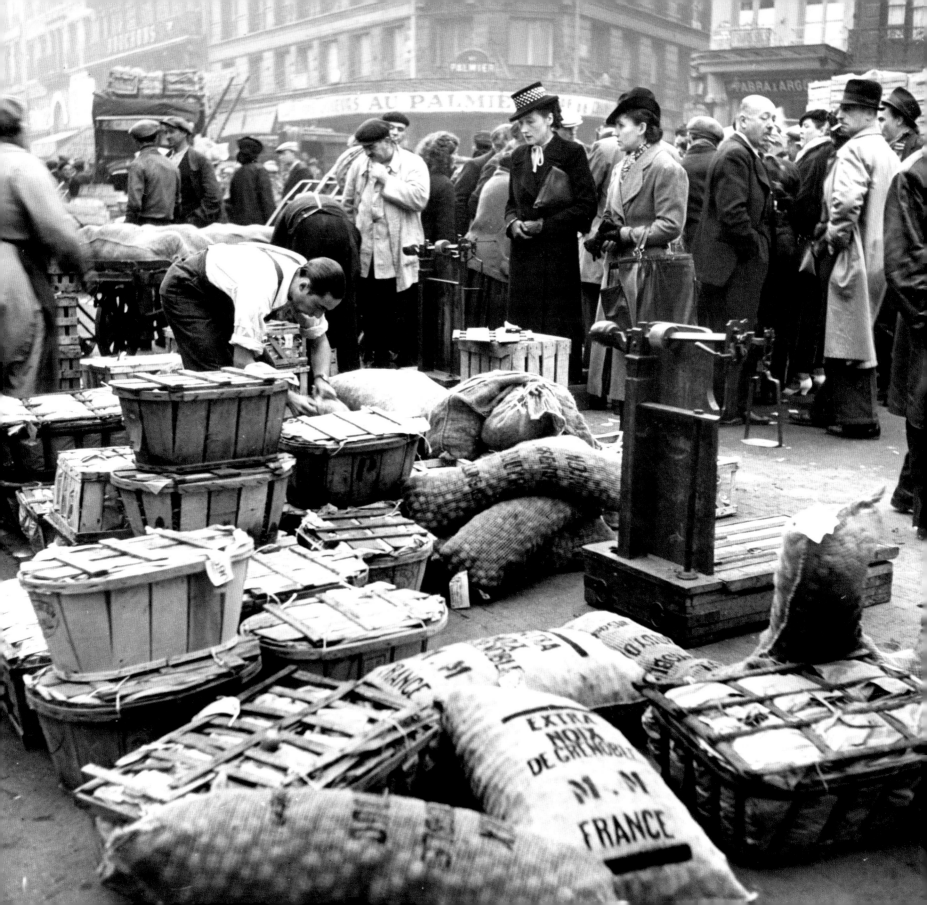

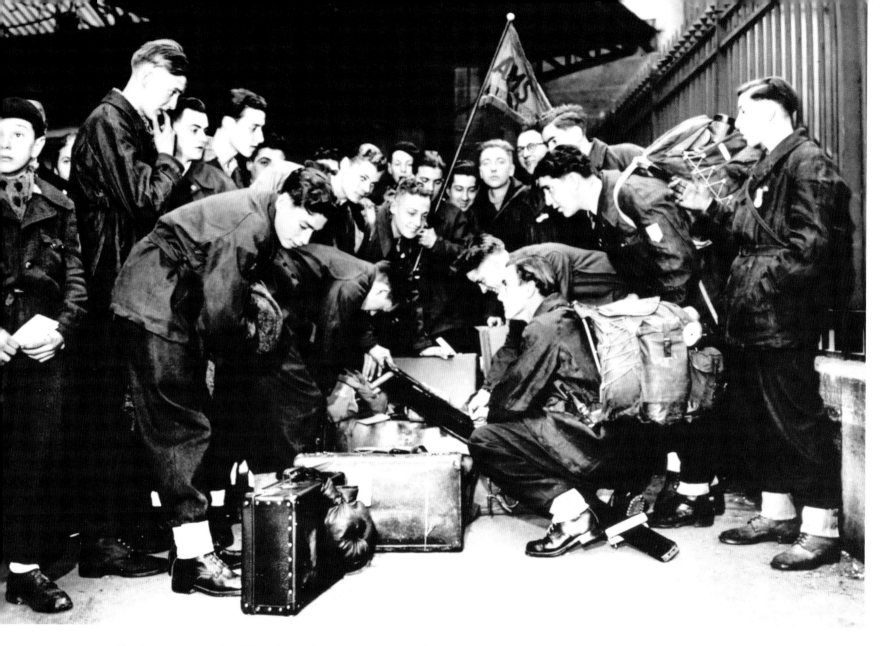

ABOVE: The Germans required Frenchmen between the ages of 20 and 23 to work for two years in war industries in France and Germany. Here young French volunteers leave Paris for Germany for work, 21 January 1943.

RIGHT: Two children amidst the destruction of Montmartre after the allied bombing of Paris in April 1944.

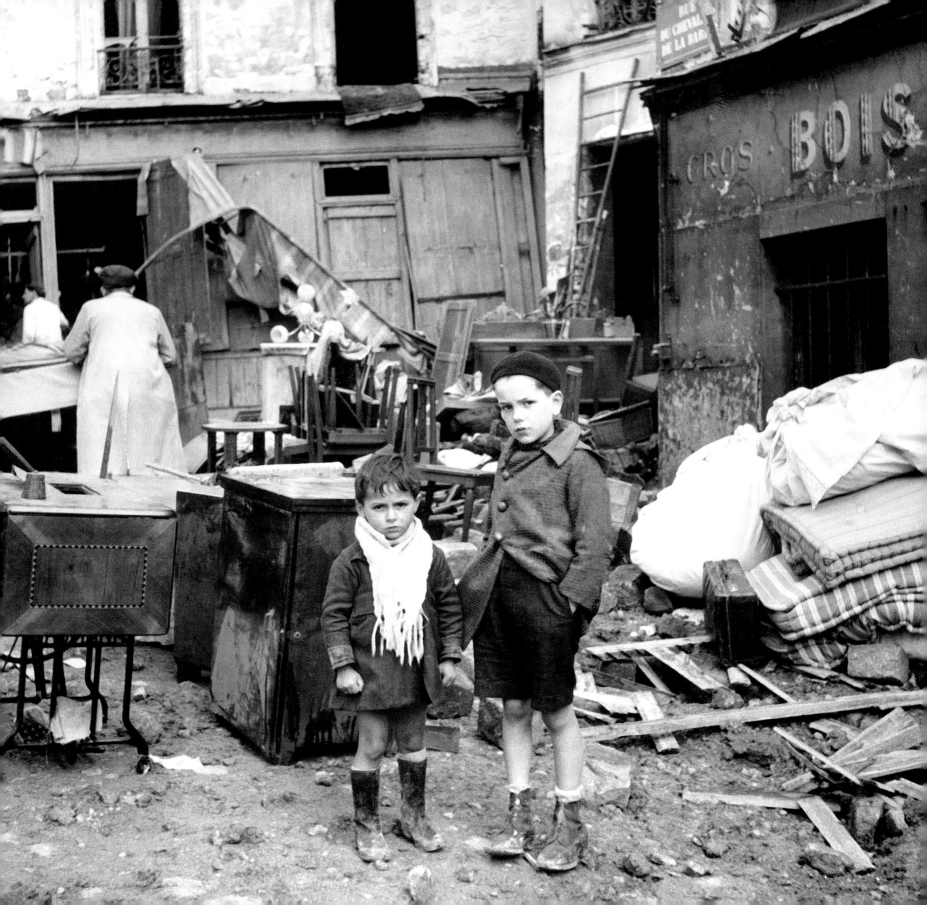

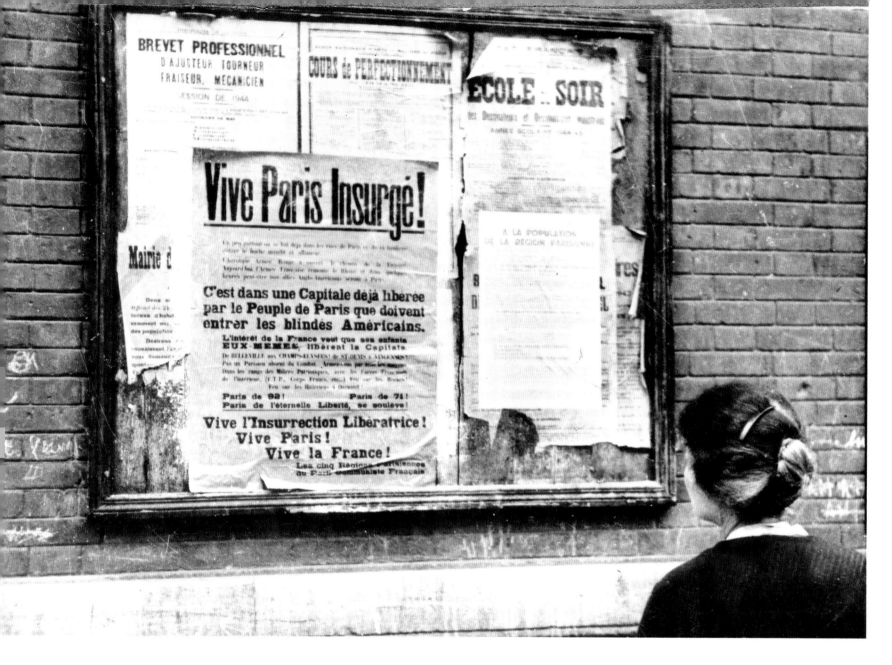

ABOVE: A poster encouraging the people of Paris to rise up and liberate the city, August 1944.

RIGHT: A French man and woman fight with arms taken from the Germans in Paris, August 1944. After Allies defeated the Germans in Normandy, Parisians revolted against their Nazi occupiers. More than 500 resistance fighters and 127 civilians died in the struggle for Paris between 19–24 August 1944.

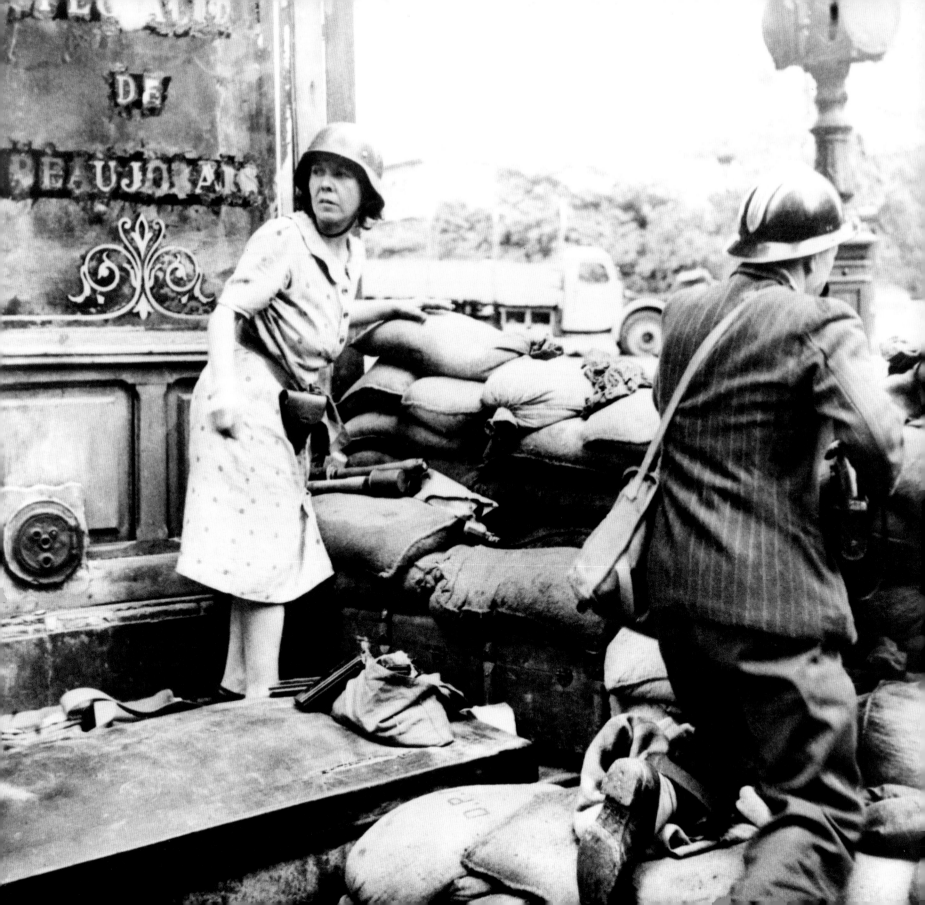

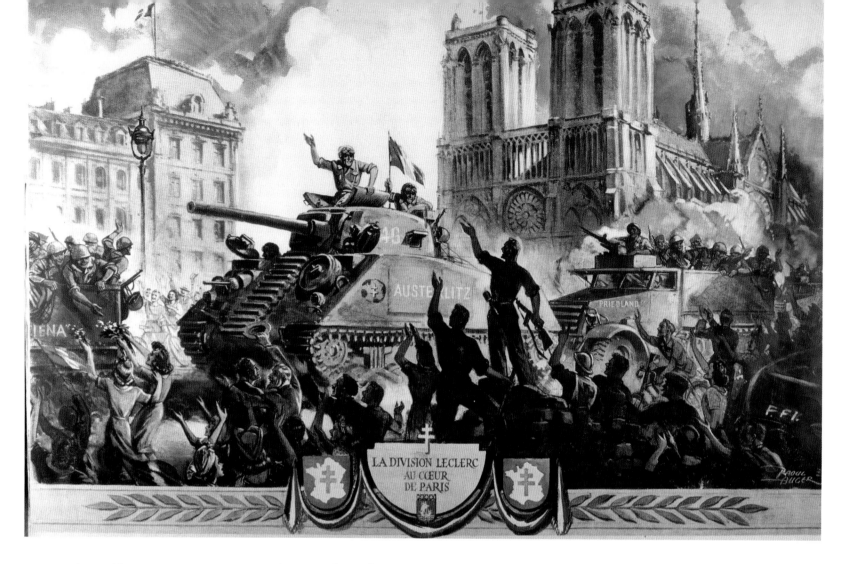

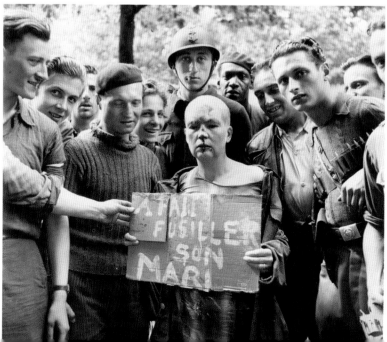

ABOVE: A graphic representation of the Free French forces commanded by General Leclerc entering Paris 24 August 1944 and being greeted enthusiastically after five years of Nazi occupation.

RIGHT: A group of people parade and taunt a woman for being a collaborator outside the police station at 36 Quai des Orfevres during celebrations for the liberation of Paris in August 1944. Her hair has been shaved and she carries a sign which reads, 'I had my husband shot'.

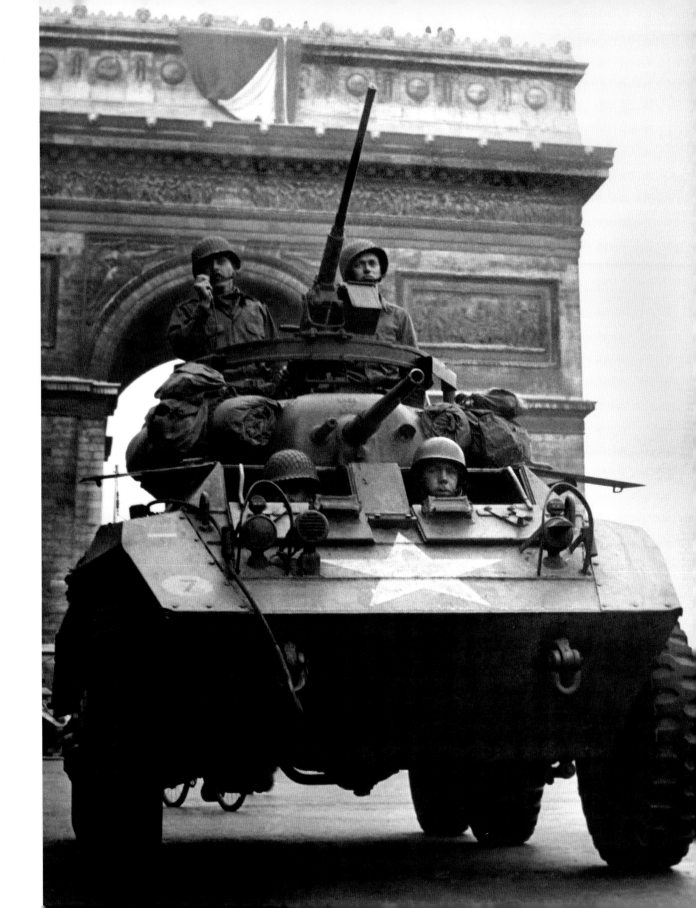

RIGHT: An American tank passes the Arc de Triomphe during the liberation of Paris, 25–29 August 1944.

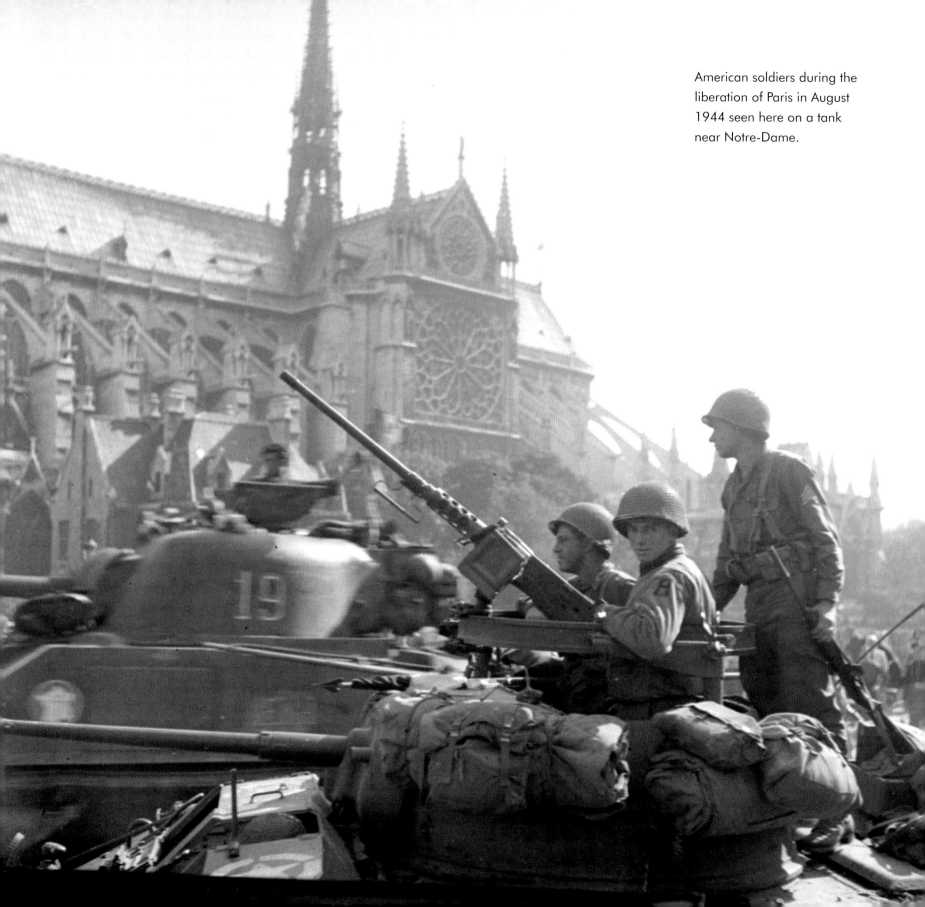

American soldiers during the liberation of Paris in August 1944 seen here on a tank near Notre-Dame.

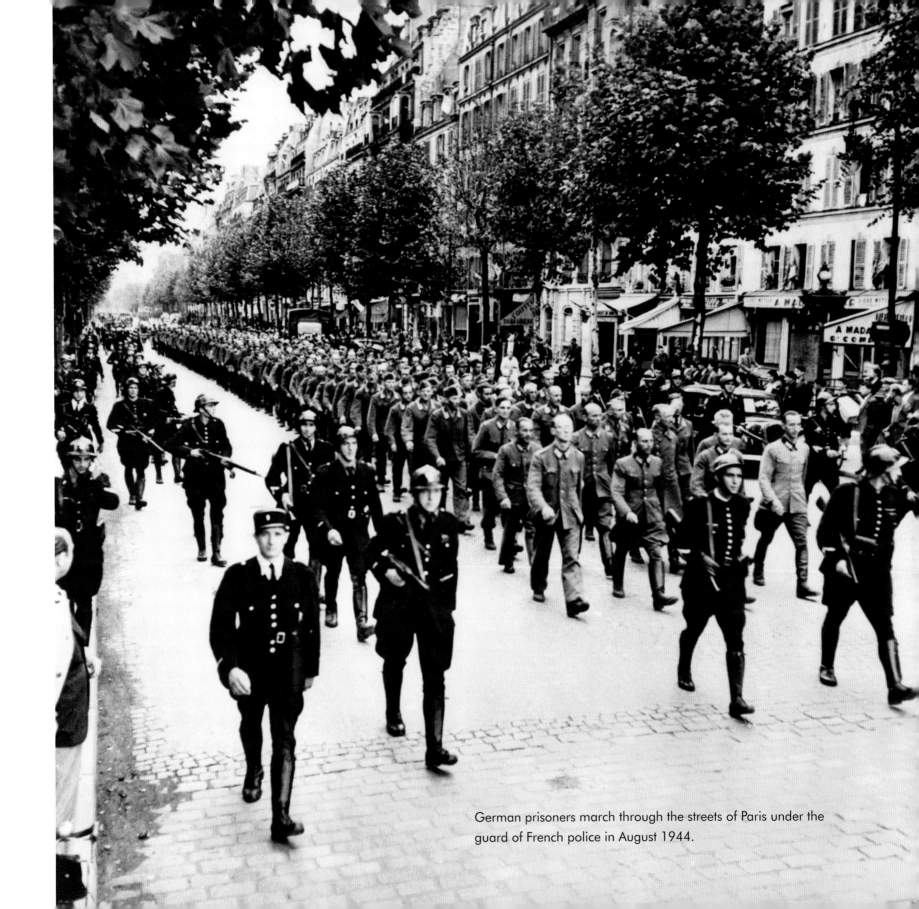

German prisoners march through the streets of Paris under the guard of French police in August 1944.

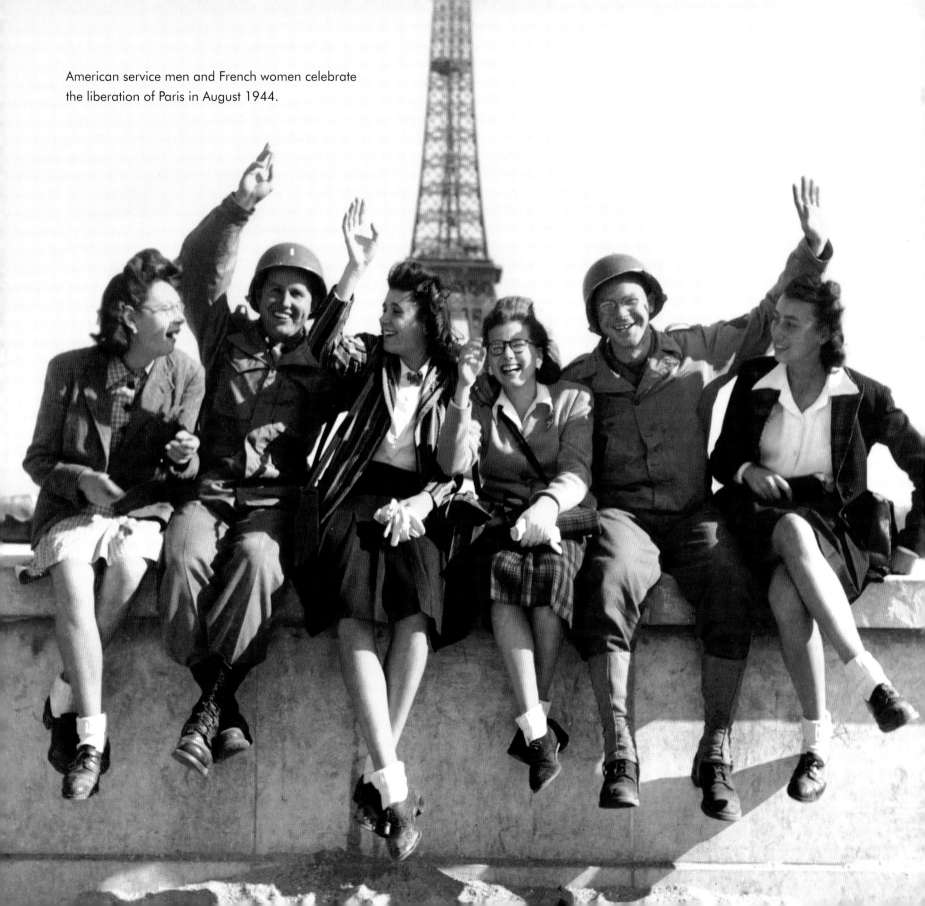

American service men and French women celebrate the liberation of Paris in August 1944.

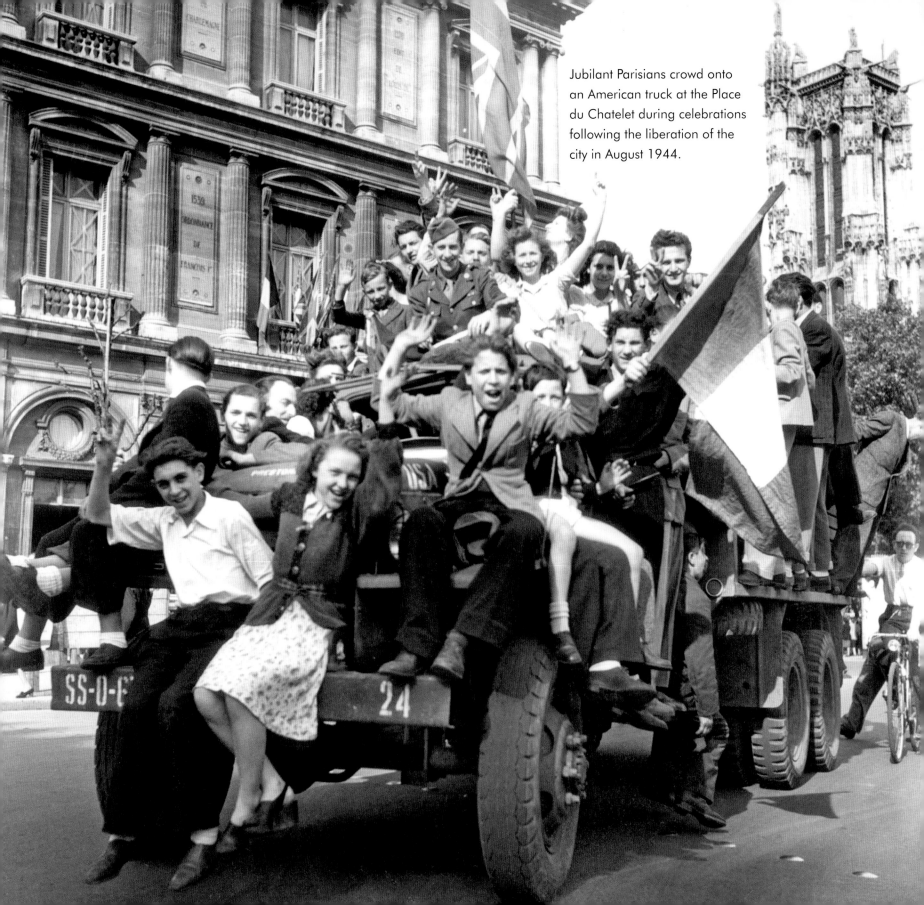

Jubilant Parisians crowd onto an American truck at the Place du Chatelet during celebrations following the liberation of the city in August 1944.

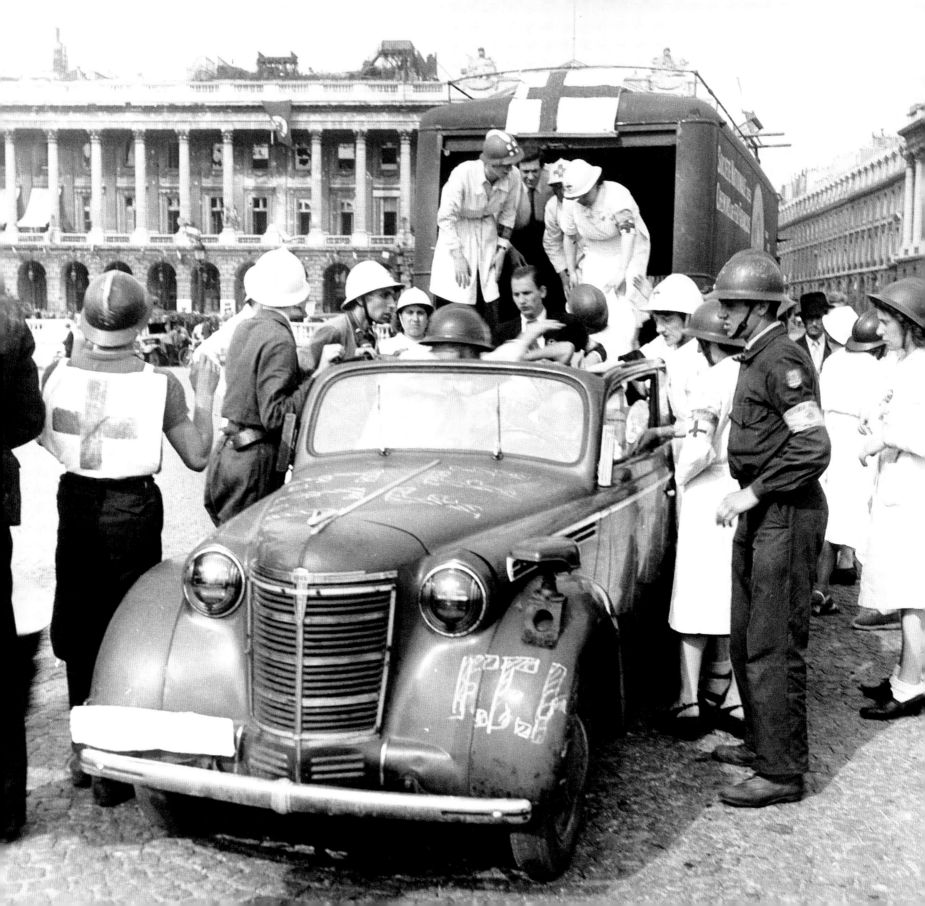

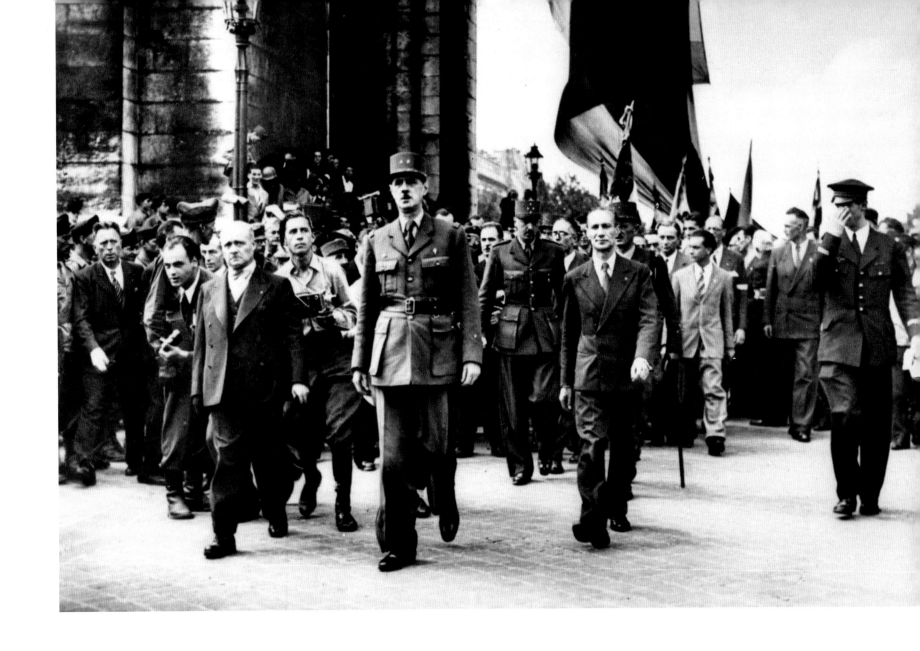

LEFT: The Red Cross looking for wounded during the liberation of Paris on the 26 August 1944 in the *Place de la Concorde*.

ABOVE: Charles de Gaulle, leader of the Free French, is surrounded by a delirious crowd as he walks from the Arc de Triomphe down the Champs-Élysées to the Place de la Concorde in celebration of the liberation of Paris on 26 August 1944.

PARIS AT NIGHT

"It is night in the Paris of a thousand memories.
And the Place de la Concorde lies in silver blue
under springtime skies. And up the Champs-Élysées
the elfin lamps shimmer in the moist leaves
like a million topaz tears. And the boulevards
are a-thrill with the melody of living."

Europe after 8.15 (1914) by H.L. MENCKEN

MOULIN ROUGE

There are two sides of Paris at night – the dazzling vistas beautifully illuminated and the many pleasures of its multi-faceted night life. A combination of the two creates the image that Paris is indeed the playground of the world.

Seeing the Eiffel Tower or the Arc de Triomphe lit up at night is a truly majestic sight. And, where would we be without all the brightly-lit cafés, restaurants and shops? Lighting has played an important part in the city of lights during the various world fairs, state visits and royal tours such as the visit of George VI in 1938. The city has maintained its sparkling glow since the first gas lights were installed in 1829. This was followed by the arrival of electric lighting in 1878. The first electric street lights in Paris were installed around the Arc de Triomphe to celebrate the opening of the Paris Universal Exposition. Today, Paris is subtly lit in various ways and there are even night tours to see all of Paris' illuminations.

When it comes to the nocturnal adventures that Paris has to offer it is wise to remember that there is the Paris of the Parisians and the Paris for the tourists. Before World War I, one of the most intriguing tours of Parisian night spots became known as La Tournée des Grands Ducs, which came about in the late 19th century due to the antics of the Russian nobility. To escape the restrictions of the Russian court, the Russian elite flocked to Paris where life was more relaxed. As they spoke excellent French, they could visit all the fashionable nightclubs, restaurants, and cabarets including the legendary Maxim's and the Moulin Rouge with its can-can dancers. The Russian invasion was most evident at the smart Chateau Caveau with the Cabaret Caucasiens. Here the waiters were dressed as Cossacks and the cabaret featured the songs and dances of Russia. The male dancers were fine handsome men, many ex-officers of the Imperial guard.

Eventually, the Tour of the Grand Ducs became synonymous with any reckless, extended night-time exploration of fun and frolics. As Russia changed with the revolution, the time-honoured tradition was taken up by Americans who flocked to Paris in the Jazz age after which the tour was re-christened Tournee des Americains.

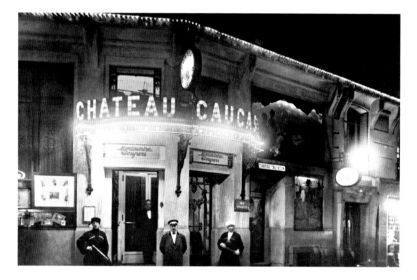

Staff standing outside the Russian Nightclub 'Chateau Caucasien' in the Rue Pigalle, Montmartre, (1931).

According to Ralph Nevill in *Night life* (1926), Paris after the war had 'lost much of the spontaneous gaiety which formerly was such an attractive feature'. Equally, it became perfectly clear that the foreign invasion of Paris in the 1920s had virtually driven the Parisians out of restaurants and cabarets. Many venues were viewed as tourist traps. The French actually called the seeker of the night romance of Paris *une belle poire* which roughly translates as 'sucker'. As Basil Woon said in *The Paris That's Not in Guide Books* (1926), 'the particularly salacious side of the Gay City is a sideshow especially contrived for the benefit of Americans'.

Nightclubs and cabarets after the war continued to boom as everyone became jazz and dancing mad. New 'dancings' emerged each season with a hub in Montmartre, Place Pigalle and the Rue Caumartin. The Acacias, though short lived, was a highly fashionable venue in the *Rue Acacias* that opened in 1920. Popular as a summer haunt, it was a hall in the rear of the Hôtel Acacias with a garden that was first run by Maurice Chevalier. Oscar Mouvet then made it into a Southern plantation, before Harry Pilcer took it over on more traditional lines. Other

PREVIOUS SPREAD: The neon signs light up the Moulin Rouge music hall.

92

salubrious and popular venues were the Jardin de Ma Souer (the Embassy), Zelli's Royal Box, Le Capitole and Le Perroquet within the Casino de Paris.

Of course the social season in Paris would not be complete without visits to the fashionable resorts in the Bois de Boulogne in the summer, including Le Pré Catelan, a restaurant in the Bois de Boulogne which is still in operation today.

Night resorts continued to proliferate during the 1930s and beyond. Although most of the music halls endured, many of the old 'dancings' were simply reused for whatever the current trend or fad might be – big band music, swing, twist, disco and even comedy clubs. Cabaret in many forms continued unabated and many new haunts sprung up in the 50s and 60s all over Paris, particularly in the Latin Quarter and Montparnasse, catering for all tastes including the Parisian fascination with jazz.

One aspect of Parisian night life that was eternally fascinating was that of the Apache, a violent criminal underworld subculture. There was a trend for 'slumming it' by visiting the low cabaret haunts of the ordinary, if somewhat rougher element of Parisian society. The strange and brutal lives of Apaches (criminals, night muggers and bullies) were peculiar to Paris. They lived on money made from lives of shame and yet they retained a certain patriotism. Immortalised by the famous dance called the Apache that originated before the war, the British actor Ivor Novello also played a typical apache in three films made by Gainsborough Pictures in the 1920s called collectively 'the Rat trilogy'.

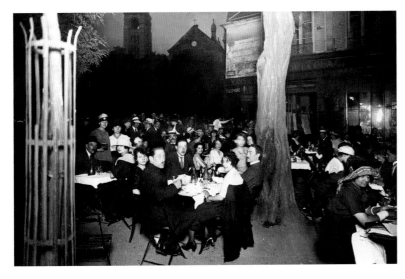

A sidewalk café in on the Place du Tertre, Montmartre at night, (1927).

Through the centuries Paris has continually been seen as a landscape inhabited by beautiful women. Even if you do not approve, the ladies of the night have become a visible attraction and part of the allure of the naughtier side of Paris. According to Basil Woon, the French often complained that Paris was advertised as 'a wicked place of dissipation and sin and not as the capital of the arts' and yet he charmingly captured his observations about the ladies of the night by saying that the sordid side of Paris was not cleverly concealed. In 1926 there were more than 70,000 registered 'daughters of the crimson'.

Of course, besides the dancing, the music and the vibrant café scene, the most important night-time activity is eating out. Sommerville Story in *Dining in Paris* (1929) made it clear that there is the 'incontestable assertion, that the best food in the world as regards preparation and variety, quality and daintiness is to be found in Paris. We must not forget that this is because the capital is a mirror or concentrated expression of the French provinces. Its wealth, organisation and resources enable it to procure everything – and the best of everything'. Paris was, and still is, renowned for its cuisine and a fine dinner in Paris can be at once a ceremony and an evening entertainment. To eat and drink in Paris is still considered to be one of the chief enchantments of life.

Bon appetit et bon soir.

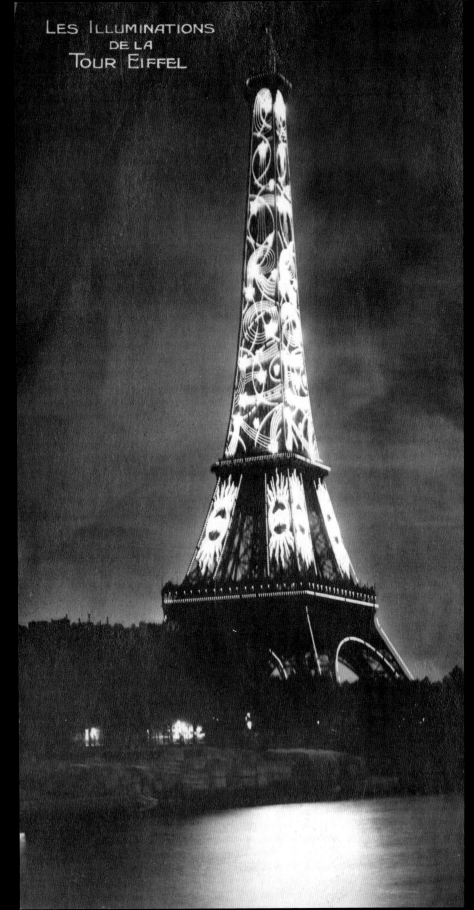

LES ILLUMINATIONS
DE LA
TOUR EIFFEL

ABOVE: 'Welcome to Paris at night' and what a night! The French actress Damia at the Concert Mayol, Paris, (1927).

LEFT: The Eiffel Tower illuminated at night for the Exhibition of Decorative Arts in 1925. The lighting scheme illustrates the logo of Citroën, which has become one of the most famous advertisements in history.

RIGHT: The Arc de Triomphe lit up in the Paris night, (1931).

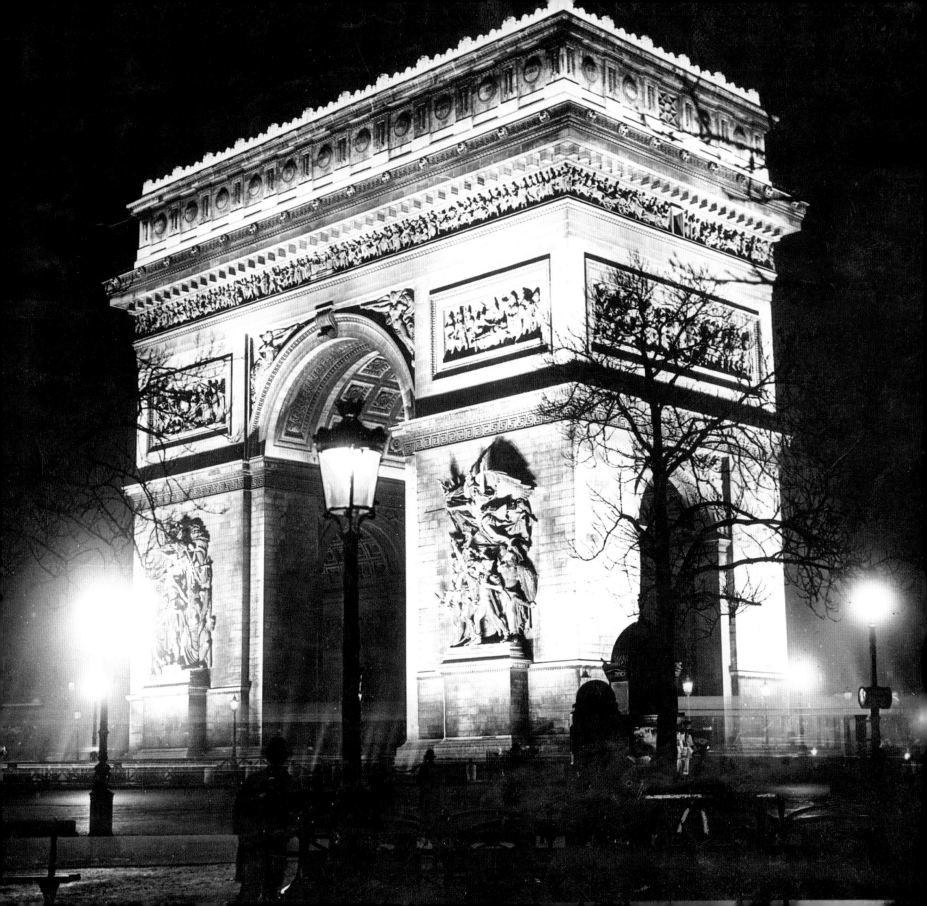

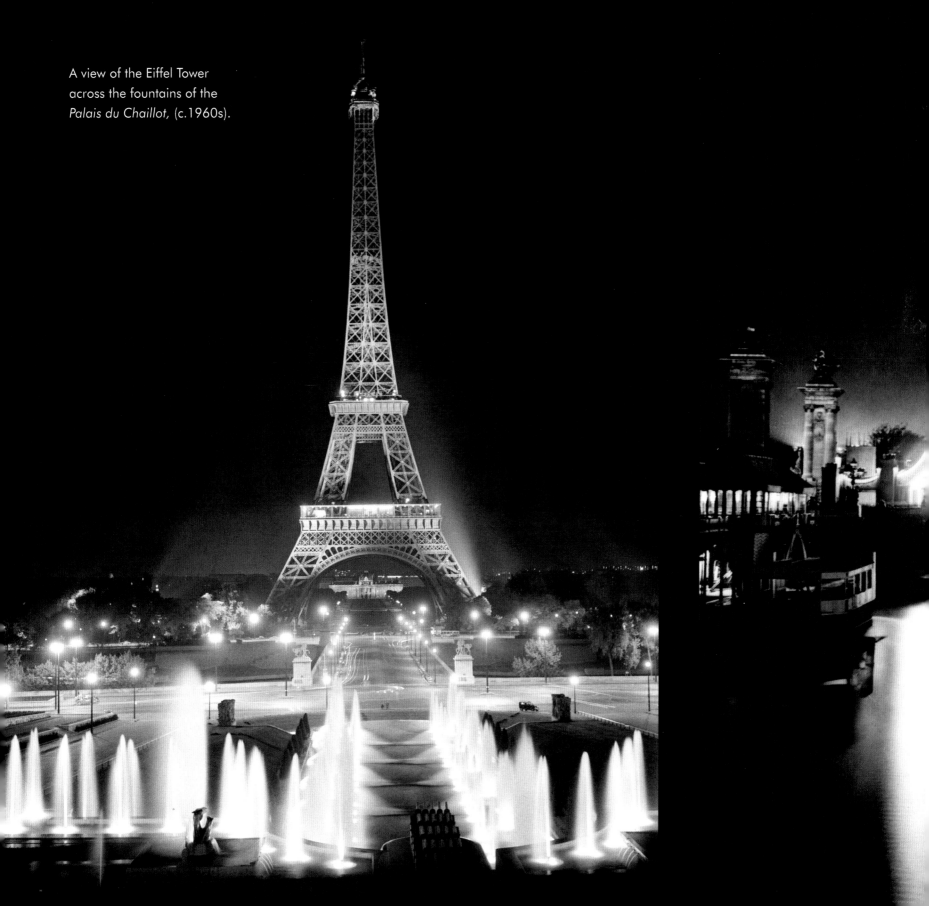

A view of the Eiffel Tower across the fountains of the *Palais du Chaillot*, (c.1960s).

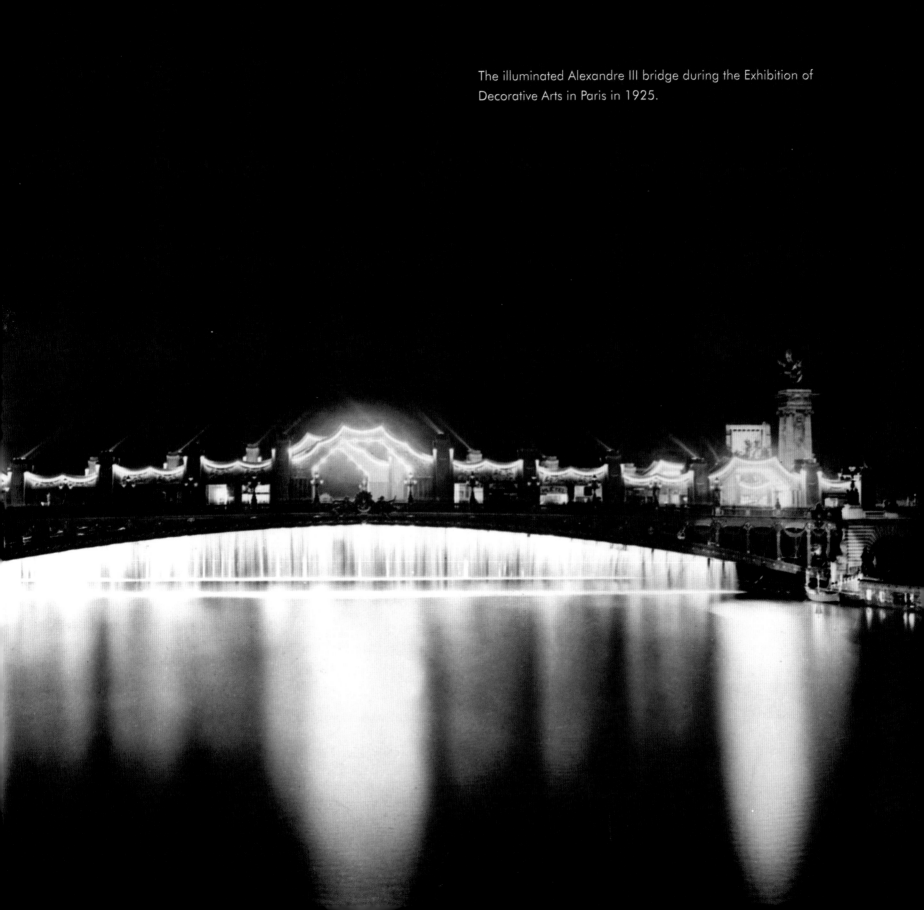

The illuminated Alexandre III bridge during the Exhibition of Decorative Arts in Paris in 1925.

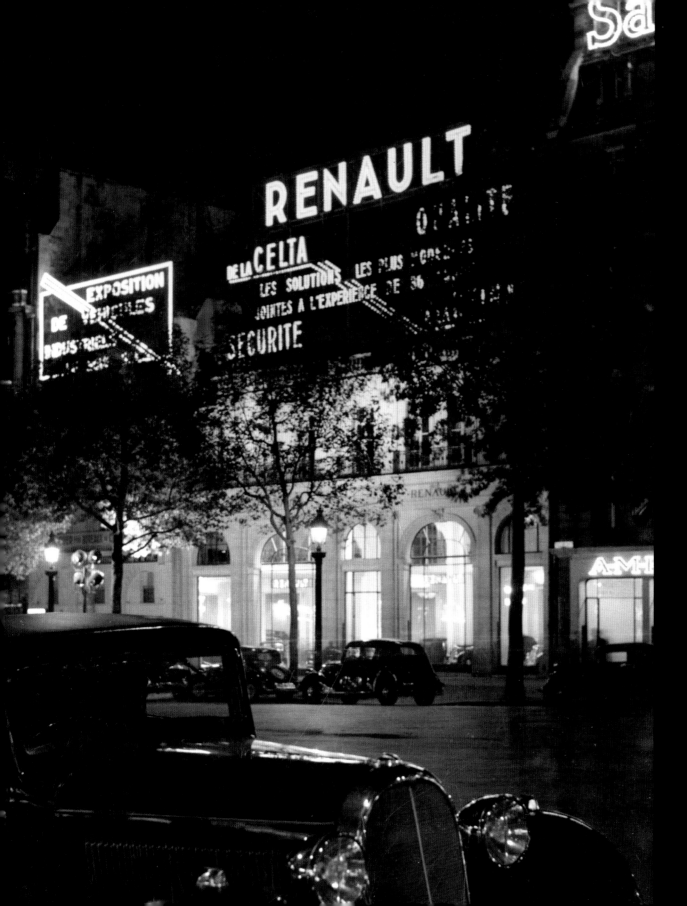

LEFT: A Renault showroom in Paris illuminated at night, (c.1930s).

RIGHT: The illuminated Champs-Élysées and floodlights shining above the Arc de Triomphe for the visit of King George VI and Queen Elizabeth to Paris in 1938.

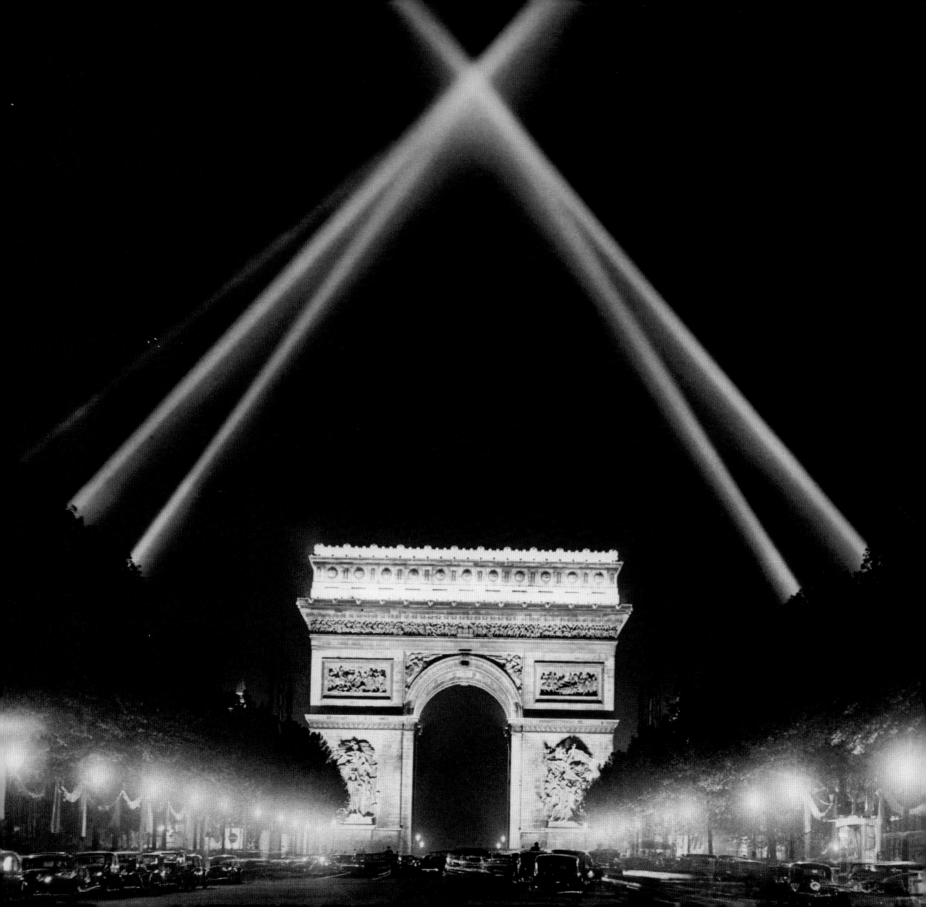

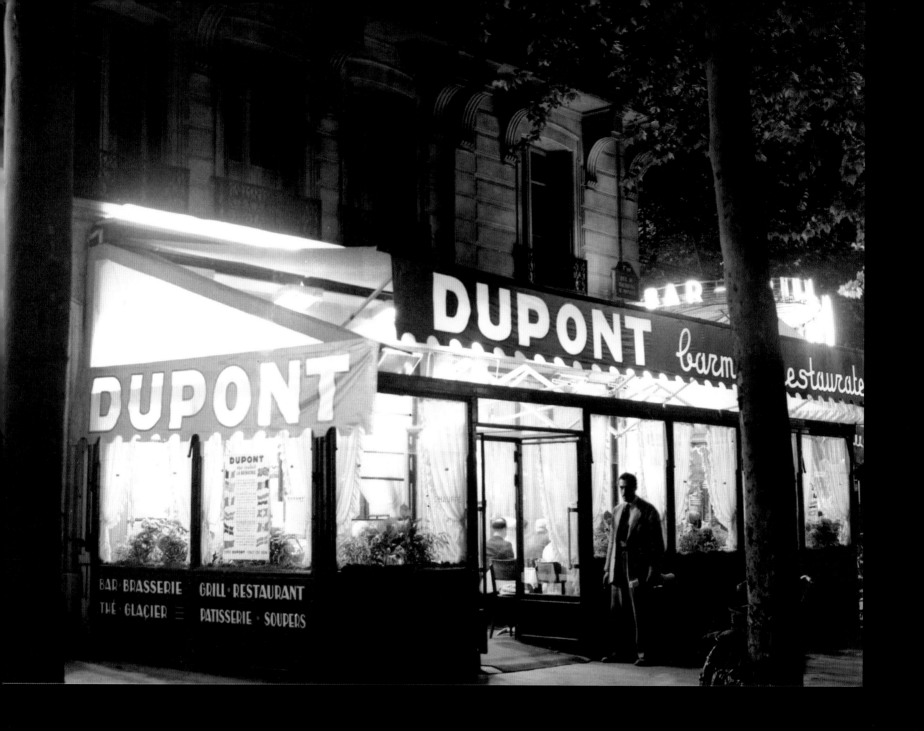

ABOVE: The restaurant Dupont in Faubourg Saint Honoré, (c.1950s).

RIGHT: A street view in 1970 with Christmas decorations in the entertainment district of Montmartre.

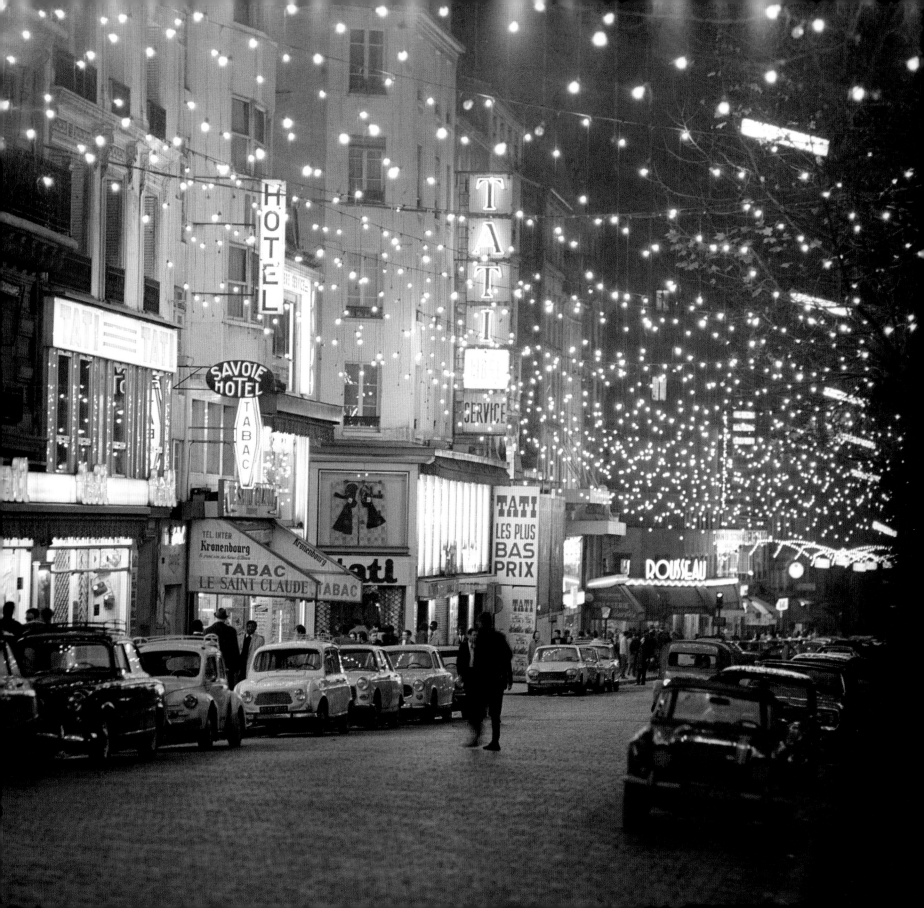

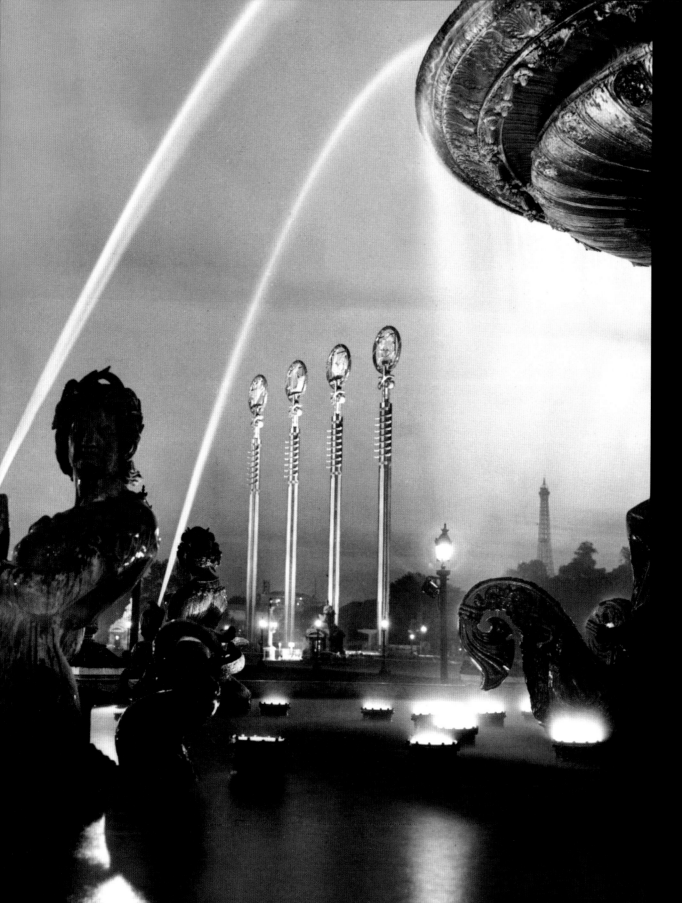

LEFT: An evocative view of the Place de la Concorde at night during the Universal Exhibition of 1937.

RIGHT: The Christmas lights at department store, Galeries Lafayette, (c.1930).

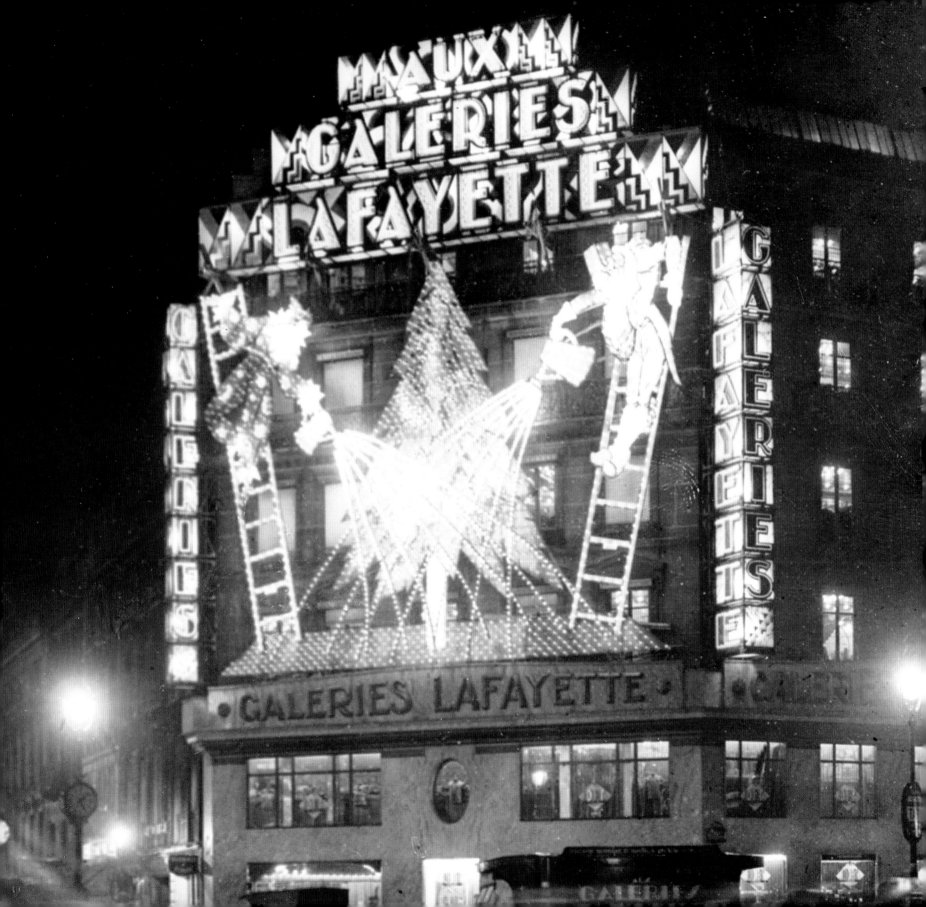

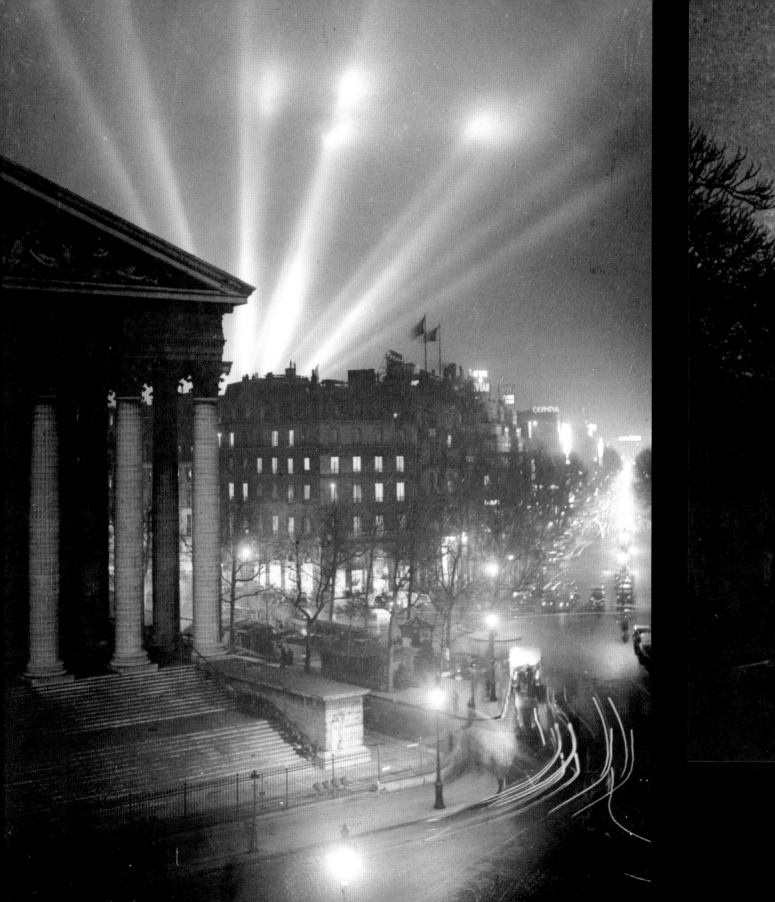

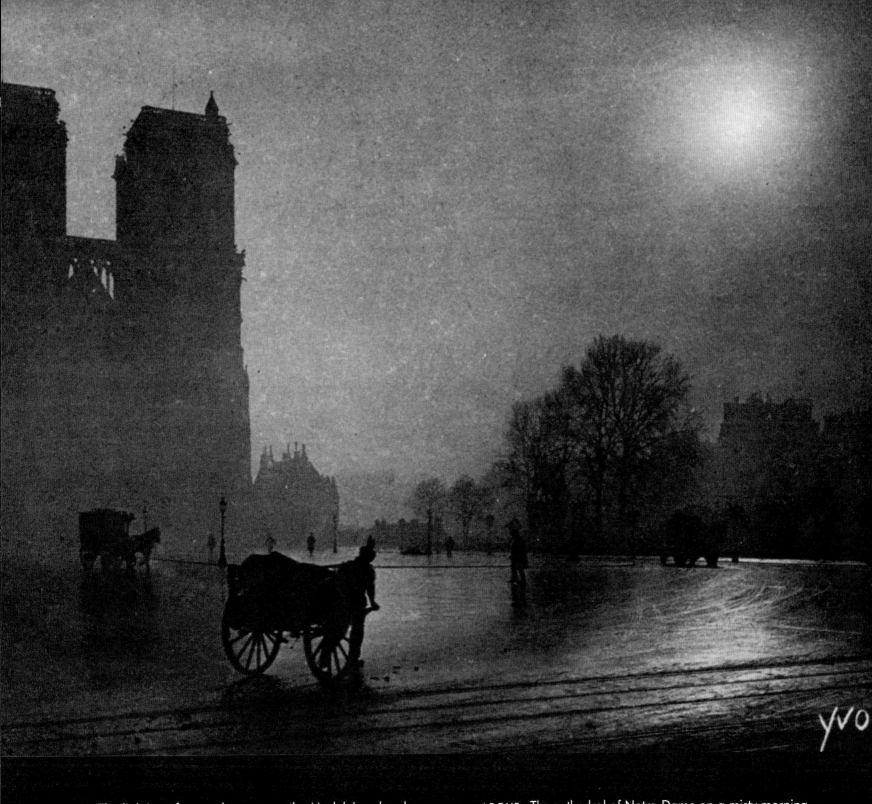

yvo

LEFT: The lighting of a warehouse near the Madeleine church creates a majestic night-time vision, (c.1930).

ABOVE: The cathedral of Notre-Dame on a misty morning, (c.1925).

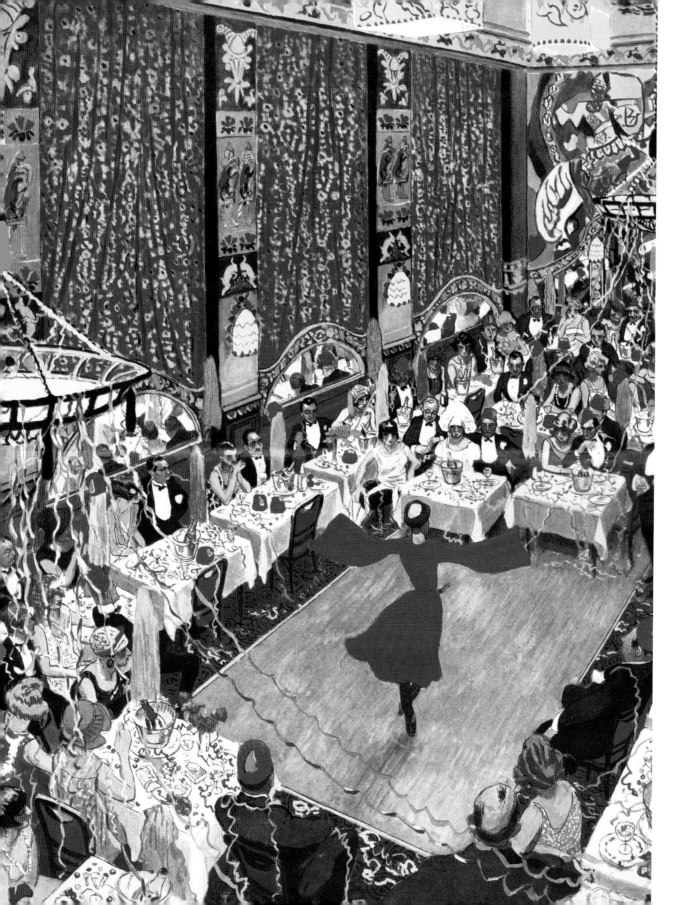

ABOVE: Night-time festivities on the Rue Pigalle in Montmarte, (c.1920s).

LEFT: A sketch of the interior of the Chateau Caucasien and the cabaret specialising in Russian songs and dances in progress, (c.1920s).

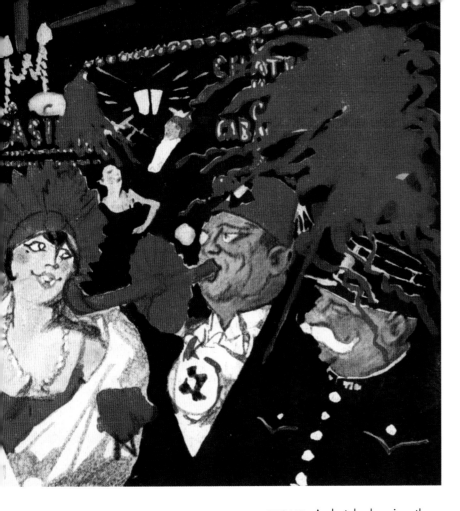

RIGHT: A sketch showing the Place du Tertre, Montmartre at midnight, (1914).

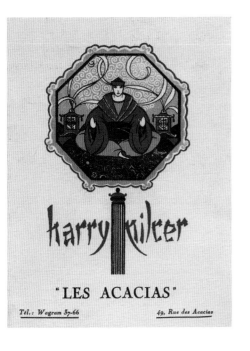

LEFT: Programme cover for Les Acacias nightclub run by Harry Pilcer, Paris, (1925).

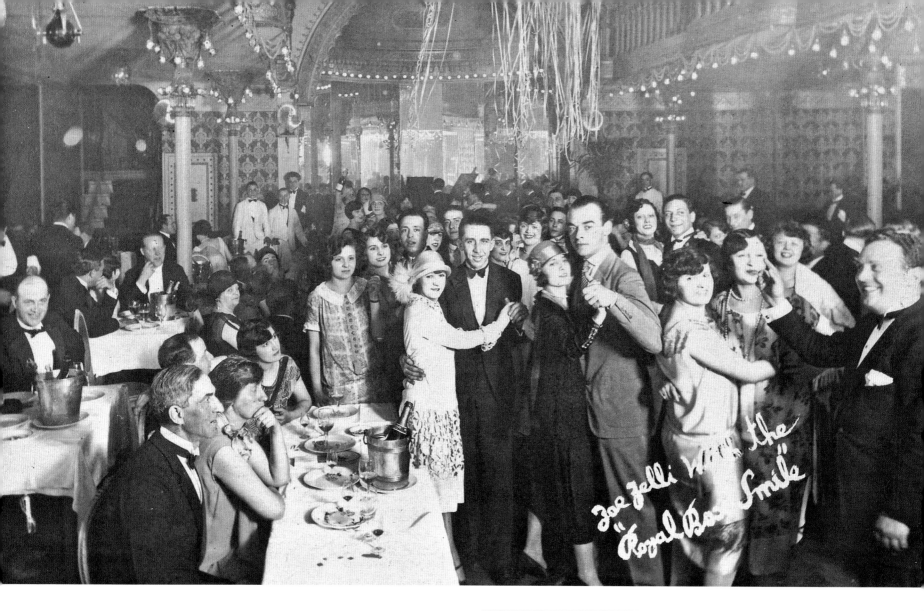

ABOVE: An interior view of a party at Zelli's nightclub called
The Royal Box, 16 Rue Fontaine in Montmartre in the 1920s.
A favoured rendezvous for Americans, it was run by American
Joe Zelli (far right).

RIGHT: The crowded dance floor of the Capitole night spot at 58,
Rue Notre-Dame de Lorette, (c.1920s).

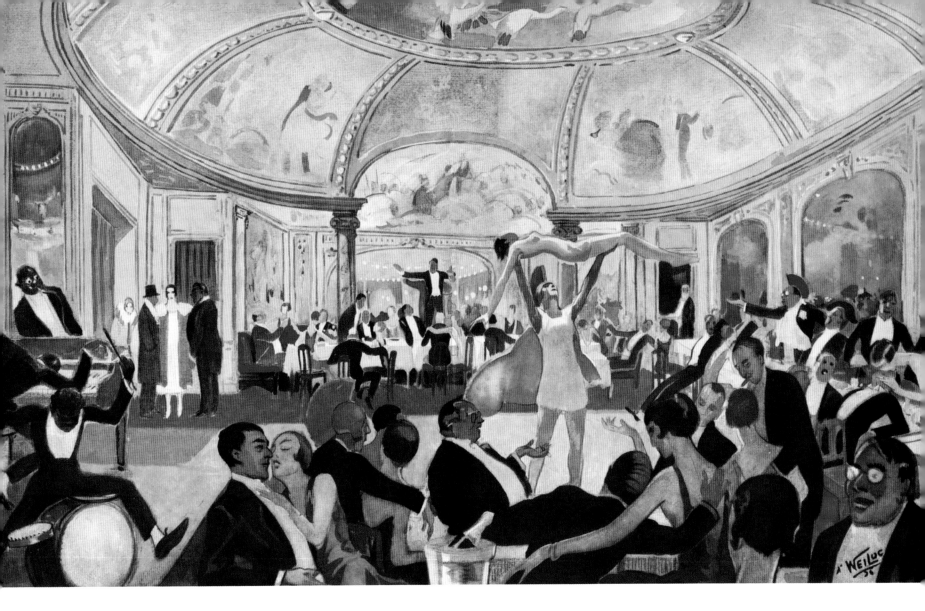

ABOVE: The interior of Le Capitole, restaurant, cabaret and dancing venue in Paris, 1920s showing a performance in the middle of the room by an exhibition dancing duo to a black jazz band on the left.

RIGHT: A sketch of Louis Mitchell's famous night spot Le Grand Duc in the Place Pigalle, Paris, (c.1920s). Mitchell formed one of the first black jazz bands in Paris playing at the Le Perroquet cabaret within the Casino de Paris but later ran this venue that was often called Harlem in Montmartre.

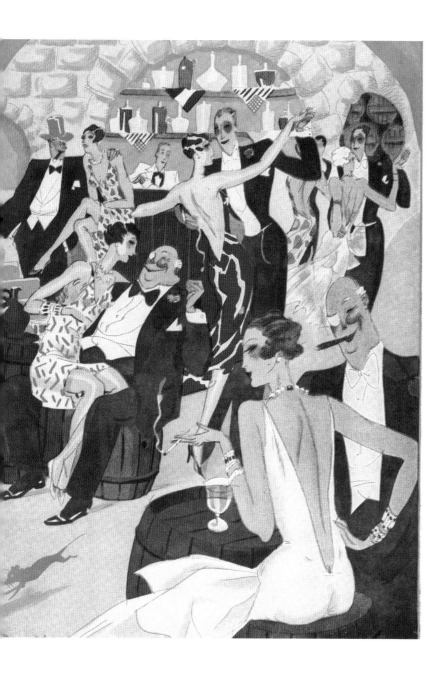

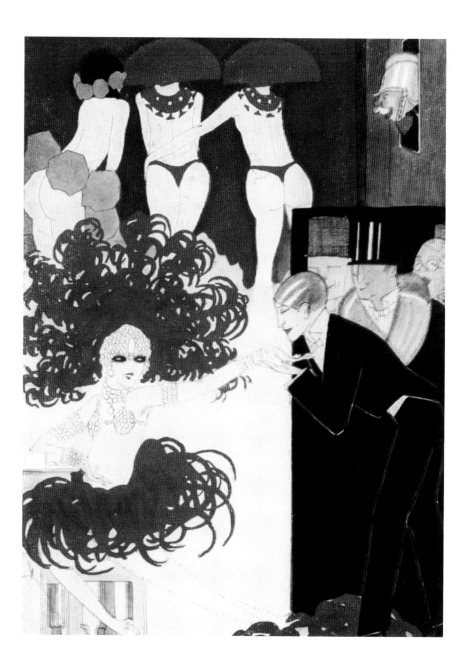

ABOVE: A humorous sketch of
the *habitués* of a typical small
café in Paris, (1925).

ABOVE: A tongue-in-cheek sketch depicting a scene in a Paris
nightclub at midnight with semi-naked dancers and their admirers,
(1926).

RIGHT: Artwork for Le Boeuf Sur Le Toit with characters created by
Cocteau and decor by Dufy, (1920).

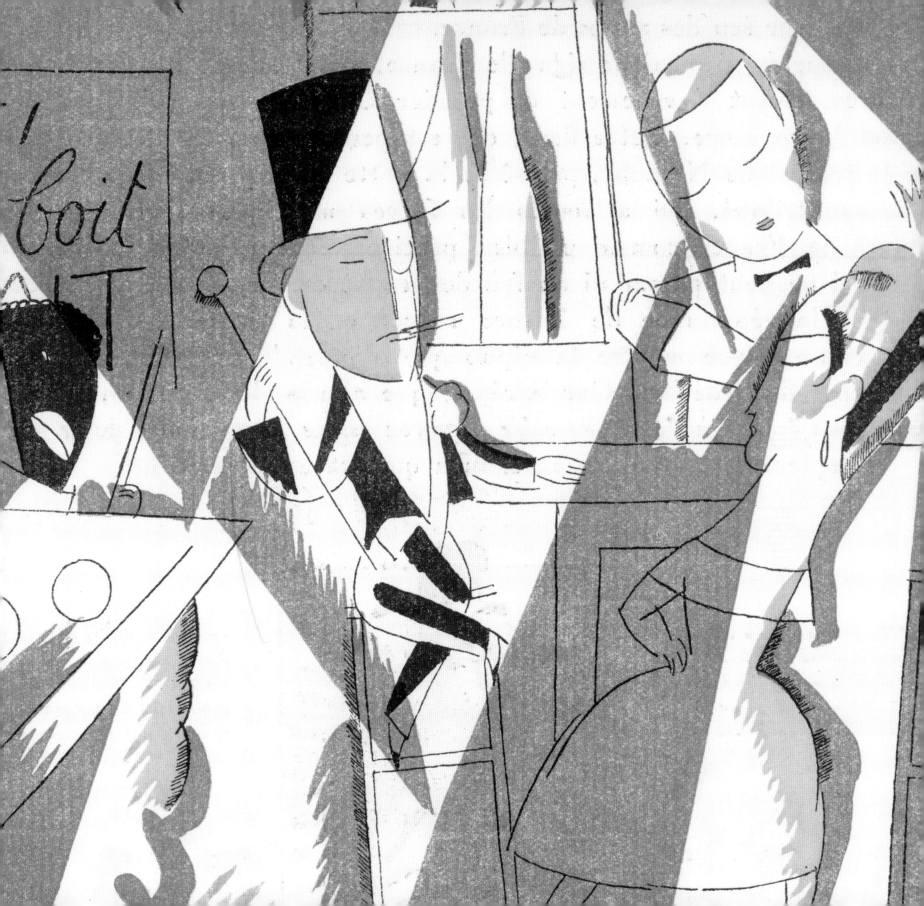

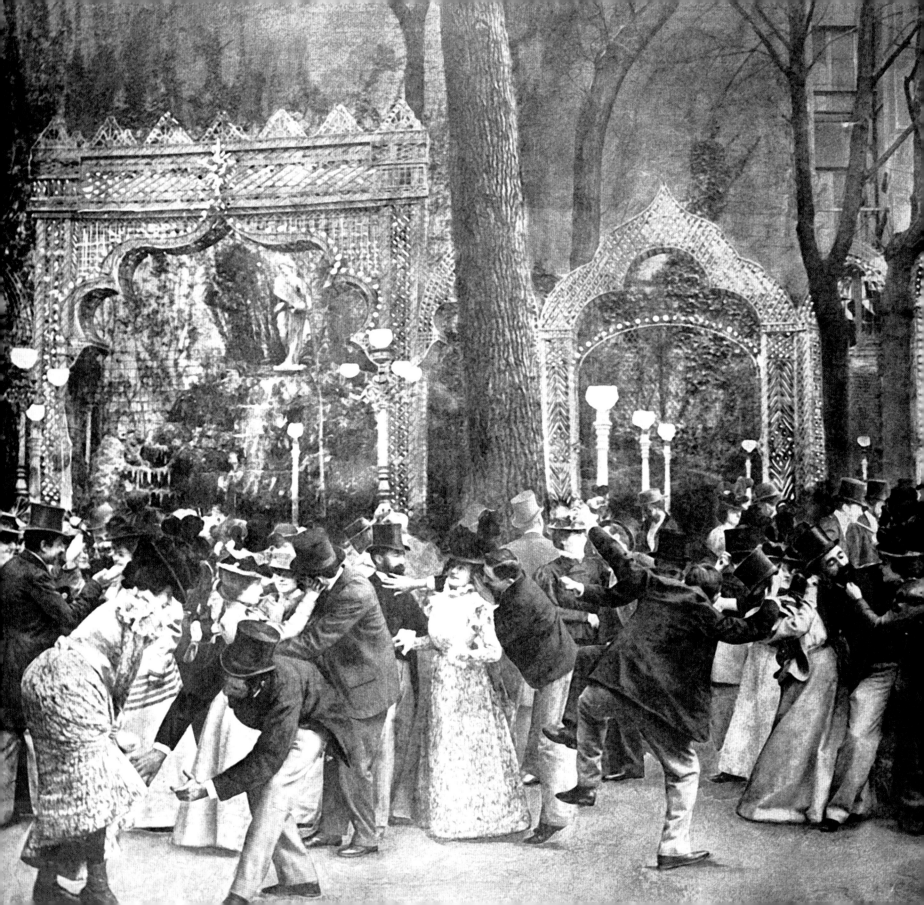

LEFT: One of the most famous dancing venues in Paris from 1859–1940 was the Bal Bullier at 39 Avenue Georges Bernados, south of the Jardin du Luxembourg. Built on a former monastery, the curious building had a Moorish façade and a mix of indoor and outdoor space, (1909).

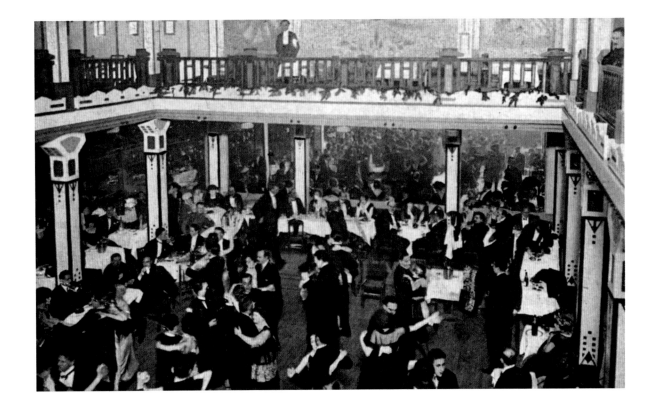

RIGHT: The interior of the popular dancing venue in the 1920s, Shéhérazade in the Rue du Faubourg, Montmartre.

RIGHT: A sketch representing dancers at the integrated Bal Negre nightclub in the Rue Blomet west of Montmartre, (1929). Opened in 1924 by Jean Rezard as Le Bal Colonial, it became a favoured mixed-race dancing and jazz place and continued as a music venue after World War II.

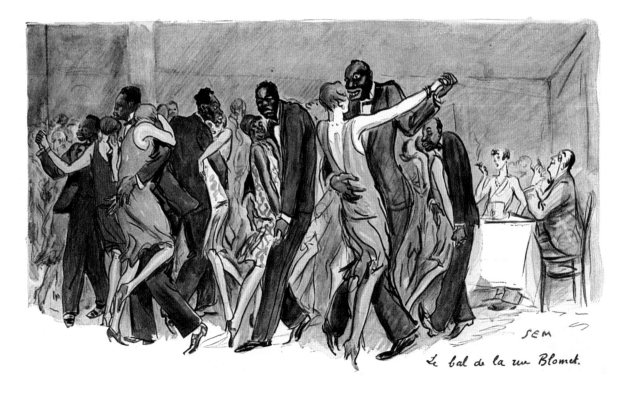

Le bal de la rue Blomet.

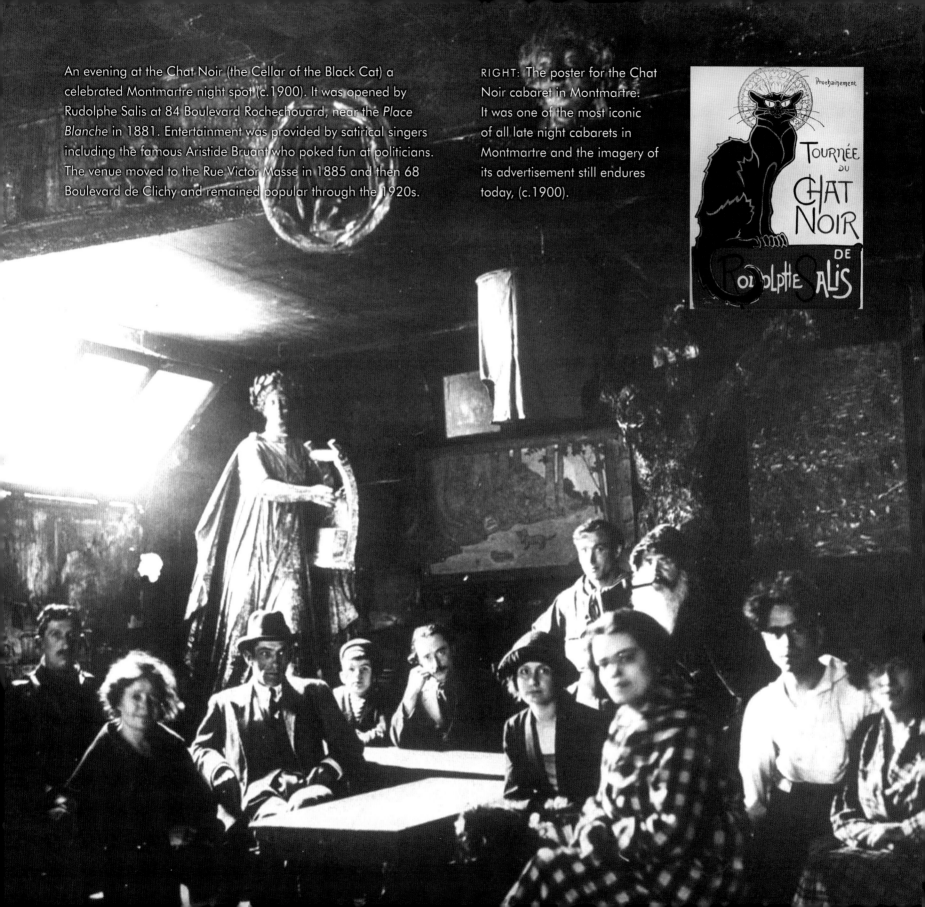

An evening at the Chat Noir (the Cellar of the Black Cat) a celebrated Montmartre night spot (c.1900). It was opened by Rudolphe Salis at 84 Boulevard Rochechouard, near the *Place Blanche* in 1881. Entertainment was provided by satirical singers including the famous Aristide Bruant who poked fun at politicians. The venue moved to the Rue Victor Masse in 1885 and then 68 Boulevard de Clichy and remained popular through the 1920s.

RIGHT: The poster for the Chat Noir cabaret in Montmartre. It was one of the most iconic of all late night cabarets in Montmartre and the imagery of its advertisement still endures today, (c.1900).

Prochainement

TOURNÉE
DU
CHAT
NOIR
DE
Rodolphe SALIS

RIGHT: A sketch of elegant couples enjoying a popular Montmartre 'dancing', (1929). It was noted at the time that dancing was an integral part of the daily life of a *Parisienne* (woman) who has any self-respect.

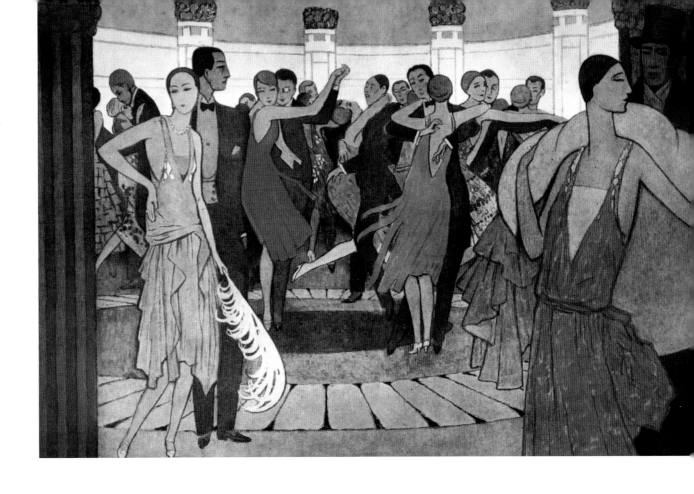

RIGHT: Illustration by Webster Murray in *The Bystander*, 1931, of a typical bohemian society in a Parisian café enjoying a Bal Musette. Couples dance the tango and other dances to traditional music in which the accordion and guitar take centre stage.

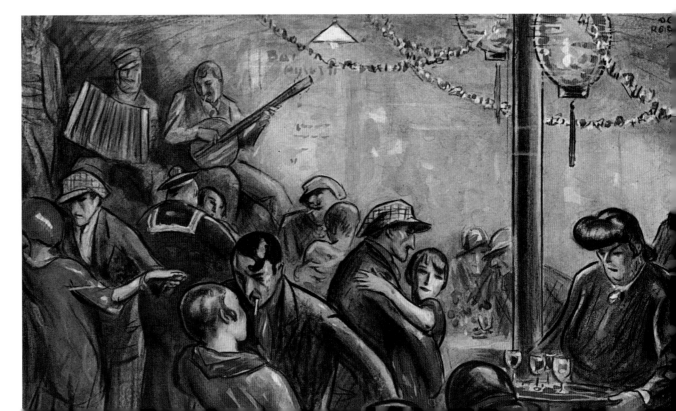

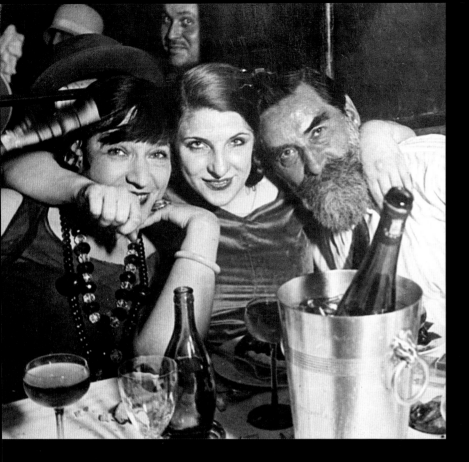

LEFT: The famous Kiki of Montparnasse, a model, artist and performer with two friends enjoying night-time frivolity and Champagne in a Paris cabaret, (c. early 1930s).

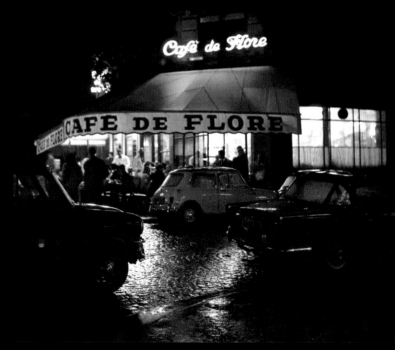

ABOVE: Café de Flore in Saint-Germain-des-Prés in 1966.

LEFT: Dancing at the Tabou nightclub on the Rue Dauphine, Saint-Germain-des-Prés, shortly after its opening in 1947. One of the first cave clubs for intellectuals and the avant-garde, it became a hip place for dancing, jazz music, poetry and literature and stayed open until 4am.

BELOW: An illustration of the Paris blackout (1940–1941). Parisians needed to use torches to help them find their way about. Seemingly there are some benefits, (c.1940s).

BELOW: Depiction of the blackout in Paris, romantic to some, but also the cause of accidents. As an officer and his lady look on, a man stumbles into a lamppost in February 1918.

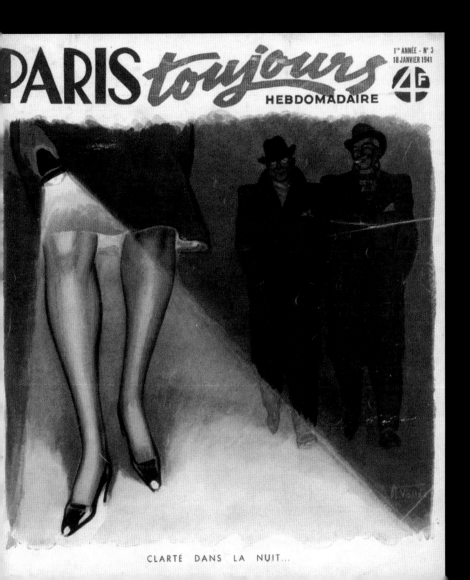

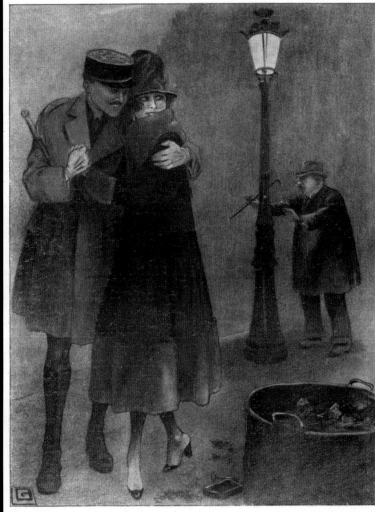

Wild dancing at an Existentialiste ball in Saint-Germain-des-Pres, 20 January 1949.

People dancing the twist in a Paris club, (1963).

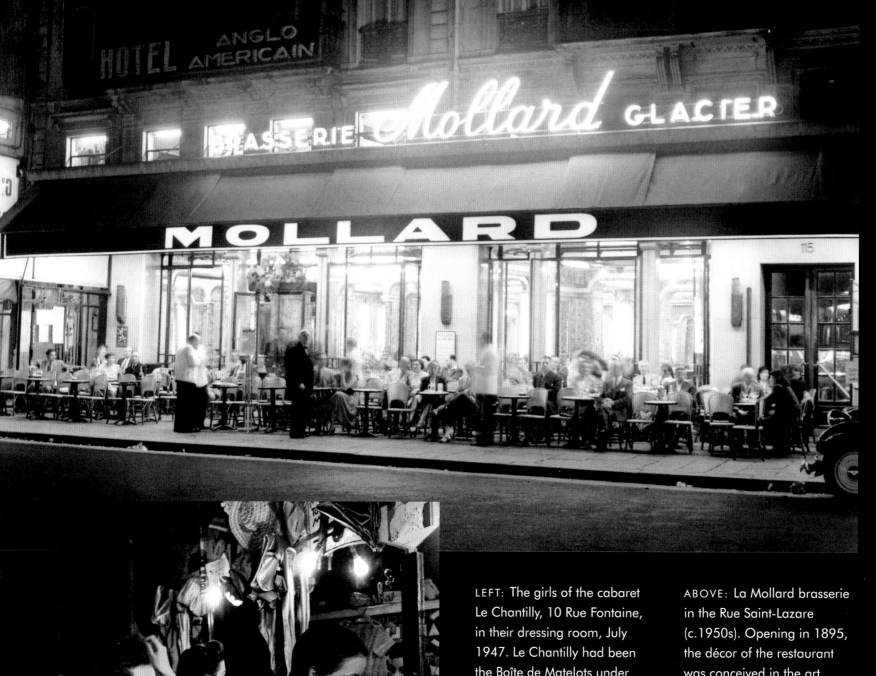

LEFT: The girls of the cabaret Le Chantilly, 10 Rue Fontaine, in their dressing room, July 1947. Le Chantilly had been the Boîte de Matelots under the direction of Leon Volterra in the 1930s and is now Theatre Fontaine.

ABOVE: La Mollard brasserie in the Rue Saint-Lazare (c.1950s). Opening in 1895, the décor of the restaurant was conceived in the art nouveau style by Edouard Niermans who had been the designer behind the Moulin Rouge, the Negresco Hôtel in Nice and the Hôtel de Paris in Monte Carlo.

A view of a dance theatre called the
Garden of Montmartre, (1970).

"CAN'T HELP LOVIN' THAT MAN!"

BY HELEN McKIE

ABOVE: Ivor Novello in the British film *The Return of the Rat* (1929) directed by Graham Cutts for Gainsborough Pictures. The Rat was an Apache and the film followed his adventures among the *demi-monde* and Parisian underworld.

ABOVE: An illustration depicting a red-haired woman staring into the eyes of her lover – a magnetic but dangerous looking Apache. These savage members of the Parisian underworld haunted areas such as Montmartre and La Villette in the early 20th century. Apache 'types' were a popular subject for illustrators during the 1920s, possessing as they did a streak of exotic sexuality, though they were often depicted as being casual or even cruel to their

RIGHT: Illustration of a prostitute standing at the corner of a street in Montmartre, (1927).

BELOW: A prostitute in front of a bar in Paris, (1966).

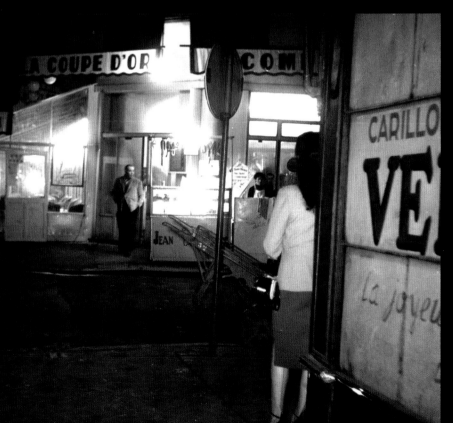

PARIS LA NUIT

En vertu des édits réglant le couvre-feu,
Toute histoire d'amour doit être un conte bleu.

ABOVE: A woman walks the streets of Paris at night, under curfew during World War I, feeling that it is a particularly 'blue time' for love to flourish, (c.1917).

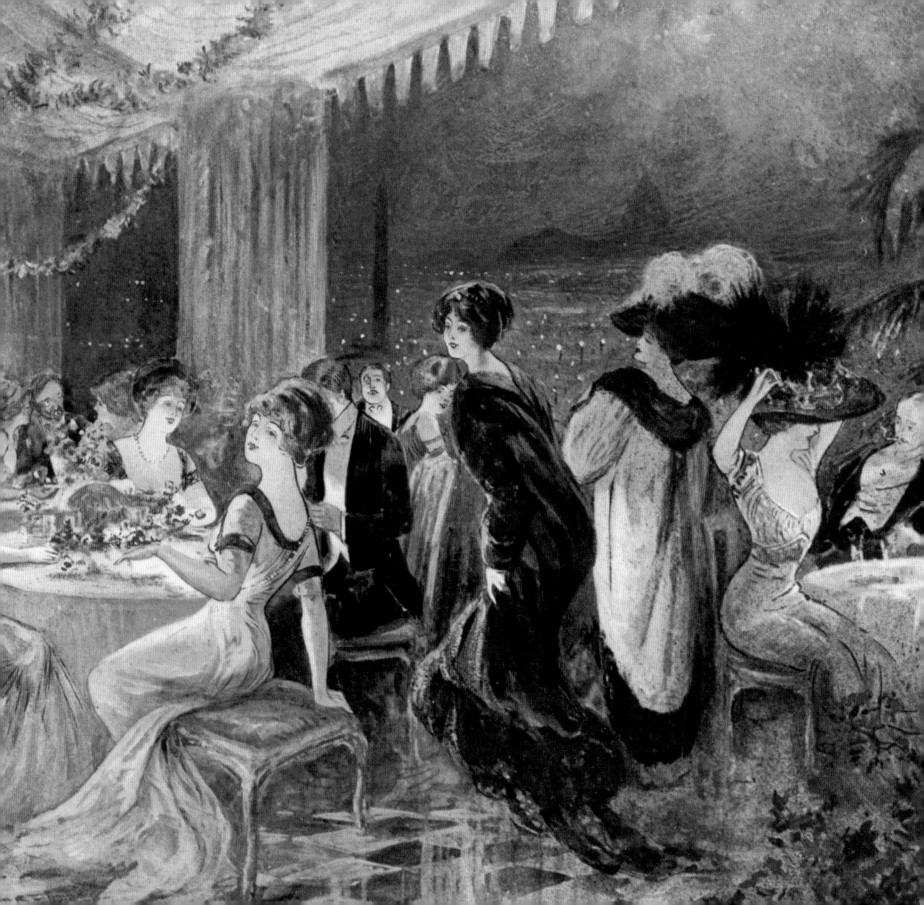

RIGHT: An evening party at the Pré-Catelan in the Bois de Boulogne, showing diners inside and people wandering outside, (1909).

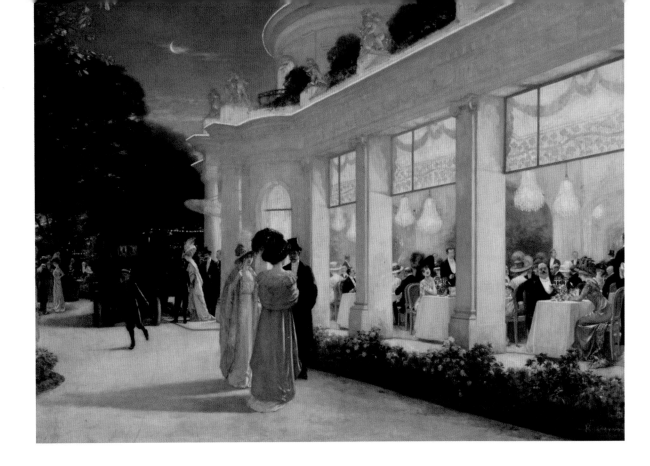

RIGHT: An illustration of high society enjoying an evening in a glamorous and smart Paris restaurant in 1910.

LEFT: Sketch of fashionable diners at the Pré-Catelan restaurant, in the Bois de Boulogne, (1913).

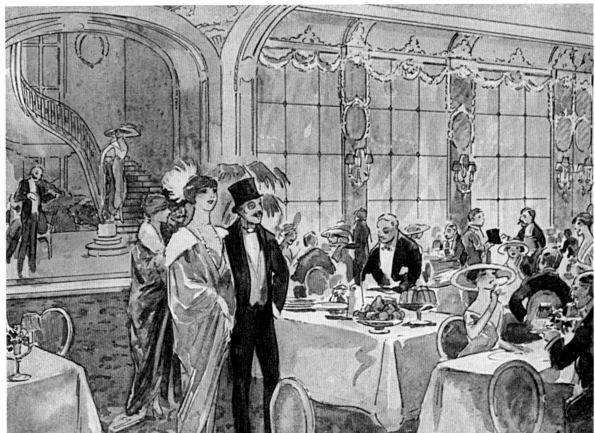

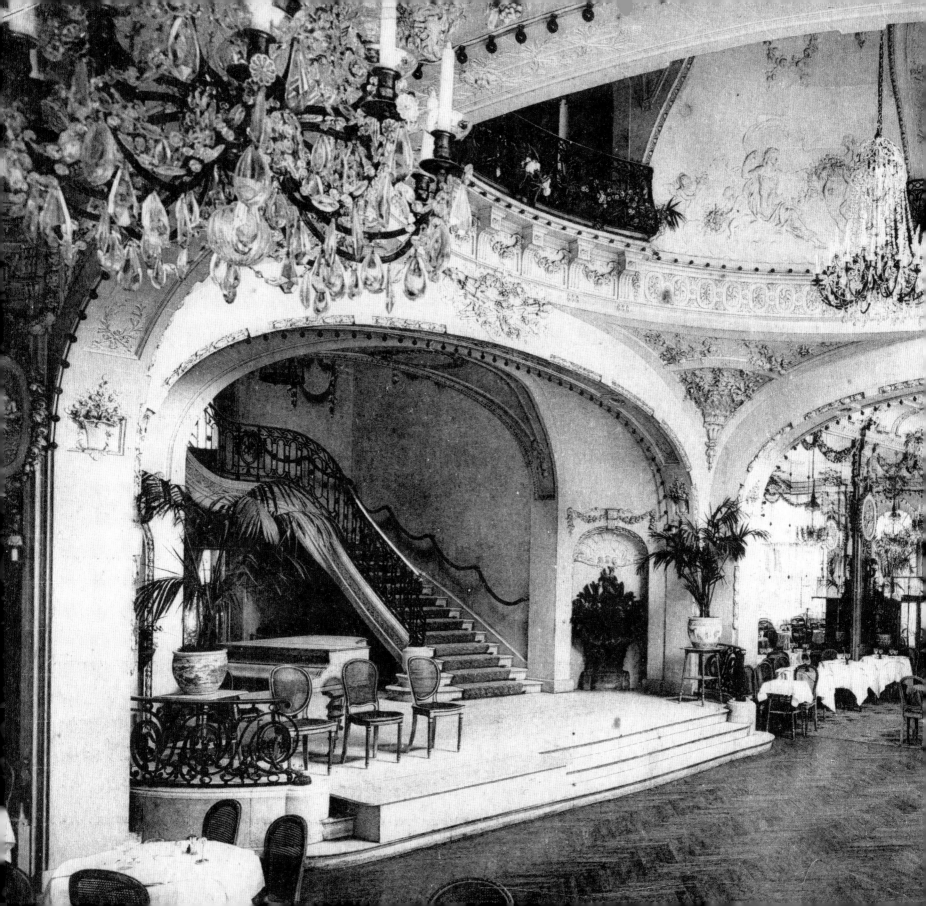

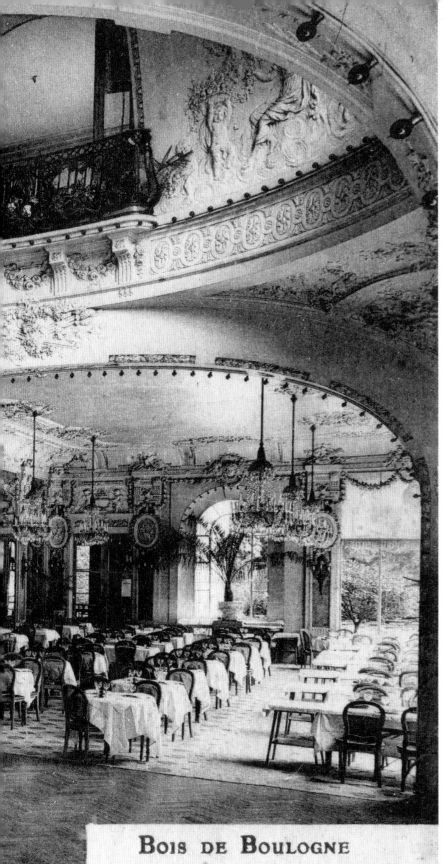

BOIS DE BOULOGNE
LE PRÉ-CATELAN

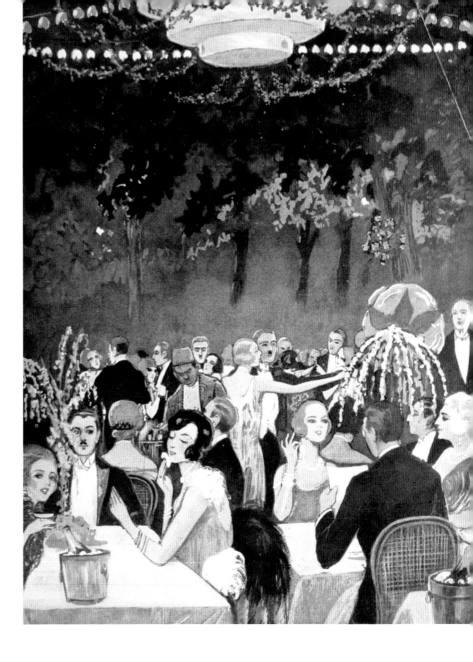

LEFT: The interior of the Pré-Catelan restaurant, one of the most popular restaurants to visit in the summer months in the Bois de Boulogne, (c.1920s).

ABOVE: Illustration of the Pré-Catelan in 1924. The fashionable guests are shown in formal evening attire dining and dancing in the open air against a backdrop of trees and coloured lights.

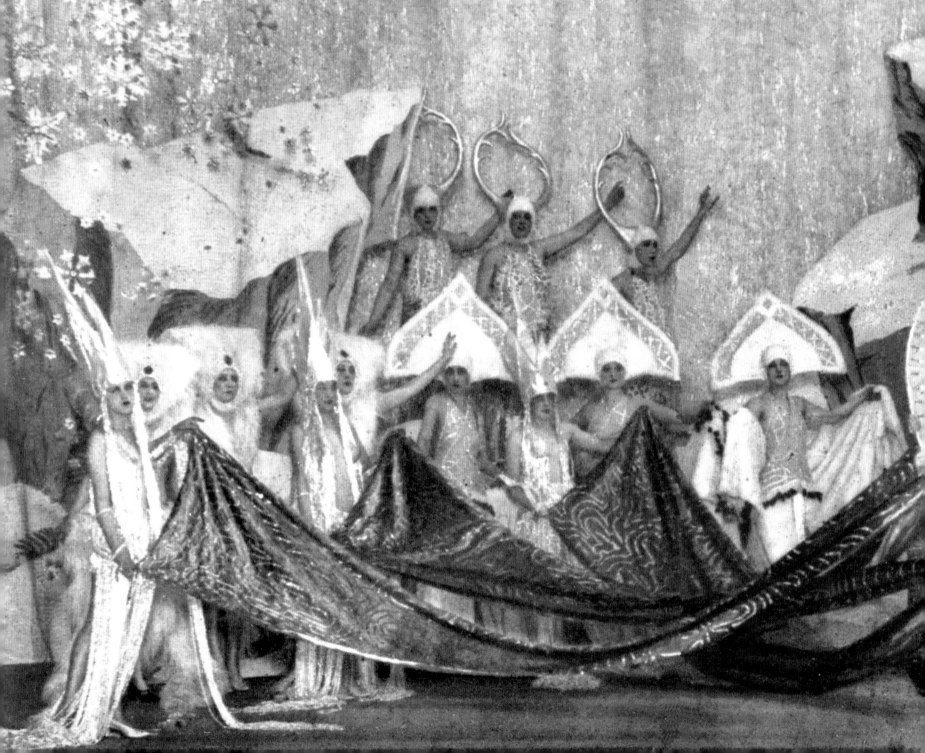
PARIS ENTERTAINMENT

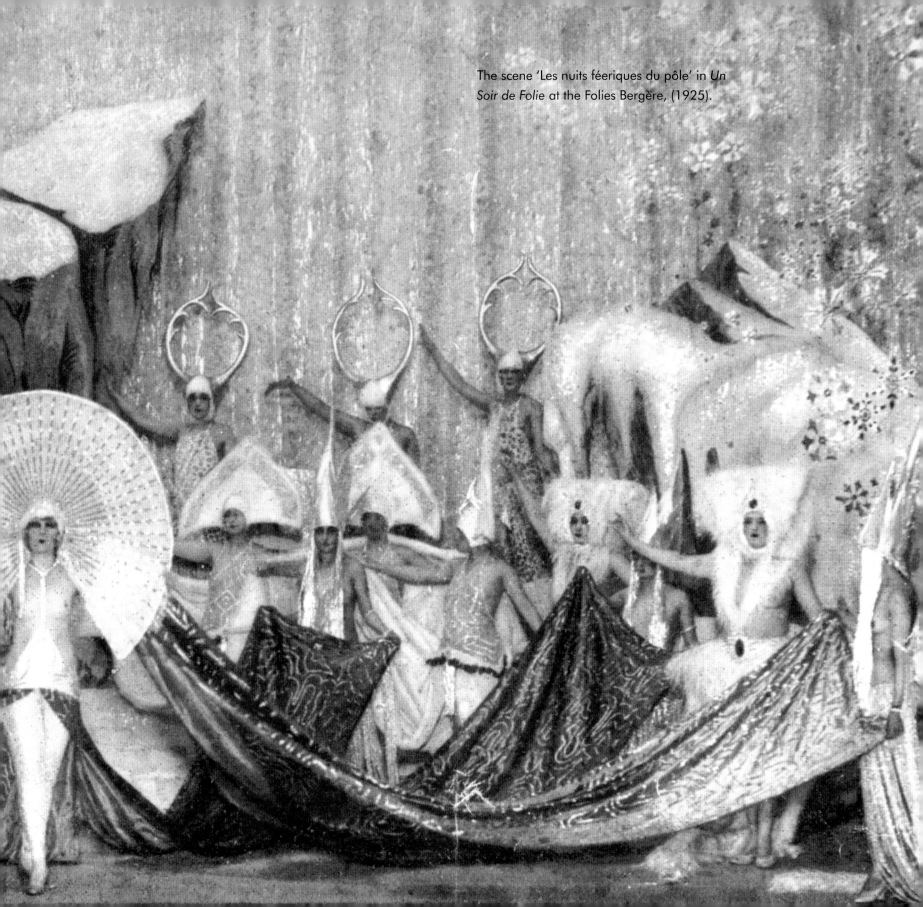

The scene 'Les nuits féeriques du pôle' in *Un Soir de Folie* at the Folies Bergère, (1925).

In addition to the allure of the myriad nightclub haunts, 'dancings' and restaurants, Paris has always offered finer and more extravagant entertainments: the music hall, opera, theatre, circus, amusement parks, cinema, horse racing, jazz clubs and the magic of French chanson. All were acceptable to Parisians and visitors alike.

The most important and noticeable form of entertainment is the Paris music hall; the home of the big spectacular revue. Many influences contributed to its development between 1900 and World War I driven by leading theatre directors such as Jacques-Charles, Léon Volterra and Paul Derval. Their ideal was to believe that the future of French music hall lay not with Parisian musical style, but with the sumptuous international productions that would attract tourists as well as the local Parisians. The directors gathered around them the leading talents of the day and transformed the lavish revue into a spectacle that reached a pinnacle of extravagance in the 1920s and 1930s. Significantly, it was the costume designers – Gesmar, Alec Shanks, Dolly Tree, Zig, Dany and Erté – whose innovative work shone most brilliantly.

Huge stars reigned supreme; Maurice Chevalier, Edmonde Guy and Van Duren and the Dolly Sisters. However, none were more influential than the incomparable Mistinguett. Her main rival was Josephine Baker, the American black performer with whom Paris fell in love from the time she arrived in 1925. The sumptuous productions staged at the key venues of the Casino de Paris, Concert Mayol, the Ambassadeurs, Folies Bergère, the Palace and the Moulin Rouge became legendary. This excellence still continues today.

Paris is also blessed with a plethora of theatres that show more traditional productions. The Comédie-Française, the state run national theatre of France, is a beacon of excellence. Founded in 1680 it has exercised a lasting influence on the development of French theatre and arts and has given the world some of the theatre's most illustrious actors. But the city abounds with dozens of other theatres such as de Théâtre Michel à Paris, Théâtre Daunou, Théâtre Vaudeville, Théâtre de la Potiniere and many more. The Théâtre des Bouffes-Parisiens followed in the tradition of operetta and comedy. The Théâtre du Châtelet staged operetta, variety, ballet and music concerts and Maurice Lehmann, was the first to bring in popular Broadway musicals. The Théâtre du Grand-Guignol presented an unusual mix of horrors, thrills and laughs. Avant-garde theatre, influenced by Dada and surrealism, was also a significant development during the inter-war years with more experimentation after World War II considered de riguer. A host of well-known stage stars rose to prominence in the 1920s; Jane Renouard, Spinelly, Cécile Sorel, Alice Cocea, Sacha Guitry and Yvonne Printemps.

Of particular interest to Parisians was the uniqueness of its singers who became triumphant at elevating la chanson to new heights. The chansonnière were smart, democratic and sophisticated. Yvette Guilbert was one of the first recognisable stars who represented the quintessential spirit of Paris at home and abroad. She was followed by the likes of Cora Madou, Yvonne George, Fréhel, American, Josephine Baker and the men (*les chansonnier*), Yves Montand, Charles Trenet and Charles Aznavour. Édith Piaf undoubtedly became the greatest star of French *chanson* and the most popular French singer of popular songs *(chanteuse)* of all time.

The circus was hugely popular. At one time there wer four in Paris: Cirque d'hiver, Cirque de Paris, Cirque

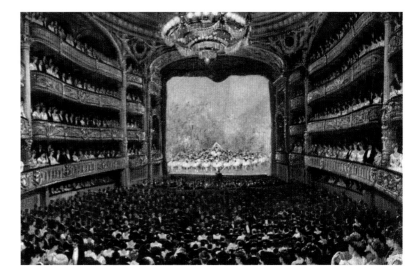

Interior view of the Opéra national de Paris, showing the stage, the stalls and some of the boxes when the theatre is full, (c.1905).

Nouveau and Cirque Medrano. According to Arthur Phillips in The Gay City (1925) the circus 'appeals to a wider public than any other form of entertainment in Paris'. It was the perfection of an art form and hugely influential in the development of the modern Cirque du Soleil. In the 1920s the Cirque d'Hiver was considered to be the best, partly because the show starred the famous clowns, the three Fratellini brothers. Since 1934, it became the Cirque d'Hiver-Bouglione, operated by the Bouglione brothers and their heirs.

Cinema (a word derived from *cinematographe*) was born in 1895 in Paris when the Lumière brothers presented the first commercial motion picture. Paris was fascinated and a bouyant film industry emerged with the formation of Gaumont and Pathé Frères. Between 1919 and 1929 the construction of cinemas doubled and although, like Great Britain, the domestic market was swamped with American imports, there was a thriving and innovative film-making community both mainstream and avant-garde. There were many leading directors including René Clair, Jean Renoir and Jacques Feyder. Abel Glance made the hugely influential *La Roue* (1923) and the epic *Napoléon* (1927) and Marcel L'Herbier filmed *L'Argent* (1928). There were also many well-known film stars including Genevieve Felix, Lily Damita, Arlette Marchal and Jean Gabin.

However, the lack of capital led to outside investment largely from German and Russian interests. For example, in 1927 the film *Casanova* was made by a Russian and German consortium based in Paris.

Not only did film making flourish in Paris but it was also a most sought after location. In 1923, the American serial queen Pearl White filmed *Terreur* (The Peril of Paris) in the actual sewers of Paris and in 1925 Gloria Swanson starred in the lavish Paramount production of *Madame Sans-Gêne* directed by Léonce Perret. And of course, there was Ivor Novello in the British film, *The Rat* (1925) set in the Paris underworld.

With the coming of sound, production faltered and in 1929 only 59 films were made. But after World War II French cinema blossomed again with a new wave of directors such as Jean-Luc Godard, Francois Truffaut and such stars as Brigitte Bardot, Catherine Deneuve and Alain Delon.

The pinnacle of entertainment in Paris is at the Opera in the grand Palais Garnier. Here in quite sumptuous surroundings one could see opera, ballet and be part of a special gala or ball such as the Bal du Grand Prix. Of huge importance at the turn of the century was Serge Diaghilev's Ballets Russes. Diaghilev had presented a season of Russian music, art and opera in 1906. It began a long involvement with France and Paris in particular. Developing a reputation for experimentation and the use of many innovative artists and performers, the Ballets Russes became the most influential ballet company in the 20th century. In 1908 Diaghilev mounted the first production of Mussorgsky's *Boris Godunov* outside Russia at the Paris Opera. Further productions followed through the 1920s, many staged at the Théâtre du Châtelet and the Paris Opera that took Paris by storm.

Amongst other Parisian pastimes, there were ice-skating at the Palais de Glace, the languid indulgence of the Le Lido and the endless fun of the two amusement areas of Luna Park and the Magic City and the Tour de France, the famous cycling race first held in 1903. There was also the Vélodrome d'Hiver, an indoor bicycle racing track and stadium situated not far from the Eiffel Tower which also staged ice hockey, wrestling, boxing, roller skating and other spectacular events. Horse racing in the summer months was, and remains, a very popular activity and was the vehicle for Parisian couturiers to advertise their latest creations. Everyone congregated at the three big racing venues of Longchamps, Auteuil and Chantilly with the climax at Longchamps for the Grand Prix de Paris on the last Sunday in October.

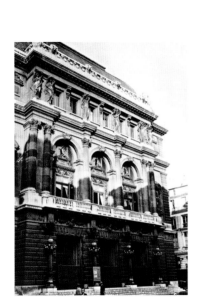

Street front view of the *Théâtre National de l'Opéra Comique*, (1935).

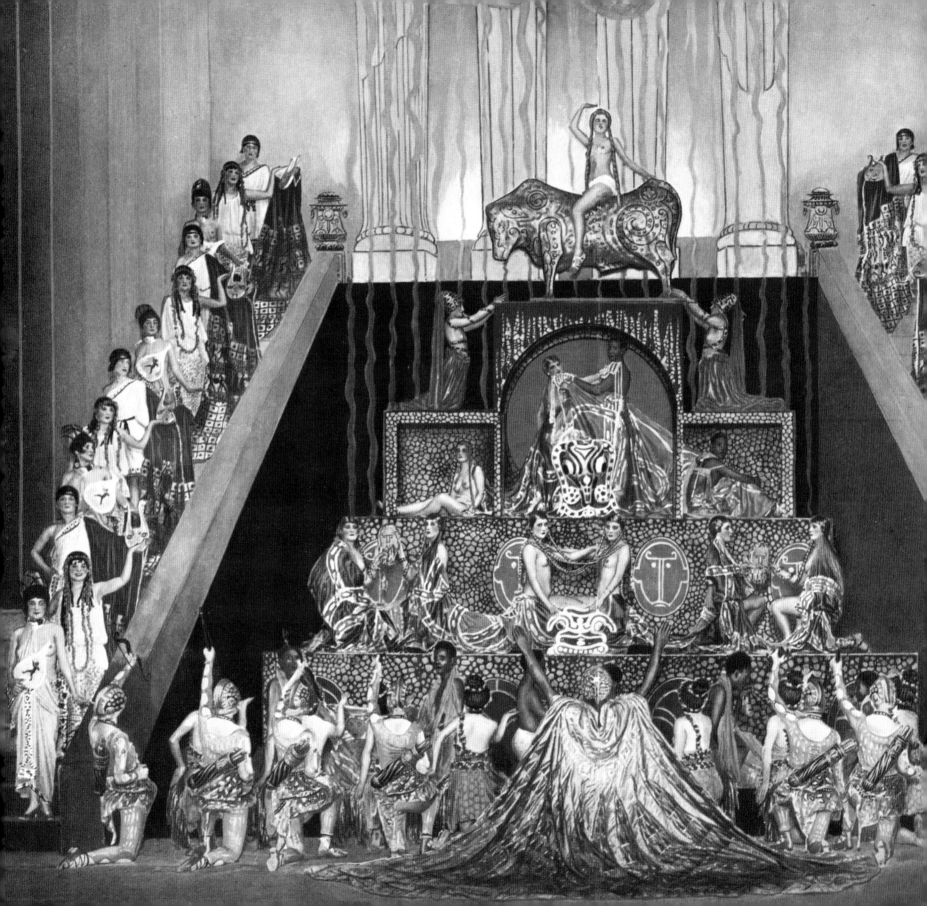

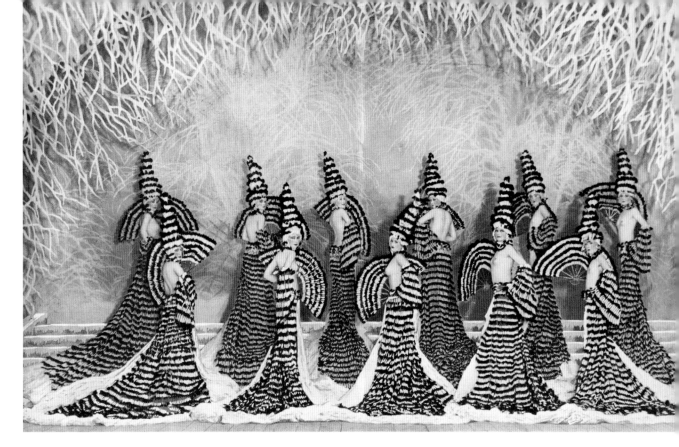

ABOVE: The scene 'Une Femme dans le Fourrure' from *Les Ailes de Paris* at the Casino de Paris, (1927).

LEFT: Tableau 'l'adoration perpétuelle' (Perpetual Adoration) in *Un Soir de Folie* at the Folies Bergère featuring costumes designed by Erté, (1925).

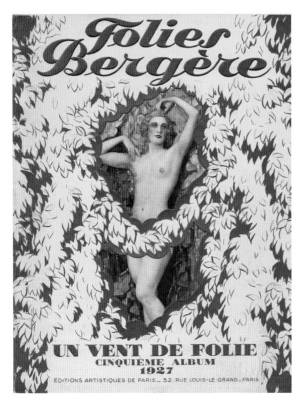

LEFT: Cover of souvenir brochure for Un Vent de Folie at the Folies Bergère, (1927).

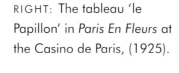

RIGHT: The tableau 'le Papillon' in *Paris En Fleurs* at the Casino de Paris, (1925).

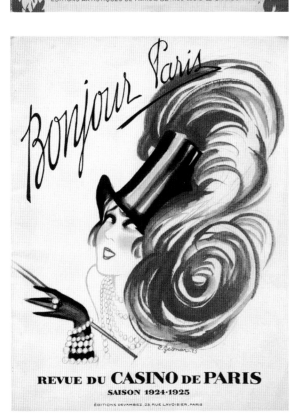

LEFT: Cover of souvenir brochure for Bonjour Paris at the Casino de Paris, featuring Mistinguett, 1924–25. Artwork by the talented illustrator and costume designer Gesmar who died in 1928, (c.1920s).

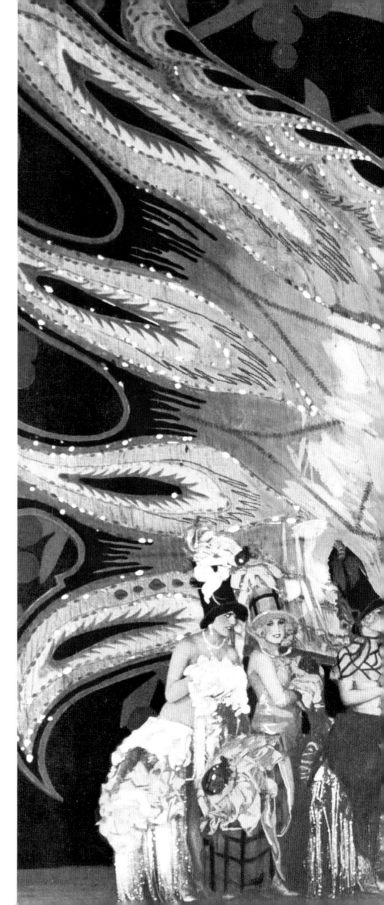

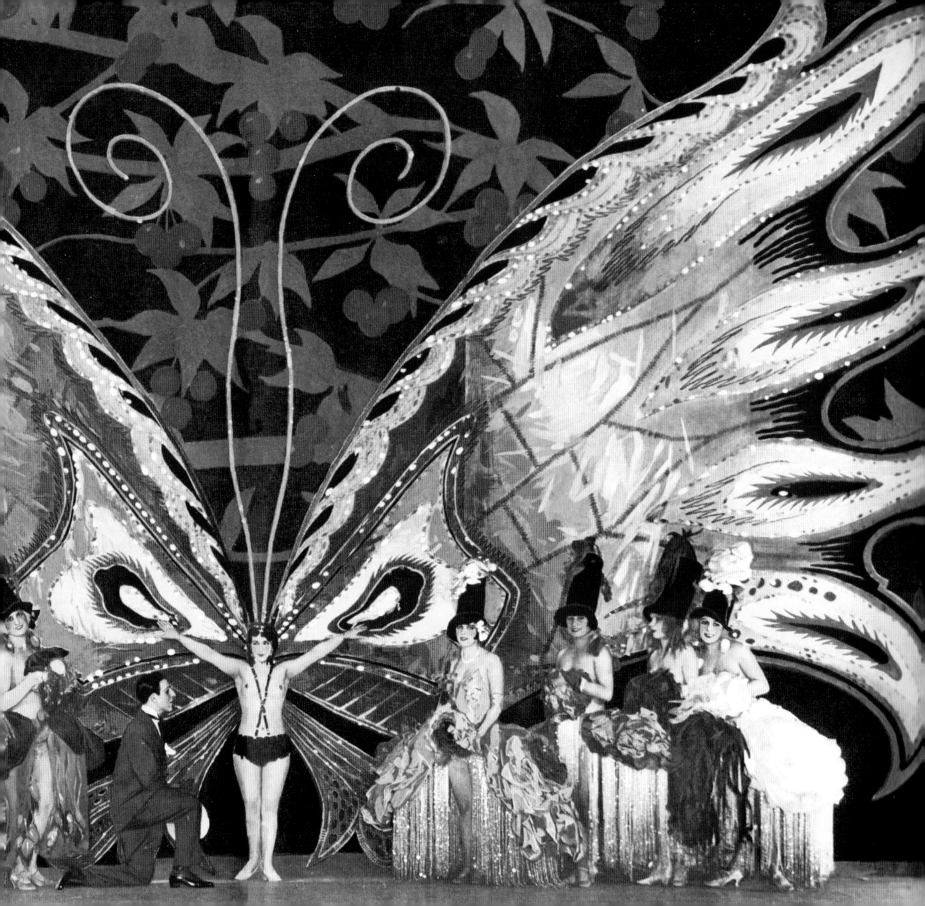

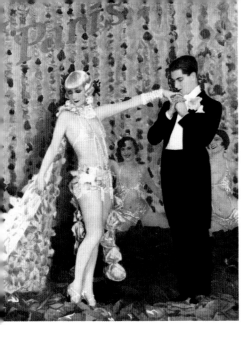

LEFT: Cover of a souvenir brochure for *Paris*, featuring Edmonde Guy and Van Duren, Casino de Paris, (1927).

RIGHT: Cover of a souvenir brochure for the show *Paris* at the Casino de Paris, featuring Maurice Chevalier, (1927).

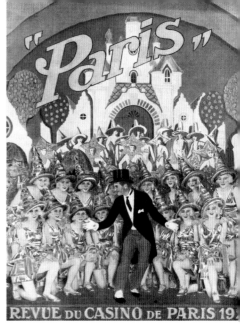

BELOW: A sketch of the interior of the *Moulin Rouge*, (c.1920s).

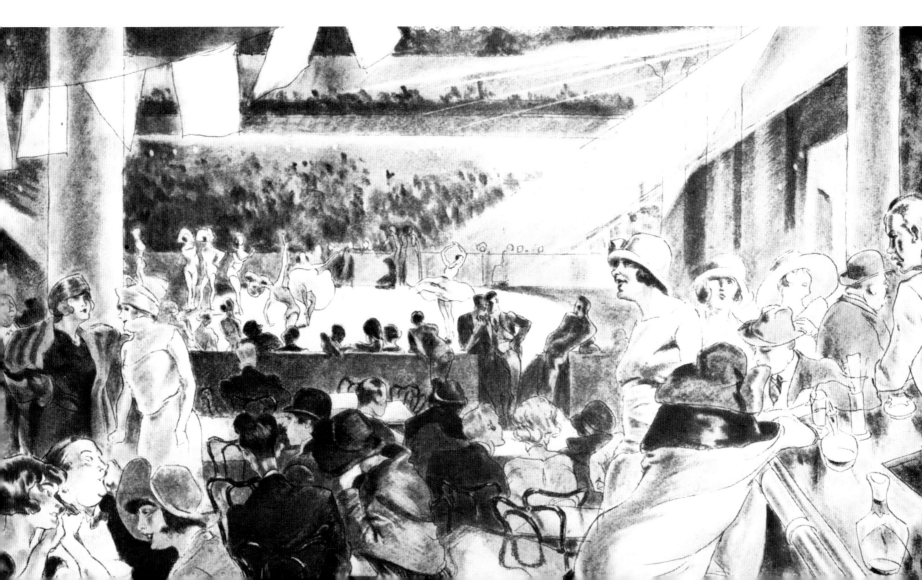

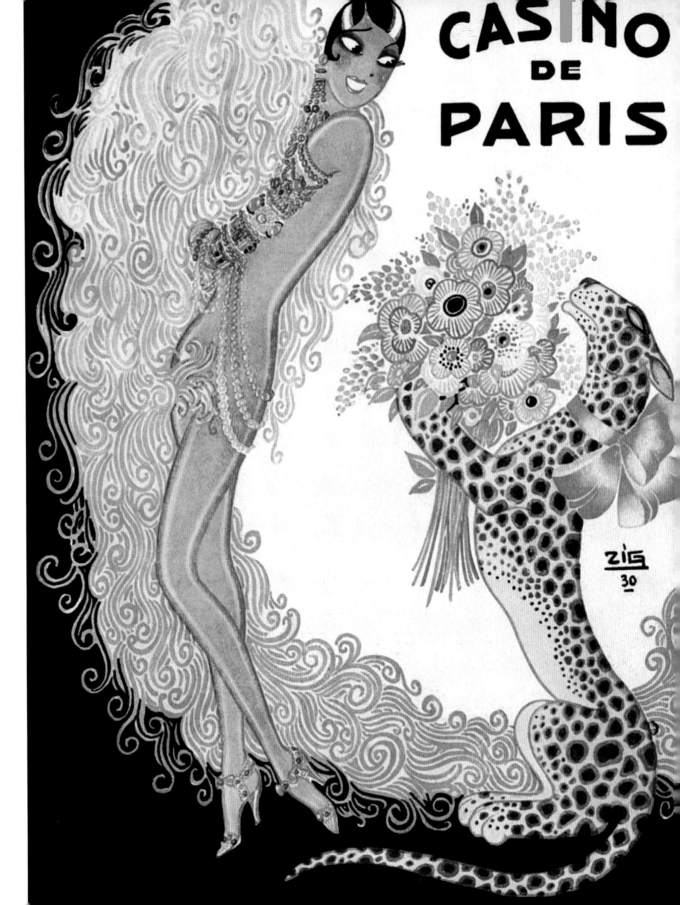

RIGHT: Programme cover for Paris Qui Remue starring Josephine Baker at the Casino de Paris, costume design by Zig, (1930).

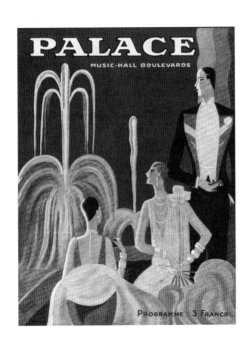

ABOVE: Programme cover for the Palace Theatre, (1931).

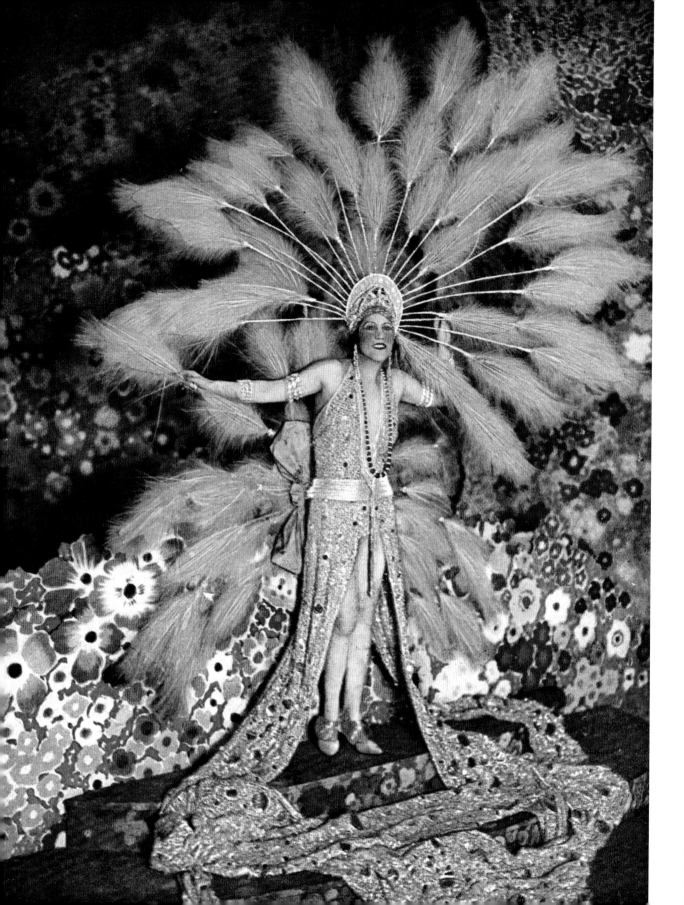

LEFT: Jane Marnac in the finale of the first act of the show *Tout Paris* at the Casino de Paris, (1928).

BELOW: Costume design by Dolly Tree for a girl in a blue and silver dress in an unknown Paris music hall production, (c.1920s).

RIGHT: Costume design by
Alec Shanks for the Paris
Music Hall, (c.1930s).

BELOW: Costume design by
Zig for showgirl in green and
silver gown with elaborate
feathered headdress, for an
unknown Paris music hall
production, (c.1920s).

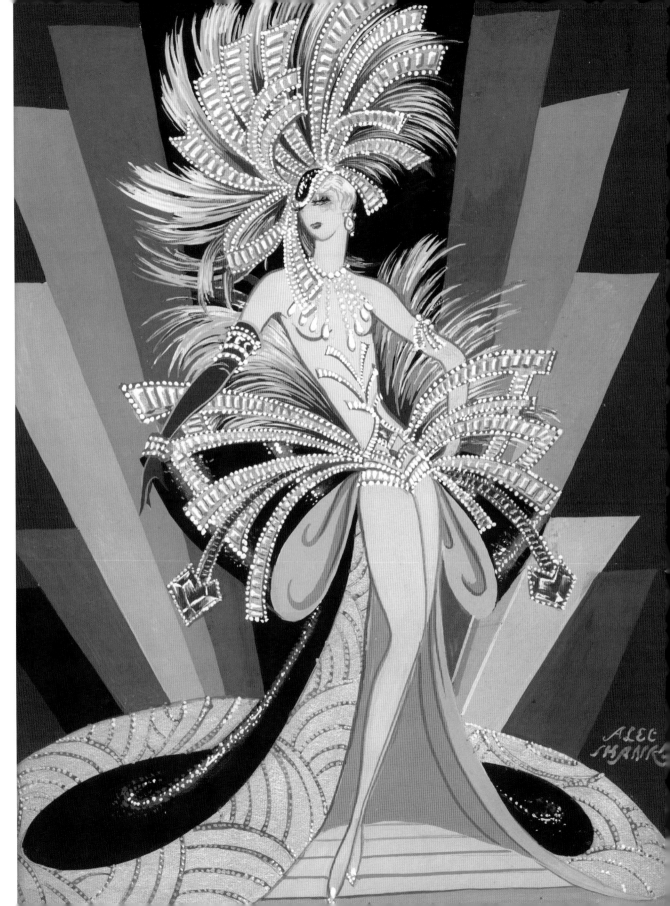

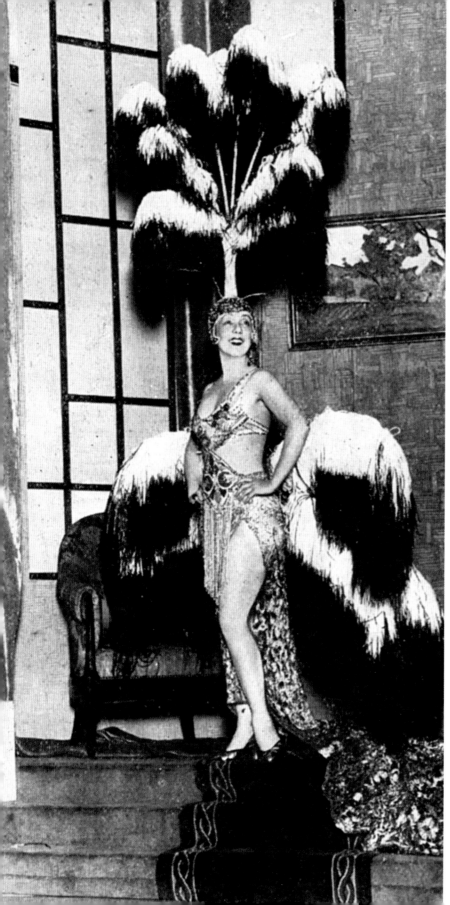

ABOVE: Jane Renouard and M. Stephen in *Eve Toute Nue* at the Théâtre Michel, (1927).

LEFT: Mlle Spinelly in *Le Club des Loufoques* at the Théâtre de la Madeleine, (1927).

RIGHT: A scene from a show at the Théâtre du Grand-Guignol, (1931).

140

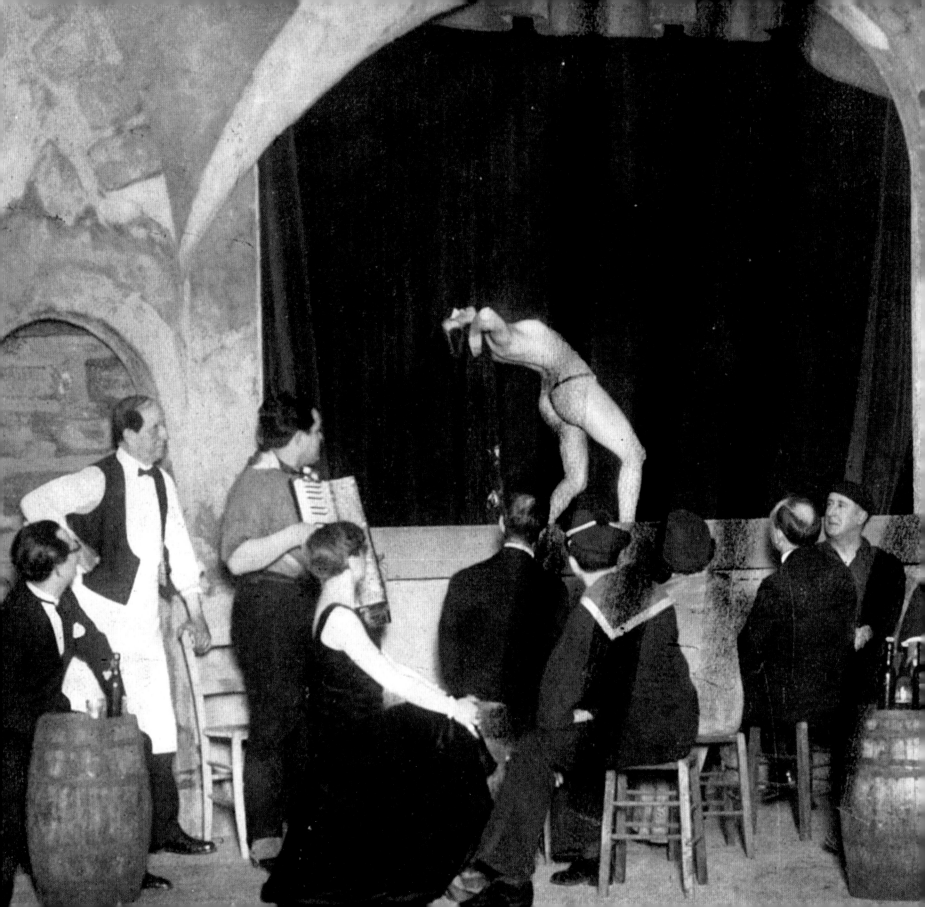

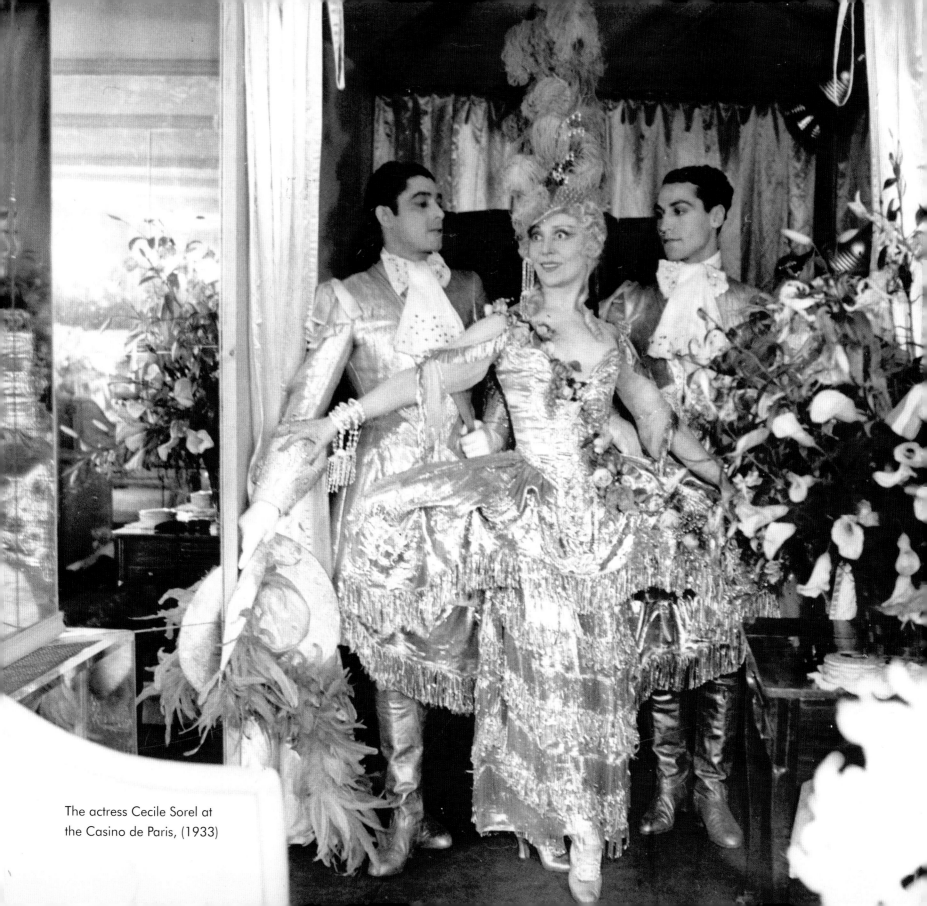

The actress Cecile Sorel at
the Casino de Paris, (1933)

ABOVE: Scenes from the play *Ma Femme* at the Théâtre de la Potiniere, (1928).

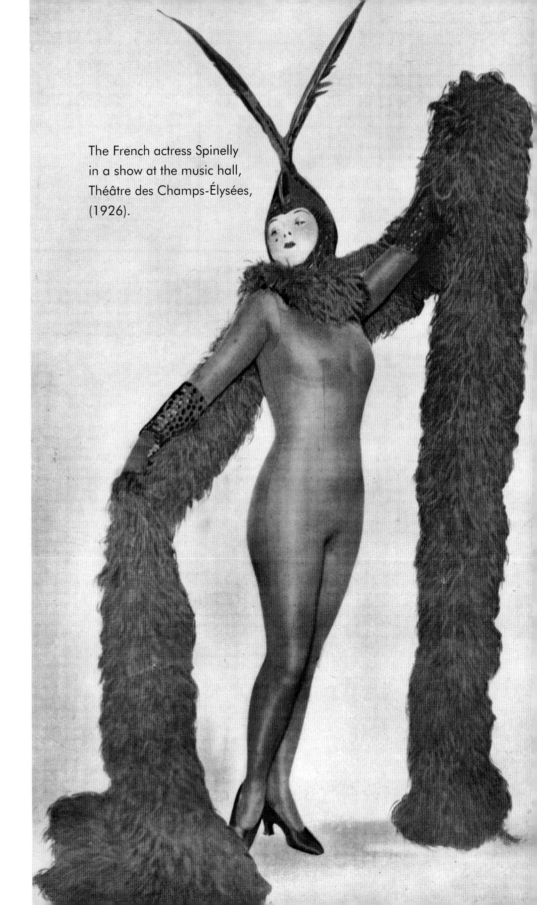

The French actress Spinelly in a show at the music hall, Théâtre des Champs-Élysées, (1926).

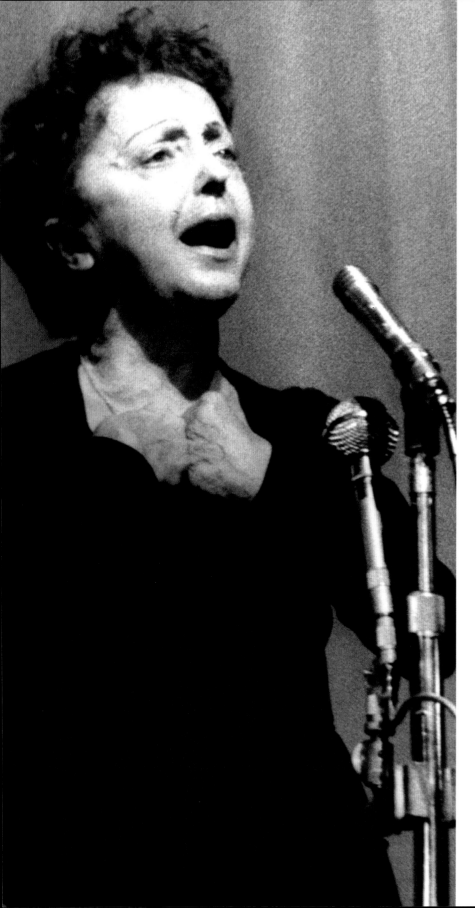

LEFT: The French singer and national diva, Édith Piaf performing at the Olympia, 28 September 1962.

ABOVE: Belgian actress and singer Yvonne George, was the woman who inspired many of Robert Desnos's greatest poems, (c.1925).

BELOW: The French-Armenian musician and singer Charles Aznavour who has sold more than 180 million records and remains one of France's most popular and enduring performers, (c.1970).

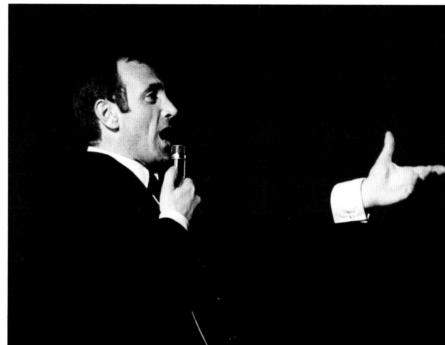

BELOW: The French singer, Charles Trenet. Regarded as the most influential and popular French songwriter of the mid-20th century, his most famous song *La Mer* (The Sea) released in 1946 sold more than 70 million records, (c.1950s).

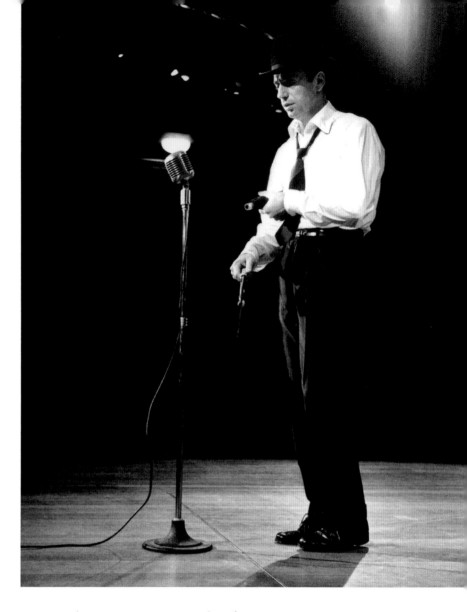

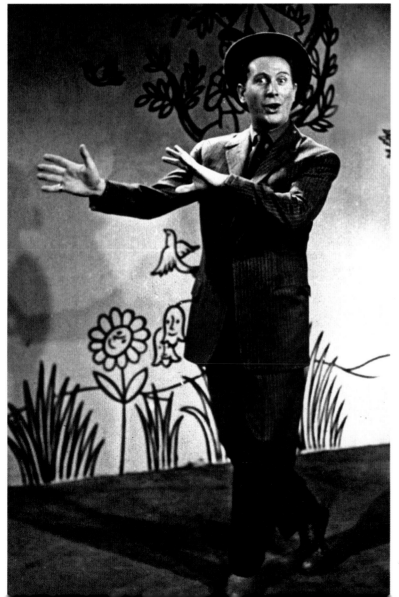

ABOVE: The singer Yves Montand performing on stage, (c.1957). Of Italian extraction, Yves Montand became a French citizen and became one of France's most venerated performers. He married famous French actress, Simone Signoret.

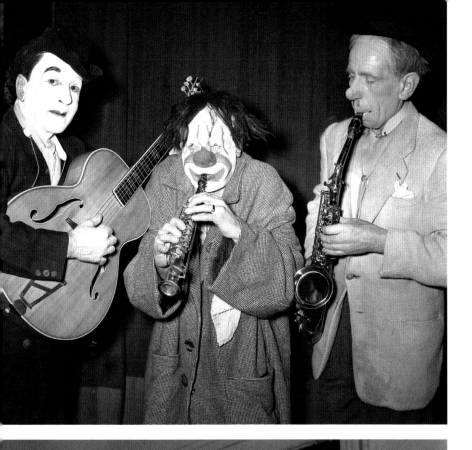

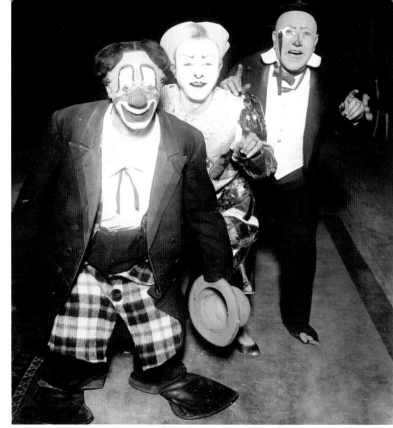

ABOVE LEFT: The Fratellini clowns at the Cirque d'Hiver in Paris, 28 September 1956.

ABOVE: The famous Fratellini brothers stars of the Cirque de Paris, (c.1930).

RIGHT: Poster design for Cirque d'Hiver showing a clown pointing to the circus entrance. In 1934, the Bouglione Brothers took over the management of this circus, (c.1934).

LEFT: Actors Michel Simon and Blanchette Brunoy congratulating the famous Clown Grock at the Cirque Medrano in January 1952.

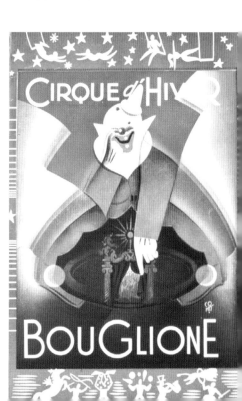

RIGHT: The Dolly Sisters wearing creations by Jean Patou in 'La Valse Lumineuse', in *Paris En Fleurs* at the Casino de Paris, (1925).

BELOW: Programme cover for Théâtre National de l'Odéon, (c.1920s).

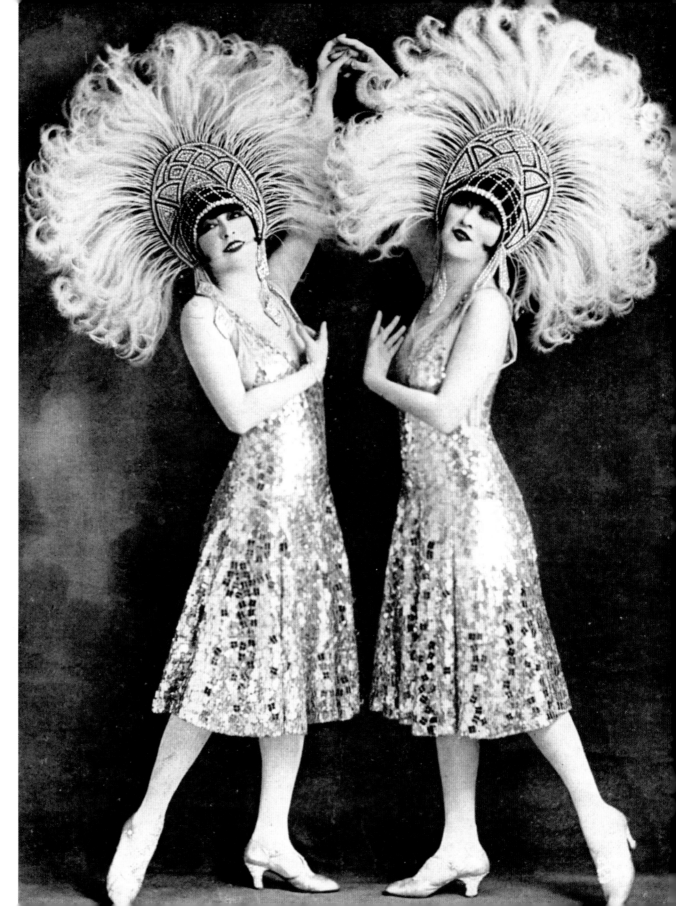

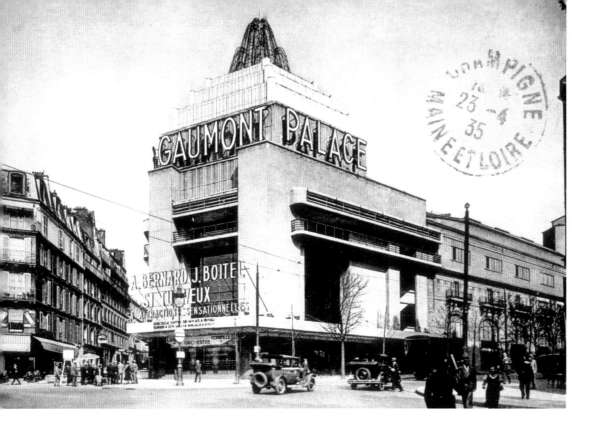

LEFT: The Gaumont Palace movie theatre, (1935).

BELOW LEFT: The Normandie cinema on the *Champs-Élysées*, where Leni Riefenstahl's film *Jeunesse Olympique* of the 1936 Berlin Olympic Games, was shown, (c.1930s).

BELOW: Ivor Novello in *The Rat* (1925) – the story of a Parisian apache – directed by Graham Cutts for Gainsborough Pictures.

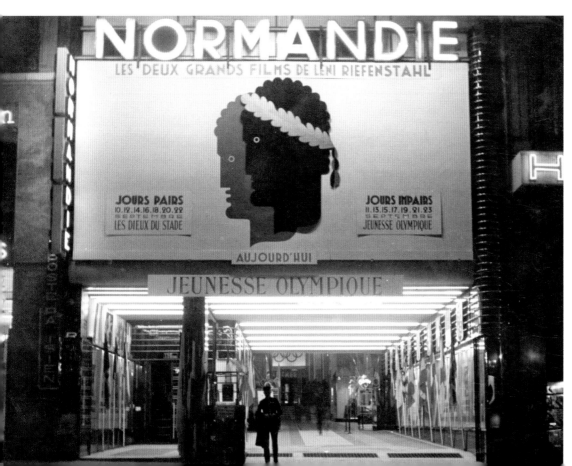

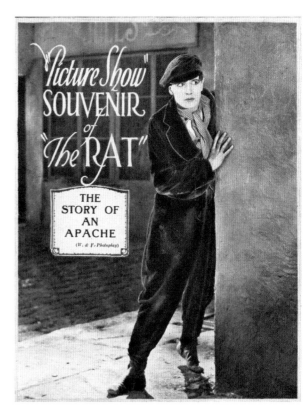

RIGHT: The French film actress Lily Damita, later worked in Hollywood and married Errol Flynn, (1928).

BELOW: Scenes from *Madame Sans-Gêne* (1925) starring Gloria Swanson. Filmed in Paris, this lavishly produced romantic costume comedy-drama was directed by Léonce Perret. On set Swanson fell for her translator Henri de la Falaise, who later became her third husband.

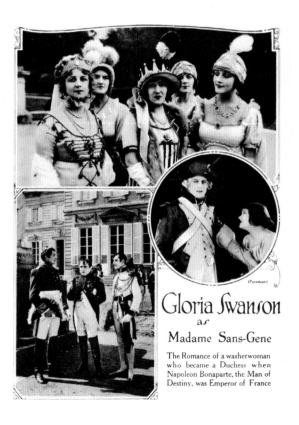

Gloria Swanson
as
Madame Sans-Gene

The Romance of a washerwoman who became a Duchess when Napoleon Bonaparte, the Man of Destiny, was Emperor of France

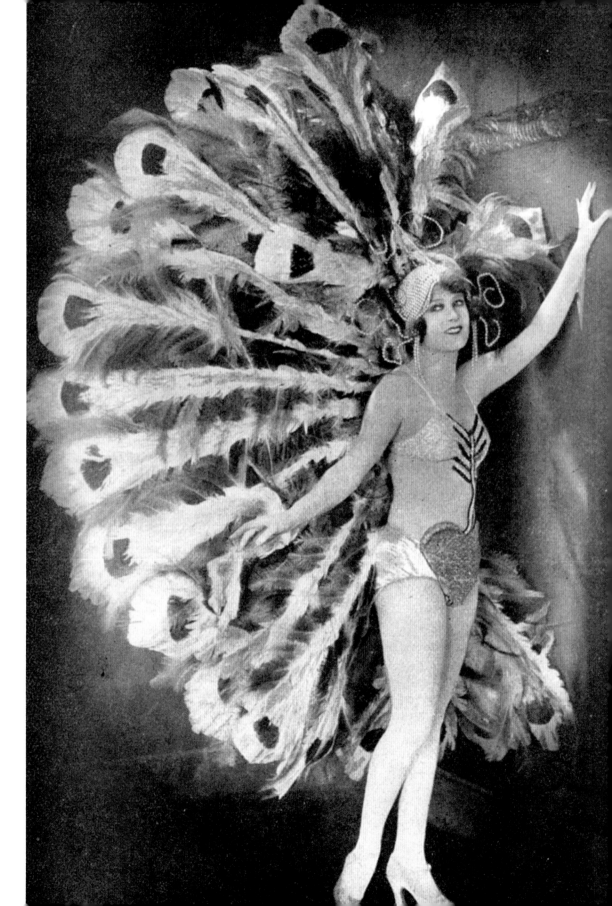

ABOVE: The French actor
Jean Gabin in *Gueule
d'Amour* (*Lady Killer*), (1937).

BELOW: *Cine-Miroir* featuring
the French film star Geneviève
Félix in *L'Engrenage,* (1925).

Le grand film
Casanova

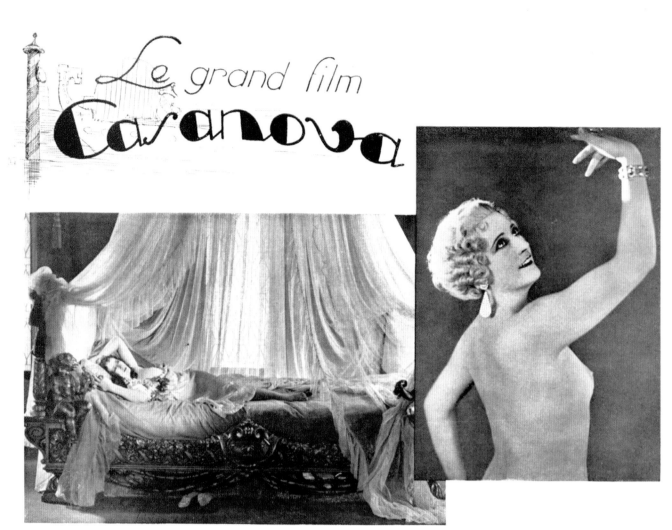

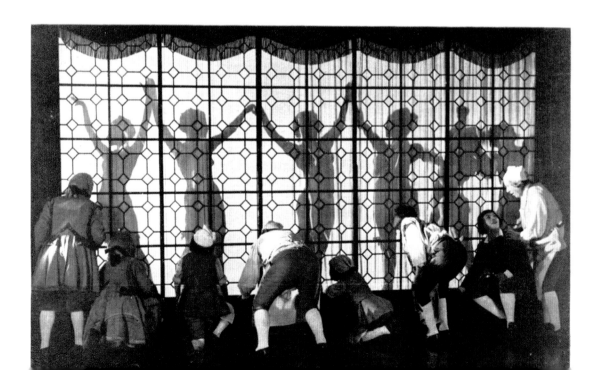

LEFT: Scenes from the French film *Casanova* (1927) directed by Russian Alexandra Volkoff with a largely German cast. A sumptuous costume drama, filmed partly in Venice, it was dazzlingly ambiguous, mildly risque and overwhelmingly stylish. It was released with the English title, *The Loves of Casanova*.

BELOW: Abel Gance (1889–1981) film director, seen here as Saint-Just in his epic film *Napoleon*, (1927).

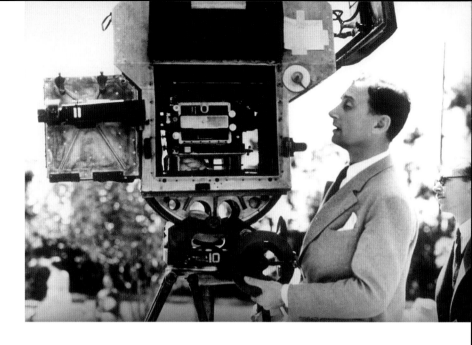

ABOVE: Film director Jacques Feyder on the set of a film, (c.1920s).

BELOW: Abel Glance and British film star Ivy Close discussing his film, *La Roue,* (1924).

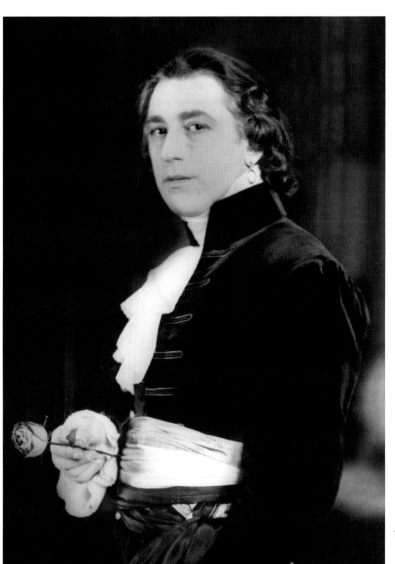

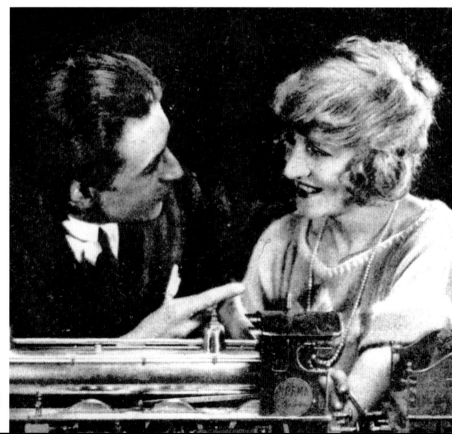

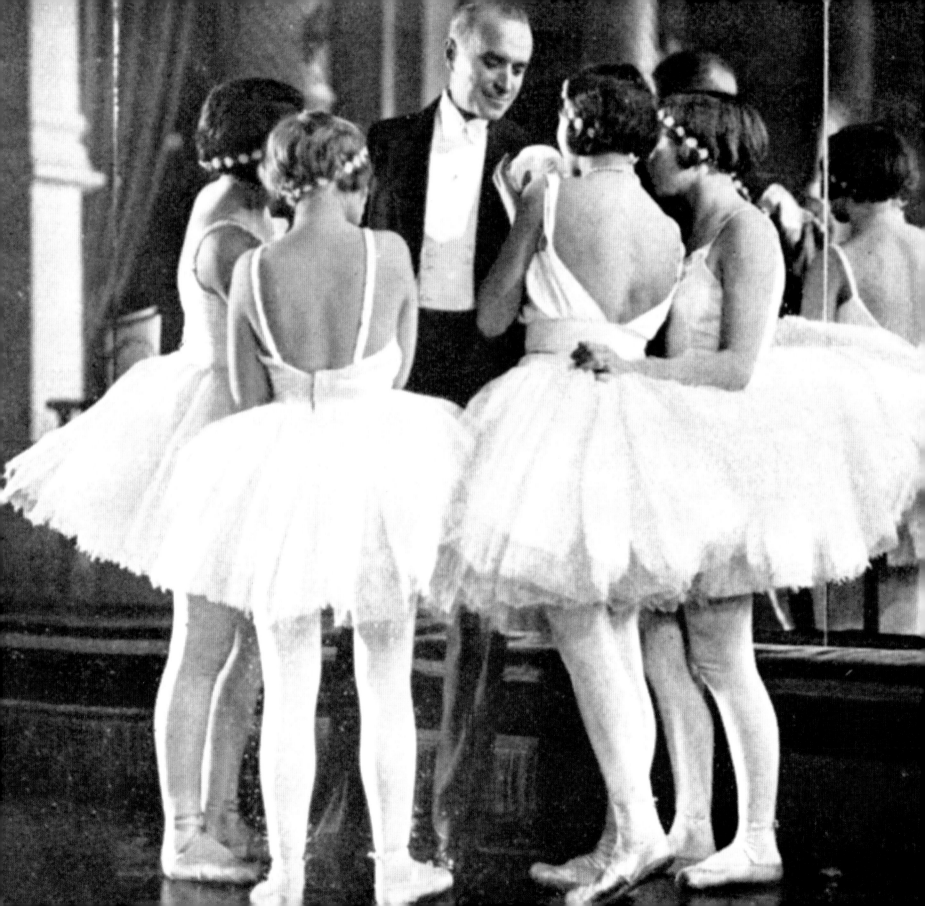

LEFT: A scene from the film
Ces Nouveaux Messieurs
(1928) directed by Jacques
Feyder.

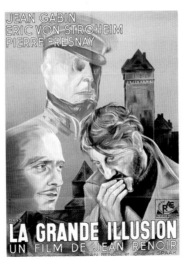

LEFT: Publicity poster for the French war film *La Grande Illusion*
(1937) by Jean Renoir regarded as one of the masterpieces of
French cinema, starring Jean Gabin and Erich Von Stroheim.

BELOW: Cinema queue for the film *Stagecoach* – the last American
film seen by Parisians before the German occupation in World
War II, (c.1939).

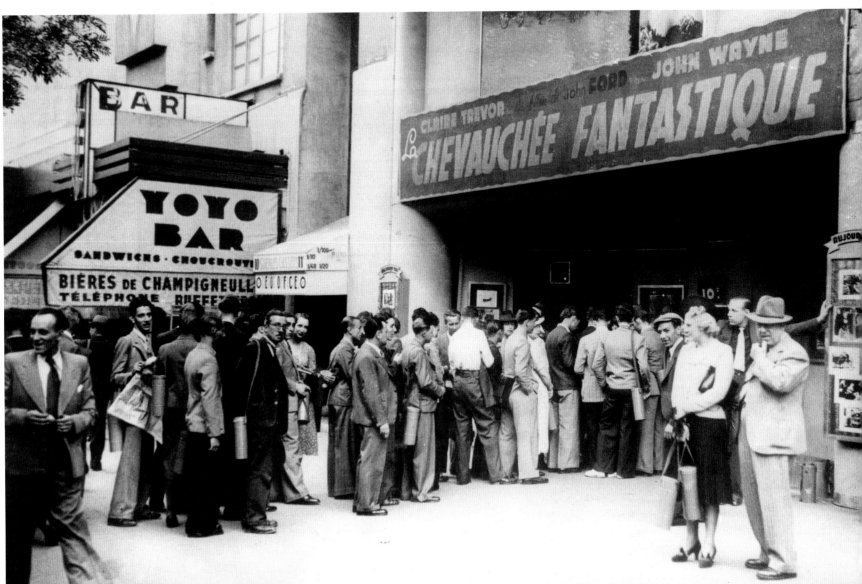

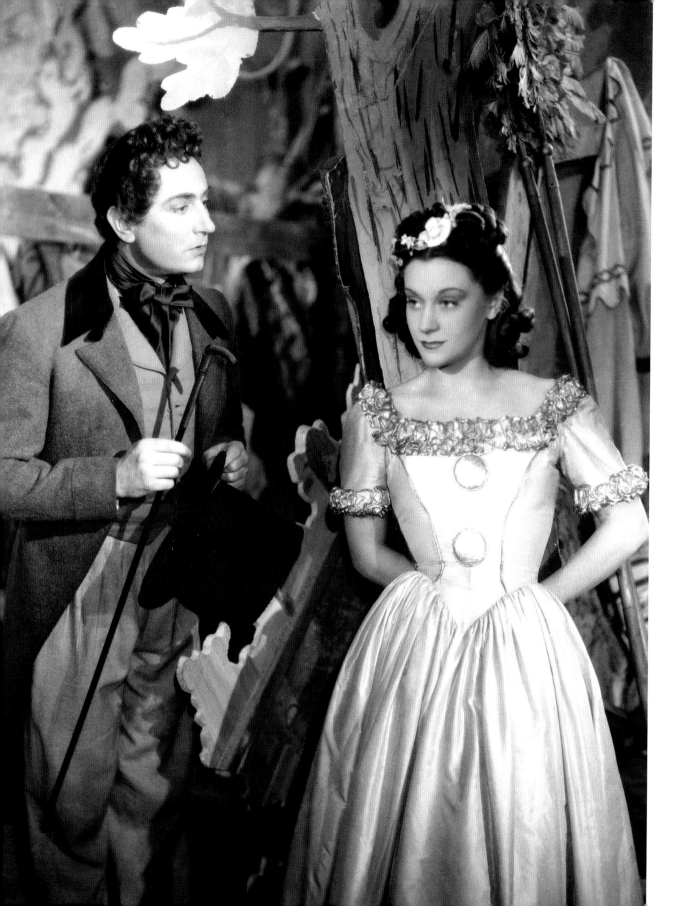

LEFT: *Les Enfants du Paradis (Children of Paradise)* directed by Marcel Carné was made during the German occupation and released in 1945. The film is set around the Parisian theatre in 1828 and tells the story of a beautiful courtesan, Garance, and the four men who love her: a mime, an actor, a criminal and an aristocrat. It became a huge success.

RIGHT: The audience arrives at the Paris Opera, (c.1912).

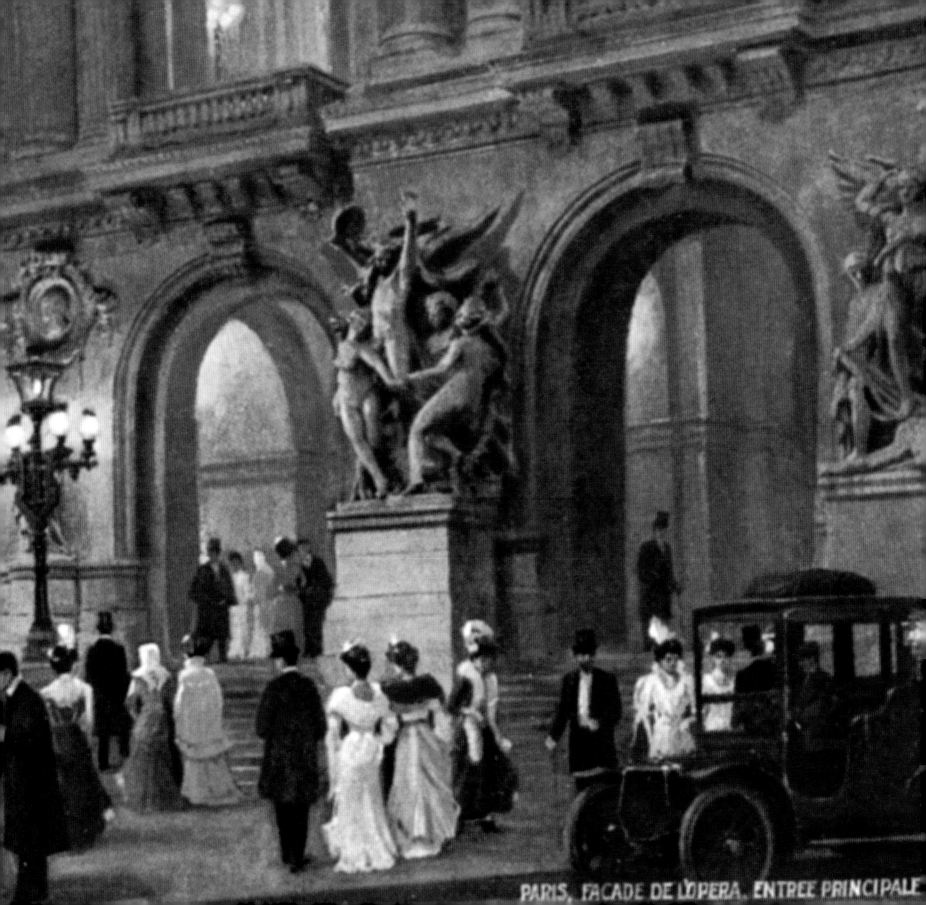

PARIS. FACADE DE L'OPÉRA. ENTRÉE PRINCIPALE

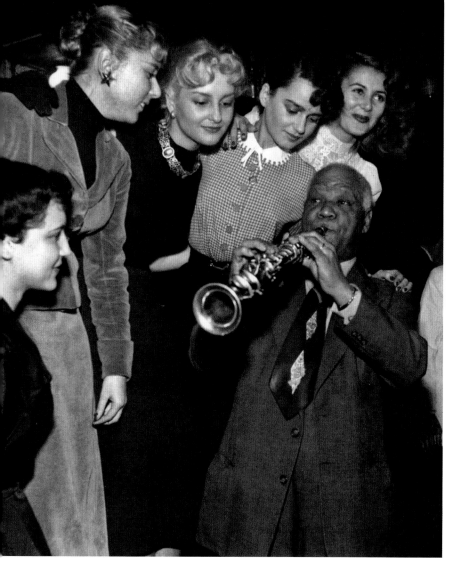

LEFT: The American jazz musician Sidney Bechet, who became a popular figure in the Parisian jazz scene in the 1950s, surrounded by starlets in a Parisian cabaret, (1952).

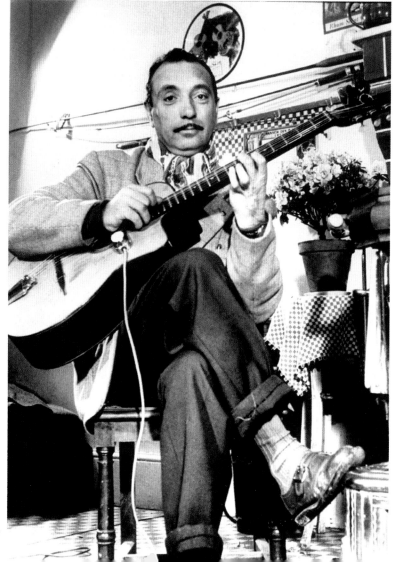

RIGHT: The gypsy-born jazz guitarist Django Reinhardt, one of the leading exponents of the French jazz movement, (c.1953).

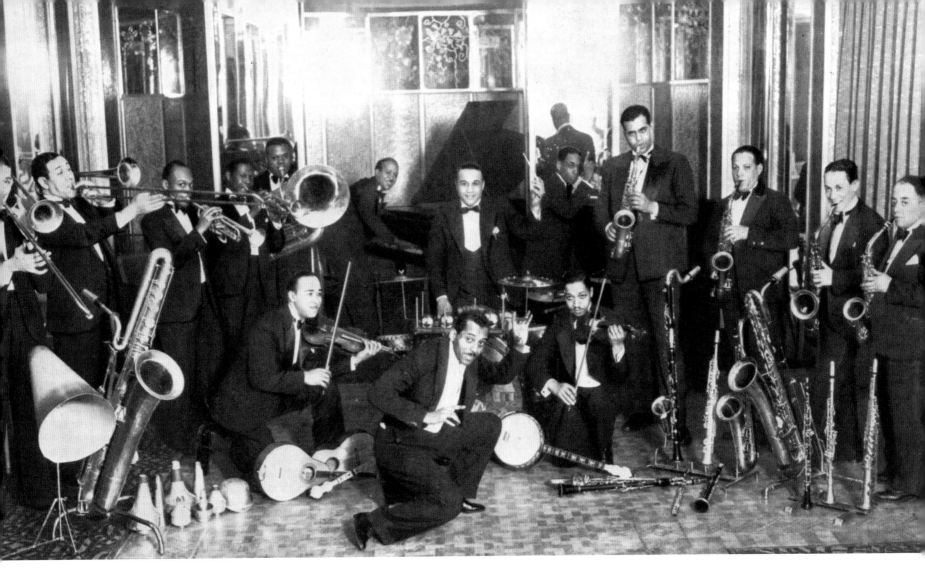

ABOVE: The American
jazz band leader Noble
Sissle and his Orchestra in
Edmound Sayag's, Café des
Ambassadeurs show in 1930.

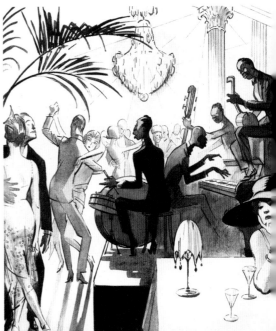

RIGHT: An illustration of an
American jazz band in Paris,
(1921).

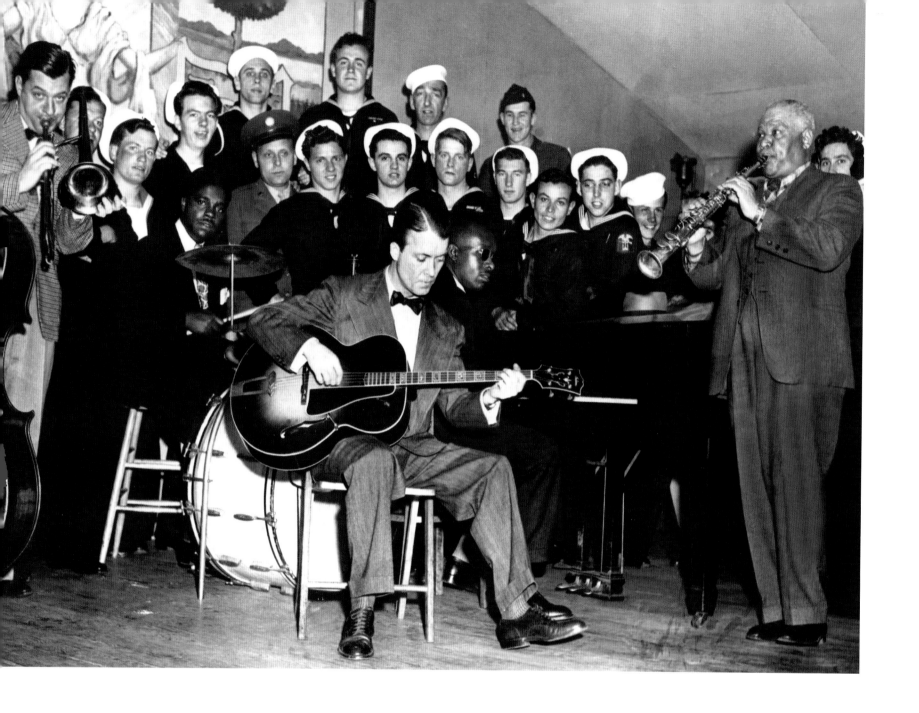

ABOVE: American jazz musician Sidney Bechet playing clarinet in front of a group of sailors with Eddy Condon (guitar) and Brad Gowans (trombone), (1948).

RIGHT: Among sixty musicians at the Parisian cabaret *Le Lido* are Aimé Barelli, Don Bijas, Jacques Diéval, James Moody, Claude Luter, Pierre Broglawski, Rene Leroux, (1949).

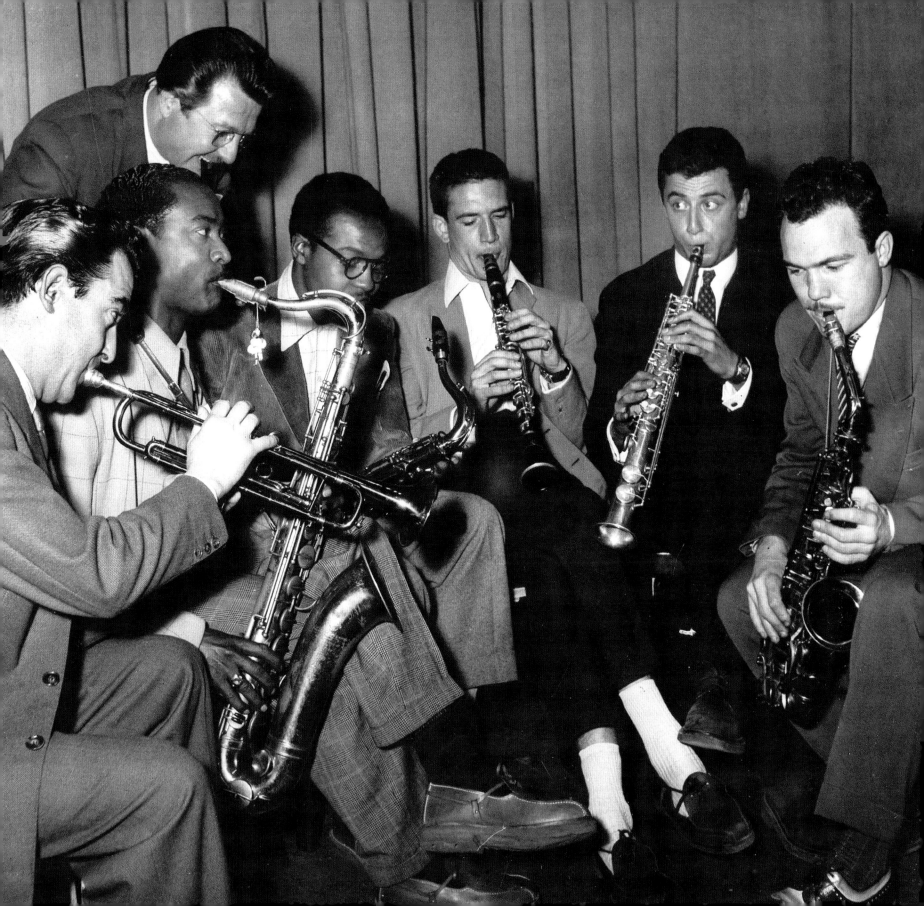

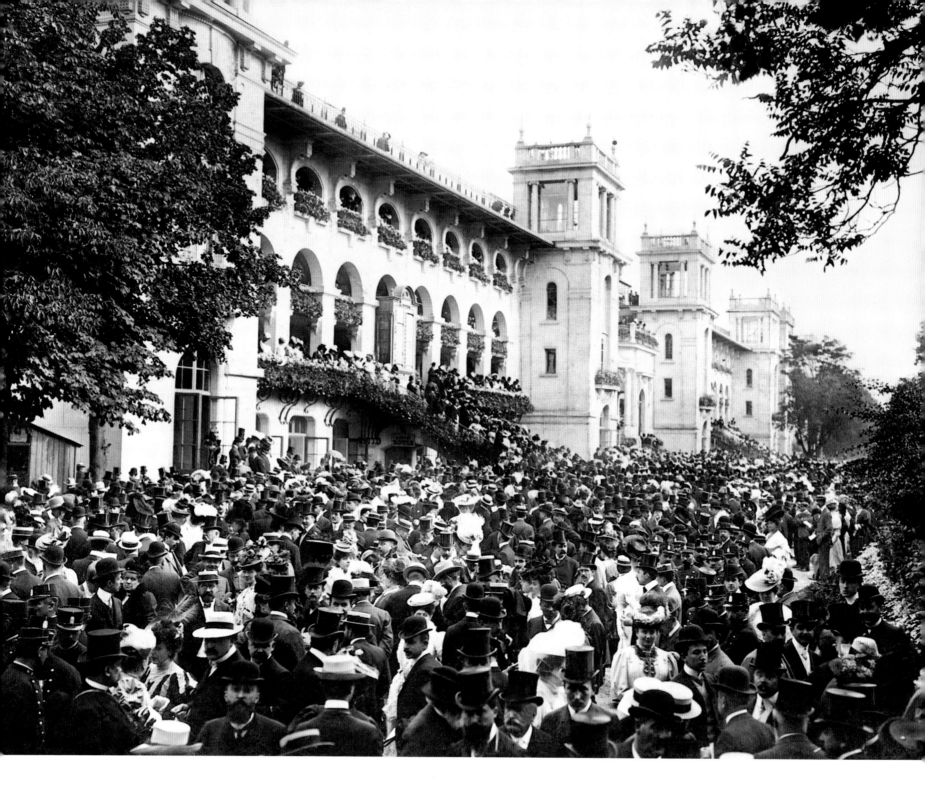

ABOVE: Spectators of the Grand Prix de Paris at the Longchamp racecourse in the Bois de Boulogne, (1906).

RIGHT: The Longchamps Grand Prix, perhaps the most 'Parisian' spectacle of the season, (1935).

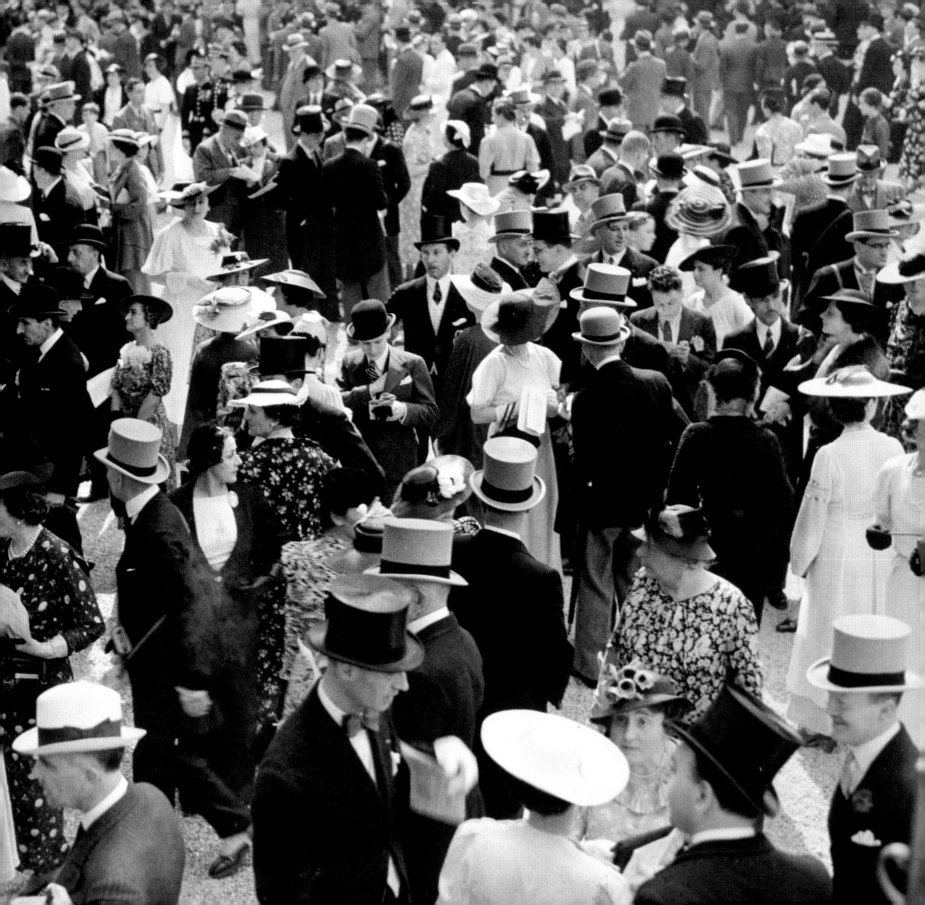

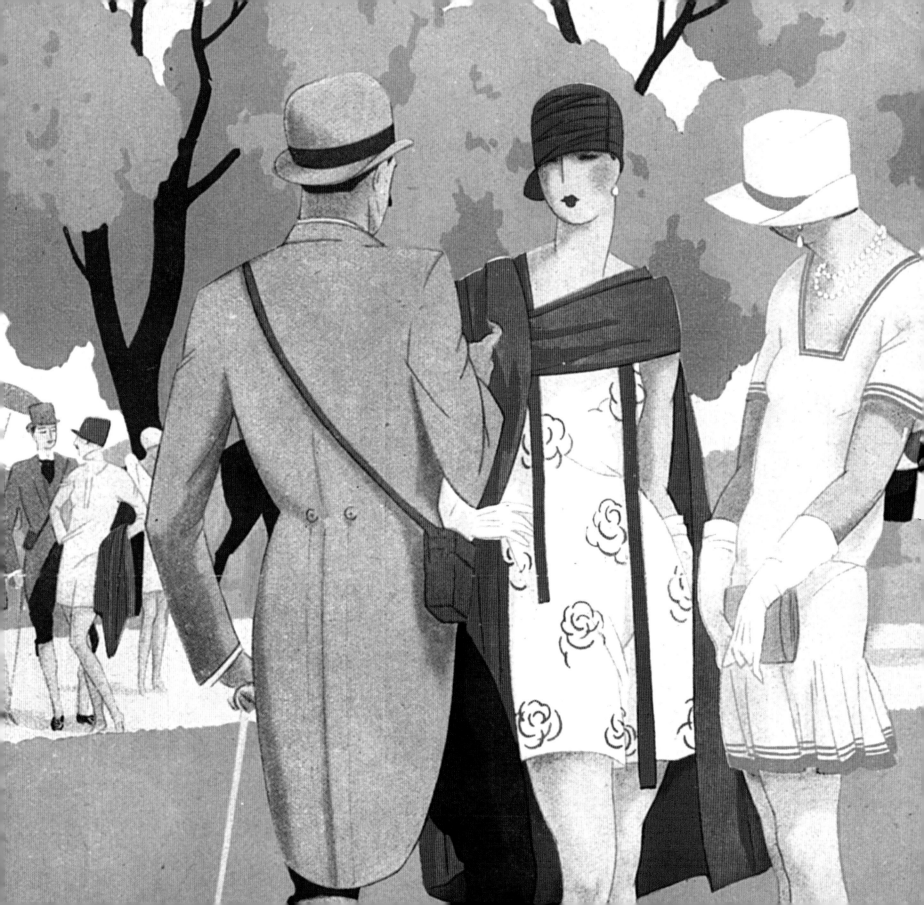

PARIS FASHION

Racegoers at Longchamps epitomise the best fashions of the day, (1927)

It has always been accepted that Paris is the centre of haute couture. Parisian couturiers are held in awe as the most artistic and trend setting; their gowns constructed with impeccable precision and skill. Paris has maintained an hypnotic spell almost intact for 150 years and yet, it is interesting to note that it was the British designer Charles Frederick Worth who was credited with establishing the first couture house in Paris in 1858 at 7 Rue de Paix.

Worth was the first to put his signature on his clothes and the first to establish the supremacy of his own taste and then to use it to set new styles. His back-draped, flattened crinoline look, that became the bustle, was the first new silhouette introduced by an individual designer. The house of Worth flourished and became the Imperial dressmakers and the main arbiter of fashion in Europe.

The houses of Doucet and Pingat soon followed becoming fashionable, like Worth, for starting trends rather than merely adopting set styles. However, it wasn't until the 1890s that a flurry of new couture houses emerged including Callot Soeurs (1895) and Boue Soeurs (1899). Of major impact was Paquin (1891) who was the first French couture house to open a foreign branch in London.

The most significant appearance in the Parisian fashion scene at the turn of the century was Paul Poiret, who swiftly dominated haute couture with his new and exciting ideas and styles. Poiret was influenced by the vibrant colours of the 1905 Fauve art style and the exotic colours of the *Ballets Russes* in 1909. He also adopted many oriental influences such as incorporating tubans and styling tunics to be worn over tube-like skirts. Poiret was also one of the first to introduce the 'V' neckline .

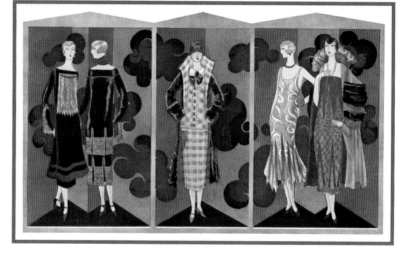

One of his main competitors was the British designer Lucile, or Lady Duff Gordon as she later became known, who was one of the most influential couturiers of the Edwardian era and the most commercial. She became the first woman to achieve universal acclaim in the world of couture, opening branches in London, Paris, New York and Chicago. Lucile created luxuriously feminine, intricate and delicately draped gowns. Her design innovations included the trend for giant plume-laden hats as seen in the stage production of *The Merry Widow* (1907). She was also the first to have a mannequin parade, which became the modern fashion show.

Poiret and Lucile advocated the radical concept of the natural figure with a slim line and abolished the restrictiveness of the corset. With the introduction of new dancing crazes such as the tango both designers pioneered the demand for new slinky dresses with slits.

The end of World War I was without doubt a watershed and ushered in a startling new revolution in fashion with the catchphrase 'modernism'. The curvy flowing, feminine teens made way for a more masculine, angular and simpler look in the 1920s. This featured a slim, waistless and curveless model, with the bosom, hips and silhouette flattened out by plain straight lines with much shorter skirts. There was an overall tendency to feature the rather exotic virtues of androgyny. This new look was partly inspired by the growing interest with art deco and cubism as an art form along with other geometric ideals and the growing awareness of female emancipation.

The understated elegance of the simplified line was exemplified by a new generation of Parisian couturiers led

Illustrations of dresses and coats by Doucet featuring fur bands, handkerchief hemlines, dentate borders, Chinese prints, plaids, two-piece dresses, slash necklines, court shoes with bars and high stand collars (c.1924).

by Coco Chanel, Jeanne Lanvin, Madelaine Vionnet, Edward Molyneaux, Lucien Lelong and Jean Patou. Their intuition and vision became global brands and their designs emulated the word over. Jeanne Lanvin prospered with her emphasis on romantic, feminine creations; Jean Patou branched into increasing stylishness for sport; Edward Molyneaux focused on the new kind of sophisticated woman with discreet designs following a simple classicism and Madeleine Vionnet became unrivalled in her elegance by her creation of the bias cut gown that followed the lines of the body and was unrestricting.

One name that continues to receive adoration today, Chanel, opened her salon at 31 Rue de Cambon in 1918. She achieved instant stardom with her introduction of a new, modern and refined simplicity with the hallmarks of comfort, ease and practicality. This included simple two- or three-piece wool suits with above the ankle skirts, jersey wool dresses and straight line classic evening gowns; all in her favoured colours of grey, black and beige. However, her defining concept was the austerity and minimalism of the little black dress. Black swiftly lost its sense of being only for mourning and instead became a statement of seriousness and ultimate chic.

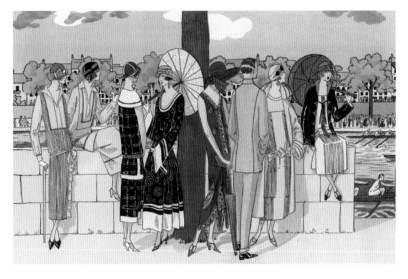

Regattas provide the perfect setting for a display of elegant summer fashions. This illustration depicts smart society ladies wearing outfits by Jean Patou, Doeuillet, Martial et Armand, and Jeanne Lanvin, (1924).

Before long each fashion house would show their latest designs at two collections each year: spring and summer; usually in February and August. But there were other showcases for the ingenuity of the couture houses including the gala evenings at the fashionable summer resorts in the Bois de Bologne and at Longchamp for the racing season. The concept of *prêt-à-porter (*ready-to-wear) spread during the wars. At the end of the 1920s, there was a movement back to the natural curves of the female form with the return of the long dress along with strapless and backless gowns.

When the economic bubble burst in October 1929 with the Wall Street crash, there were serious repercussions for the Paris fashion industry which relied heavily on export and the American market. Thousands lost their jobs as a once bouyant business felt the biggest pinch since the war. But recovery came in the early 1930s with the rise to prominence of designers such as Maggy Rouff, Elsa Schiaparelli, Balenciaga, Jacques Heim and Mainbocher.

With World War II, at a stroke, Paris was removed from world fashion. The scarcity of materials and the mood of restraint meant that fashion in general became austere and practical. After the war, Christian Dior swept away the prevailing monotony with his 'New Look' in November 1946. In came tight waists, full billowing skirts and rounded shoulders. A new breed of designers flourished exemplified by Yves St Laurent, Nina Ricci, Pierre Cardin, Pierre Balmain, Jacques Fath and André Courréges.

And yet, Paris couture waned somewhat as it was eclipsed by the young revolutionary fashions in London, pioneered by Mary Quant and other young British designers in the 1960s. Claiming to change the emphasis from the establishment to the young, she epitomised that revolutionary decade with two defining fashions of the era, the miniskirt and hotpants.

Today, even though fashion is far more global and New York, London and Milan have become more prominent, Paris retains its allure and mystical attraction as the centre of couture.

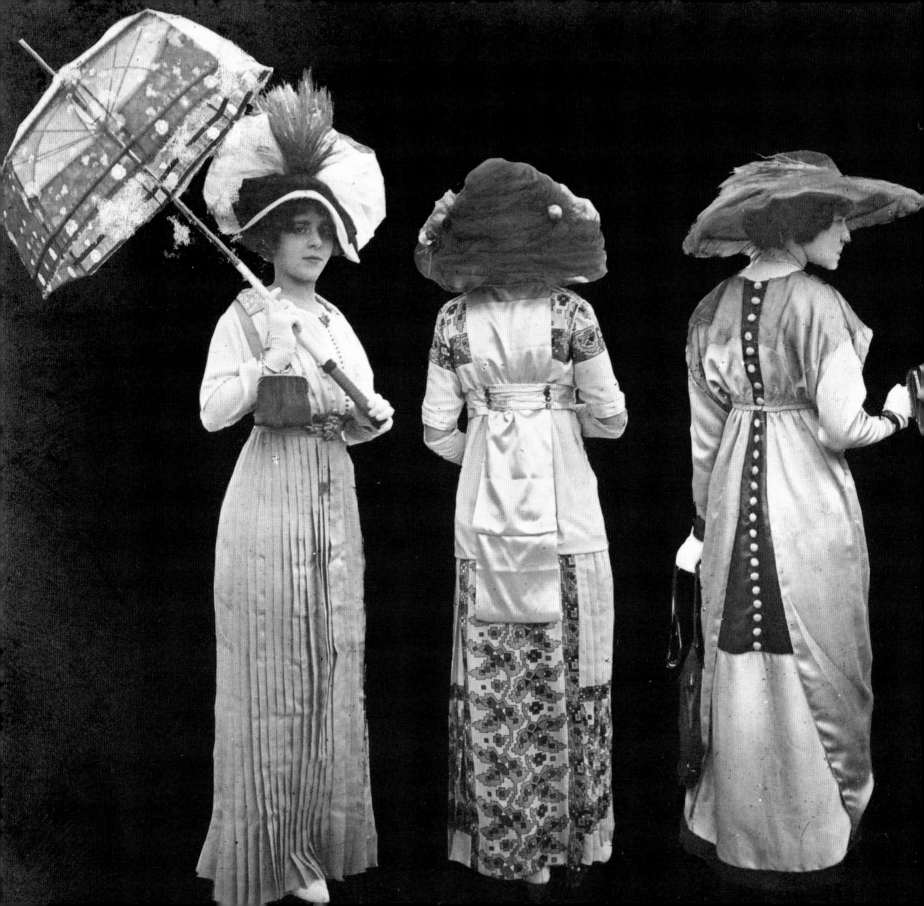

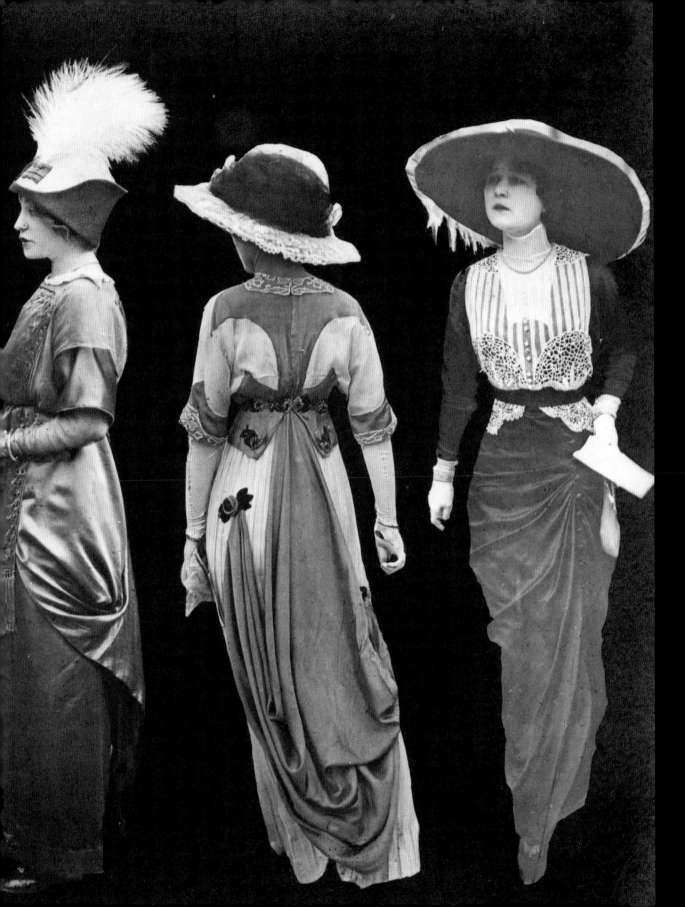

A selection of six mannequins showing the latest French Fashions in summer daywear, (c.1910s).

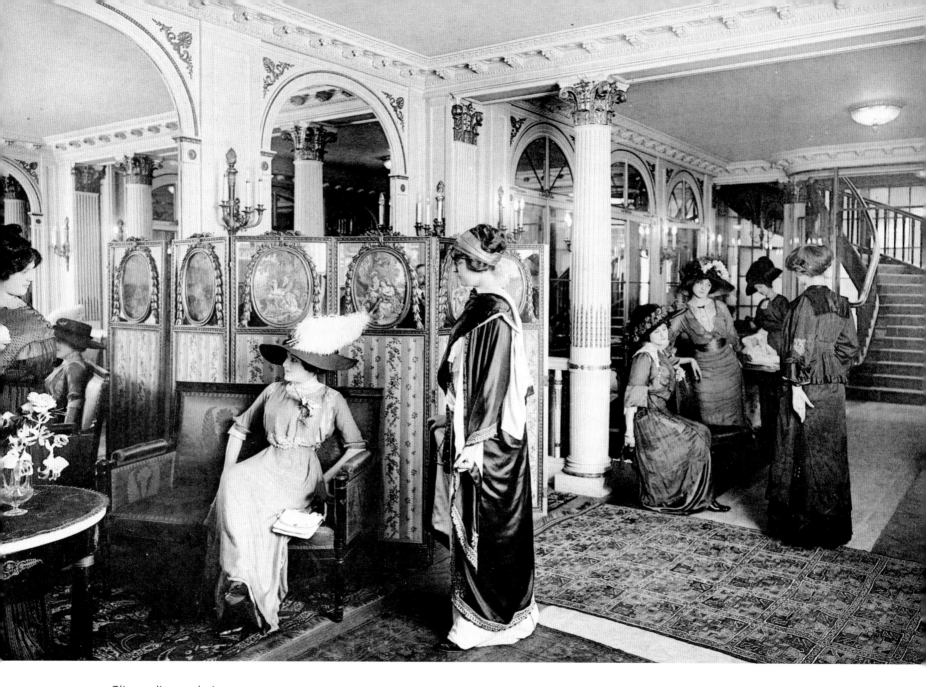

ABOVE: Clients discuss their
purchases in the Galerie de
Vente in the fashion house of
Paquin, (1910).

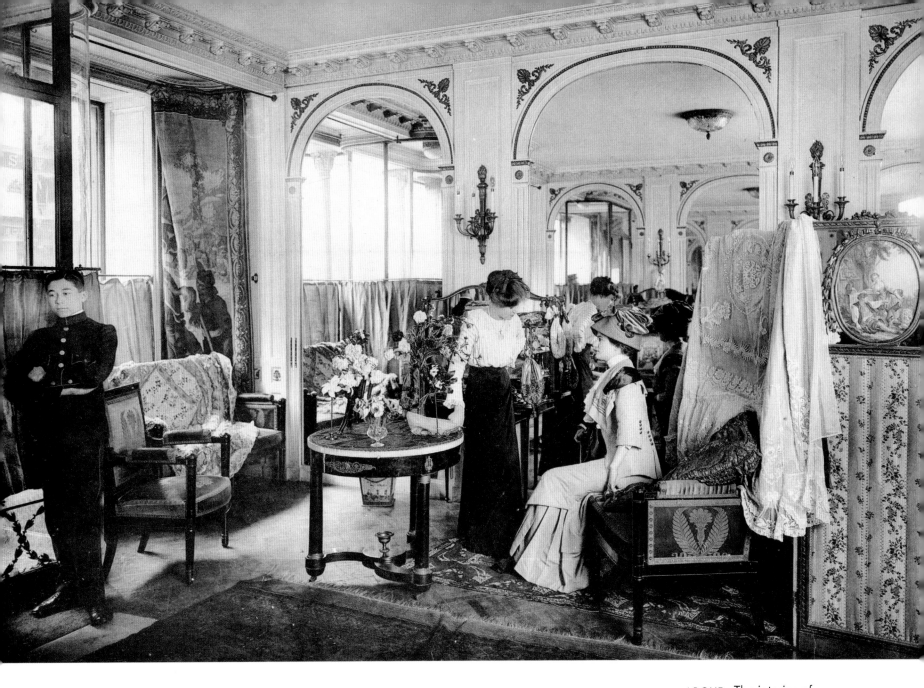

ABOVE: The interior of
the fashion house of
Paquin showing clients and
mannequins in the galerie,
(1910).

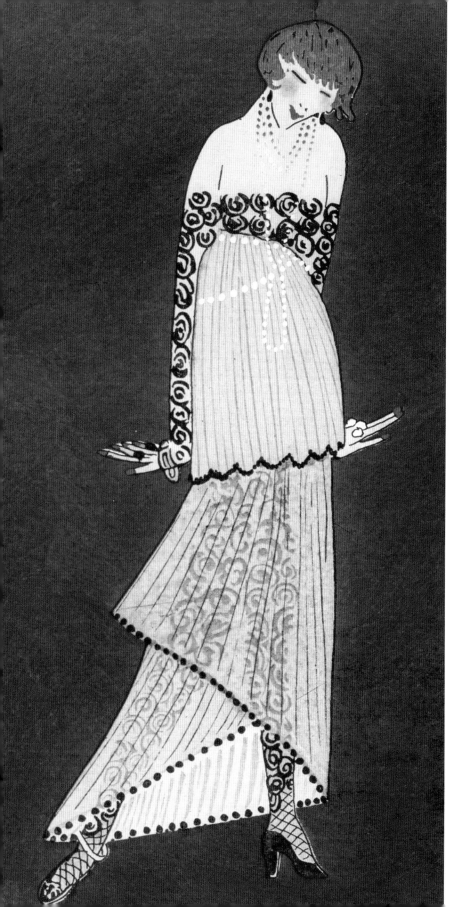

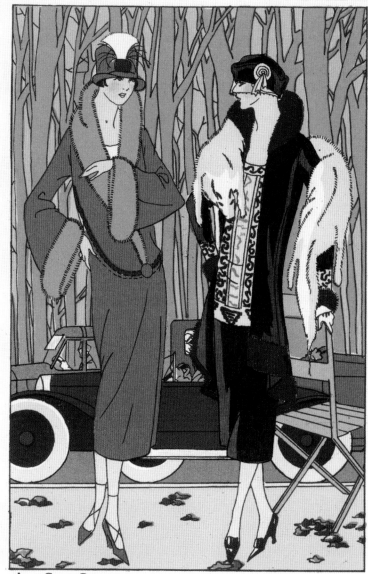

Art - Goût - Beauté

LEFT: A sketch of an elegant young woman, happy to be wearing an evening dress by Paul Poiret, (1914).

ABOVE: An illustration of two elegant ladies in the Bois de Boulogne wearing outfits by Paul Poiret and Drecoll, (1924).

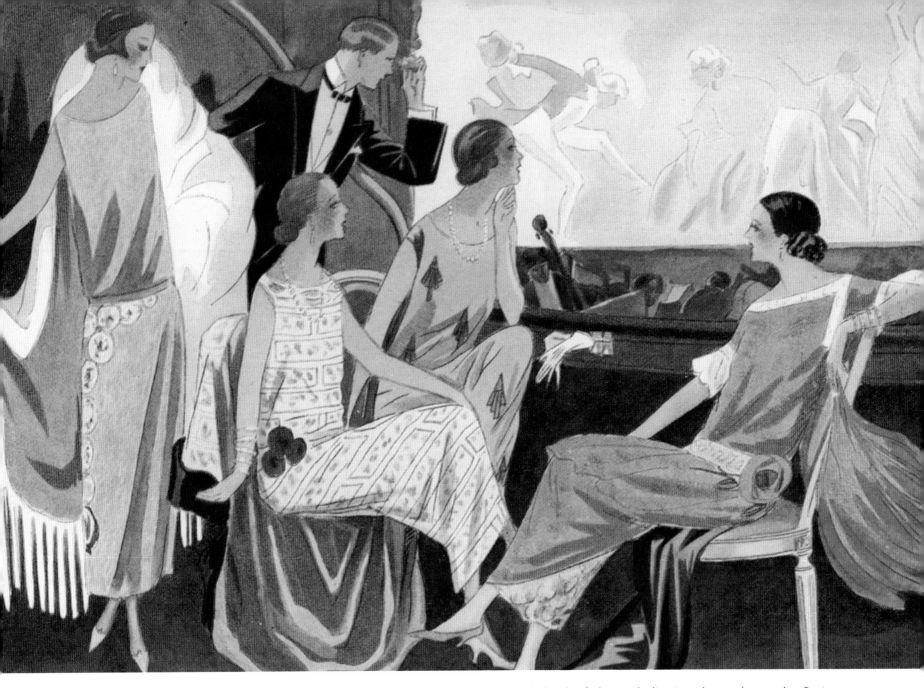

ABOVE: A sketch of elegant ladies in a theatre box at the Opéra Comique. Their evening dresses are by Molyneux, Beer and Premet, (1924).

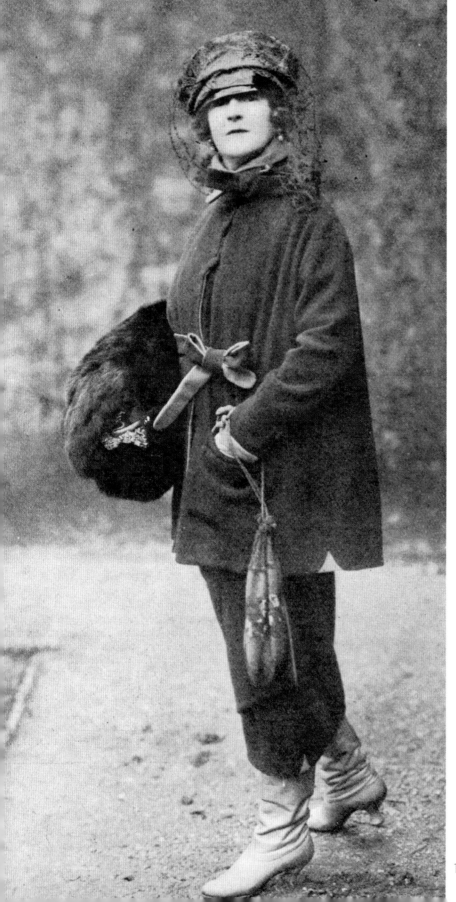

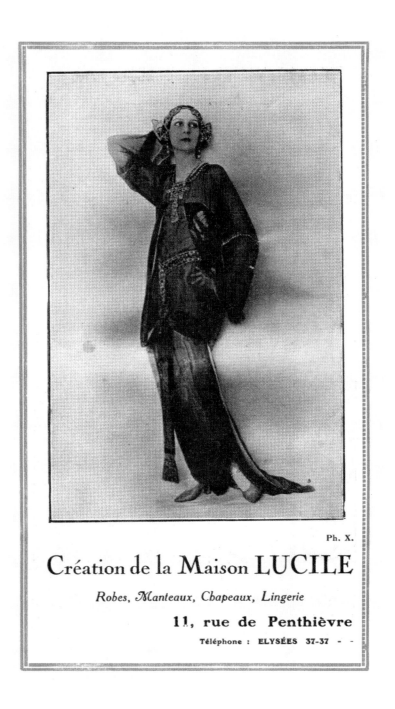

Ph. X.

Création de la Maison LUCILE

Robes, Manteaux, Chapeaux, Lingerie

11, rue de Penthièvre

Téléphone : ELYSÉES 37-37 - -

LEFT: Lady Duff Gordon, better known as 'Lucile', was one of the most influential couturiers worldwide either side of World War I, (1920).

ABOVE: Advert for the couture house of Lucile, (1920).

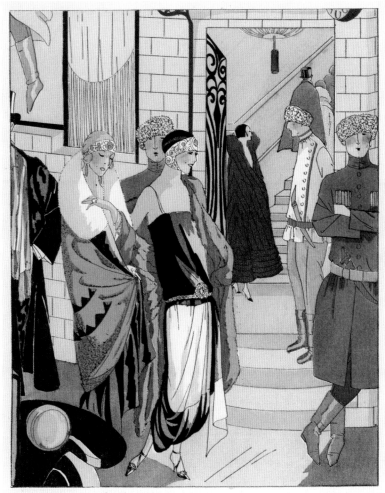

CABARET CAUCASIEN...

ABOVE: Illustration of ladies entering the Cabaret Caucasien in Montmartre wearing evening outfits by Philippe et Gaston and Paul Poiret, (1924).

RIGHT: Design of a black dress by Madeleine Vionnet inspired by recent archaeological discoveries made in Egypt; the long tubular bodice is comprised of horizontal bands along with a gored skirt and handkerchief hemline, (1923).

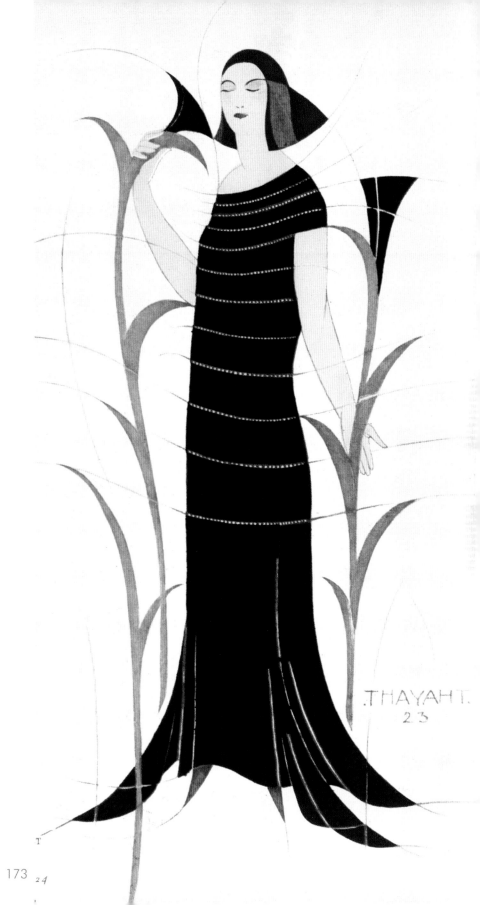

.THAYAHT.
23

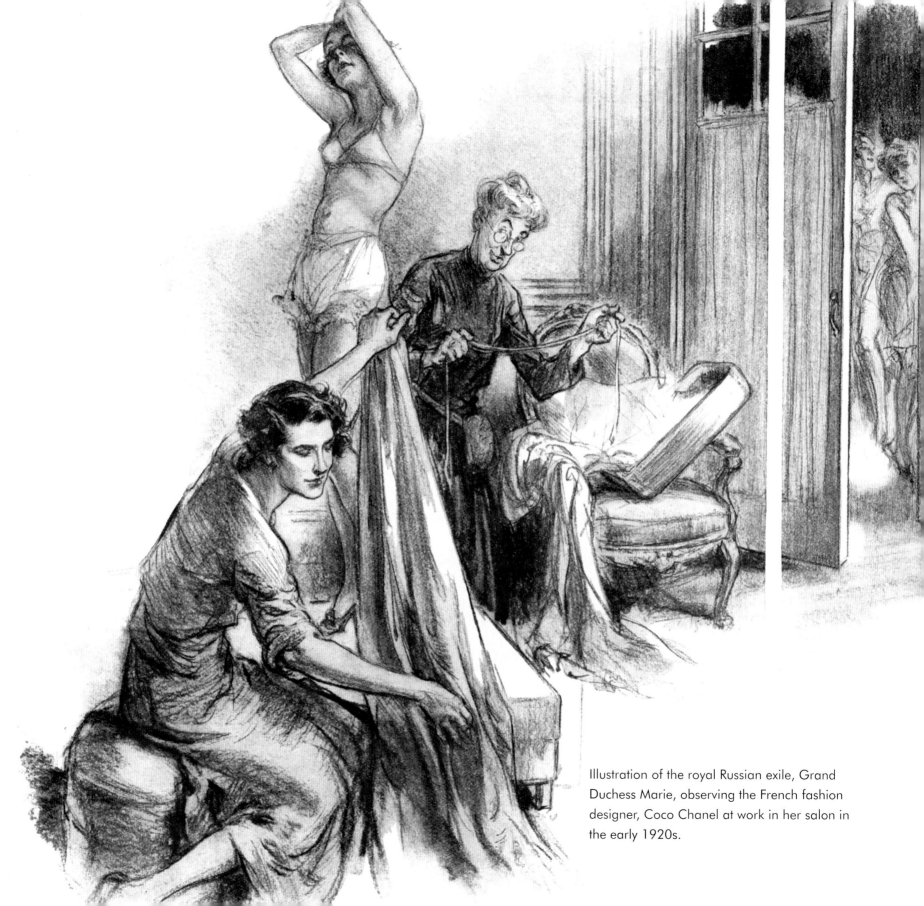

Illustration of the royal Russian exile, Grand Duchess Marie, observing the French fashion designer, Coco Chanel at work in her salon in the early 1920s.

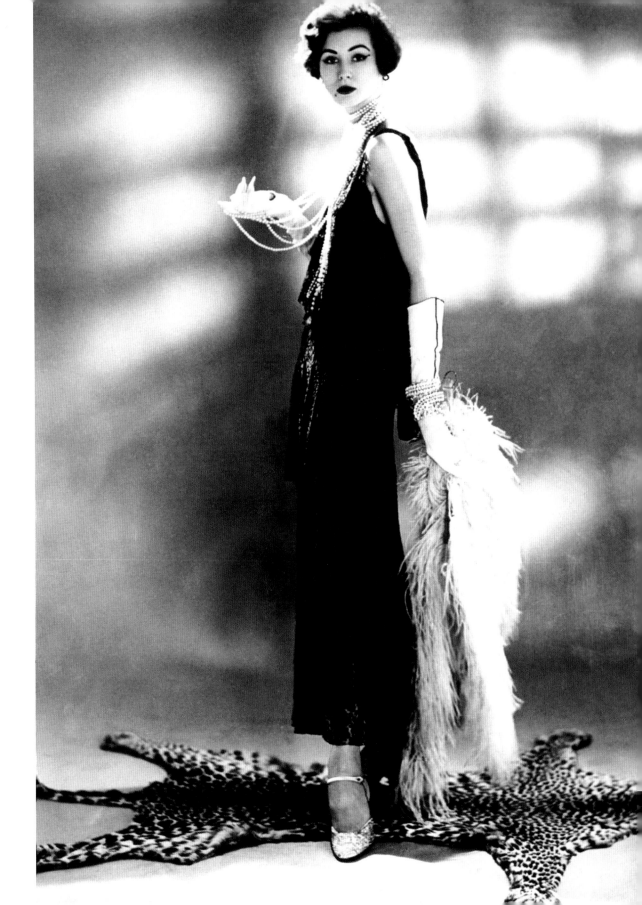

RIGHT: A woman wearing
a Chanel dress from 1928
standing on a leopard-skin
rug.

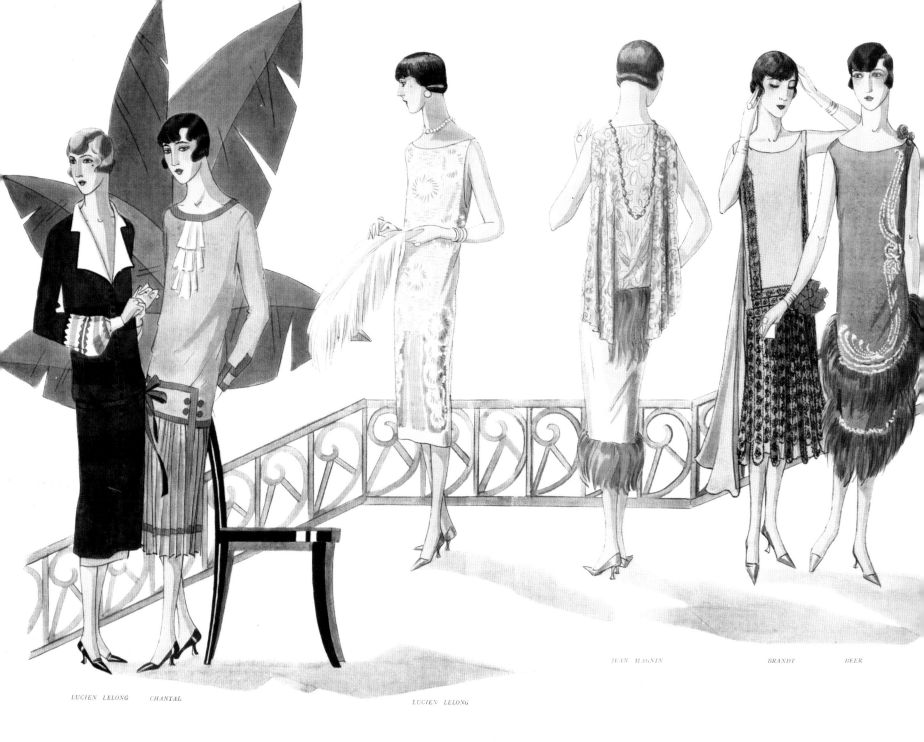

LUCIEN LELONG CHANTAL

LUCIEN LELONG

JEAN MAGNIN

BRANDT BEER

ABOVE: Sumptuous Spring fashions from Lucien Lelong, Chantal, Jena Magnin, Brandt and Beer, (1925).

ABOVE RIGHT: Three contrasting contours in Summer Parisian gowns from Lenieff, Jeanne Lanvin and Lucile, (1927).

BELOW RIGHT: Advert for the fashion house of Jeanne Lanvin, (1922).

FAR RIGHT: Sketch showing a fashionable lady wearing an elegant black winter coat with brown fur trimming by Jean Patou, (1929).

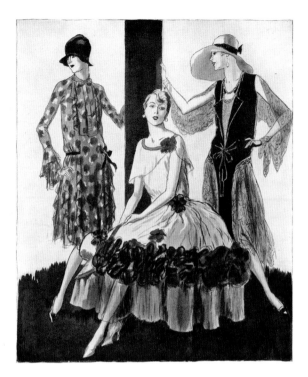

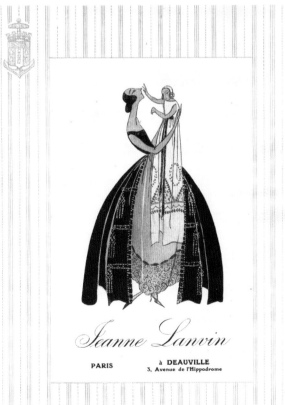

Jeanne Lanvin

PARIS à DEAUVILLE
3, Avenue de l'Hippodrome

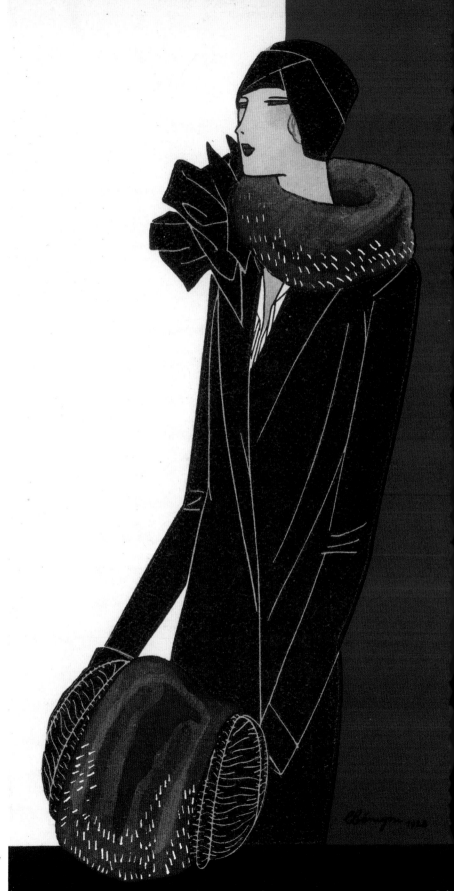

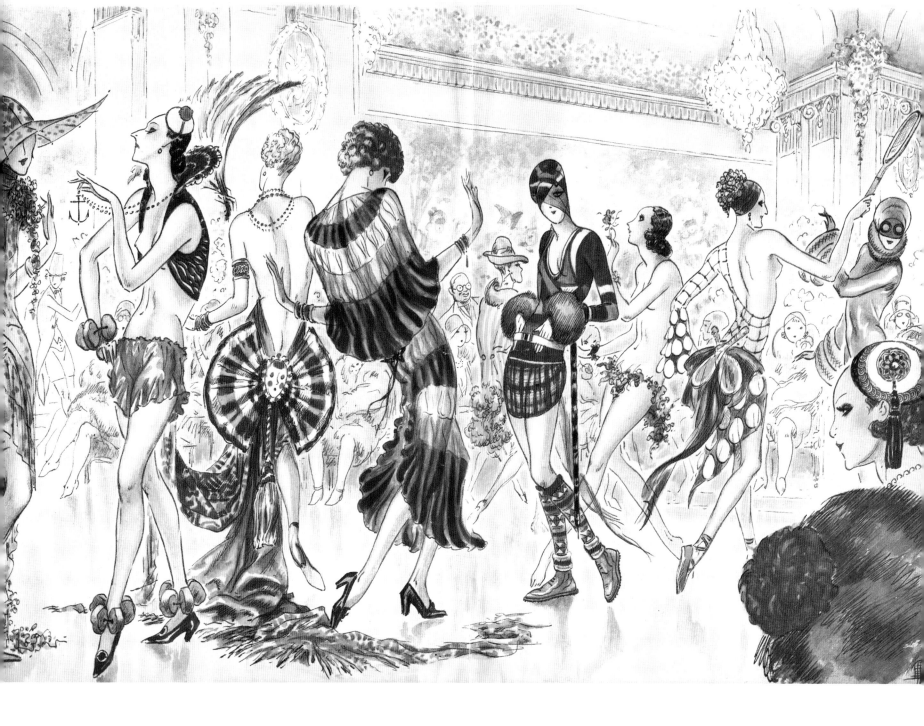

ABOVE: A humorous take
on the more bizarre Parisian
fashions, (c.1929).

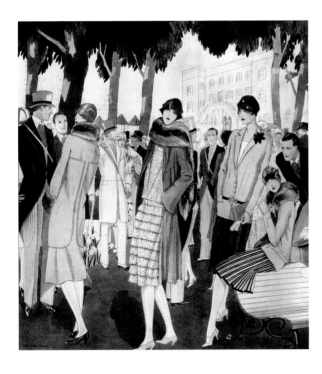

ABOVE: Drawing of fashions from Martial et
Armand, Chanel, Patou and Worth in the Auteuil
racing paddock, (1927).

RIGHT: Edward Molyneux dress designs with
gored flaring skirts, belts and matching sac
jackets. The dress of the right has chevron panels
or inserts which add interest to the skirt, (1930).

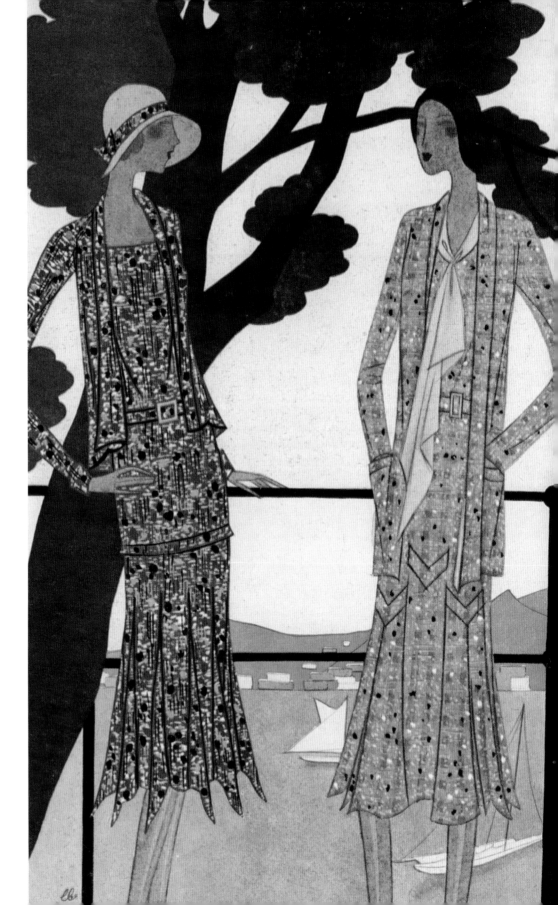

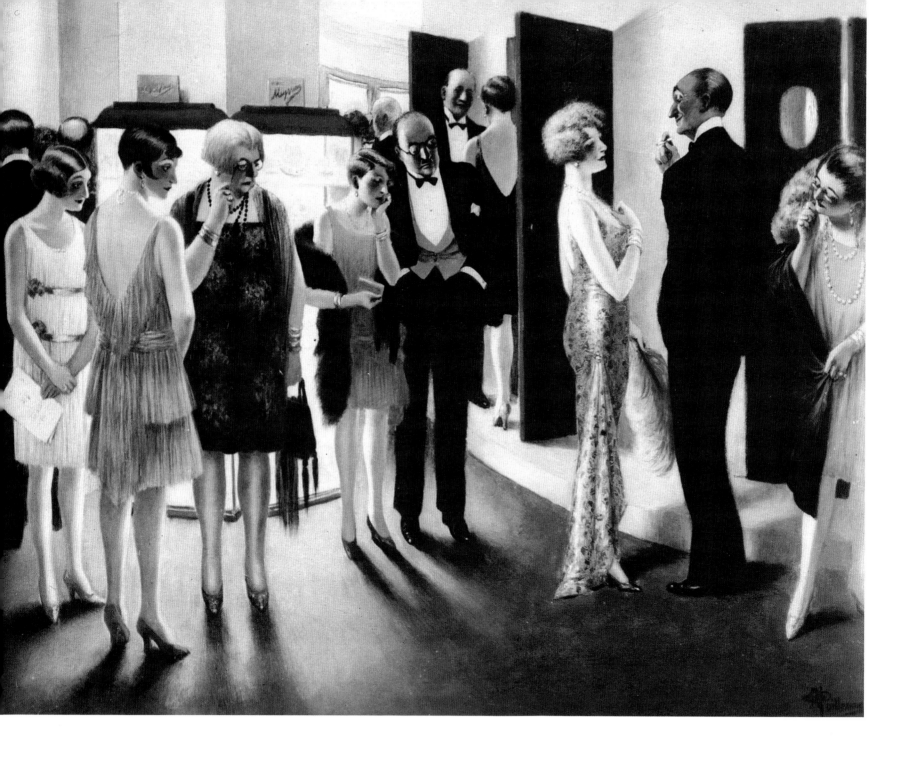

ABOVE: This illustration shows that the radical new fashion style of the long dress was a bit of a shock in Paris, (1930).

RIGHT: Jenny Dolly, one half of the famous Dolly Sisters, in her couture establishment showing one of her models, (1930).

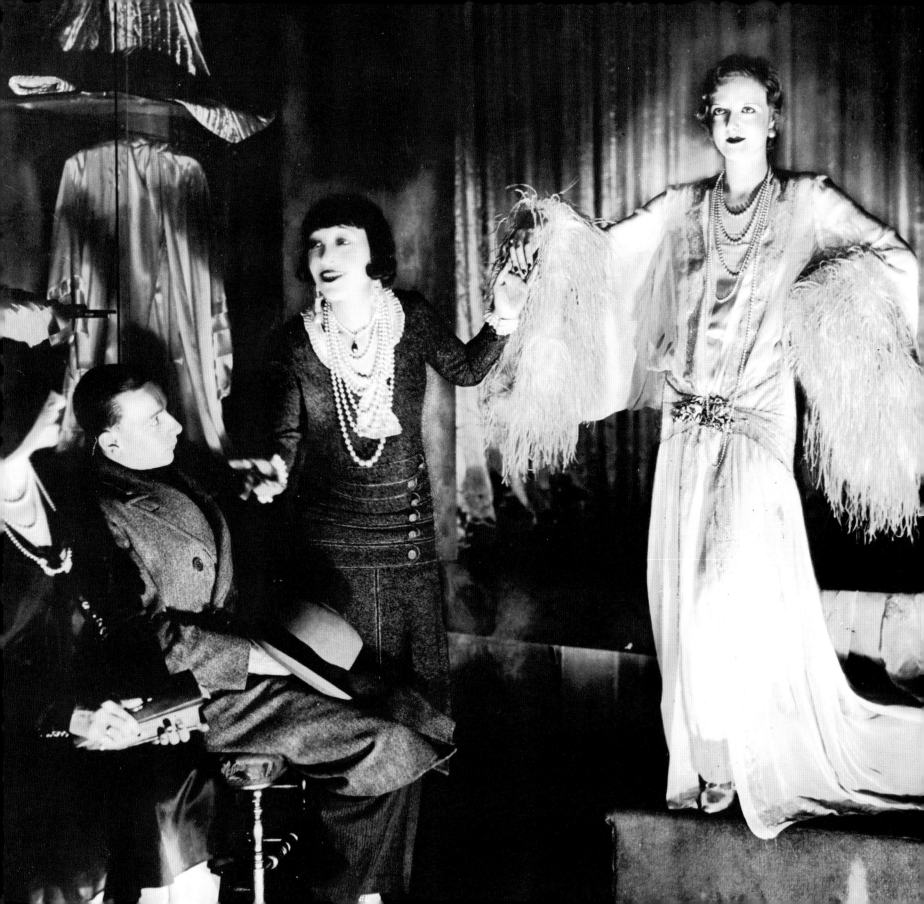

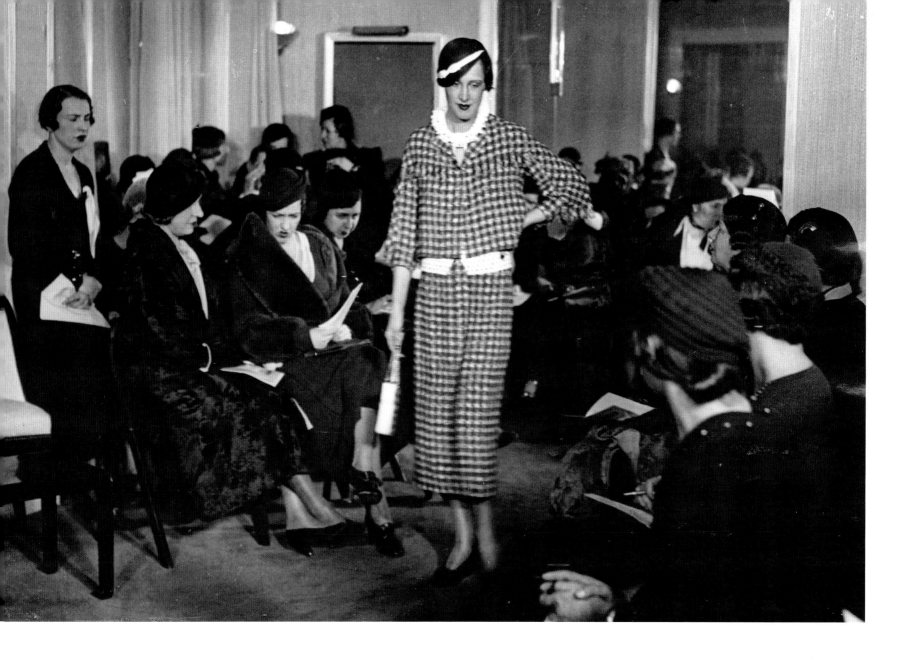

ABOVE: A fashion show at the House of Jacques Heim, 2 February 1933. Heim was particularly well known for his furs, beach and swimwear.

RIGHT: The silhouette drawing from 1931 of a design from fashion house Mainbocher, founded by the American couturier Main Rousseau Bocher (1890–1976).

FAR RIGHT: Long evening gowns by Lucien Lelong; two with low-cut backs, bustles and trains and a gown with a black skirt, pink bodice and a diamond shaped panel and bow at the waist, (1931).

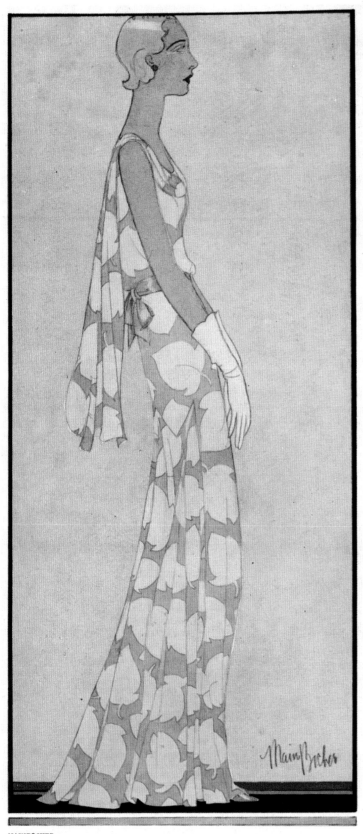

MAINBOCHER

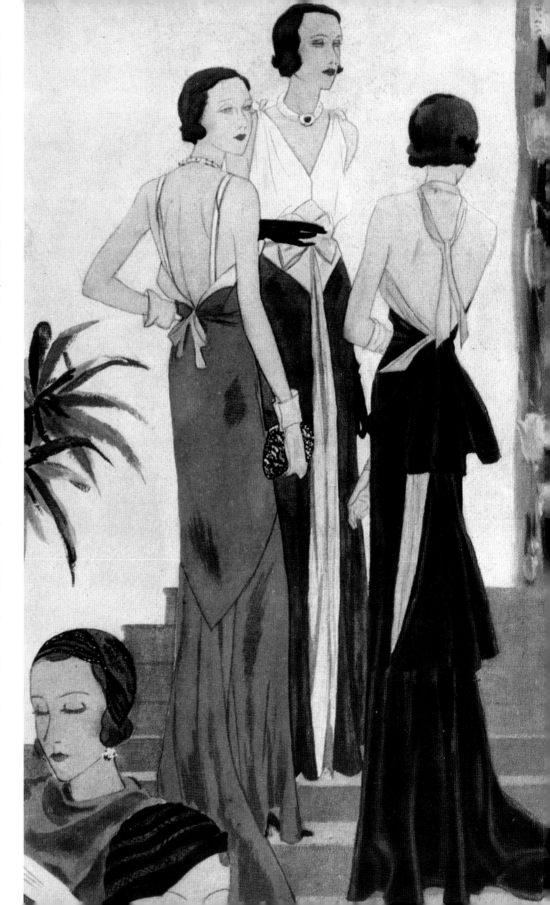

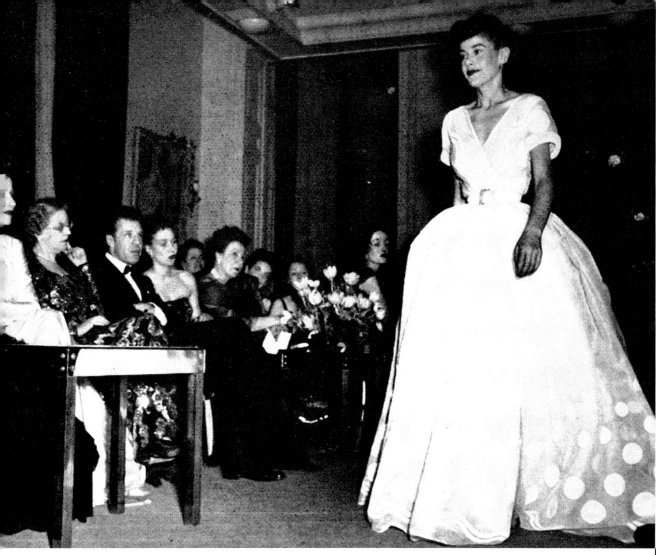

RIGHT: A Chanel dress presented on 30 January 1957.

BELOW: At her Spring Fashion Show, Maggie Rouff (Madame Maggy Besançon de Wagner) adjusts the necklace on one of her models, (1948).

ABOVE: A model parades a white organdie evening gown with large white polka dots at Maggy Rouff's Spring Fashion Show. The slender waistline was accentuated by the fullness of the skirt. Madame Maggy Besançon de Wagner, like many other designers, took inspiration from Dior's New Look, (1948).

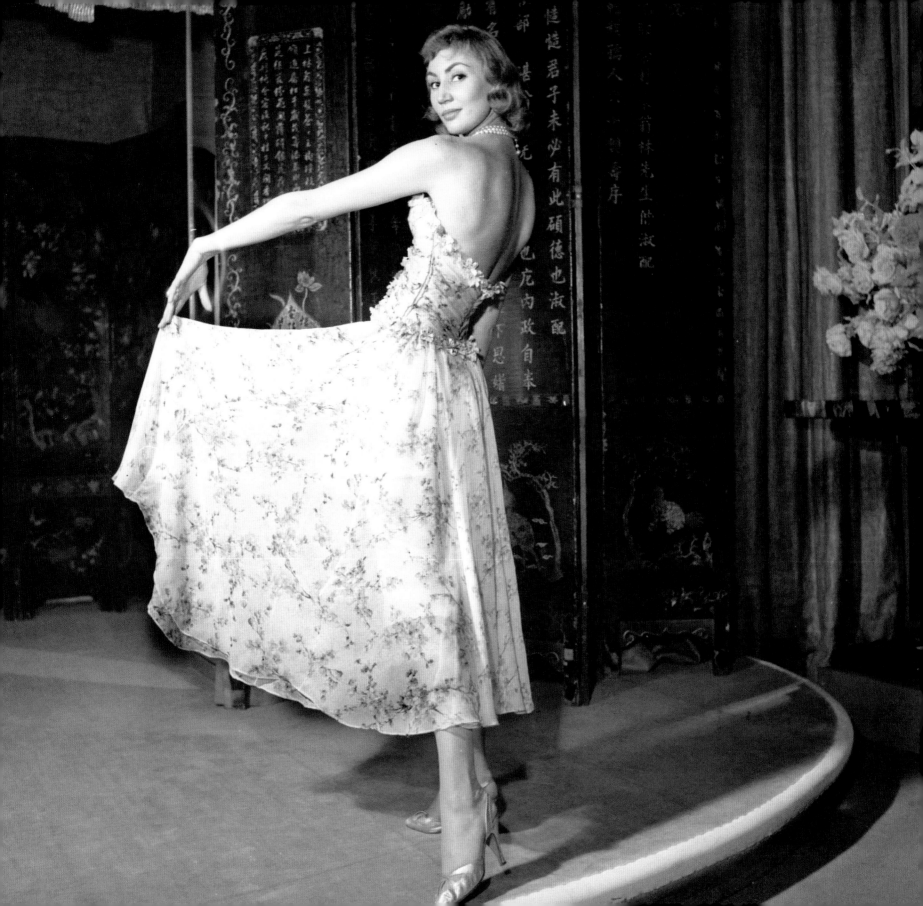

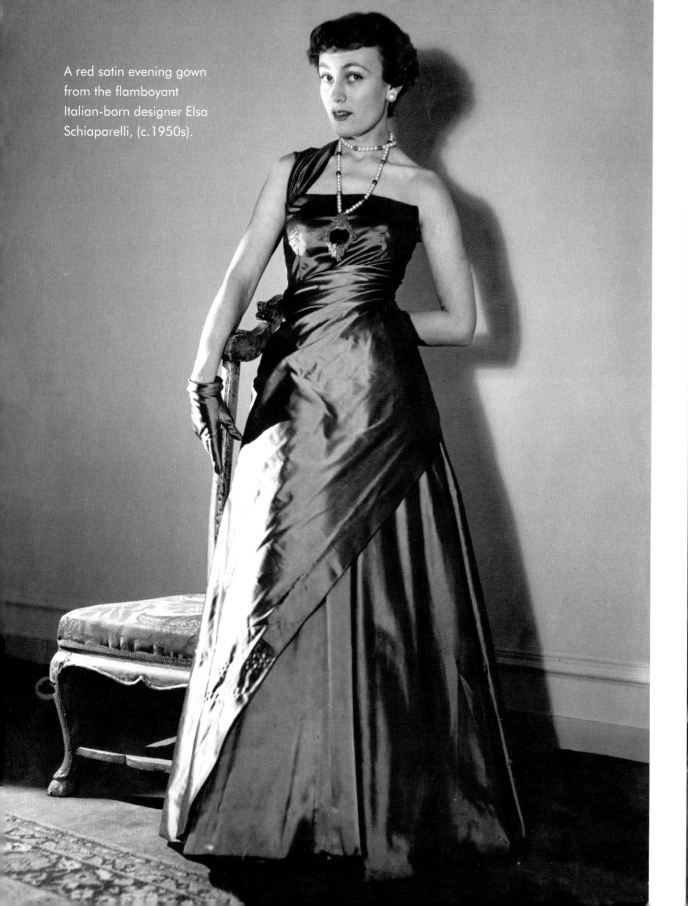

A red satin evening gown from the flamboyant Italian-born designer Elsa Schiaparelli, (c.1950s).

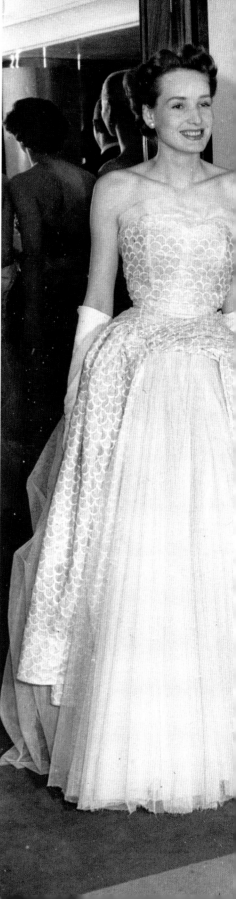

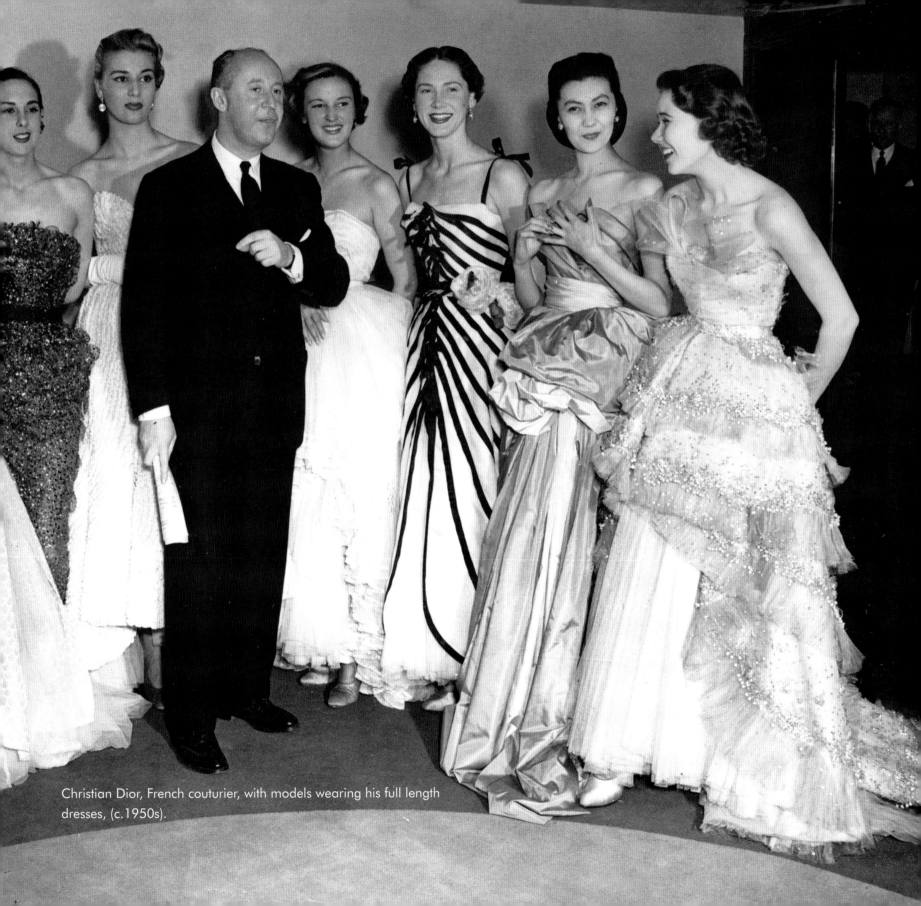

Christian Dior, French couturier, with models wearing his full length dresses, (c.1950s).

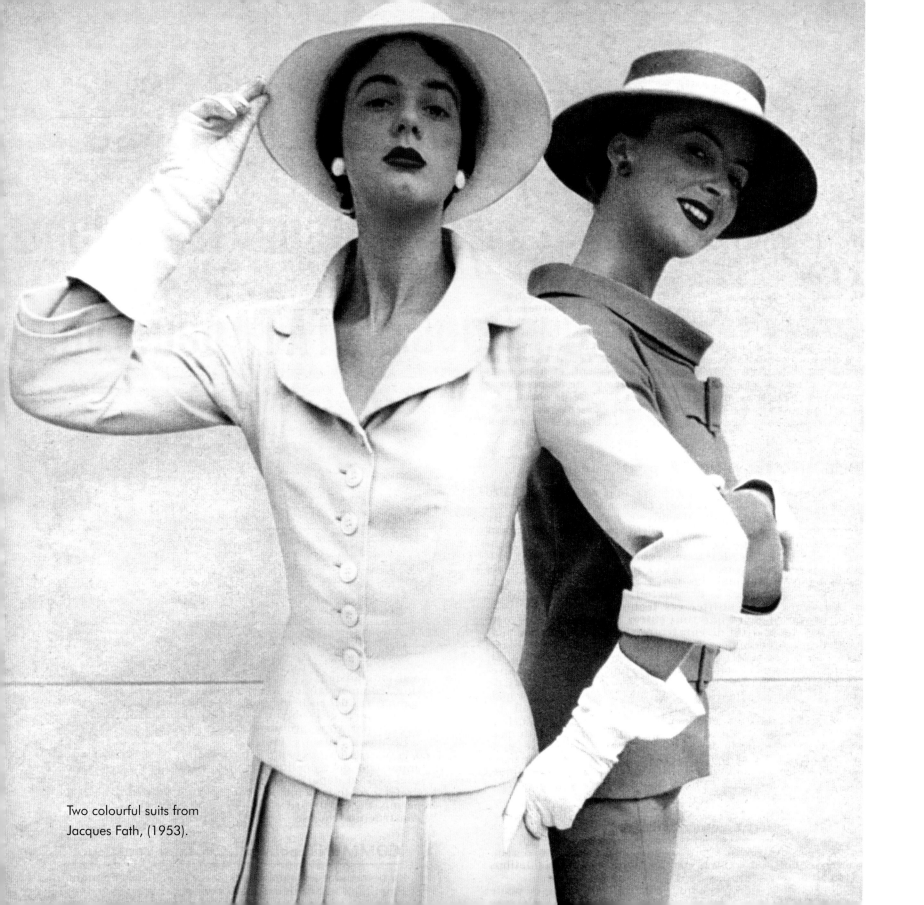

Two colourful suits from
Jacques Fath, (1953).

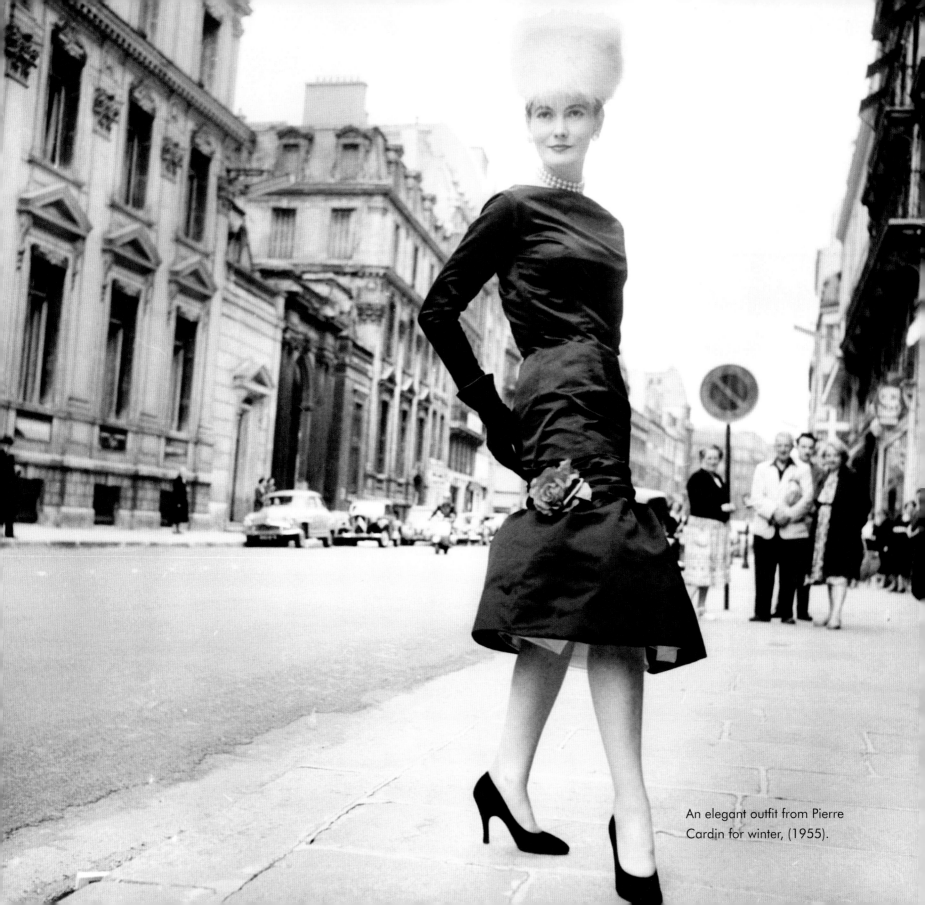

An elegant outfit from Pierre
Cardin for winter, (1955).

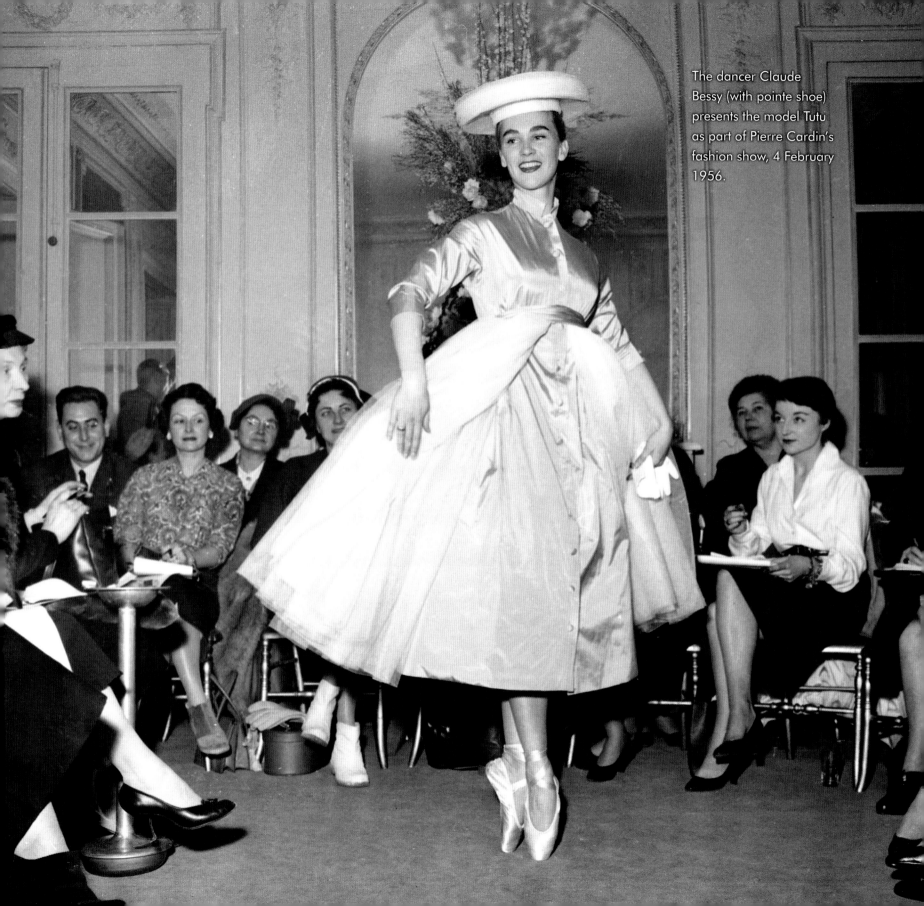

The dancer Claude Bessy (with pointe shoe) presents the model Tutu as part of Pierre Cardin's fashion show, 4 February 1956.

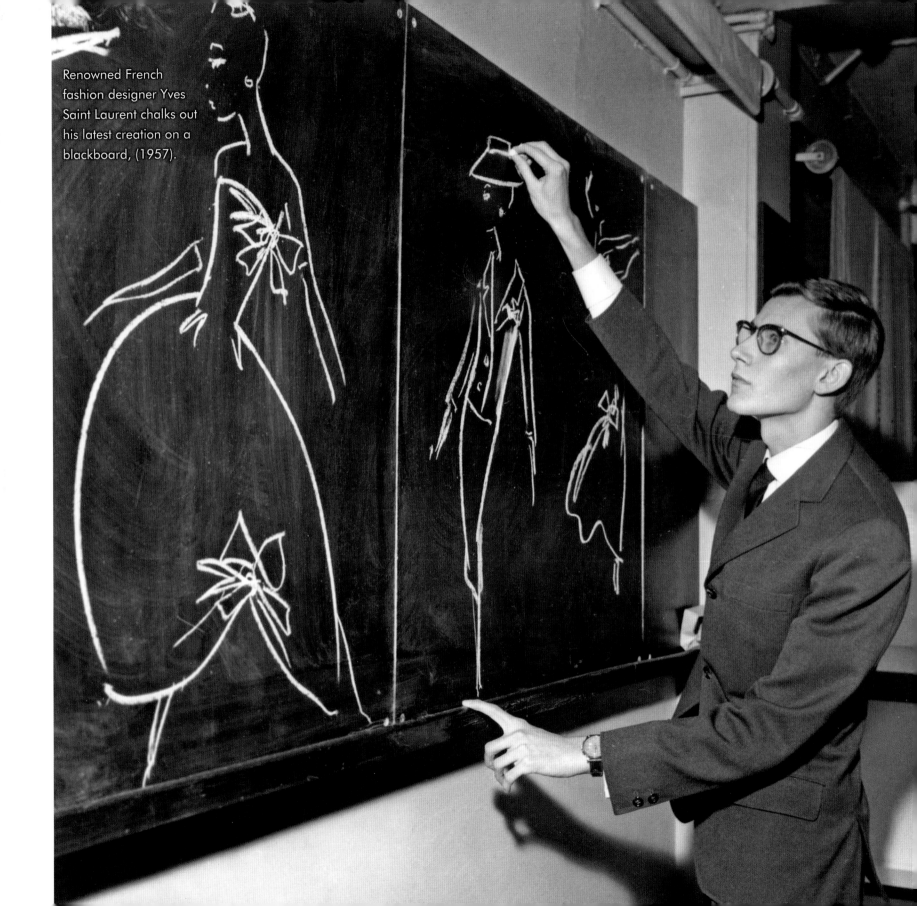

Renowned French fashion designer Yves Saint Laurent chalks out his latest creation on a blackboard, (1957).

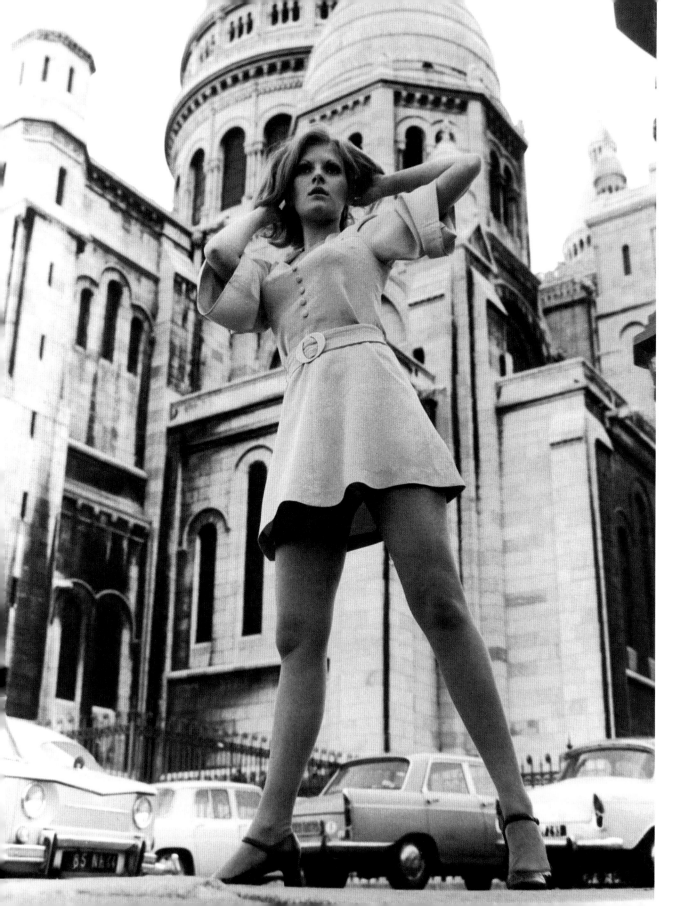

LEFT: The model Helga Berk wearing a very short miniskirt in a statuesque pose outside Sacré Cœur in Montmartre, (c.1960s).

RIGHT: Yves Saint-Laurent and his models after a Dior fashion show, 27 January 1960.

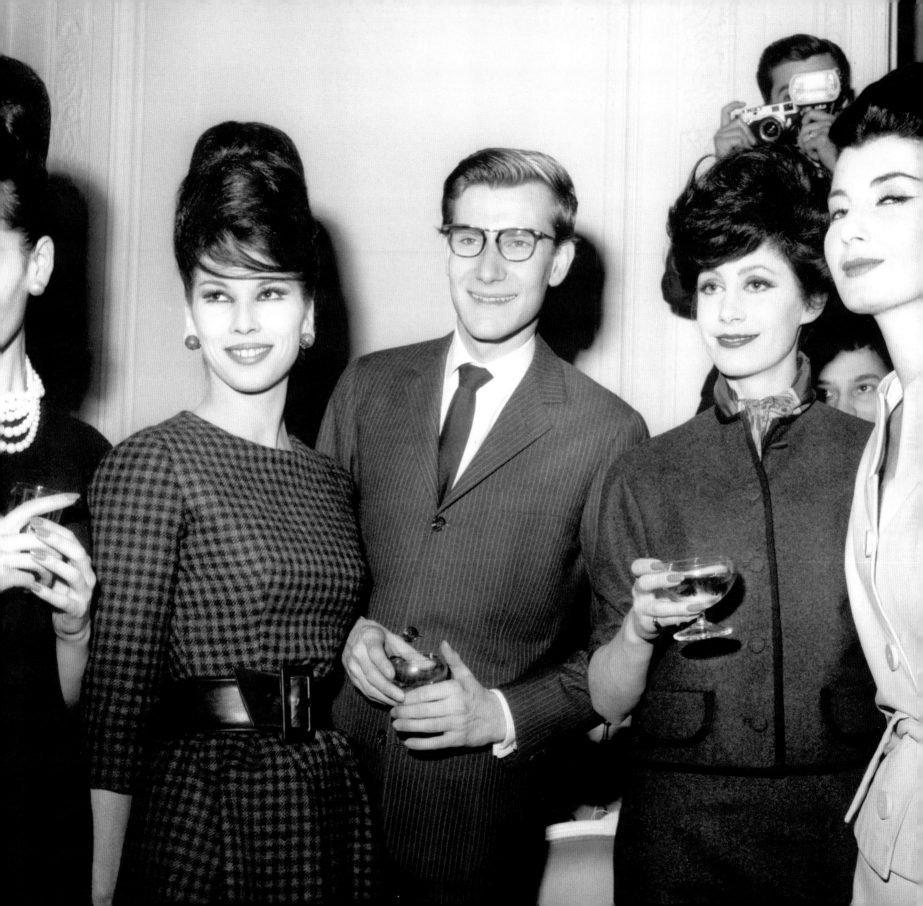

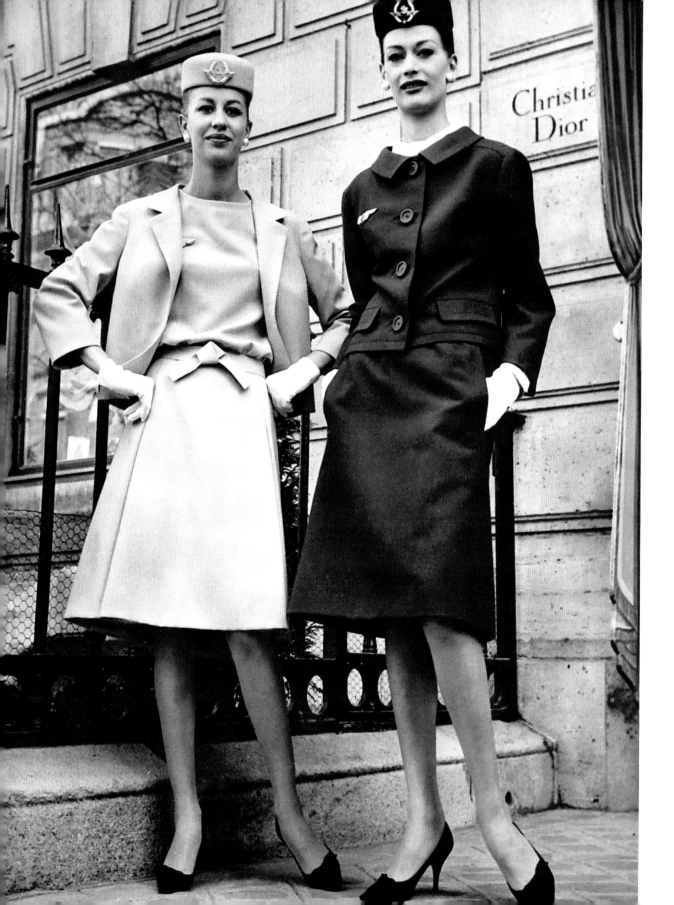

LEFT: Two models in front of the Dior fashion house wear winter and summer stewardess uniforms for Air France, by Christian Dior, (1962).

RIGHT: A Nina Ricci pebble wool cape coat is the colour of a rich marron glace reversing to stone. The dress underneath is the same marron colour, slim-fitting, collarless and short-sleeved. The large beret is made of pale beige mink, (1961).

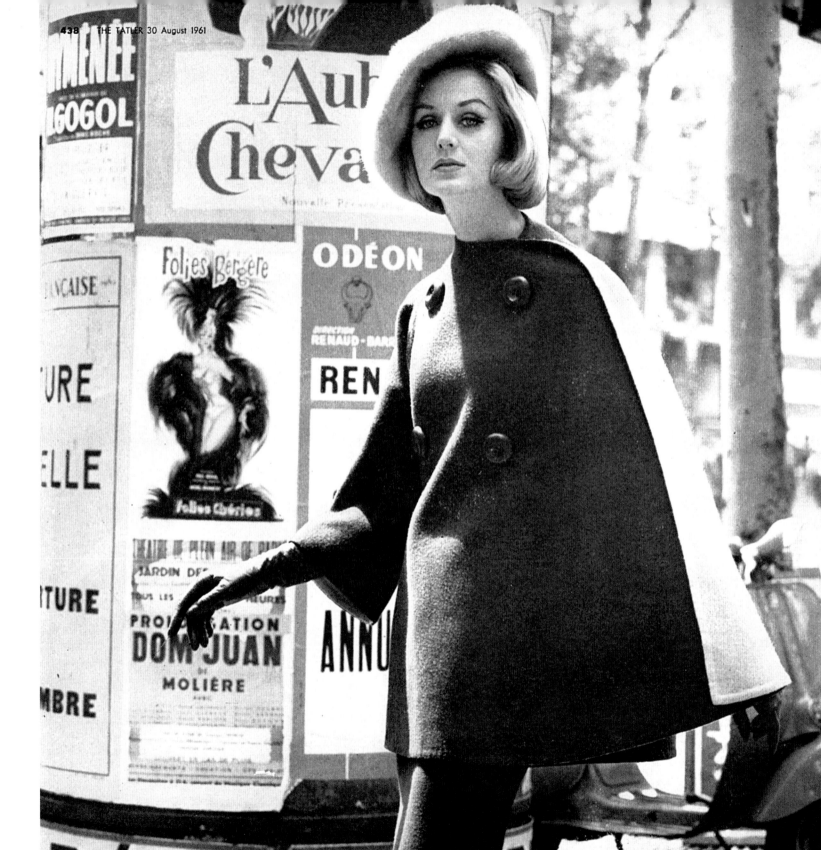

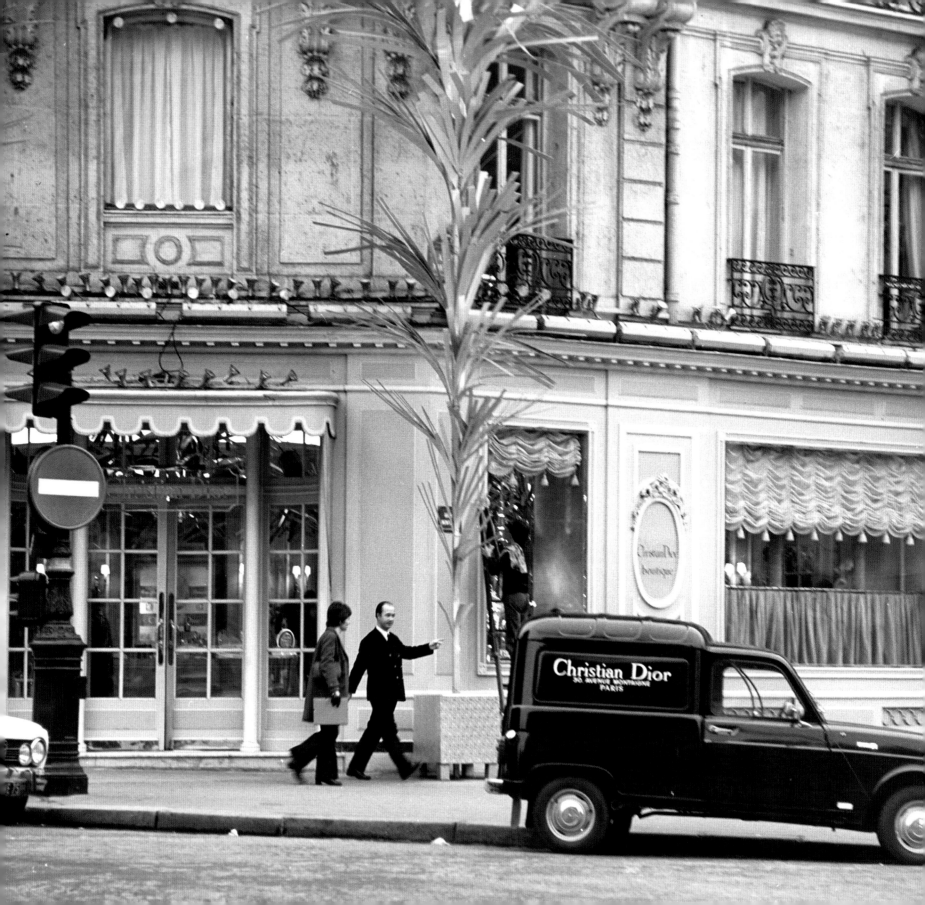

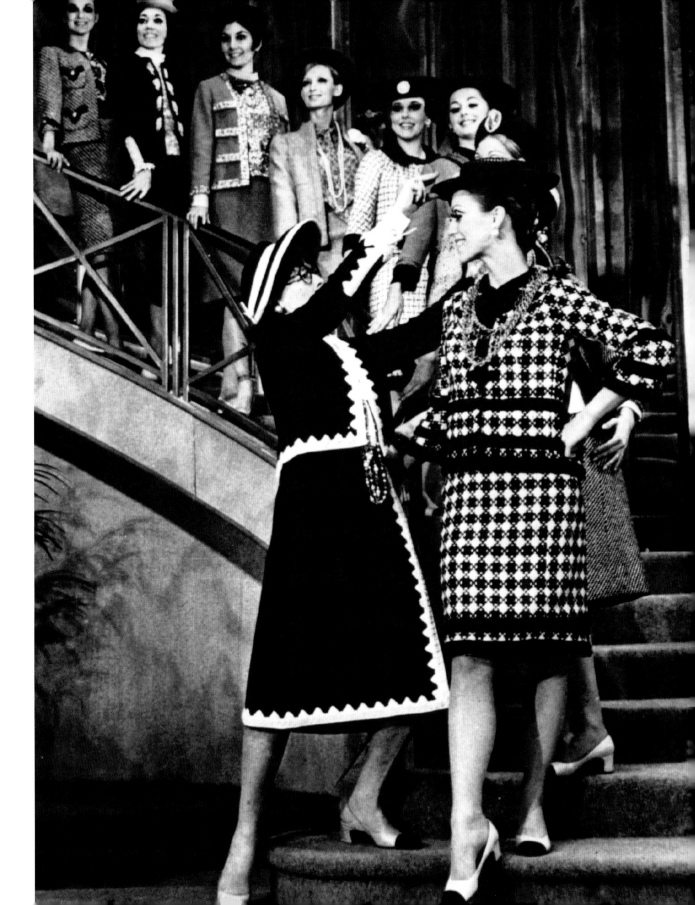

LEFT: Christian Dior's establishment on the Avenue Montaigne. Dior moved up to be the leading producer of luxury goods after World War II, (1970).

RIGHT: Coco Chanel, French couturier, with models wearing costumes for the musical Coco, (1969).

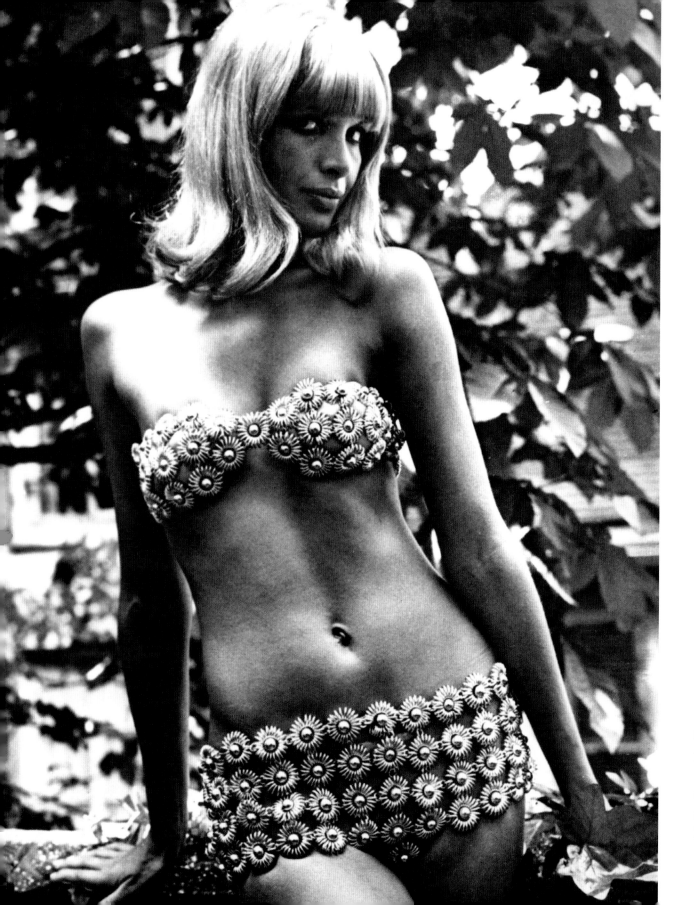

LEFT: A woman wearing a pouka pouka bikini for the Islanders collection by Jacques Heim, (1967).

RIGHT: André Courrèges presenting his Spring-Summer 1973 collection with models dressed in a variety of long dresses, frilly trousers and head scarves.

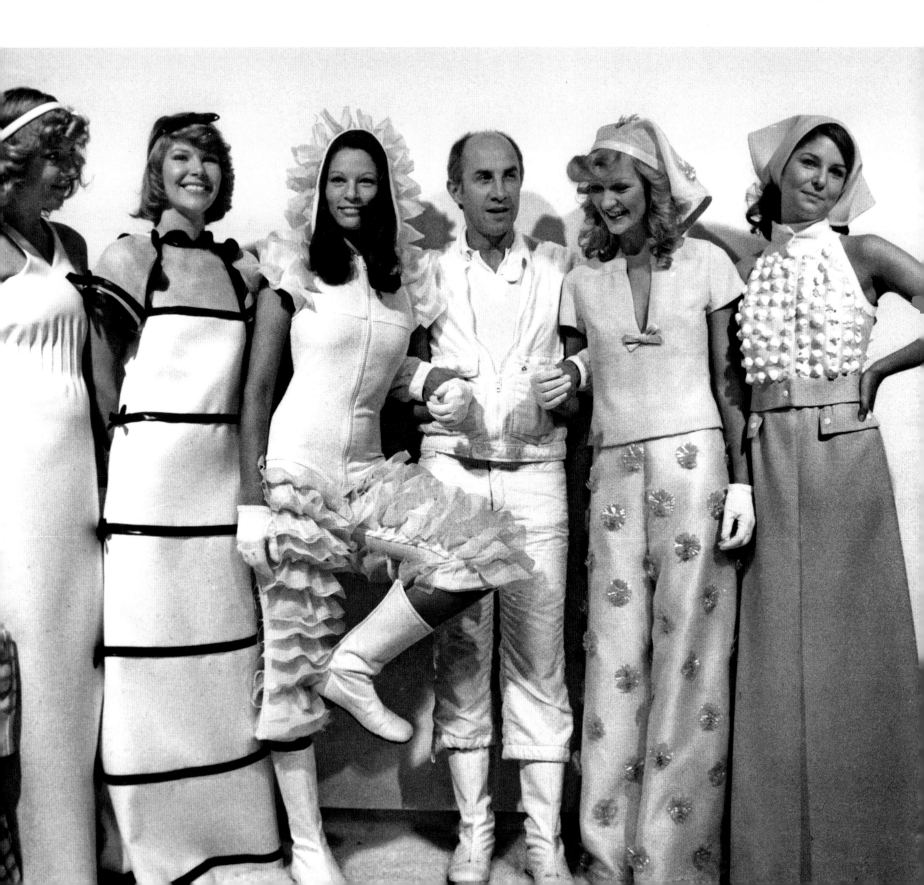

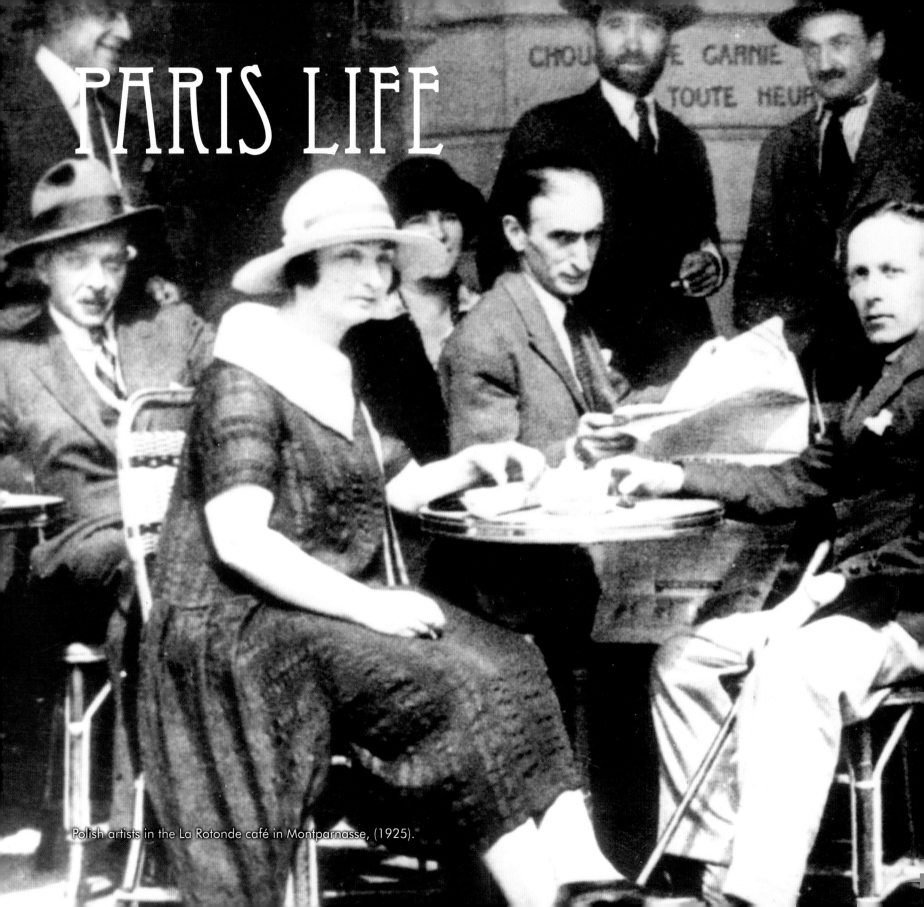

PARIS LIFE

Polish artists in the La Rotonde café in Montparnasse, (1925).

Traditional Parisian life has adapted and changed throughout the many decades of the 20th century, but much has remained the same despite some periods of extreme hardship.

A bustling metropolis like so many others, Paris is constantly on the move, with people travelling from A to B on foot, by car, taxi, bus, boat and the Métro. Basil Woon in his 1926 book, *The Paris that's not in the Guide Books* observed that the first thrill of Paris was to learn that there were no speed limits whatever – cars could go as fast as they like. In contrast French workers can go as slowly as they like with no restrictions whatever.

The iconic visions of Paris past with its typical French streets, cafés and stores remain today. People still wander the boulevards and parks, sail boats on the river and in lakes, shop at the many street markets and visit art galleries, the theatre and the cinema. Parisians still use their pavements for neighbourhood vegetable and flower markets. Flea markets are as popular as ever at weekends all over the city. The famous books stalls still inhabit the sidewalks of the river quays and newspaper kiosks are dotted everywhere.

But now, the French devote far more time to leisure and cultural activities due to improved working conditions, a shorter working week, better education and greater affluence. Signs of poverty are still visible but perhaps not as much in central Paris as in the suburbs. Many of the old signs of people struggling to make ends meet with the typical flower sellers, bird charmers, tramps, bag ladies and general road-side sellers have become a fading vision of the past.

Nowadays there are numerous festivals throughout the year devoted to music, arts, dance and film. The popular Fête Nationale held on 13–14 July each year is the biggest event as the French celebrate Bastille Day. It commemorates the fall of the prison fortress of the Bastille in 1789, the start of the French Revolution and the beginning of the French Republic. 'La Marseillaise,' the French national anthem also memorialises the Revolution. The Tour de France cycling race has also become a national institution and a celebrated event that has most often ended at the Champs-Élysées.

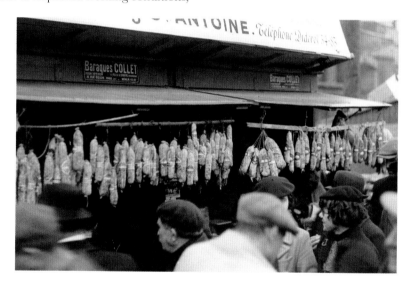

The meat trade fair in Paris. 22 March 1937.

By far the most enduring facet of Parisian life is its café culture, which quite simply defines the city. It is in the big cafés of the boulevards and in the main streets that most of the vivid and effervescent life of the city is found.

The debonair hour or two of the aperitif or cocktails is the tradition of *cinq et sept* (from 5 to 7) until the sun sets, and this is usually one of the busiest periods for Parisian cafés. At this time all of Paris begins a period of rest from a day's labour and takes a seat at the marble topped tables at the cafés. This is the most animated period between work and rest and the most interesting hour of the day. Offices and workshops have emptied. Businessmen are separated from their paperwork. Cigarettes are lit. Glasses clinked and friends and colleagues meet at their favourite rendezvous, discussing the day's events and setting the world to right, before going home or out to dinner.

As one sips a preferred aperitif – each with its own vogue – from anise, green absinthe, cassis with vermouth, bitter tonic wines to dubonnet, along come those with goods and entertainment to sell – news and flower sellers, lone violinists, accordionists, vocalists, sellers of roasted peanuts and edible delicacies, novelties and knick-knacks.

Of course there may well be more clandestine affairs taking place in these crowded cafés with flirting corners where lovers meet after work.

But this unchanged picture was not always as rosy. During World War I, the Germans bombed Paris. Parisians suffered epidemics of typhoid, measles and Spanish influenza that killed thousands during the winter of 1918–1919. It was a bleak period. The shortages and the daily news of bereavements of the men lost in trench warfare was profound. The city was filled with the war wounded and refugees and Paris became the supply depot for over four million soldiers as women took the place of men in the armament factories.

After the war, there was much unemployment, prices soared, and rationing continued. A general strike paralysed the city on 21 July 1919. And yet Paris recovered and once again became the capital of the arts and an unrivalled place of pleasure and entertainment during what became known as *les années folles*, or 'the crazy years'.

The Wall Street crash in 1929 and the following depression had its effect on Paris. A new wave of immigration from various European countries was matched by political tensions with strikes, demonstrations and confrontations between Communists, the extreme left and the extreme right. But, by the late 1930s, the life of the city was overshadowed by threatening international rivalries.

World War II brought blackouts, gas masks, empty streets, rationing and curfews. When the Germans occupied the city, it was a period of shortages and humiliations. Supplies grew scarce and over a million Parisians left the city for the provinces. Even after liberation, the hardship continued.

According to Yvan Combeau in *Histoire de Paris* (2013), in the early 1950s, thirty-five per cent of Paris apartment buildings had been built before 1871. Eighty-one percent of Paris apartments did not have their own bathroom, and fifty-five per cent did not have their own toilet. As a result major urban renewal projects were initiated. At the same time, there were strikes and demonstrations. The strife of the Algerian war of independence in the 1950s was followed by the student riots of 1968.

Bastille Day in Saint-Germain-des-Prés, (1951).

There was a feeling that Paris was losing or had lost its universal appeal and attractiveness but much effort was expended to restore Paris to recover its prestigious world stature. Paris today is still at the centre of European life.

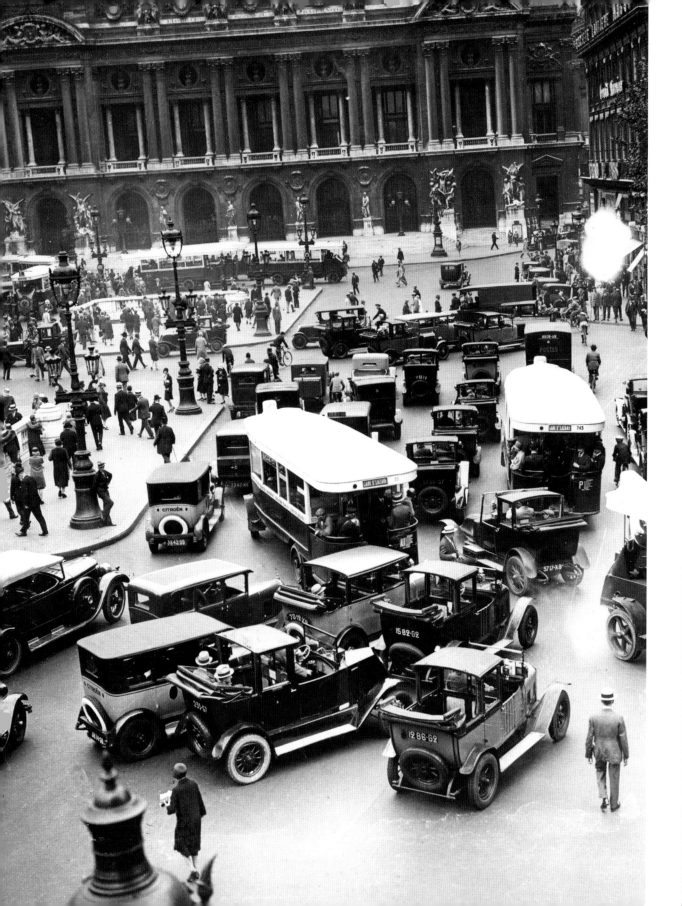

LEFT: Traffic chaos as cars and buses fight for space at the Place de l'Opéra, (c.1920s).

BELOW: A Gendarme controlling the traffic in Paris, (c.1960s).

RIGHT: An automobile rumbles along Rue Bayen, (c.1900).

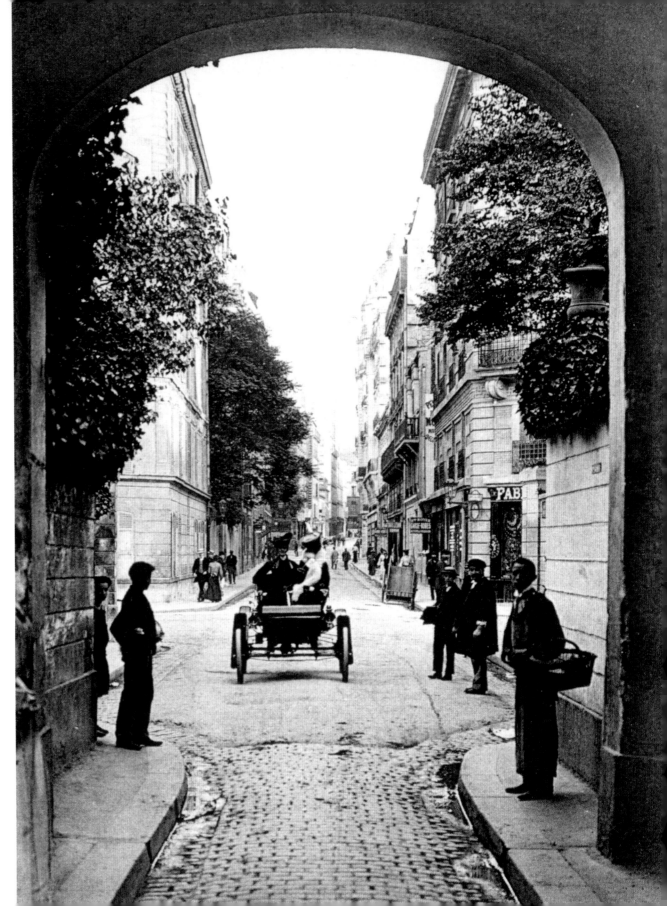

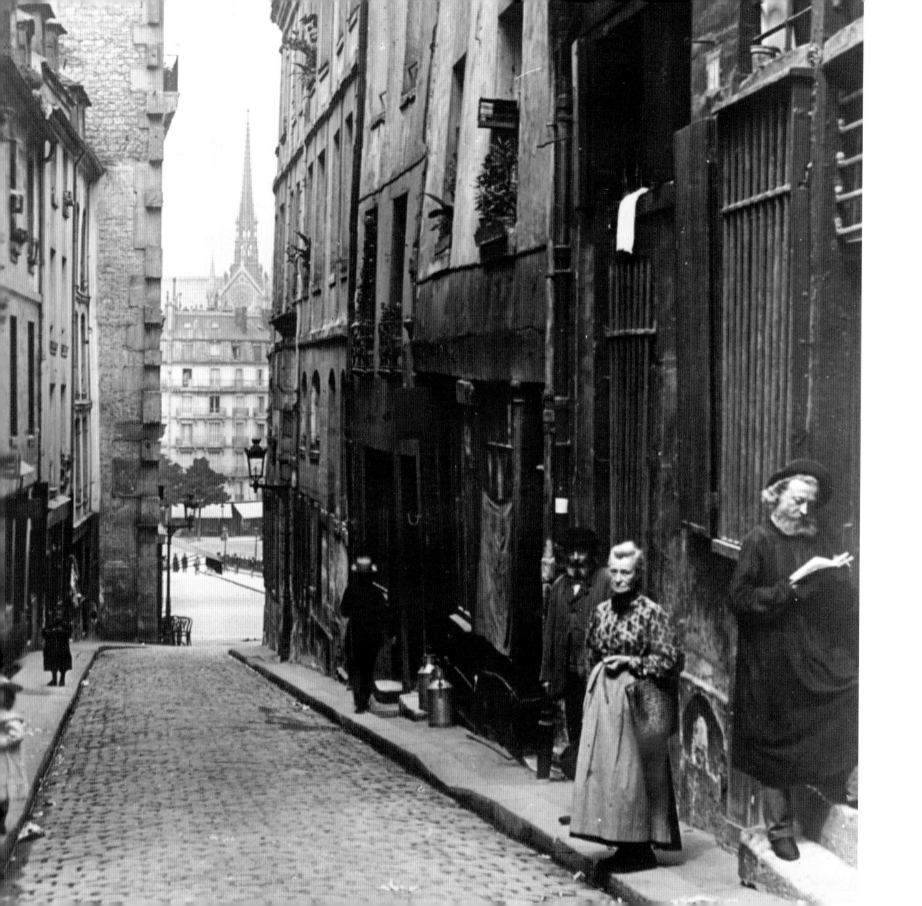

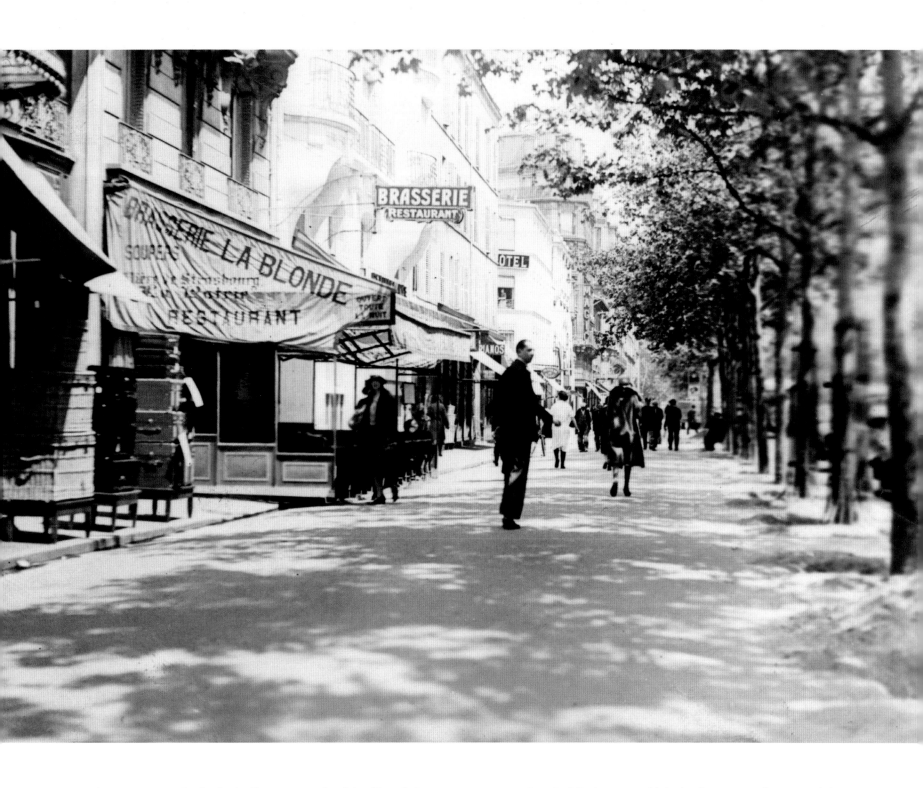

LEFT: A narrow street in the Latin Quarter, south of the River Seine, (c.1910s).

ABOVE: A typical Paris street with its leafy avenue of trees and the *Brasserie La Blonde* restaurant, (c.1930s).

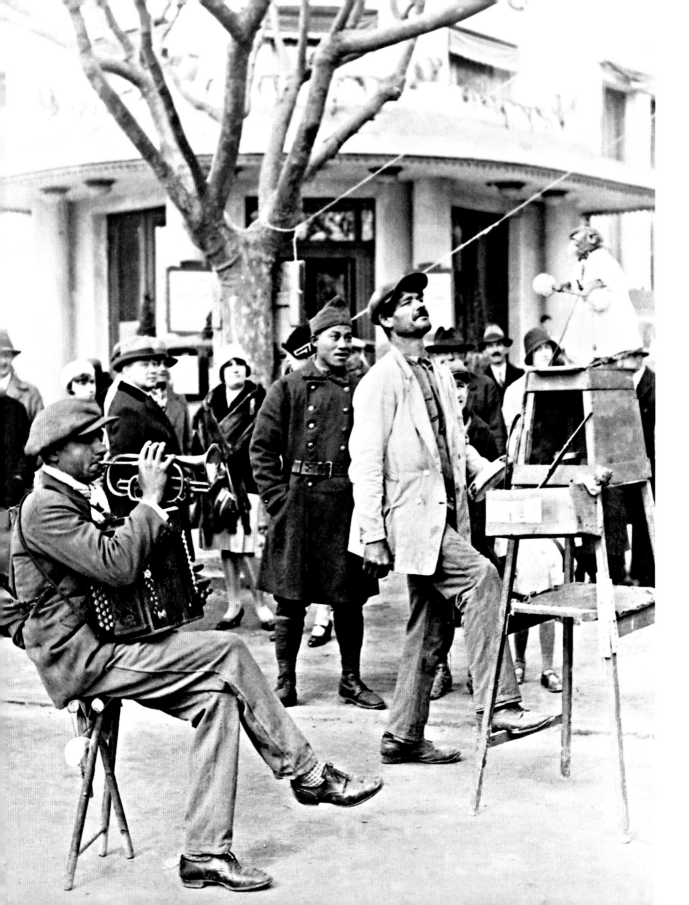

LEFT: Street musicians with trumpet, accordion and tambourine, play for an audience. A small monkey takes on the role of the drummer, (1929).

RIGHT: Jean Paul Sartre and friends at the Café de Flore in Saint-Germain-des-Prés, (1943). From left to right: Yves Deniaud, Raymond Bussiere (seated), Maurice Baquet (behind), Marianne Hardy, Roger Pigaut, Annette Poivre (seen from behind) and Jean Paul Sartre.

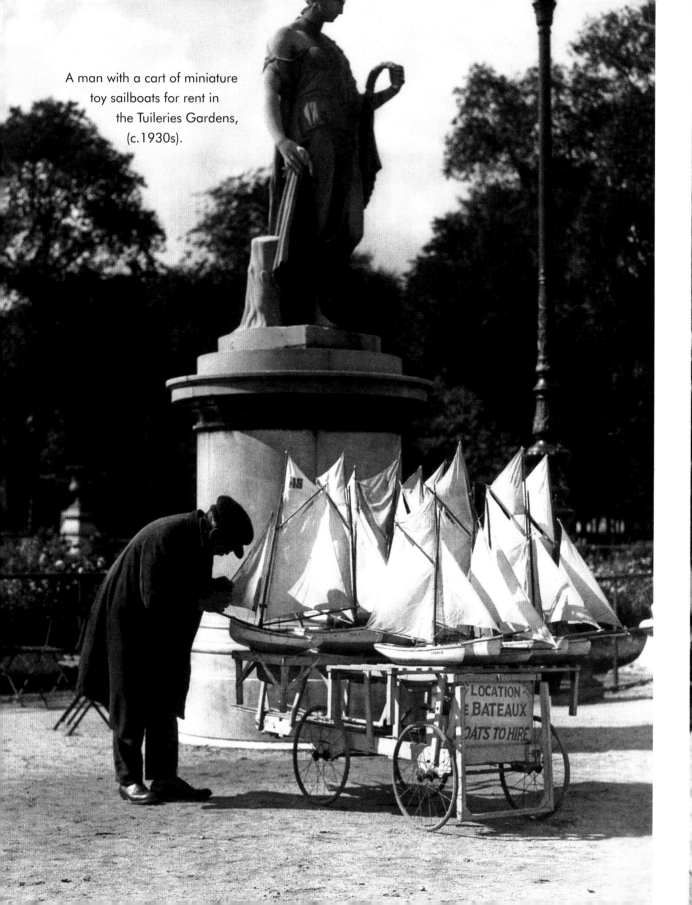

A man with a cart of miniature toy sailboats for rent in the Tuileries Gardens, (c.1930s).

LOCATION
E BATEAUX
OATS TO HIRE

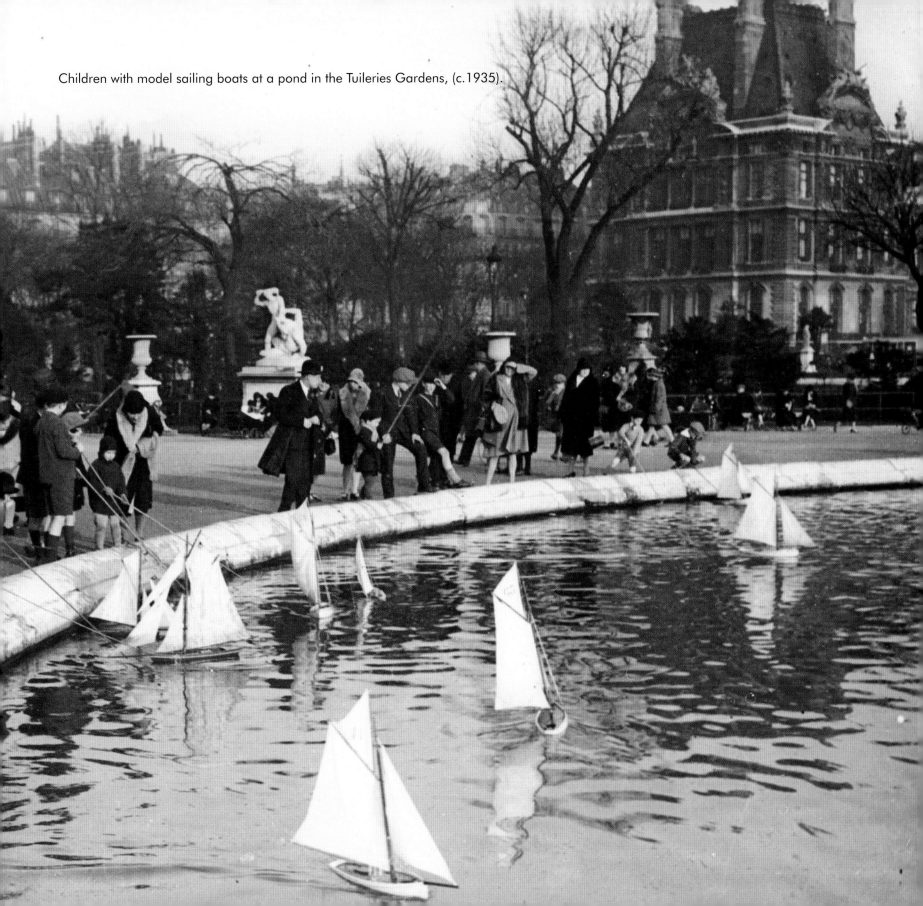

Children with model sailing boats at a pond in the Tuileries Gardens, (c.1935).

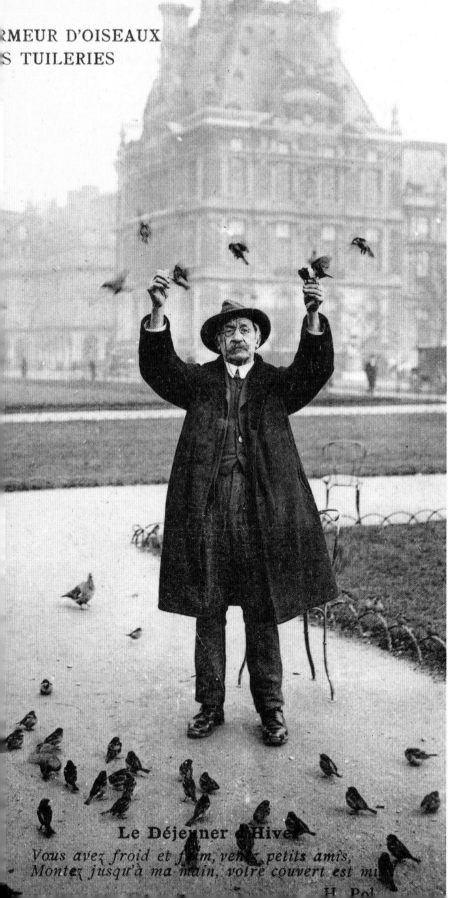

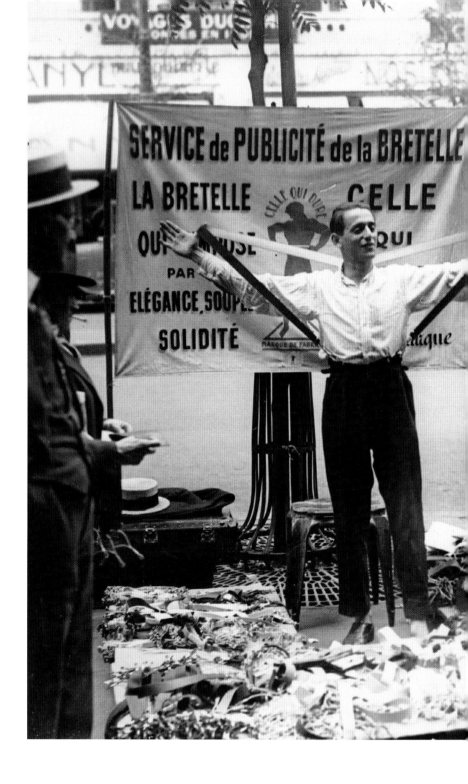

ABOVE: A street trader advertising suspenders, (c.1935).

LEFT: Bird charmer of the Tuileries Gardens, (c.1908).

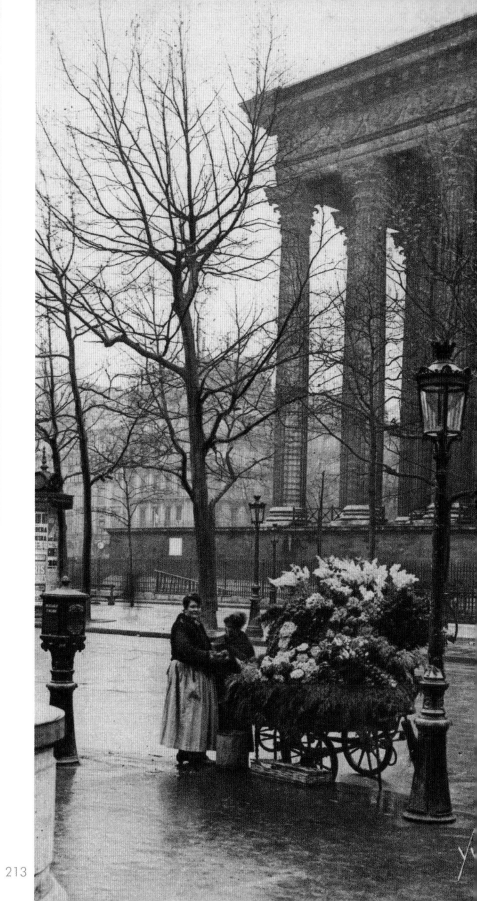

RIGHT: A flower seller in the Place de la Madeleine, (1928).

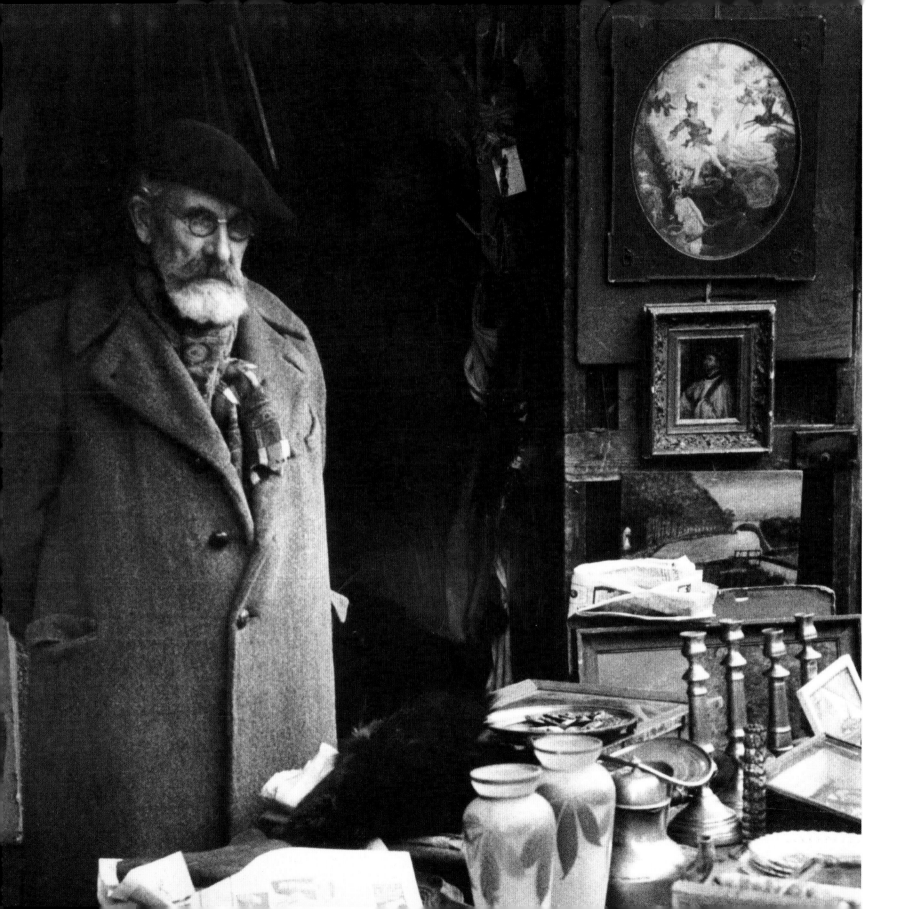

LEFT: An old man standing behind a stall in a flea market, (c.1955).

ABOVE: A postman hands a letter to a young woman, (1930).

ABOVE: A waiter anticipates the order from a guest in the restaurant at the Élysée Palace Hôtel, (1911).

BELOW: A street scene in Paris showing men reading newspapers, March 1934.

RIGHT: A Paris street scene before 1914, with horse-drawn carriages on a boulevard.

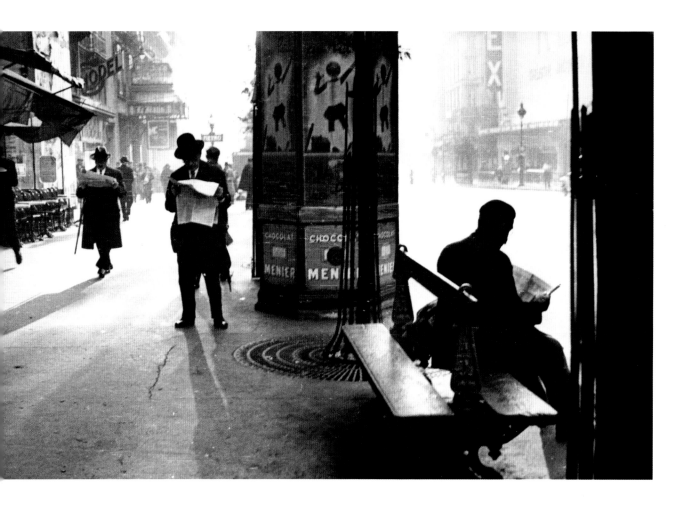

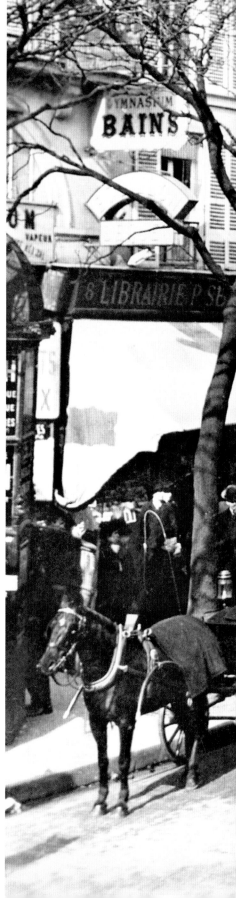

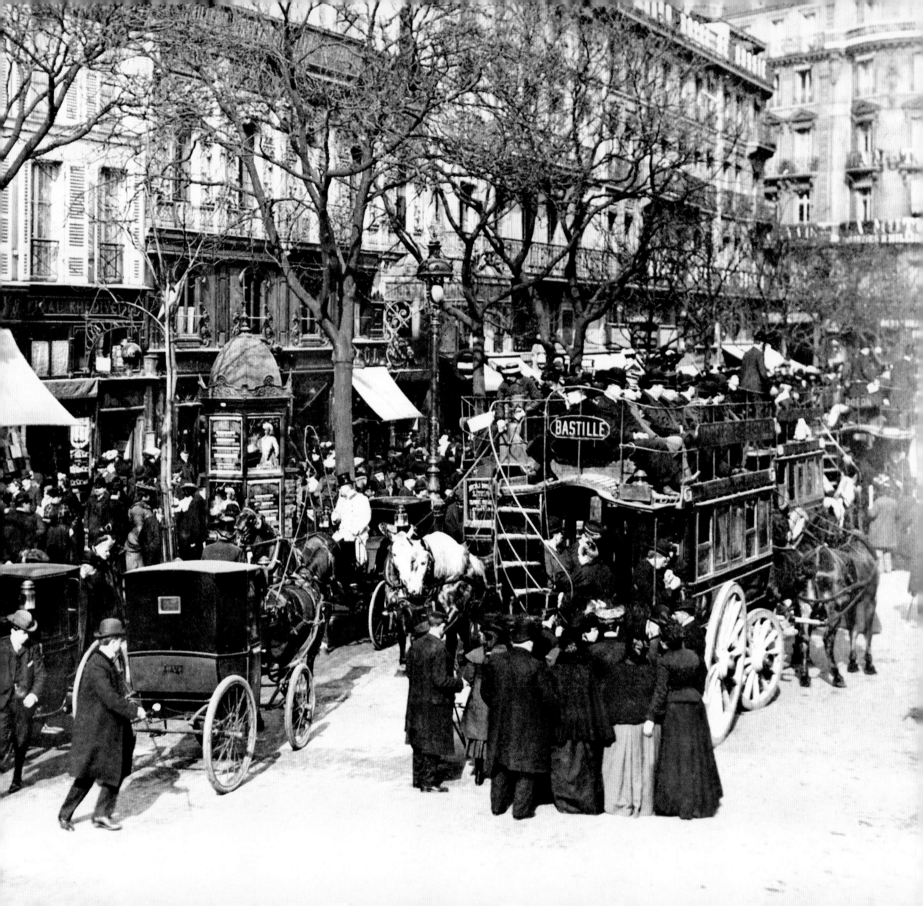

ABOVE: A man sells vegetables at his market stall in the Latin Quarter, November 1970.

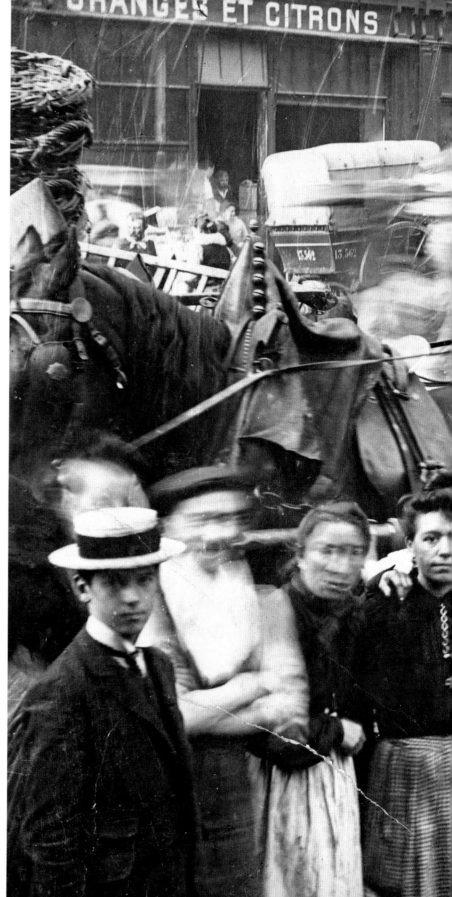

RIGHT: Some of the market traders at the Les Halles central market in 1906. Les Halles was known as the 'stomach of Paris'. The colourful ambience once associated with the bustling market area disappeared in 1971, when Les Halles was dismantled and the wholesale market was relocated to a Paris suburb.

ORANGES ET CITRONS

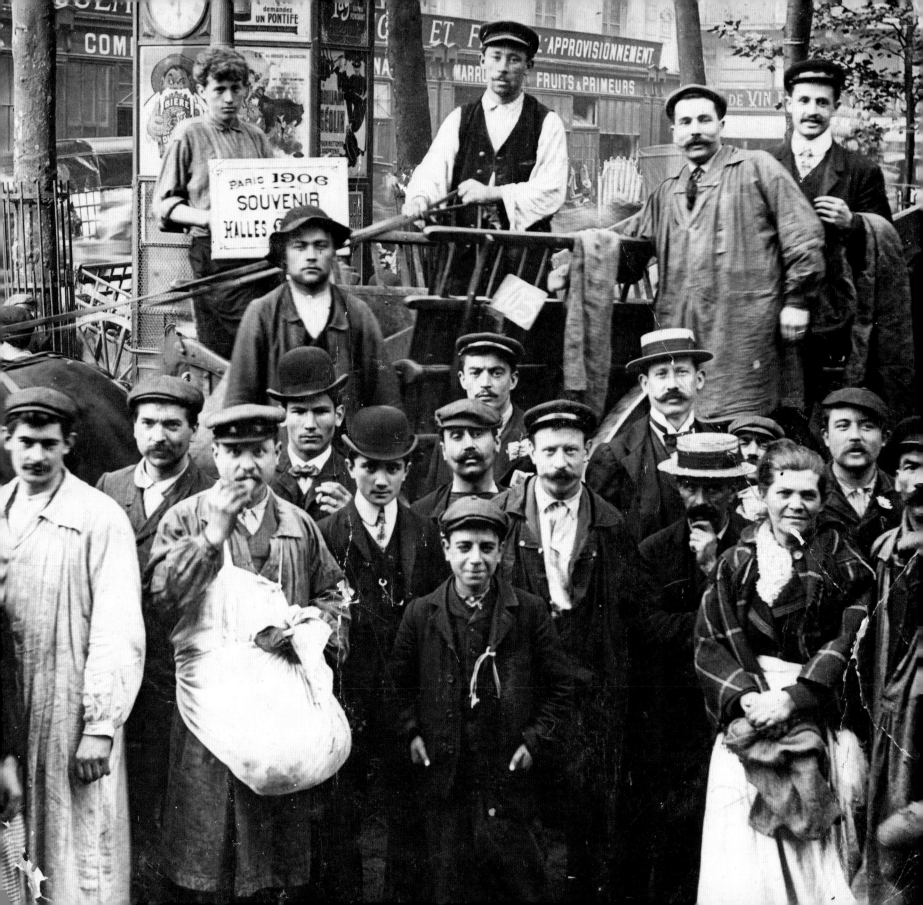

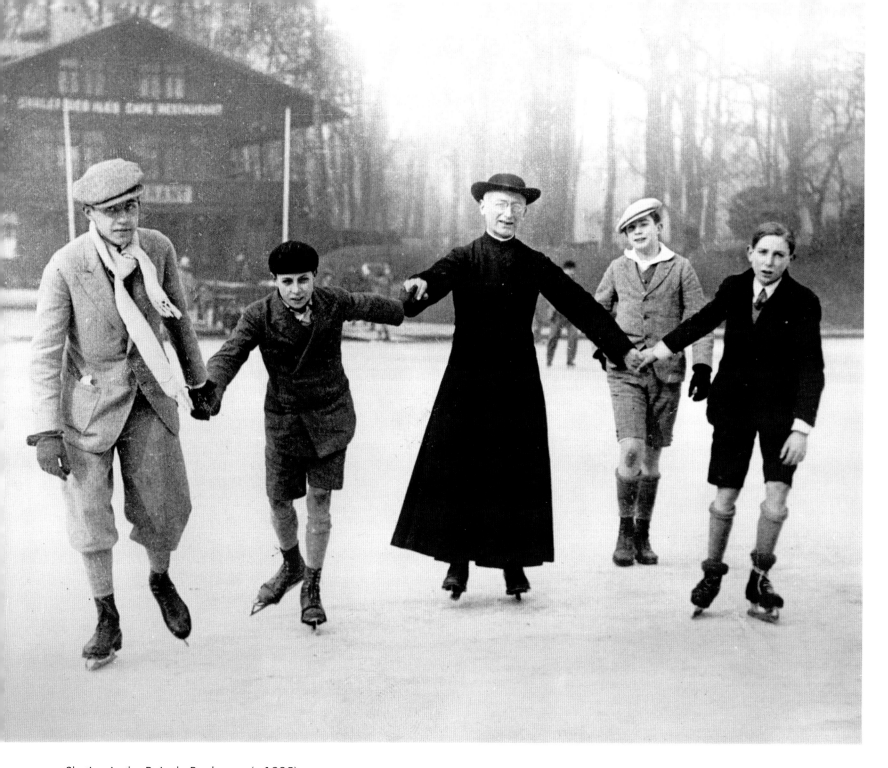

Skating in the Bois de Boulogne, (c.1935).

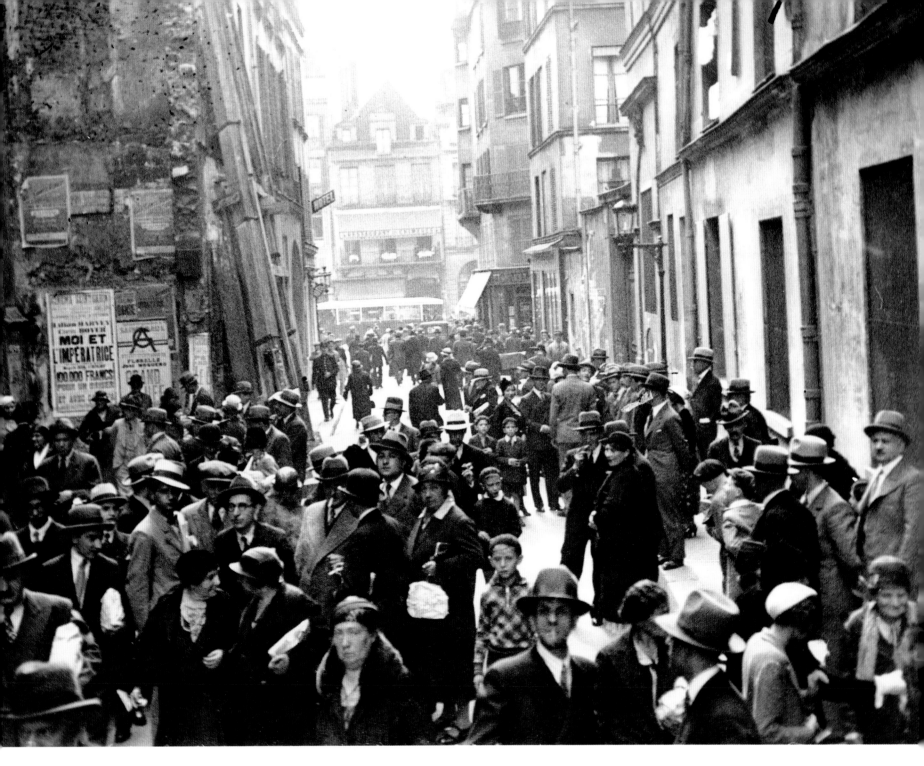

People in the street in the Jewish Quarter, (c.1930).

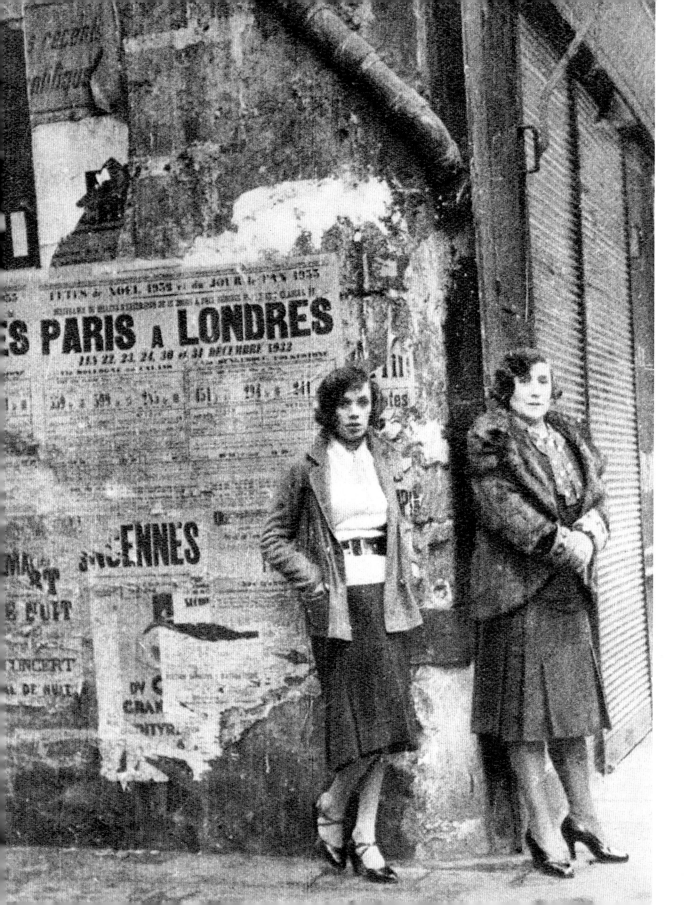

LEFT: Two Parisian street women — one young, the other distinctly middle-aged — wait on a street corner, (1933).

RIGHT: Enjoying the moment; people relax and enjoy themselves beside a fountain in a Parisian park, (1961).

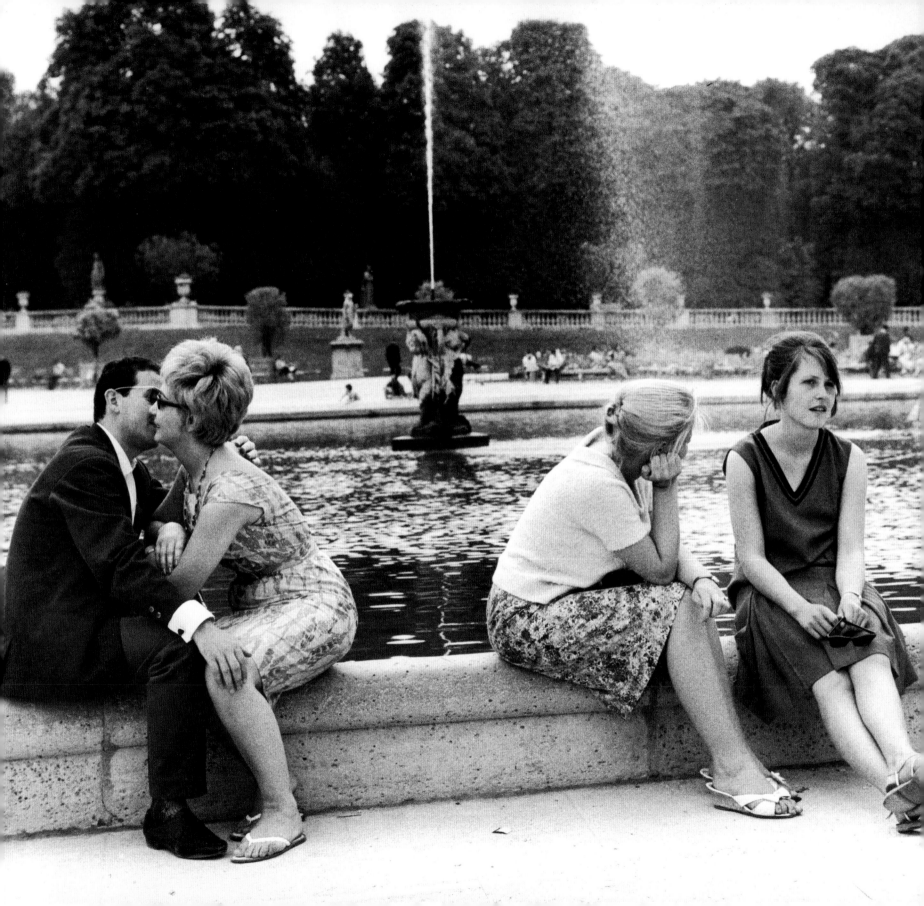

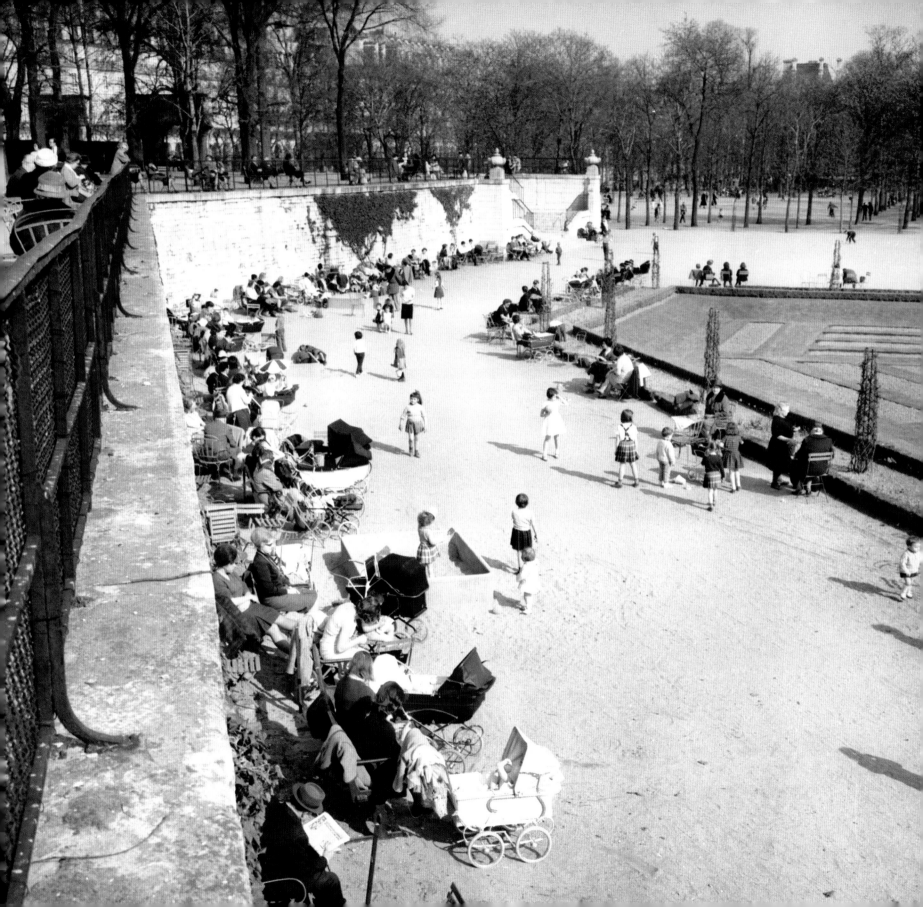

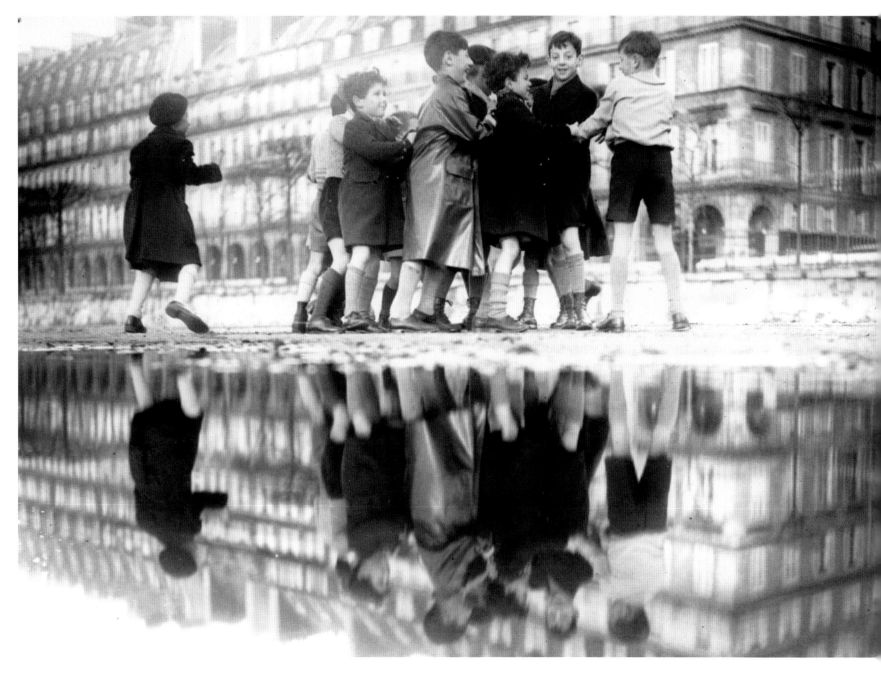

LEFT: Mothers with children at
the Tuileries Gardens, (1964).

ABOVE: Children playing
in the Tuileries Gardens,
(c.1930).

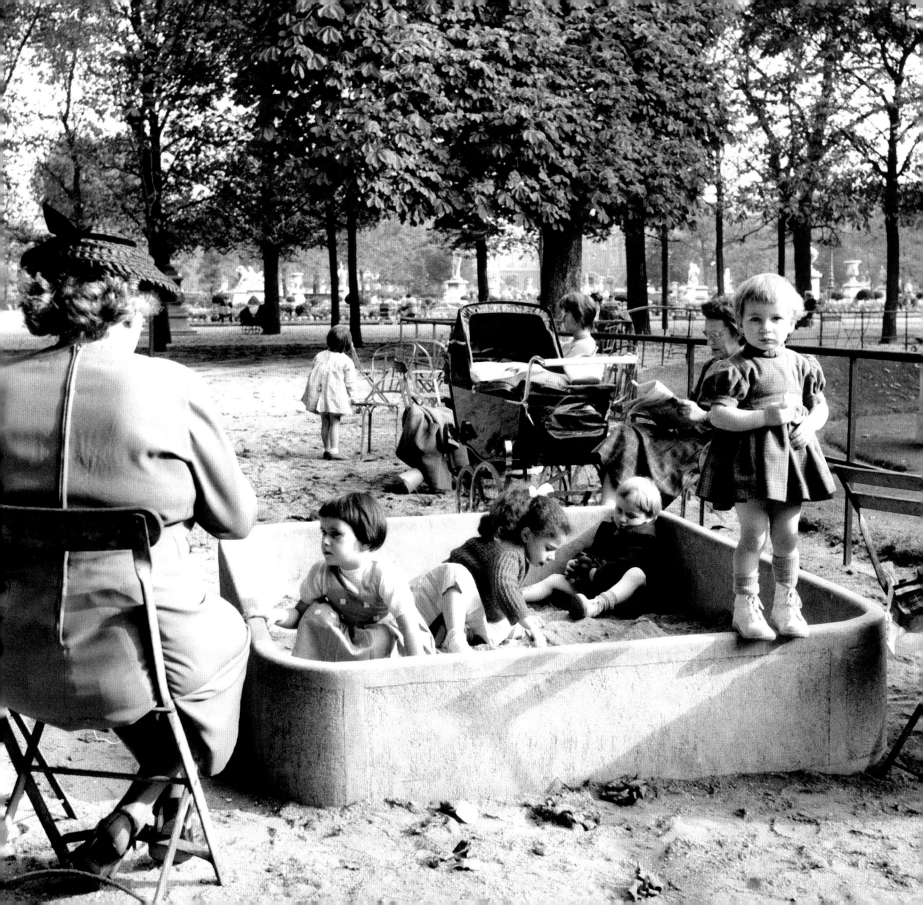

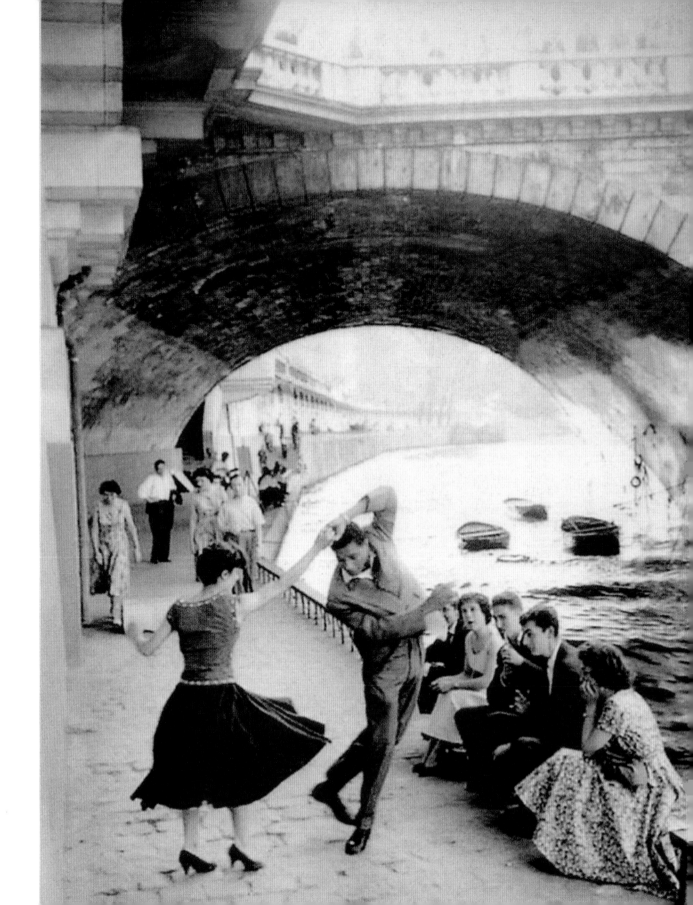

LEFT: Children playing in a sandpit in Tuileries Gardens, (1957).

RIGHT: A couple of young people dance on the Paris Quai as others look on, (c.1950s).

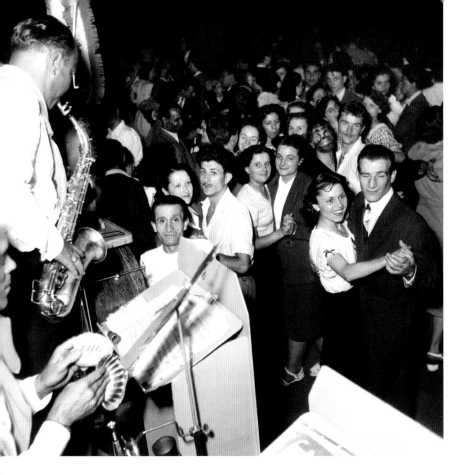

LEFT: The Bastille Day ball in Paris, 14 July 1950.

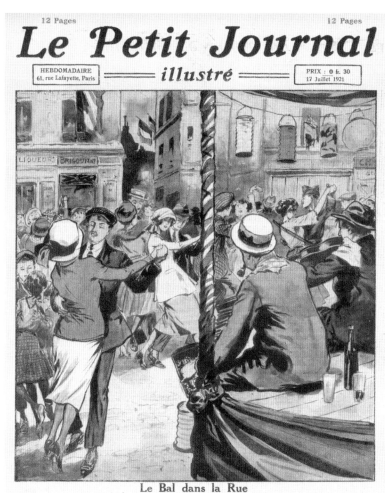

12 Pages 12 Pages

Le Petit Journal
HEBDOMADAIRE — *illustré* — PRIX : 0 fr. 30
61, rue Lafayette, Paris 17 Juillet 1921

Le Bal dans la Rue

A tous les carrefours, autour des estrades où se groupent des musiciens intrépides, les danseurs tournoient. En ce soir de Fête Nationale, tango et fox-trott simplifiés, assainis par la robustesse et la bonne humeur des Parisiens, reçoivent leur grande naturalisation.

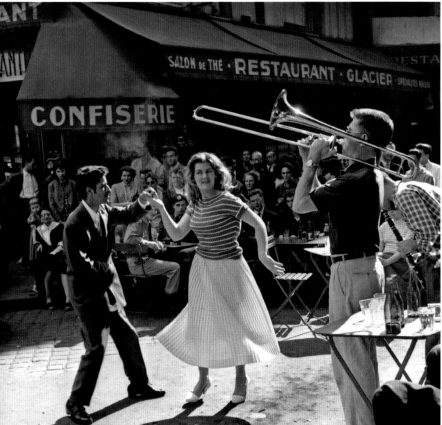

LEFT: Bastille Day at *Saint-Germain-des-Prés*, 14 July 1956.

ABOVE: Illustration in *Le Petit Journal* show Parisians celebrating *le quatorze juillet*, Bastille Day, by dancing in the street, (1921).

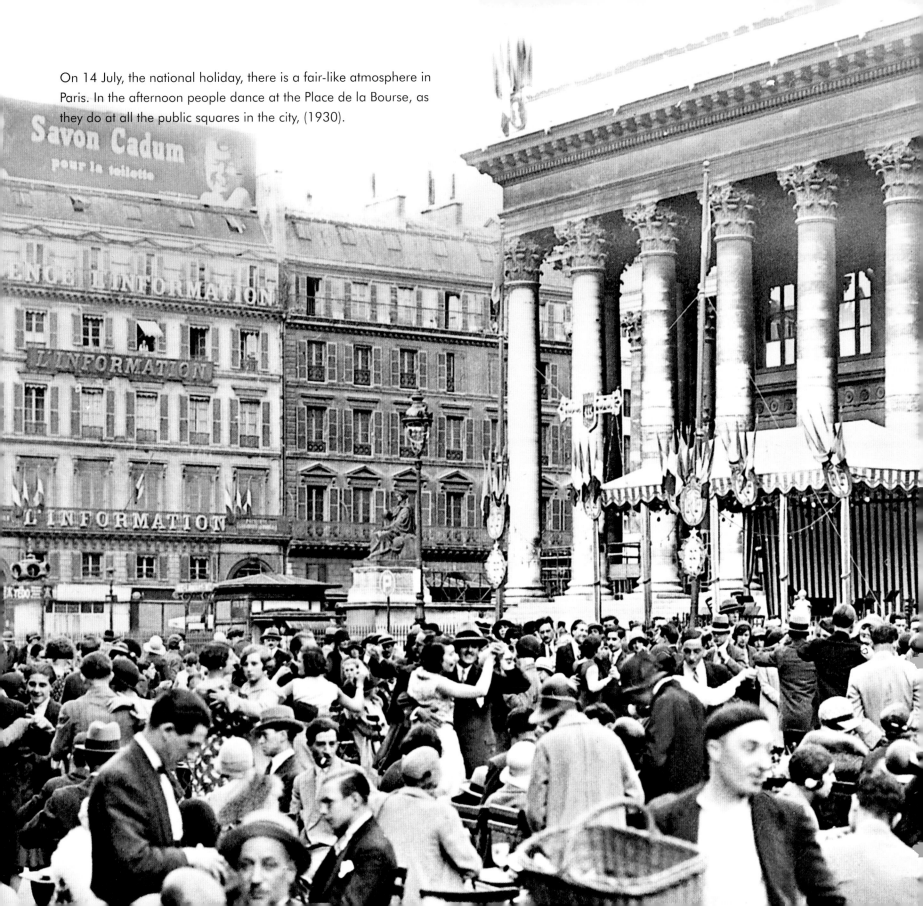

On 14 July, the national holiday, there is a fair-like atmosphere in Paris. In the afternoon people dance at the Place de la Bourse, as they do at all the public squares in the city, (1930).

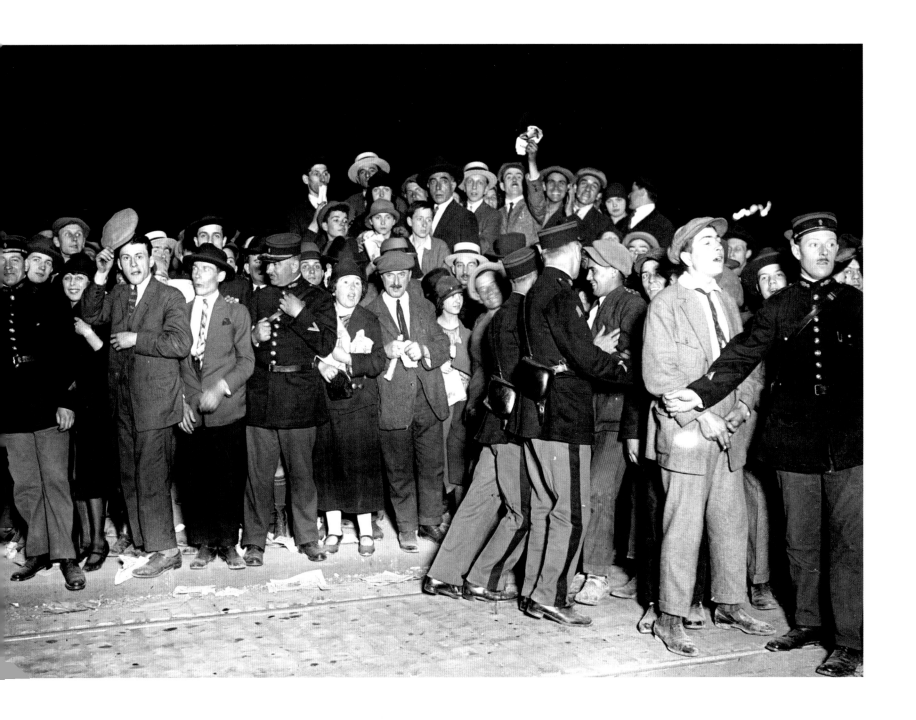

ABOVE: Departure of the Tour de France in Paris on 22 June 1925.

RIGHT: Easter Monday on the Champs-Élysées with customers at the apertif hour, (1934).

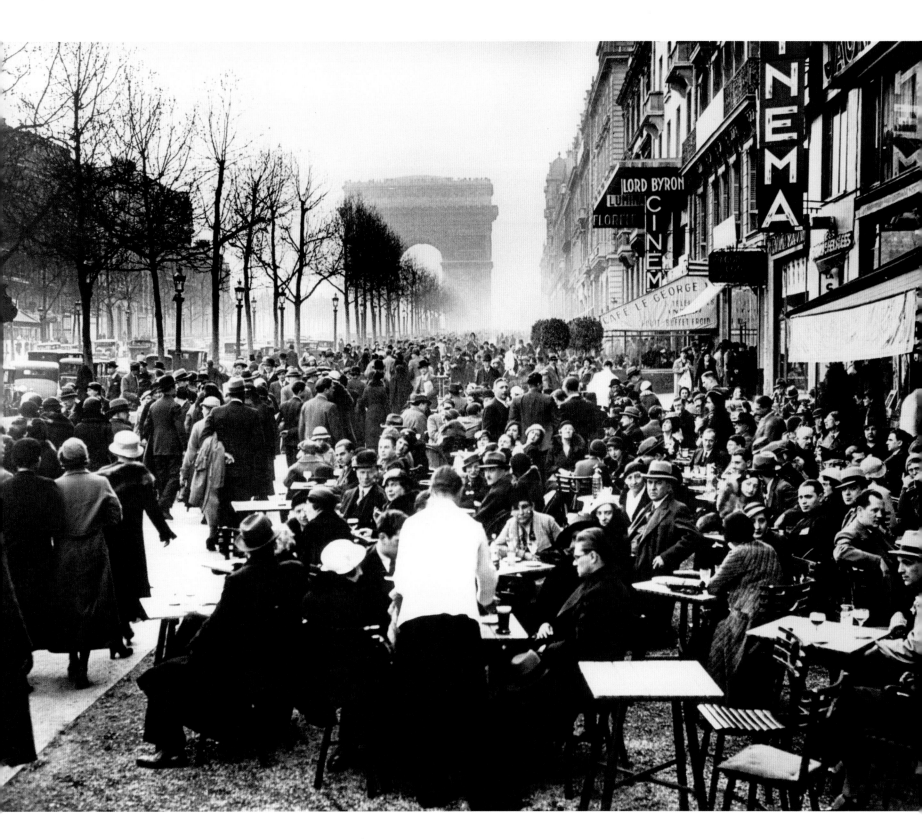

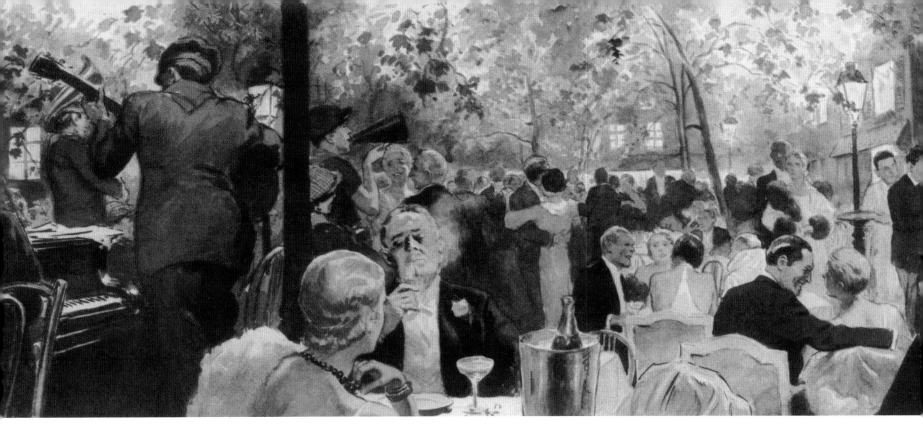

ABOVE: Sketch showing people eating and drinking outside in the Place de Tertre, Montmartre, (1933).

LEFT: A game of cards in a Paris café, (1948).

RIGHT: Customers enjoying themselves reading newspapers and drinking red wine outside a typical Paris café, (1928).

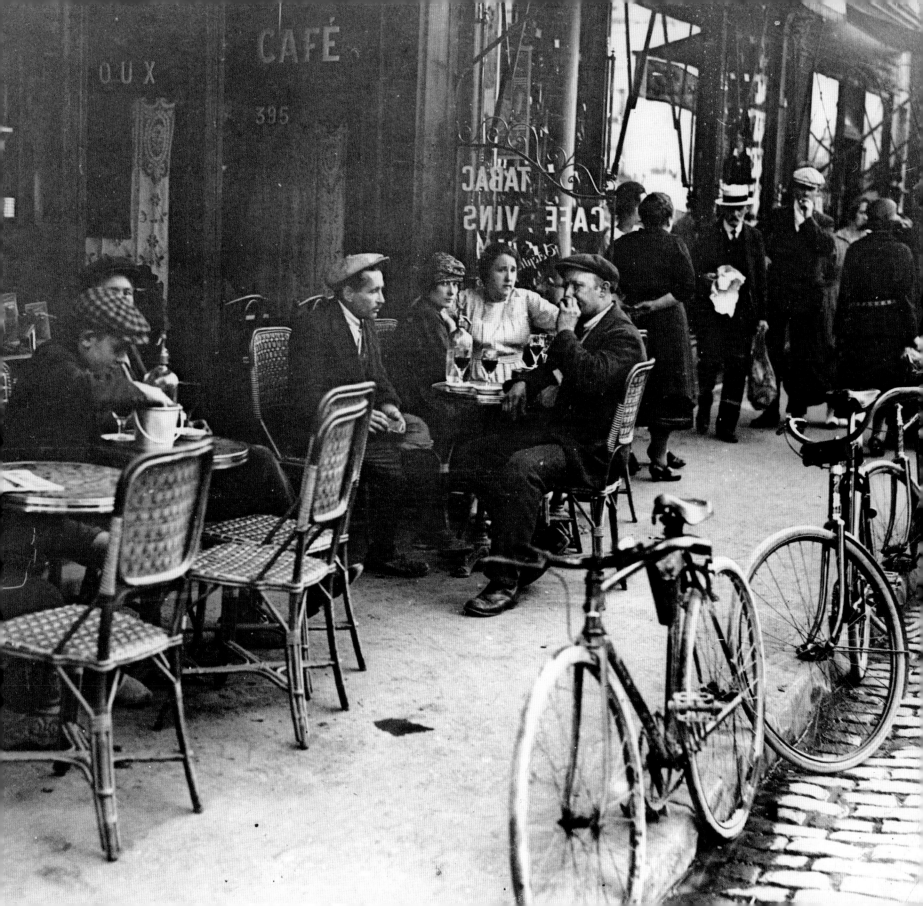

LEFT: On a strike day in Paris, when most of the restaurants remained closed, this Paris bar has laid out sandwiches on the counter for the refreshment of the striking workers, (1936).

BELOW: Striking employees of restaurants and cafés on a street in Paris, (1936).

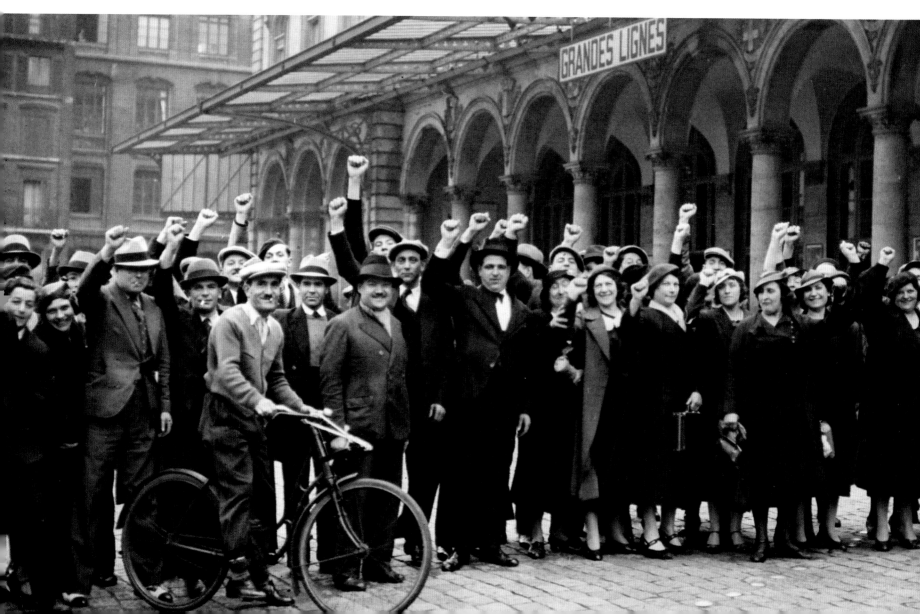

RIGHT: Striking workers near the half demolished Trocadero Palace, (1936). The Trocadero was torn down in 1937, to make room for the exhibition grounds of the World Fair.

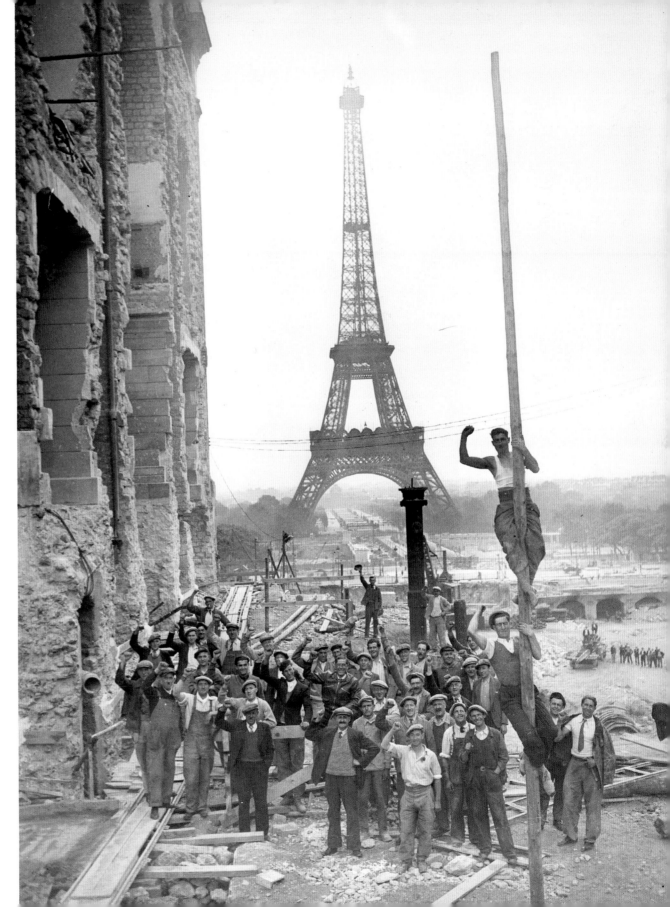

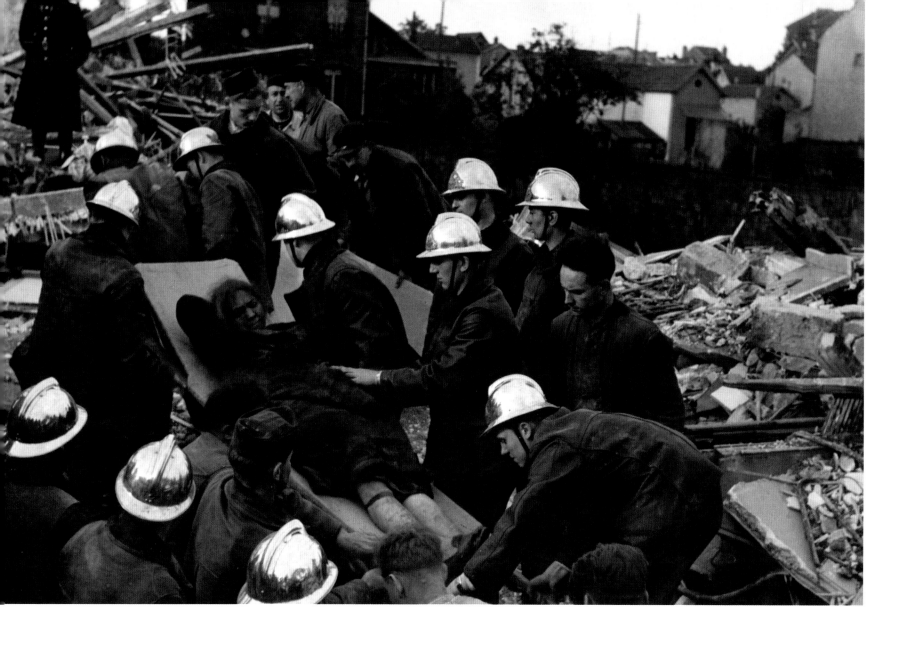

ABOVE: French Fire Brigade
rescuing a woman from air
raid debris, 30 May 1942.

RIGHT: Children listening to
a German brass band during
the occupation, (c.1941).

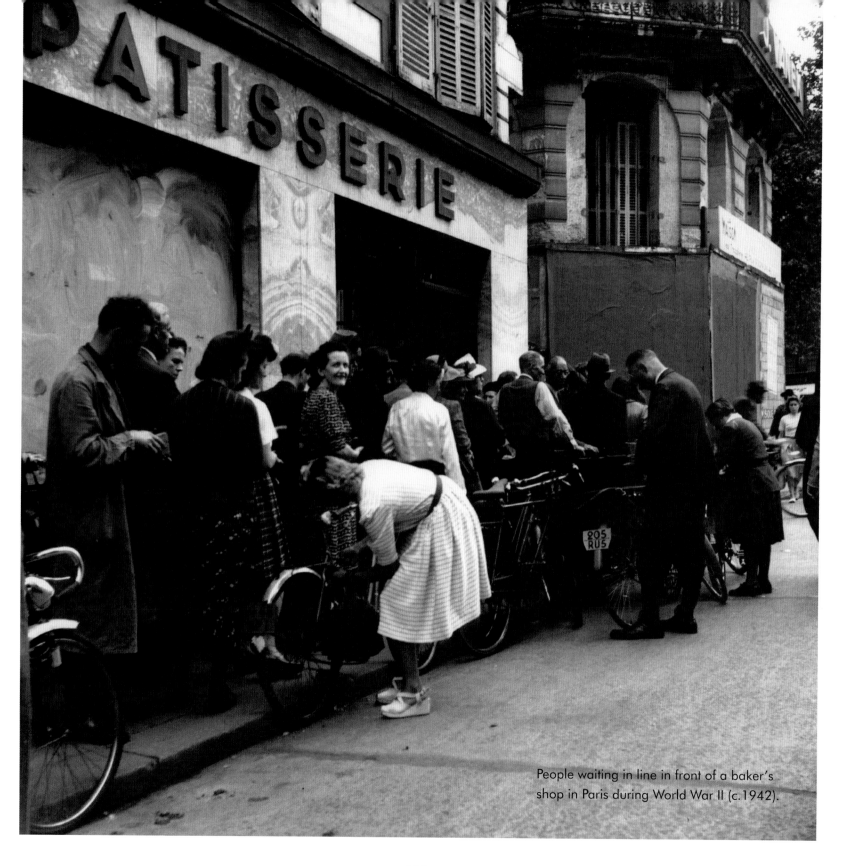

People waiting in line in front of a baker's shop in Paris during World War II (c.1942).

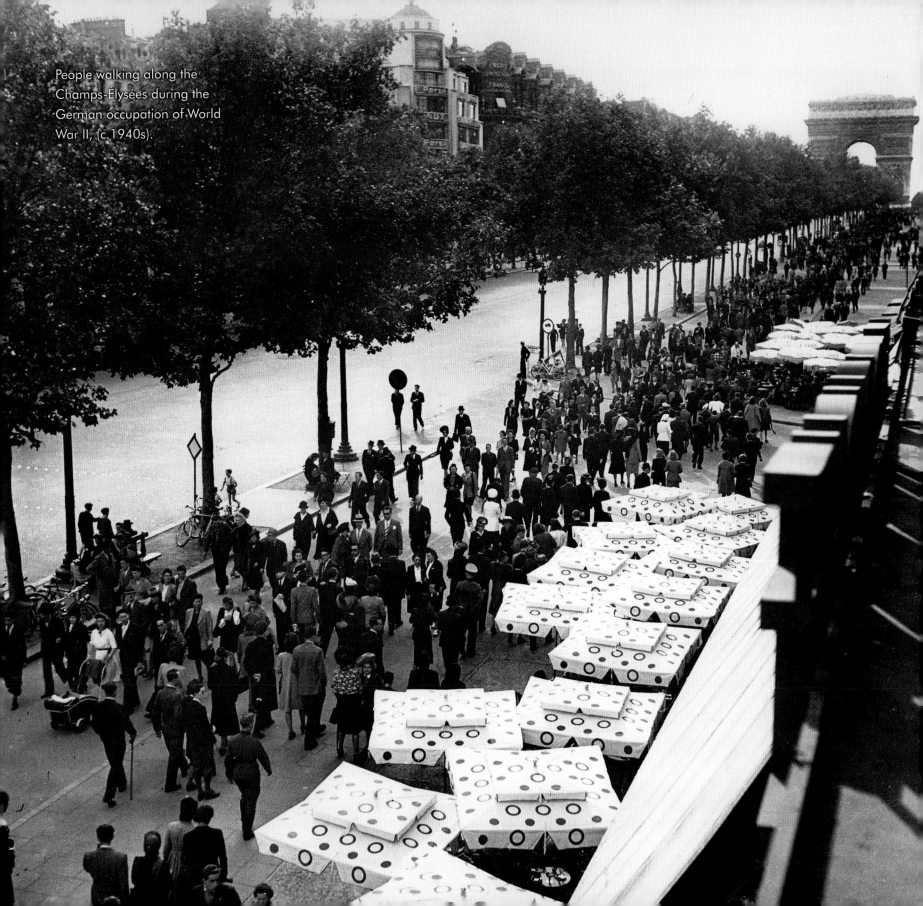

People walking along the Champs-Élysées during the German occupation of World War II, (c.1940s).

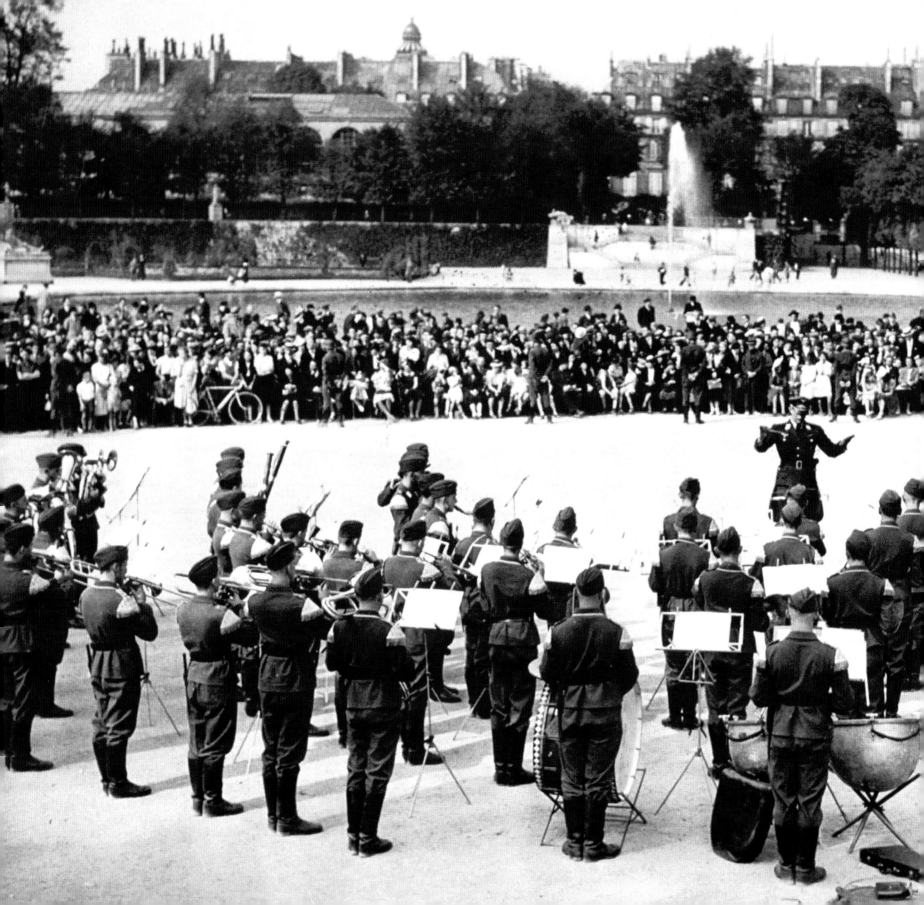

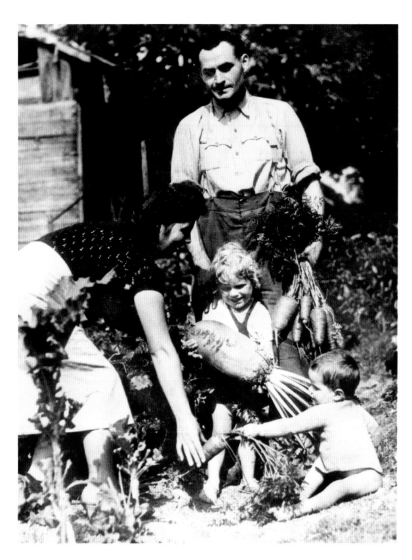

LEFT: A German army band playing in Tuileries Gardens during the German occupation, August 1940.

ABOVE: A family in the Paris region work together to harvest food from a garden during the German occupation, September 1941. A little girl cradles an enormous root vegetable, whilst a baby sits on the ground and has a go at uprooting a carrot. A father looks on grimly, clutching a bunch of carrots.

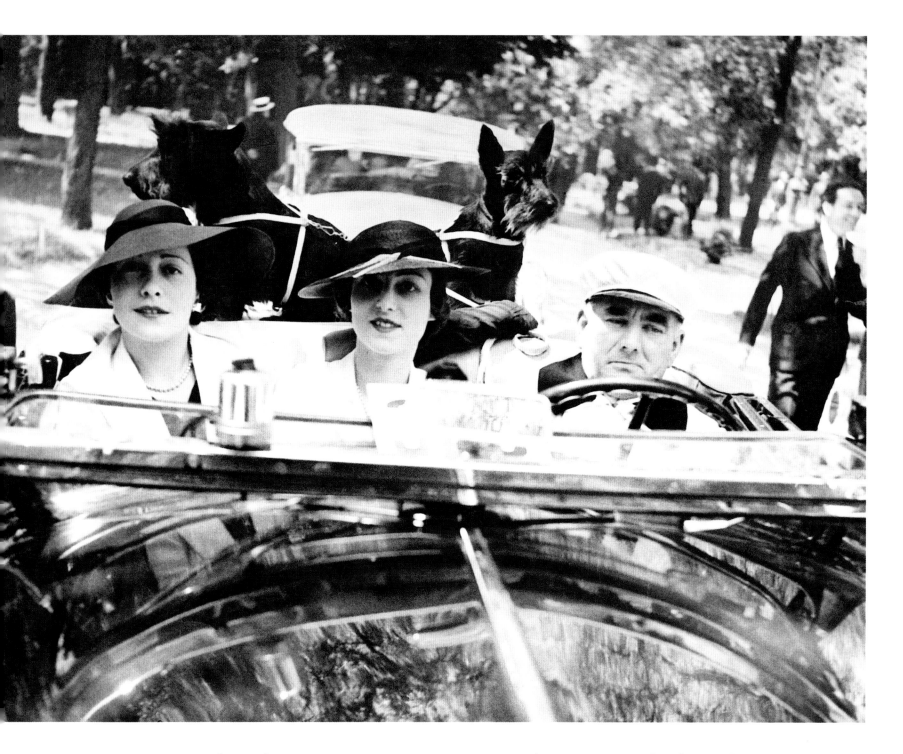

ABOVE: Two women, two dogs and a man take a car ride in the Bois de Boulogne, (1937).

RIGHT: Elegant women attending the Longchamp horseraces by bike during the German occupation of World War II, (c.early 1940s)

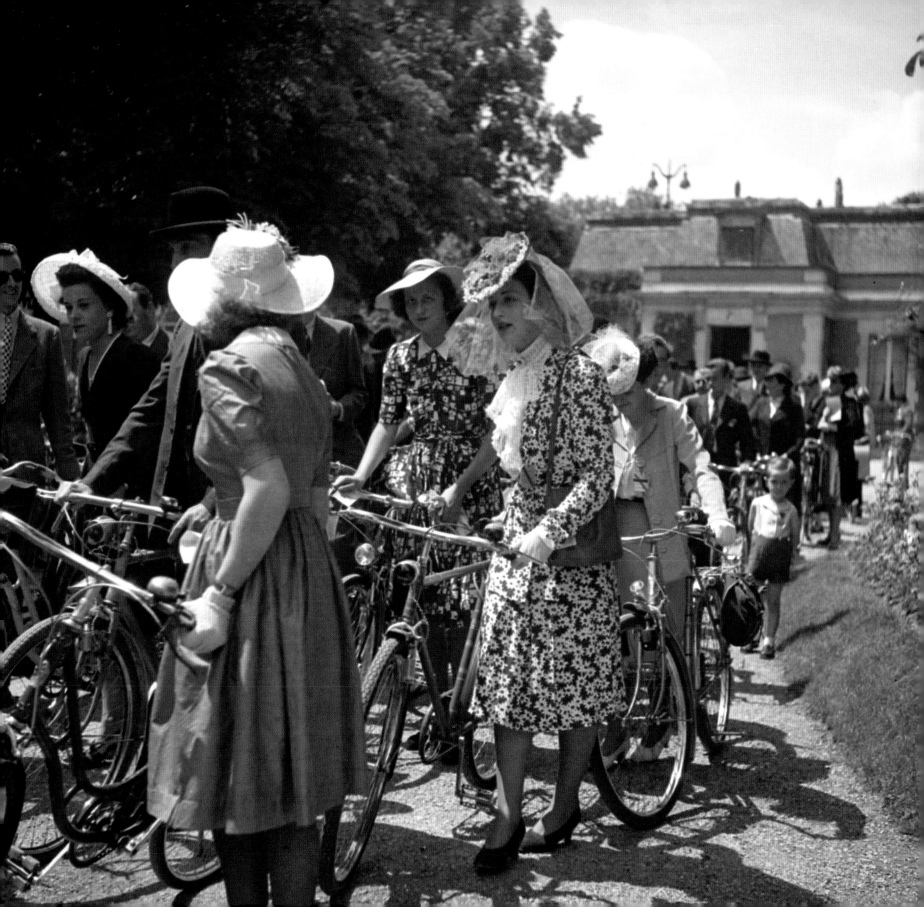

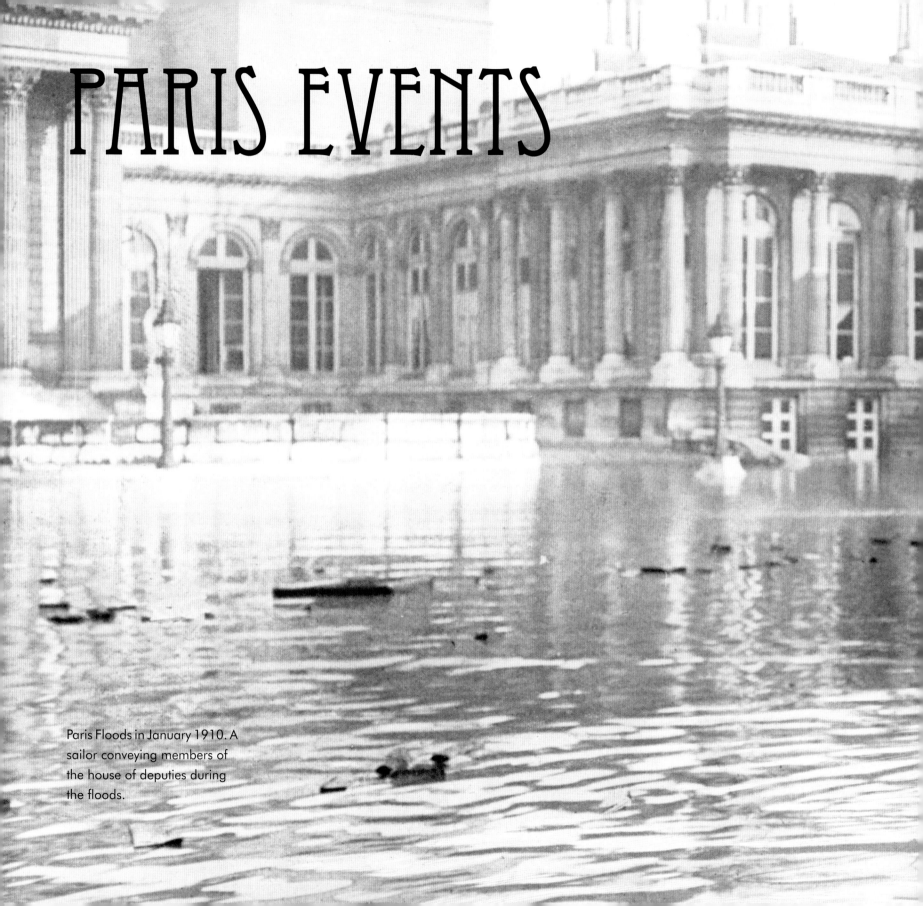

PARIS EVENTS

Paris Floods in January 1910. A sailor conveying members of the house of deputies during the floods.

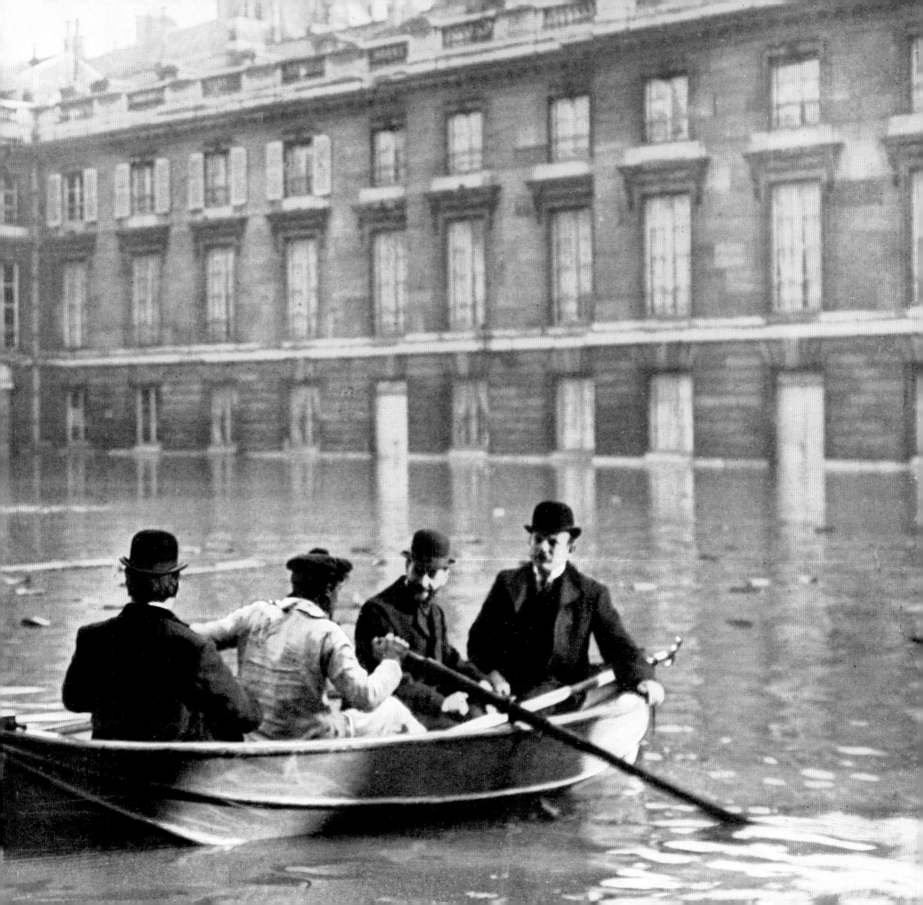

As the heart of France, Paris has been the focal point for cultural advancement, politics, protest, unrest and change. Throughout the 20th century, Paris endured much turbulence and unpleasantness especially during the two World Wars. Equally, there have been many joyous occasions of which Paris can be rightly proud.

Paris has been the city of many firsts. From the introduction of gas lighting followed by electrical illumination in the 19th century, Paris has led the way in many technological and artistic advances. After the Lumière brothers invented cinema in 1895, Georges Méliès built one of the first film studios just outside Paris in 1897. The first feature-length film from the studios, *L'Enfant Prodigue* by Michel Carré had its premier in Paris on 20 June 1907.

The French have had an enduring obsession with aeroplanes and on 23 October 1906, the Brazilian Alberto Santos-Dumont became the first aviator to fly a clumsy heavier-than-air aircraft in Europe at Bagatelle, Paris. Later, on 12 November, he set the world record by flying 220 metres for a mere 21 seconds. Then, the French aviator, inventor and engineer, Louis Blériot made the first flight across the English Channel from Calais to Dover on 25th July 1909. The first scheduled London to Paris passenger service began on 25th August 1919. The flight through Aircraft Transport and Travel Limited (AT&T), a forerunner company of today's British Airways took two and half hours to reach Le Bourget airfield outside Paris. There was a further landmark when Charles Lindbergh made the first non-stop transatlantic flight from America, arriving at Le Bourget airfield on 21st May 1927.

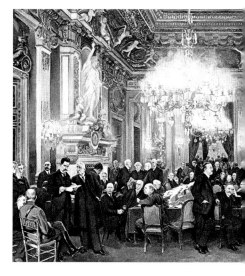

Another first for Paris was the start of the Tour de France in July 1903. The race began at Villeneuve-Saint-Georges (near Paris) and ended with a parade of the winners at the *Parc des Princes*. It remains hugely popular and sometimes a famous celebrity has started the race as did the film director, Orson Welles in 1950. While the French love of cycling is well known, so too are they obsessed with the motor car; motor racing was started in 1894 with a route from Paris to Rouen. The millionaire Gordon Bennett Jr created an international event in 1900. But the ill-fated Paris to Madrid race in 1903, resulted in a series of fatal accidents and car racing was switched to closed circuits. The first race carrying the name Grand Prix was organised by the Automobile Club of France in 1906 and became the Grand Prix Monte Carlo that we know of today. Needless to say there were regular bicycle, motorcycle and motor car exhibitions in Paris each October from 1901–1961. There were even 'automobile elegance' competitions called Concours d'Elegance. Here the rich and famous celebrated the latest automobiles as well as feminine beauty and couture.

Paris followed London in the introduction of an underground railway system in 1900. The first line of the Paris Métro opened between Porte de Versailles and Porte Maillot on 19 July 1900. Of Hector Guimard's original Art Nouveau entrances, only two original glass covered entrances are left in Paris today, at the Abbesses and Porte Dauphine stations.

The British royal family have had a special relationship with Paris for decades. Of course Edward VII (the Uncle of Europe) loved Paris and was instrumental in laying the foundations for the Entente Cordiale, the historic agreement between Britain and France, signed in 1904. His successors continued the tradition with a state visit by King George V and Queen Mary in early 1914. The Duke and Duchess of York (Lady Elizabeth Bowes-Lyon) visited the Colonial Exhibition on 17 July 1931 and returned in July 1938 after the Duke had been crowned King George VI. Later still there were visits by Princess Margaret in May 1949 and her sister as Queen Elizabeth II arrived in April 1957. But, by far the most noticeable royals were the Duke and Duchess of Windsor.

Following his abdication as King Edward VIII, the Duke and his wife, the former Wallis Simpson made their home in Paris and became permanent fixtures on the Paris social scene.

Paris has always attracted global celebrities that have provided much publicity and prestige to the city. The legendary American performer, Josephine Baker made her first appearance in *La Revue Nègre* at the Théâtre des Champs-Élysées on 2 October 1925. The Russian ballerina Anna Pavlova arrived in 1927 to perform at the same theatre. Charlie Chaplin stopped in Paris in March 1931 in the midst of an extended European vacation as his new film *City Lights* was being released. The American presidents John F. Kennedy and Richard Nixon made goodwill visits in June 1961 and March 1969 respectively. Louis Armstrong performed in Paris in 1952 and 1955, the Beatles appeared on stage at the Olympia in January 1964 and as part of his European tour, Duke Ellington and his band played at the Alcazar in November 1969.

Many momentous events have occurred in Paris, some tragic like the 1910 floods. Others were celebratory such as the Olympic Games in the summer of 1924 and the opening of the Tour Montparnasse, the first and last skyscraper in central Paris in September 1973. But none have been more influential than the various expositions that firmly put Paris on the map as the cutting-edge location for artistic and cultural advancement in Europe. There had been several universal exhibitions or *Exposition Universelle* in the 19th century designed to re-establish pride in French achievements. At the dawn of the new century the 1900 exhibition was a showcase for national and European accomplishments. Each country funded their own magnificent pavilions and the glittering Palace of Electricity, apart from being fitted with thousands of lamps, supplied electricity to all the other exhibits. In 1925 the Exhibition of Decorative Arts, *L'Exposition internationale des arts décoratifs et industriels modernes*, gave birth to the term Art Deco. The Colonial Exposition held in 1931, aimed to display the diverse people and culture of the French colonies. The 1937 exposition, *Exposition Internationale des Arts et Techniques dans la Vie Moderne*, was dedicated to art and technology in modern life. It was notable because the German and Russian pavilions were placed opposite each other – a prelude to the real confrontation as clouds of war began to gather in Europe.

Paris avoided German occupation in World War I and the joyous armistice celebrations on 11 November 1918 were followed by even more parades when U.S. President Wilson arrived to negotiate the Versailles Peace Treaty in the summer of 1919 with the other 'big four' leaders of France, Italy and Great Britain. During this period there was a general strike as political tensions grew. The 1929 Wall Street crash had long-term repercussions. Tensions and rising unemployment led to riots in February 1934 and another general strike in 1936. More humiliating for Paris was the occupation of the city by the Germans in June 1940 and Hitler's visit to the city. Three years later in August 1944, the liberation by the Americans was a jubilant occasion, as was the arrival of General Charles de Gaulle who, a month later, formed a provisional French government.

The post-war period saw continued political dissent with division between the Communists, socialists, Gaulists and conservatives. Charles de Gaulle, George Pompidou, Giscard d'Estaing, Jacques Chirac and François Mitterand all navigated the country and Paris through various periods of vicissitude, including the Algerian crisis and war of independence, the anti-Vietnam War demonstrations, student riots and terrorist attacks. They also created a new Paris, revitalising the city and its infrastructure and trying to establish a balance between the old traditions and modern life.

The Allied leaders during the preparations for the Peace Conference and the Treaty of Versailles, June 1919.

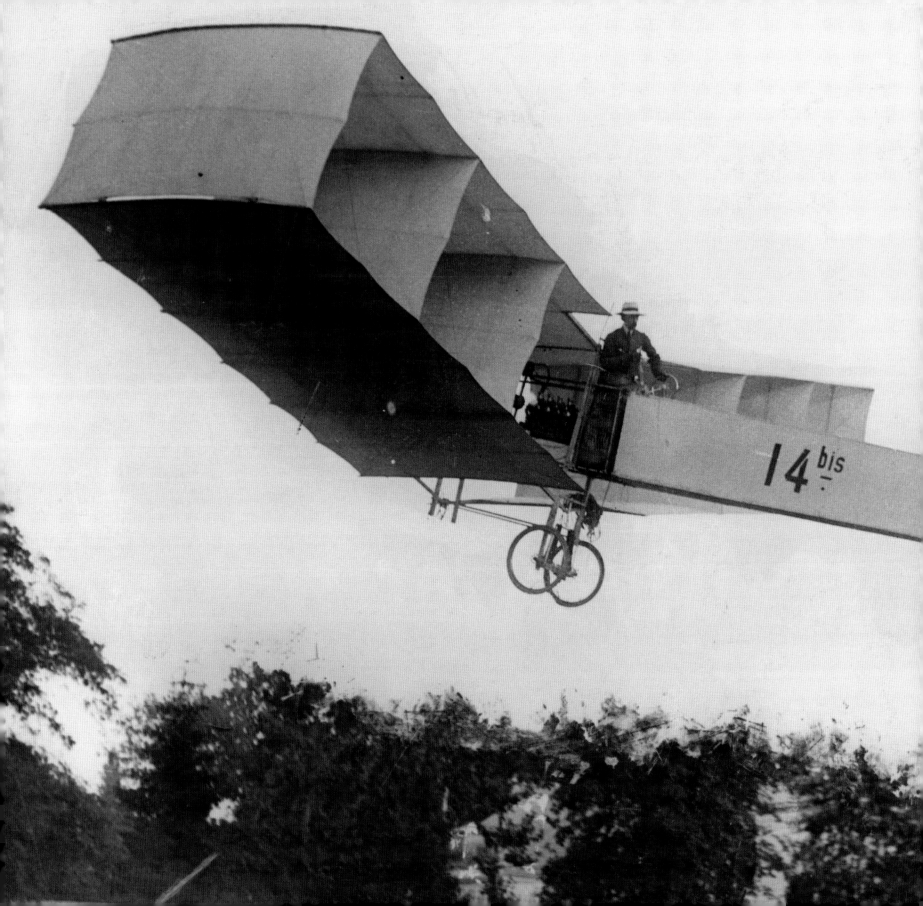

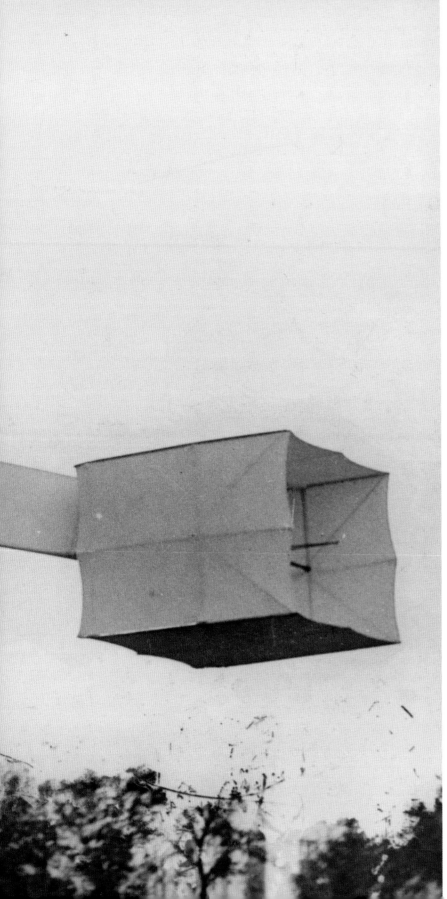

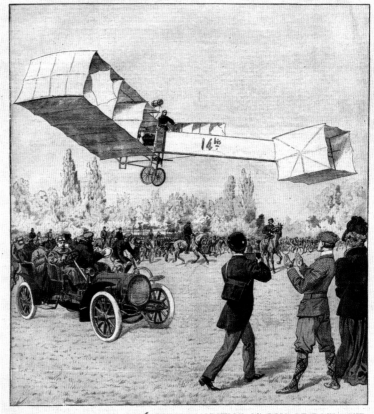

LEFT: Alberto Santos-Dumont officially flies the first aircraft in Europe at Bagatelle, Paris on 23 October 1906.

ABOVE: The headline 'The Sensational Aviation Experience' in *Le Petit Journal* (25 November 1906) as Alberto Santos-Dumont flies his 14bis aircraft again on 12 November 1906.

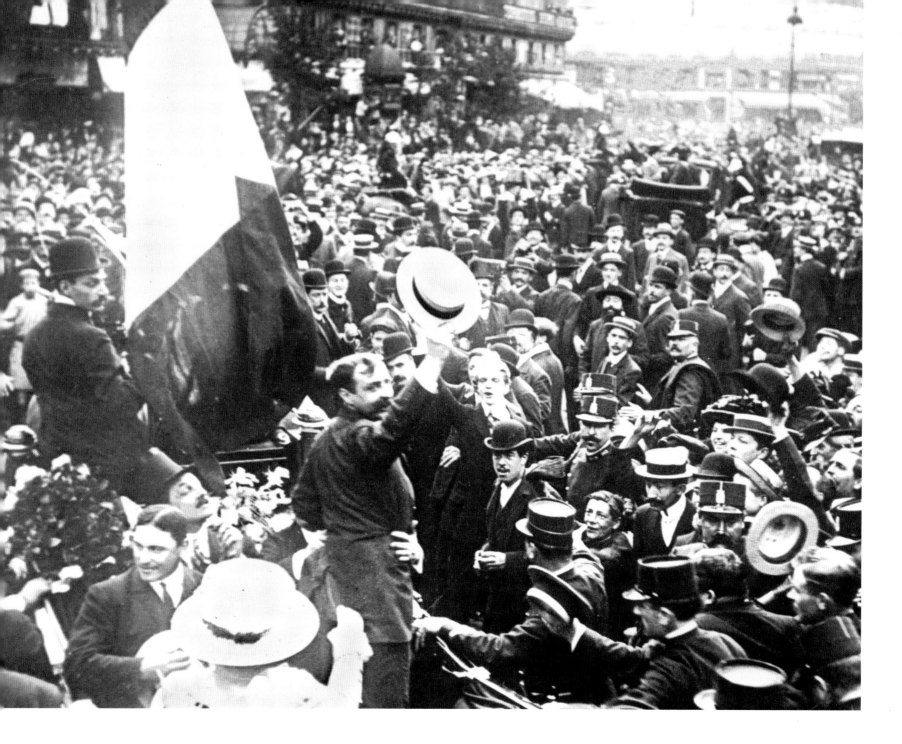

ABOVE: French aviator Louis Bleriot is celebrated in Paris on 30 July 1909 after he made the first flight over the English Channel in a self-built monoplane on 25 July 1909.

RIGHT: Charles A. Lindbergh, American pilot, in front of his single-engine, Spirit of St. Louis. With only a compass and a map he managed to navigate the first non-stop solo flight across the Atlantic between 20 and 21 May 1927. He covered the distance from New York to Paris in 33.5 hours, (1927).

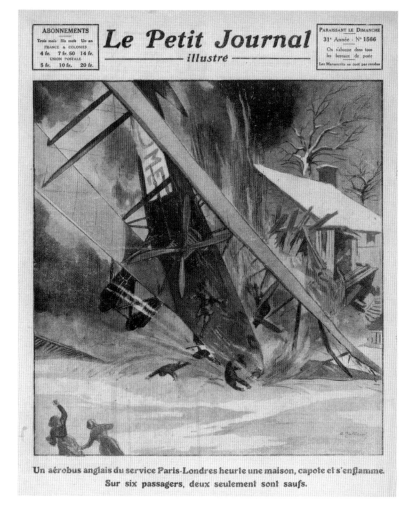

Le Petit Journal
illustré

Un aérobus anglais du service Paris-Londres heurte une maison, capote et s'enflamme.
Sur six passagers, deux seulement sont saufs.

ABOVE LEFT: Illustration in *Le Petit Journal* of a British plane travelling from Paris to London crashing after encountering bad weather in December 1920: only two of the six travellers survive.

BELOW LEFT: An advertisement advocating trips from London to Paris and home again in the same day, (1935).

TO PARIS WHILE YOU READ YOUR PAPER **AND HOME AGAIN**
THE SAME DAY!

NEARLY 1,700 PERSONS FLY BETWEEN LONDON & PARIS EVERY WEEK

The luxury of Imperial Airways' air liners is proverbial. Pullman-like comfort, meals, attentive stewards, lavatories and luggage space. For you, the chops of the Channel look like ripples and you arrive in Paris fresh and unfatigued, having spent no more time in the air than it takes to run your car from London to lunch with your cousins in the country. Air travel is not expensive and it is very delightful—try it!

LONDON TO PARIS
FROM . £4.15.0
RETURN . £7.12.0

IMPERIAL AIRWAYS
THE GREATEST AIR SERVICE IN THE WORLD

Bookings and information about Imperial Airways travel from the principal travel agents or from Airways Terminus, Victoria Station, S.W.1, or Imperial Airways Ltd., Airways House, Charles Street, Lower Regent Street, S.W.1. Telephone : VICtoria 2211 (Day & Night). Telegrams : 'Impairlim, London.'

RIGHT: The first scheduled flights between London and Paris began in August 1919. Here, a group of passengers are getting ready for a flight from London to Paris with the pilot standing on the left his goggles up on his forehead, (c.1920).

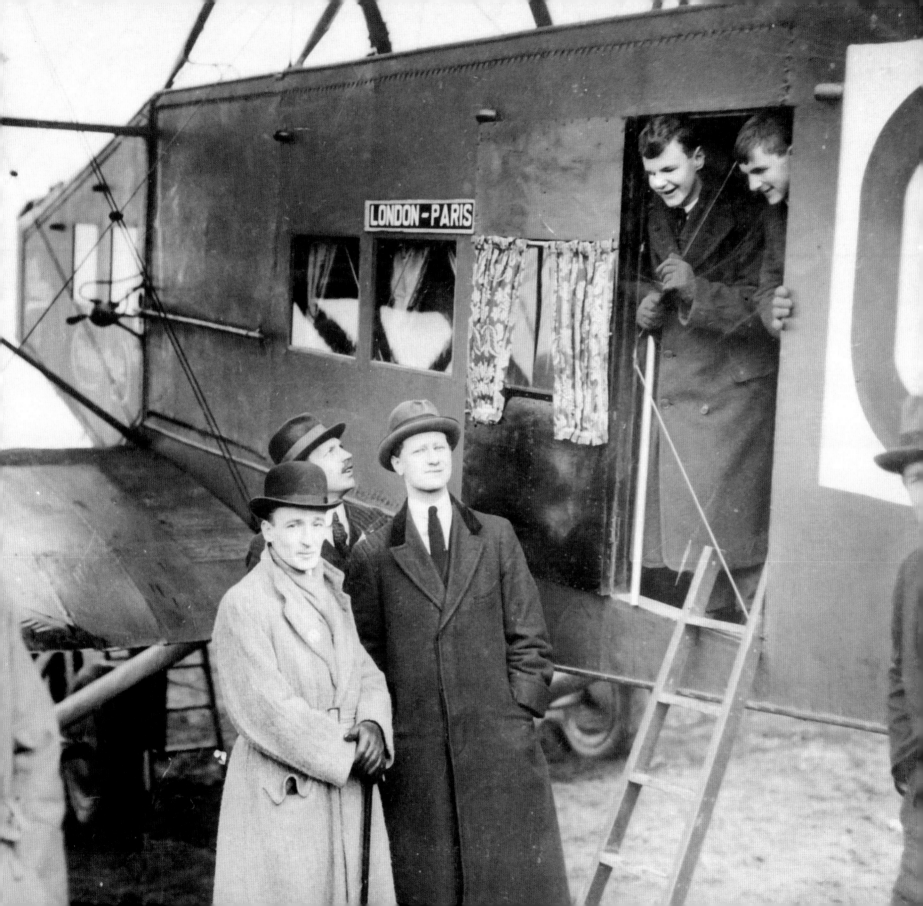

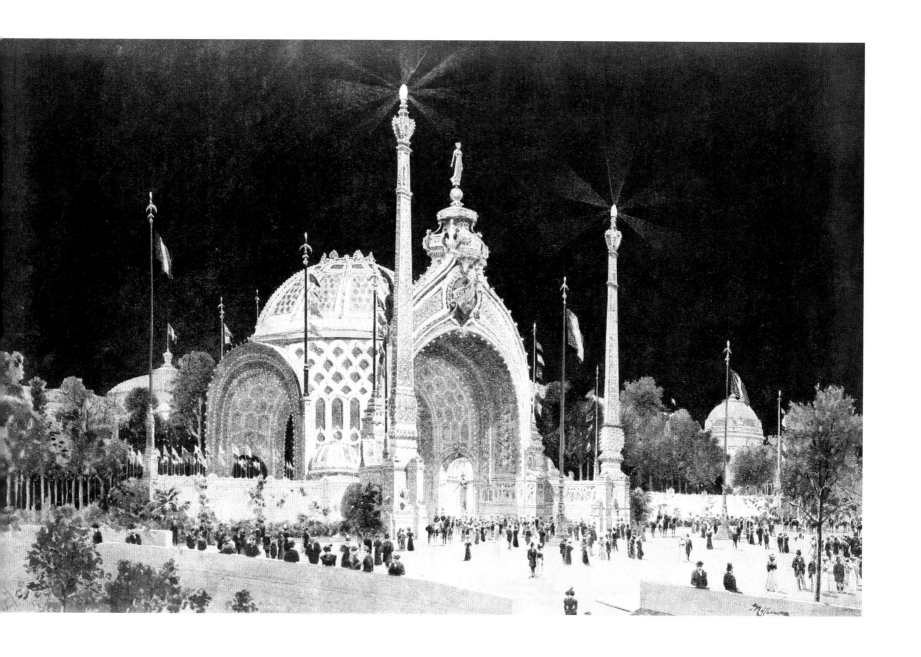

ABOVE: A view of the monumental gate and main entrance of the
Universal Exhibition (Exposition Universelle) of 1900 in the Place de
la Concorde.

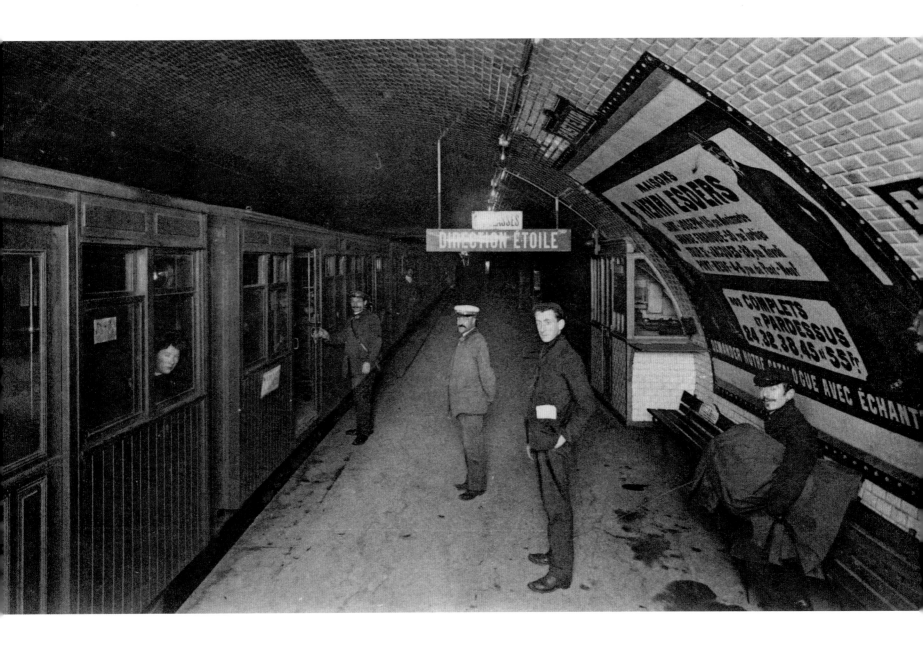

ABOVE: 19th July 1900 heralds the opening of the first line of the Paris Métro between Porte de Versailles and Porte Maillot. Here a train leaves the station Pasteur (c.1905).

255

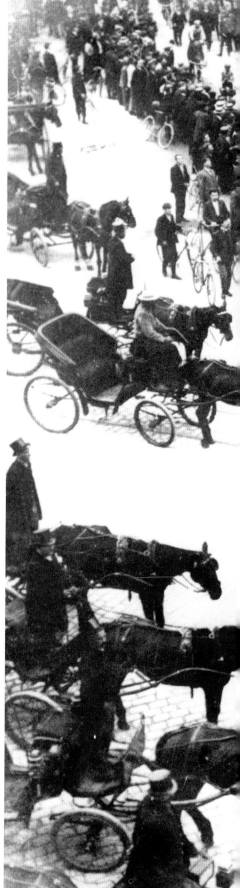

ABOVE: The film actor and director, Orson Welles waving a flag at the start of the Tour de France in Paris in 1950.

RIGHT: The first Tour de France departing from Villeneuve-Saint-Georges (near Paris) on 1 July 1903.

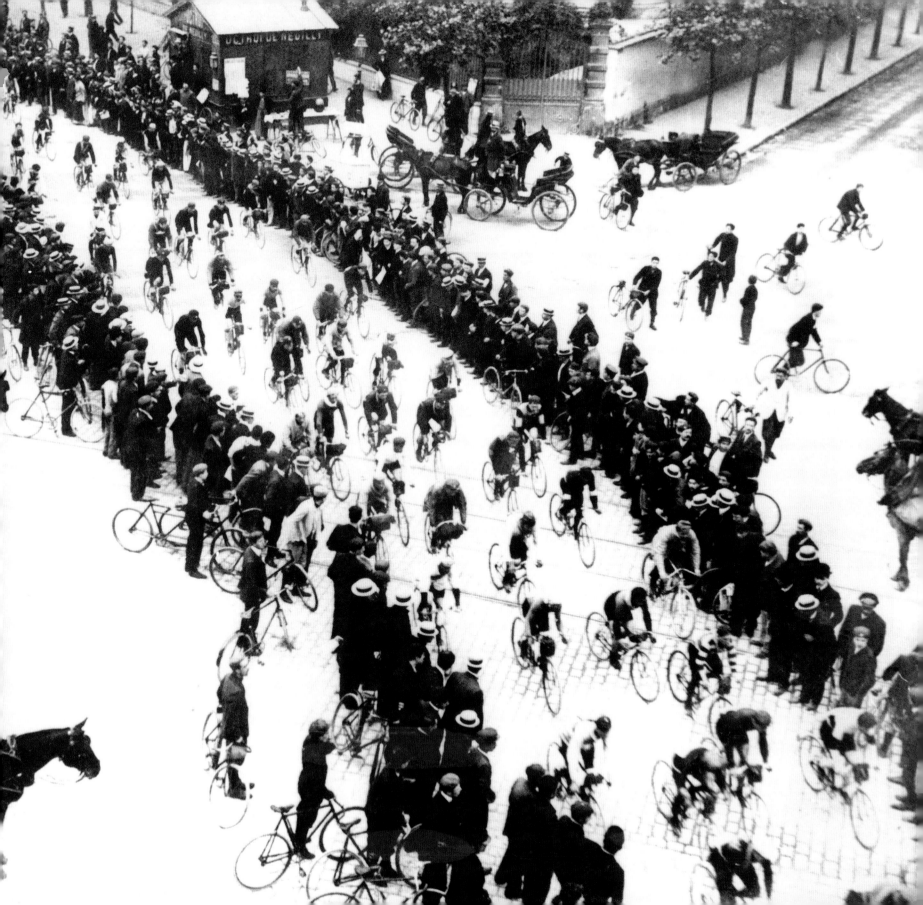

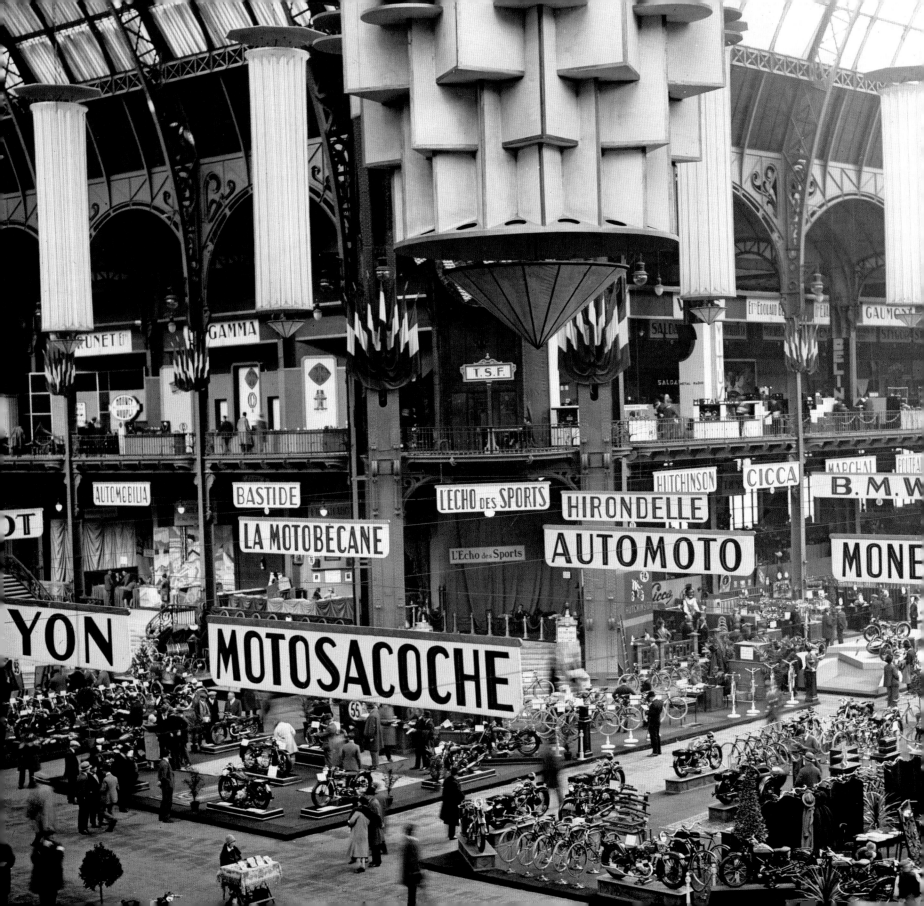

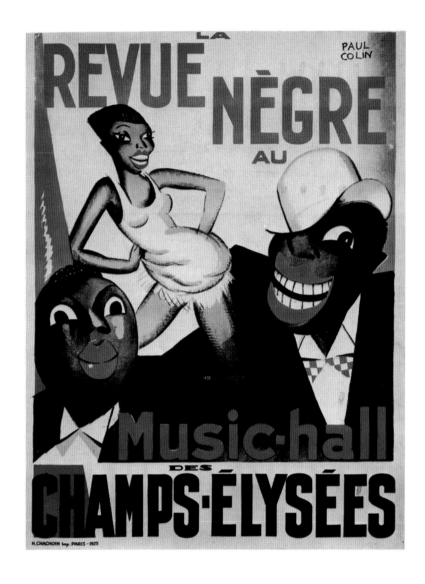

LEFT: A view of the international bicycle and motorcycle show at the Grand Palais in Paris, October 1930.

ABOVE: A poster by Paul Colin for the Revue Negre at the Music-hall des Champs Elysees that starred the legendary Josephine Baker and was launched 2nd October 1925.

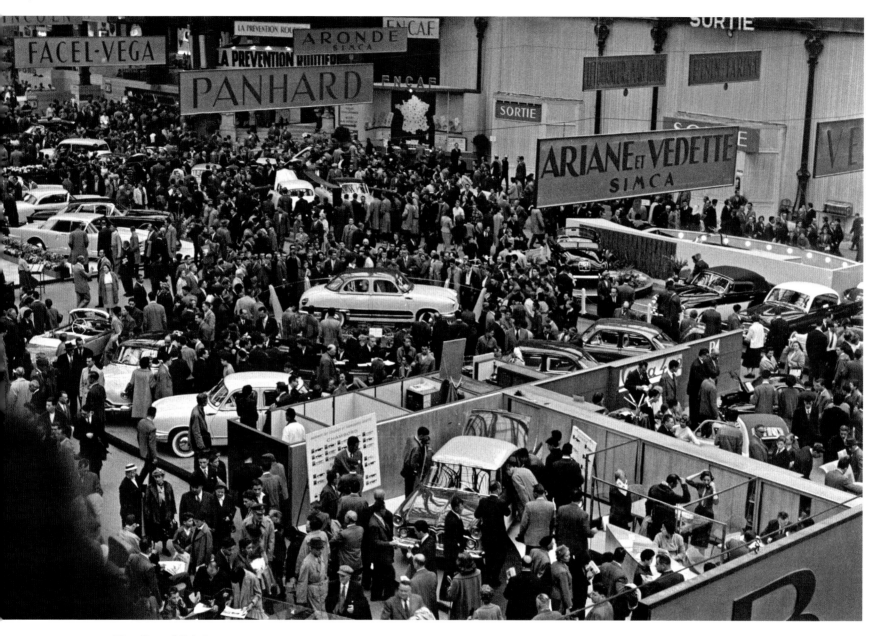

ABOVE: The Grand Palais
Automobile Show was staged
from 1901 to 1961 in
October each year, (c.1960).

RIGHT: An automobile
elegance competition,
Concours d'Elegance, being
staged at the Trocadero,
(c.1950).

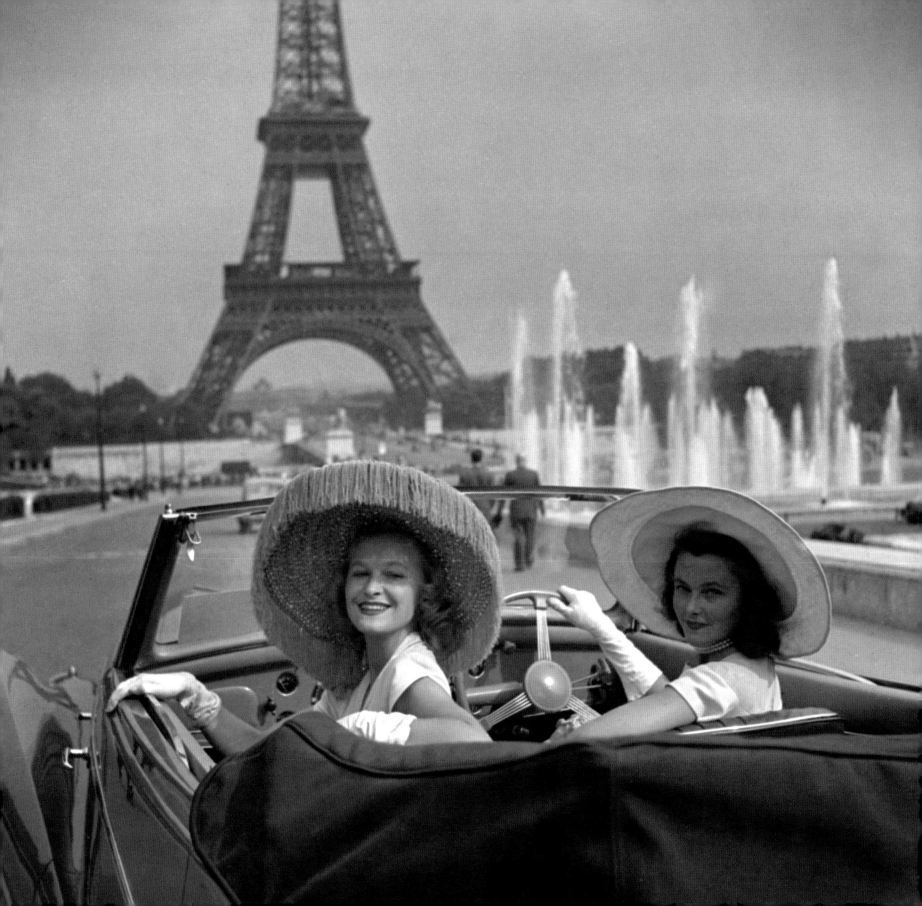

ABOVE: Edward VII (raising his hat) during a visit to Paris in 1903. Known as the 'Uncle of Europe' with his sophisticated diplomatic skills (including fluency in spoken French), the King was instrumental in laying the foundations for the Entente Cordiale, the historic agreement between Britain and France, signed in 1904.

RIGHT: The Duke and Duchess of York visit the *Exposition Coloniale* on 17 July 1931. The exhibition was an attempt to showcase French colonial possessions and the people who lived in those territories. They are being presented with a bouquet of flowers by dancers from French Indochina. Alongside the Duchess is the uniformed Marshal Lyautey, Commissioner-General of the exhibition, (1931).

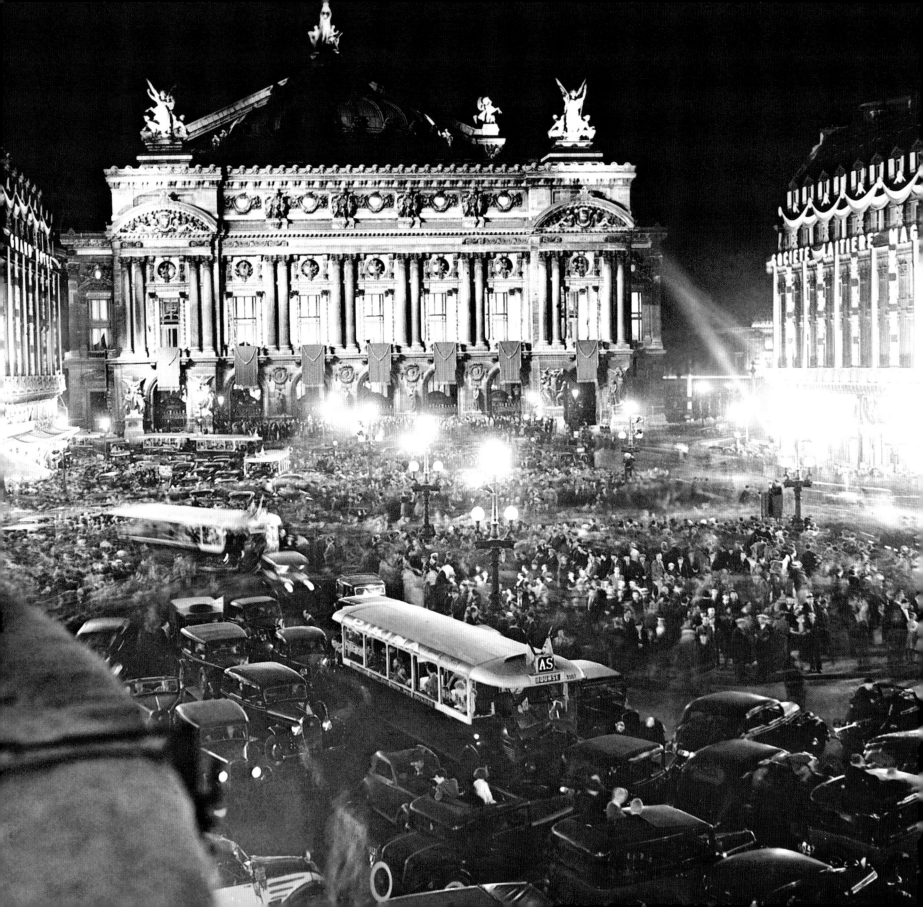

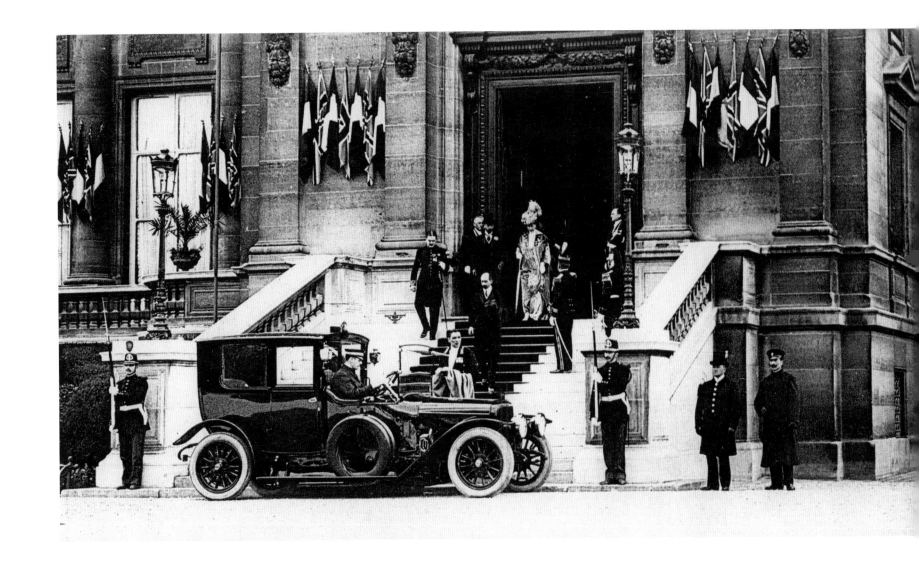

LEFT: A crowd gathered outside the Opéra Garnier at the *Place de l'Opéra*, July 1938, to get a glimpse of King George VI and his wife, Queen Elizabeth, who were on an official visit to Paris.

ABOVE: King George V and Queen Mary visit Paris in April 1914. Here they are seen leaving the Ministry of Foreign Affairs.

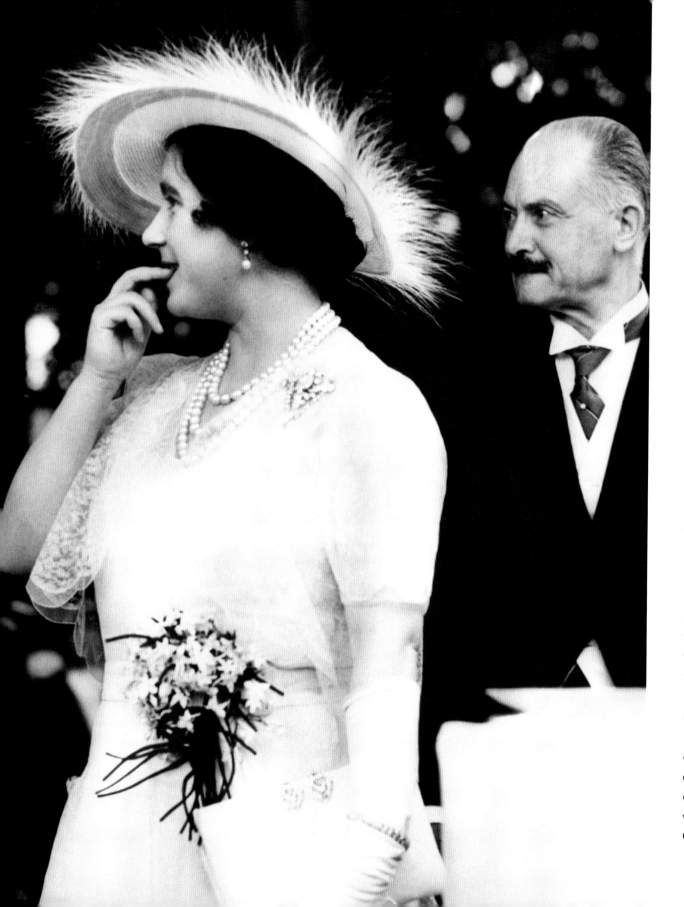

LEFT: Queen Elizabeth, the former Duchess of York, and French President Albert Lebrun, at a garden party at Bagatelle, Paris on 20 July 1938.

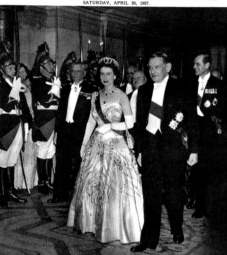

ABOVE: Queen Elizabeth II, wearing an ivory satin dress with the Legion of Honour sash, accompanied by President Coty at the Opéra national de Paris on 8 April 1957 for a state performance of the ballet, *Le Chevalier et la Damoiselle*. The Duke of Edinburgh can be seen walking behind President Coty.

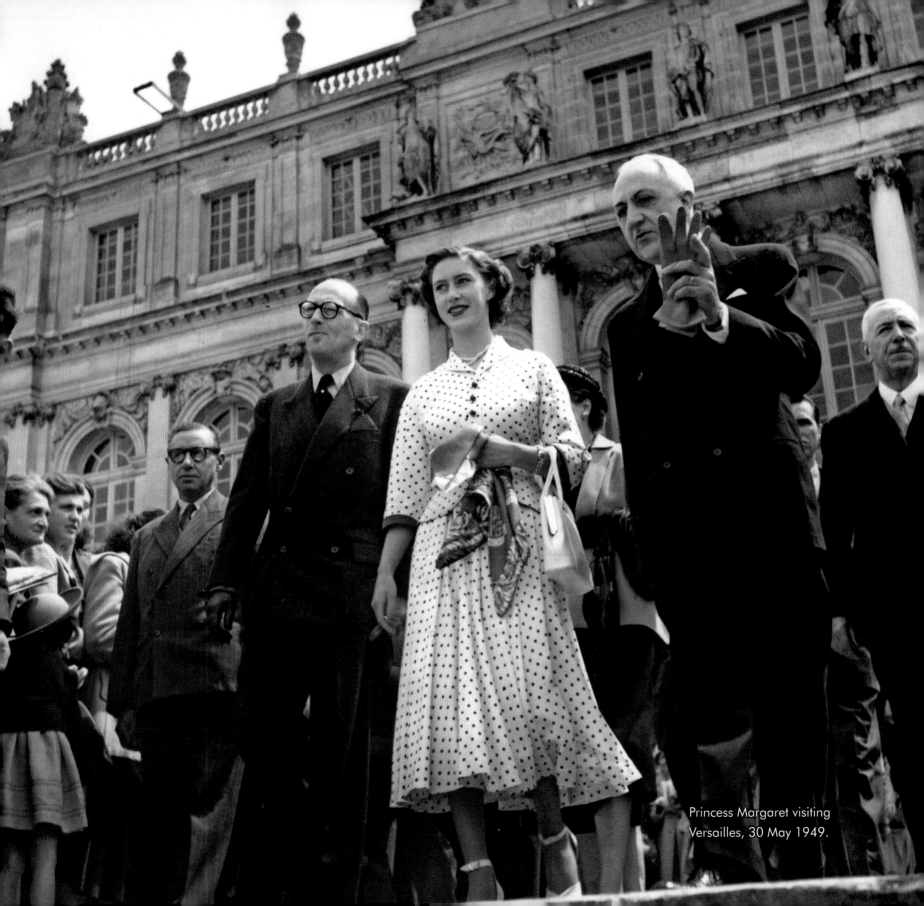

Princess Margaret visiting
Versailles, 30 May 1949.

LEFT: Anna Pavlova, the Russian ballerina, arrives in Paris. She appeared at the Théâtre des Champs-Élysées, (1927).

RIGHT: Charlie Chaplin on the balcony of the Hotel Grillon during his visit to Paris in March 1931.

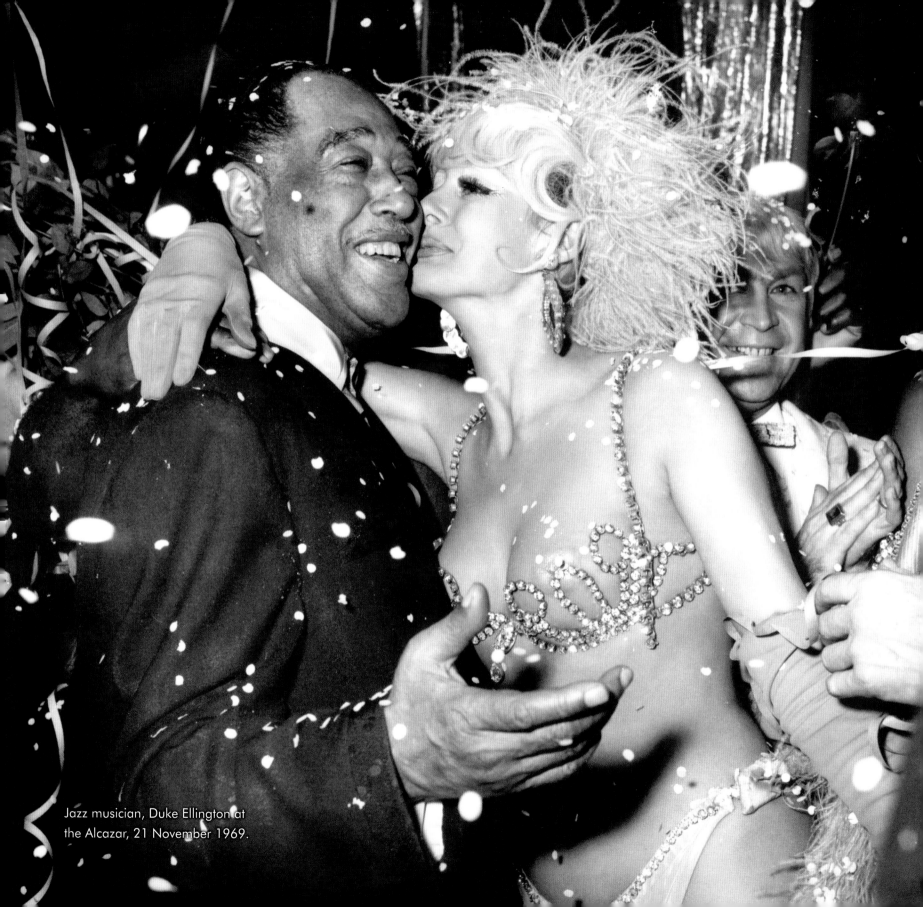

Jazz musician, Duke Ellington at
the Alcazar, 21 November 1969.

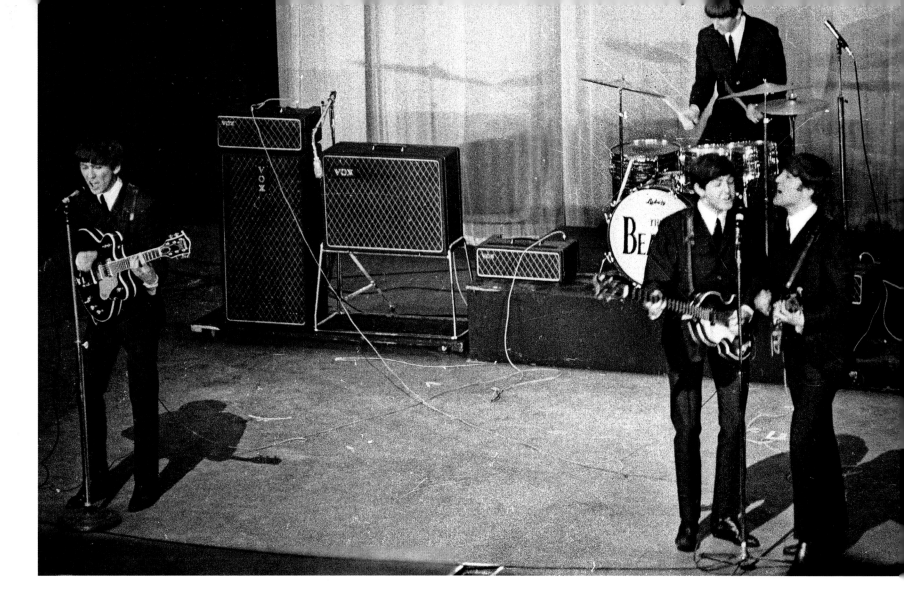

ABOVE: The Beatles on stage at the Olympia, 17 January 1964.

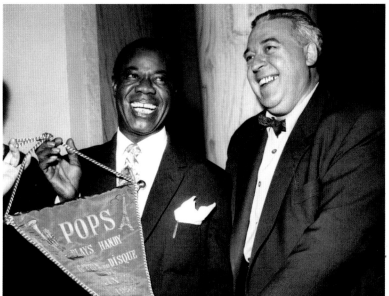

LEFT: Louis Armstrong receiving the Grand Prix du Disque du Jazz from Hugues Panassié in Paris, (1955).

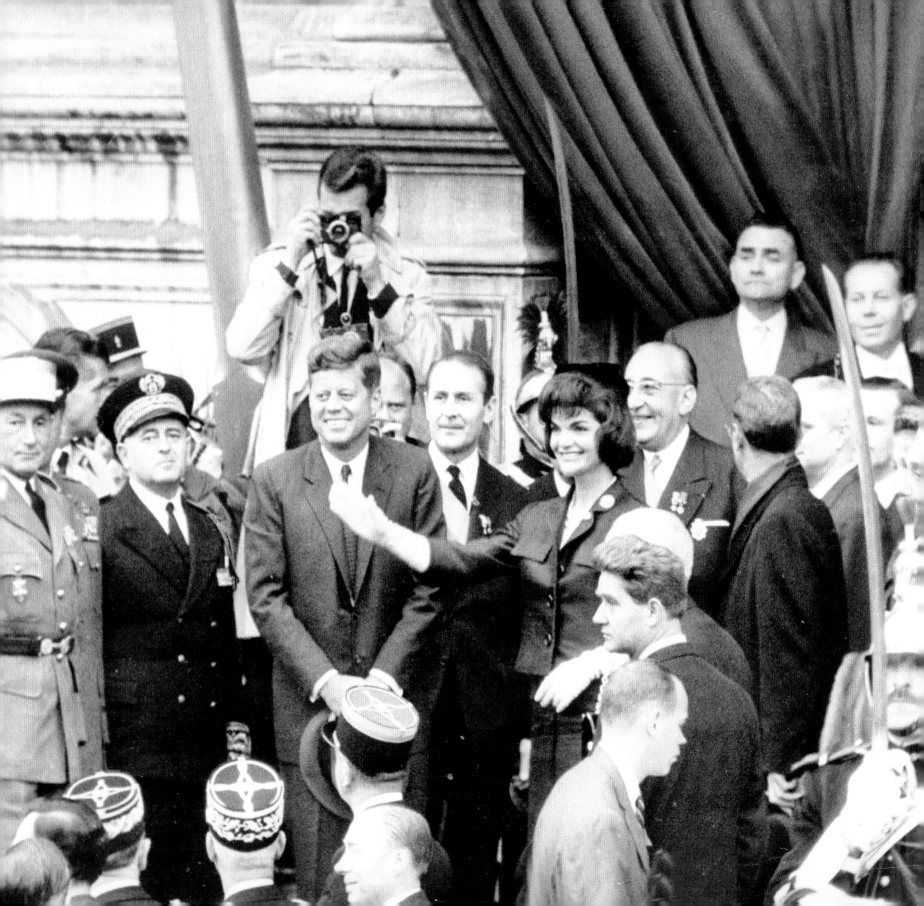

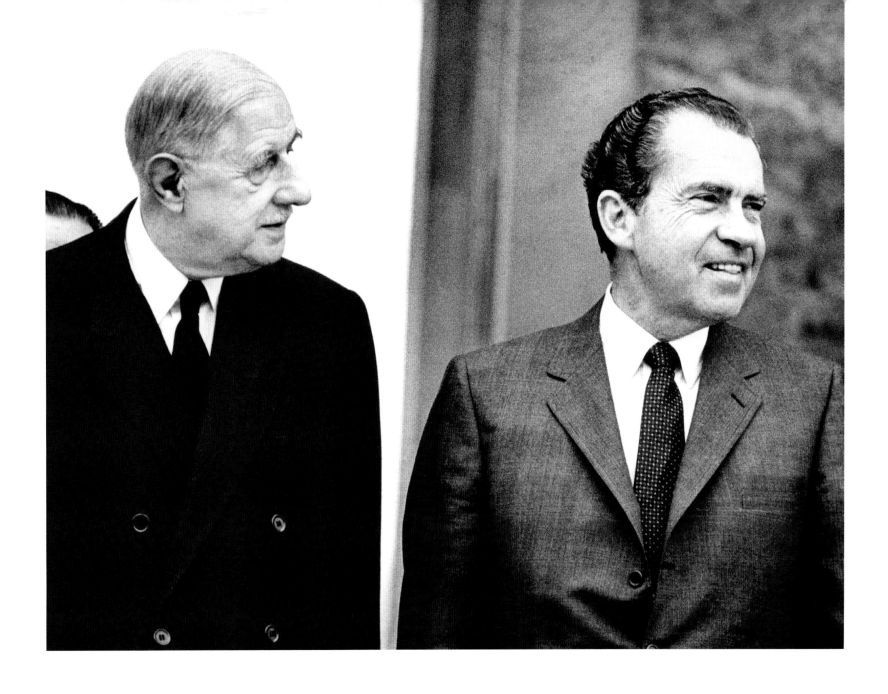

LEFT: American president, John F. Kennedy with his wife Jackie, at the Hôtel de Ville on 1 June 1961 during an official visit.

ABOVE: French President Charles de Gaulle and Richard Nixon in Paris for private talks on 1 March 1969. Newly inaugurated President Nixon was on a goodwill tour of Europe.

LEFT: Illustration by Fortunino Matania in *The Sphere* depicting ladies being rescued in the flooded streets during the Paris Floods in January 1910.

RIGHT: A group of men use a boat to move goods after a huge rise in the level of the River Seine caused extensive flooding, (1910).

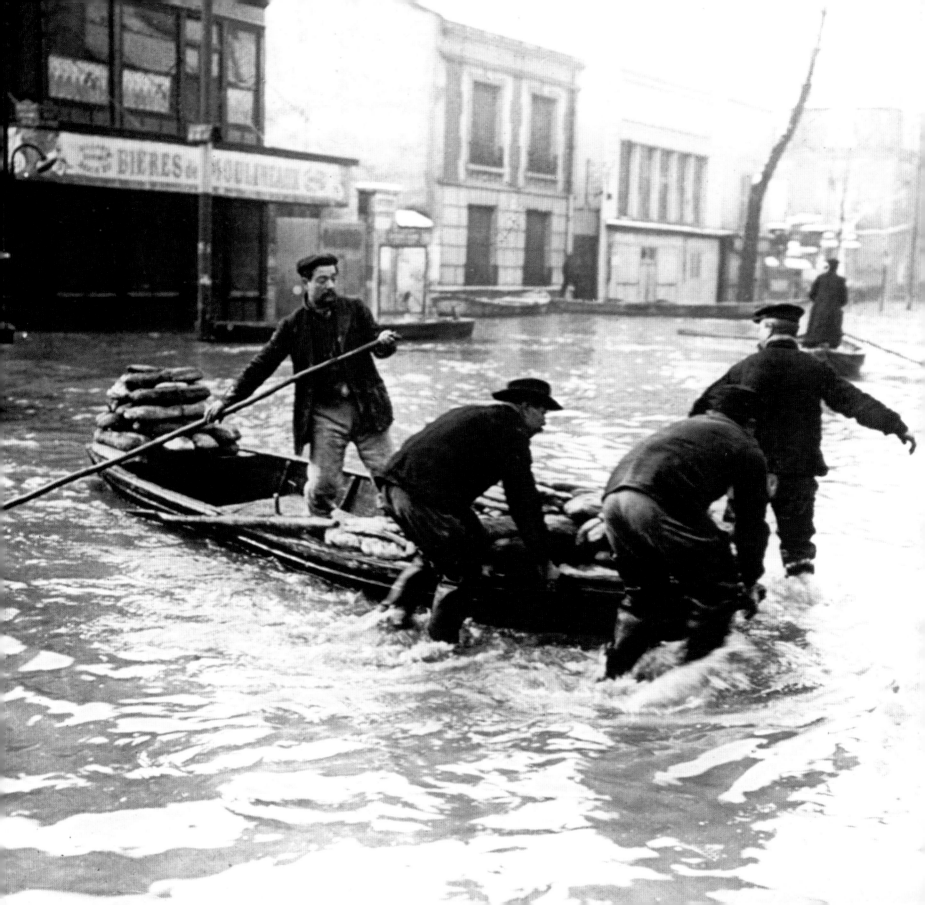

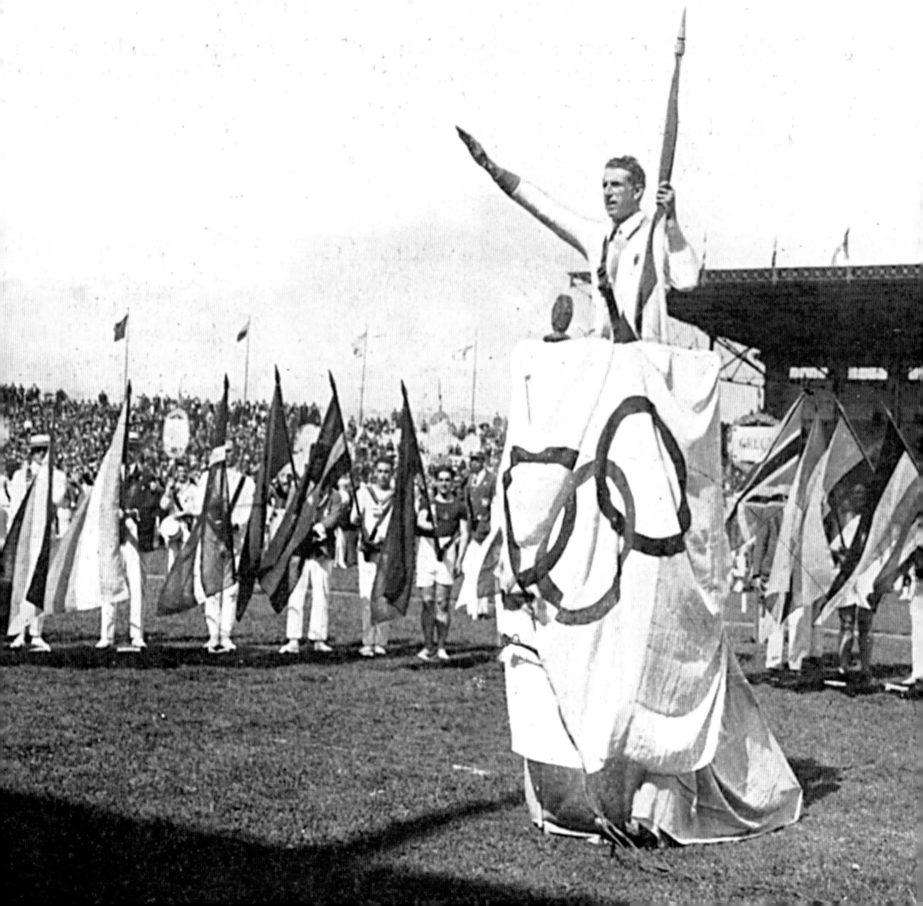

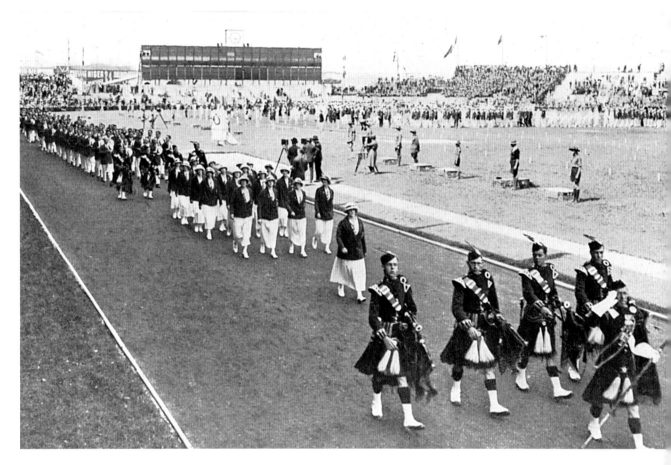

LEFT: The Opening Ceremony of the 1924 Olympic Games in Paris, 5 July 1924. Surrounded by the flags of the forty-five nations taking part in the games. Georges André, the famous French athlete, takes the oath of loyalty on behalf of all competitors.

ABOVE: The British team in the march past headed by pipers at the Opening Ceremony. It was attended by the Prince of Wales, his brother, Prince Henry and French President Gaston Doumergue, (1924).

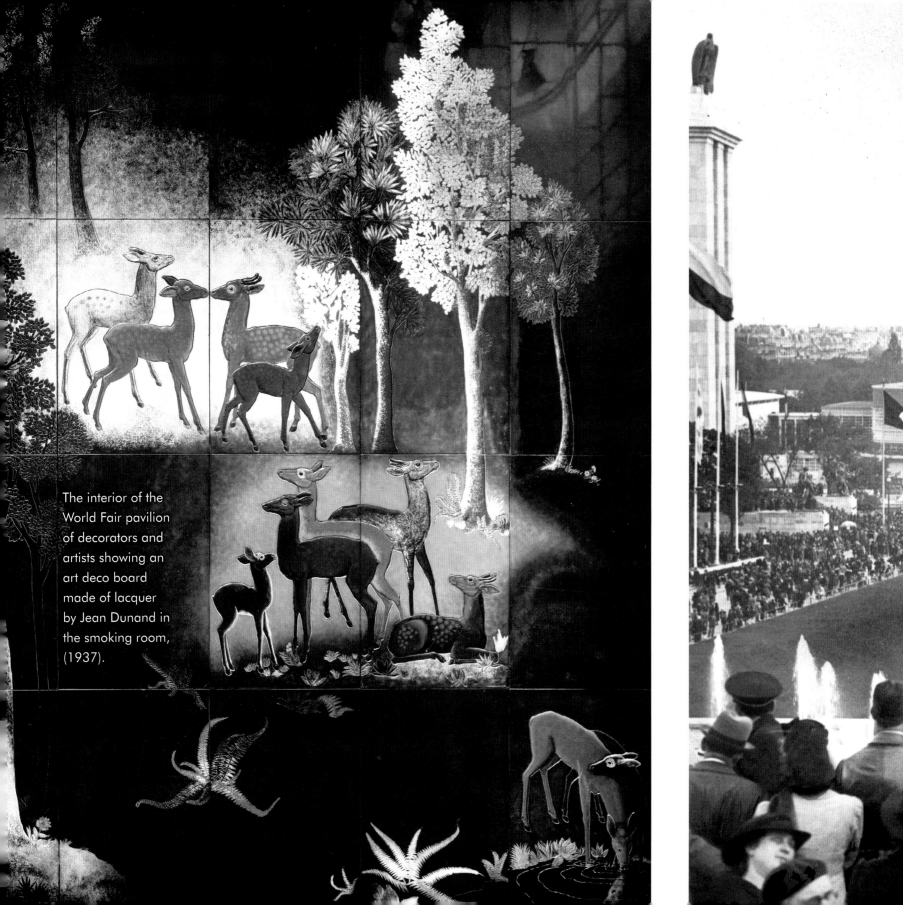

The interior of the World Fair pavilion of decorators and artists showing an art deco board made of lacquer by Jean Dunand in the smoking room, (1937).

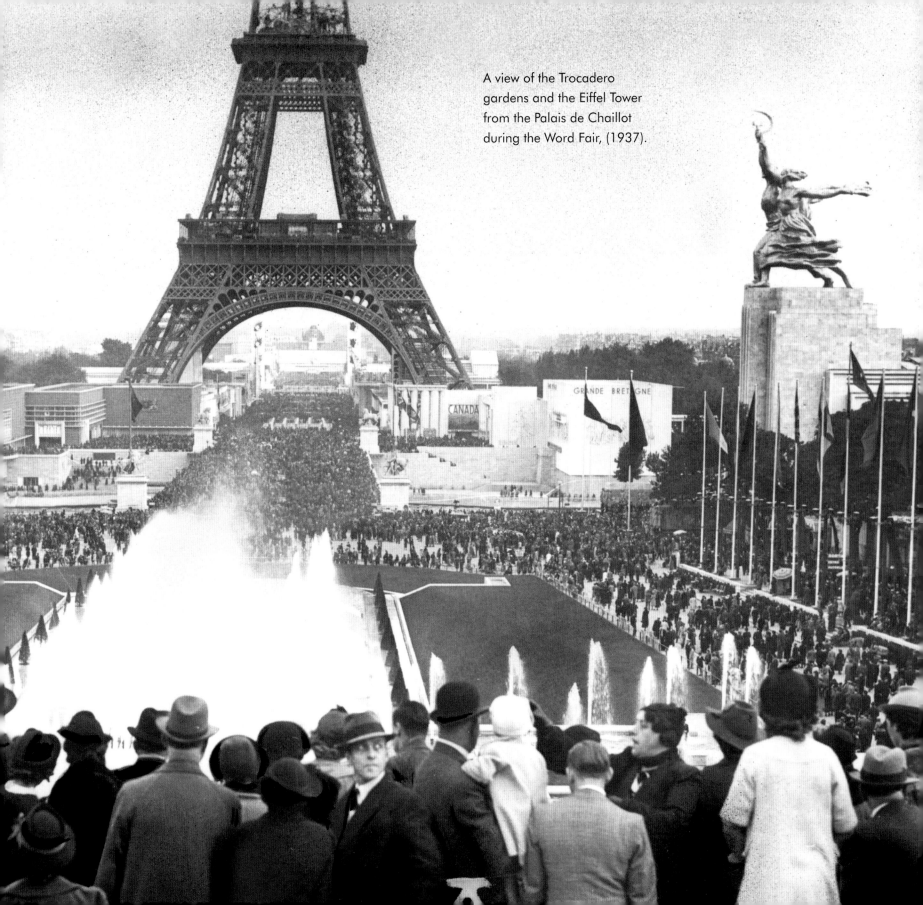

A view of the Trocadero gardens and the Eiffel Tower from the Palais de Chaillot during the Word Fair, (1937).

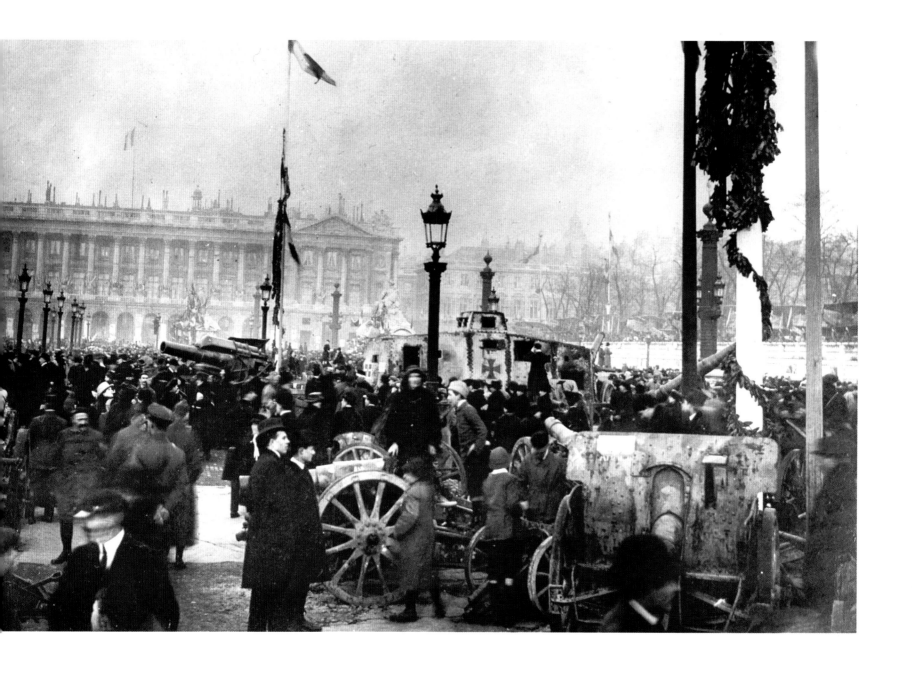

ABOVE: Parisians in the Place de la Concorde celebrate the Armistice, 11 November 1918.

RIGHT: A parade in the streets of Paris to welcome the arrival of U.S. President Woodrow Wilson for the 'Big Four' meeting to negotiate the Versailles Peace Treaty, June 1919.

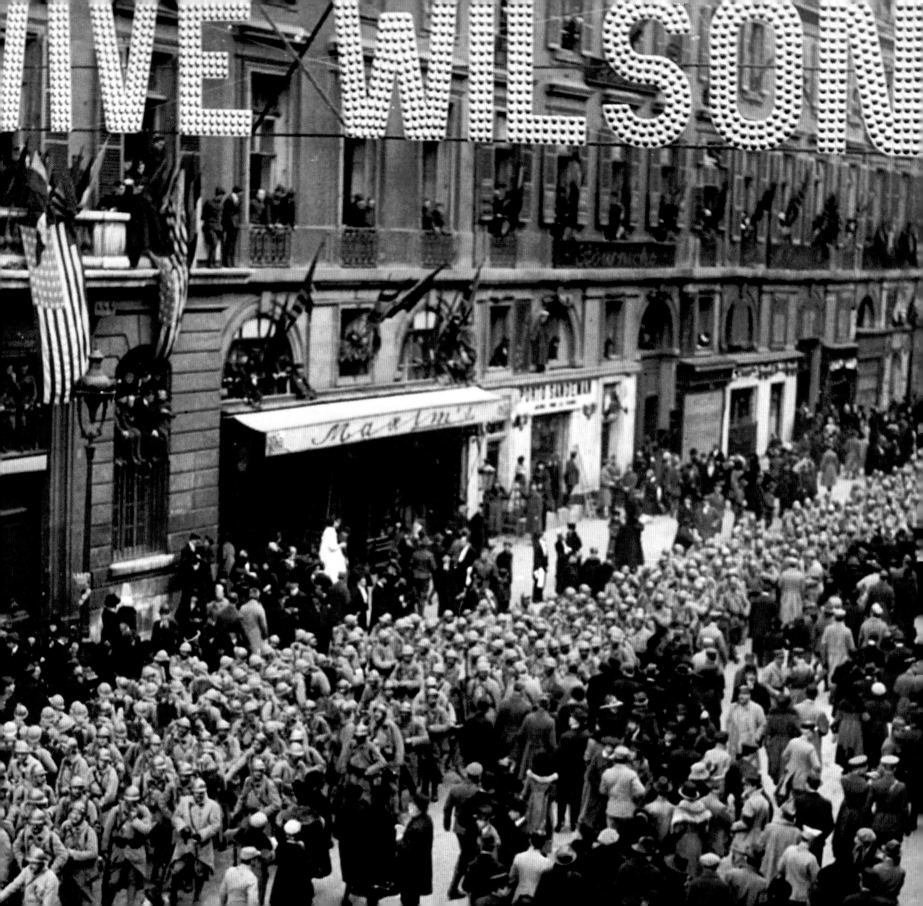

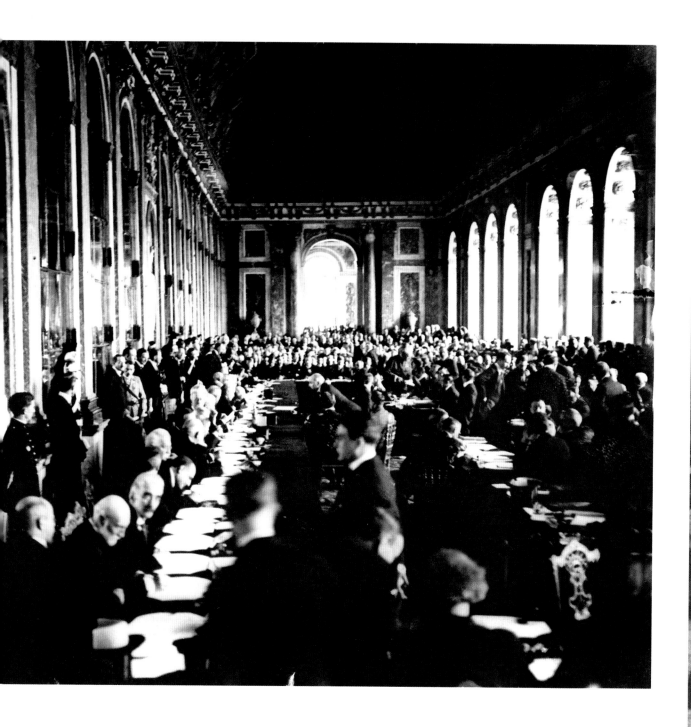

ABOVE: The signing of the Treaty of Versailles in the Hall of Mirrors at Versailles on 28 June 1919.

RIGHT: Demonstration in Paris, 1 August 1919.

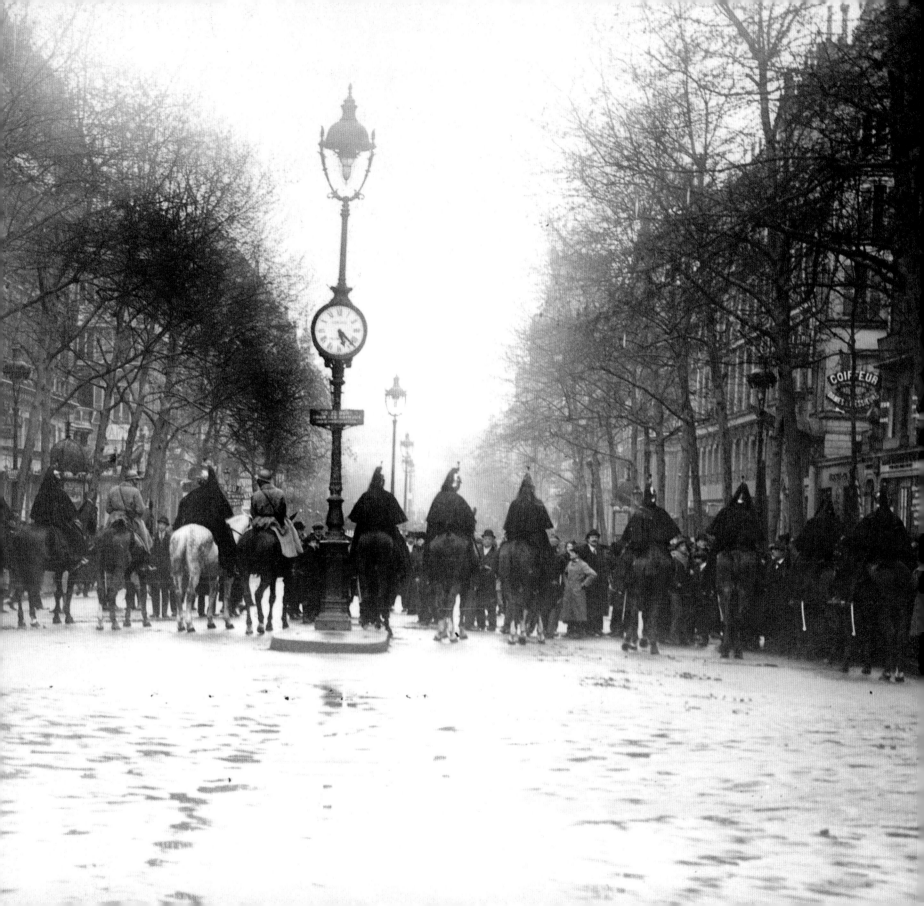

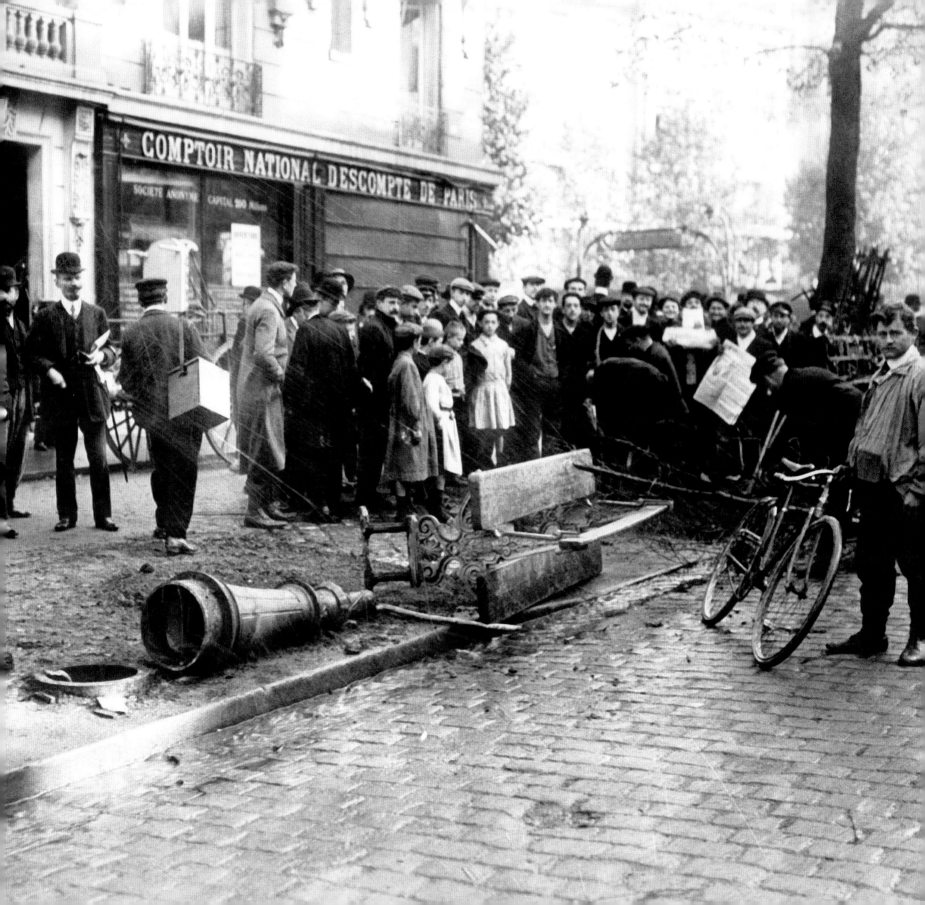

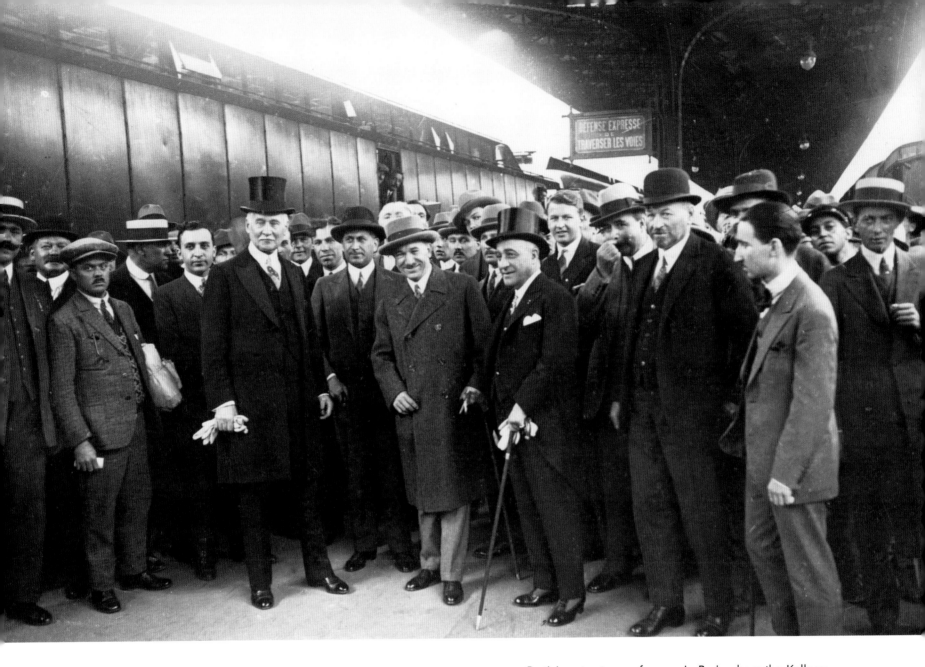

LEFT: Damage after the riots
in Paris on 13 October 1919.

ABOVE: Participants at a conference in Paris where the Kellogg-
Briand Pact was negotiated and signed on 27 August 1928.
Sponsored by France and the USA, the General Treaty for the
Renunciation of War as an Instrument of National Policy was
a international agreement to renounce the use of war and to
advocate the use of peaceful means to settle disputes.

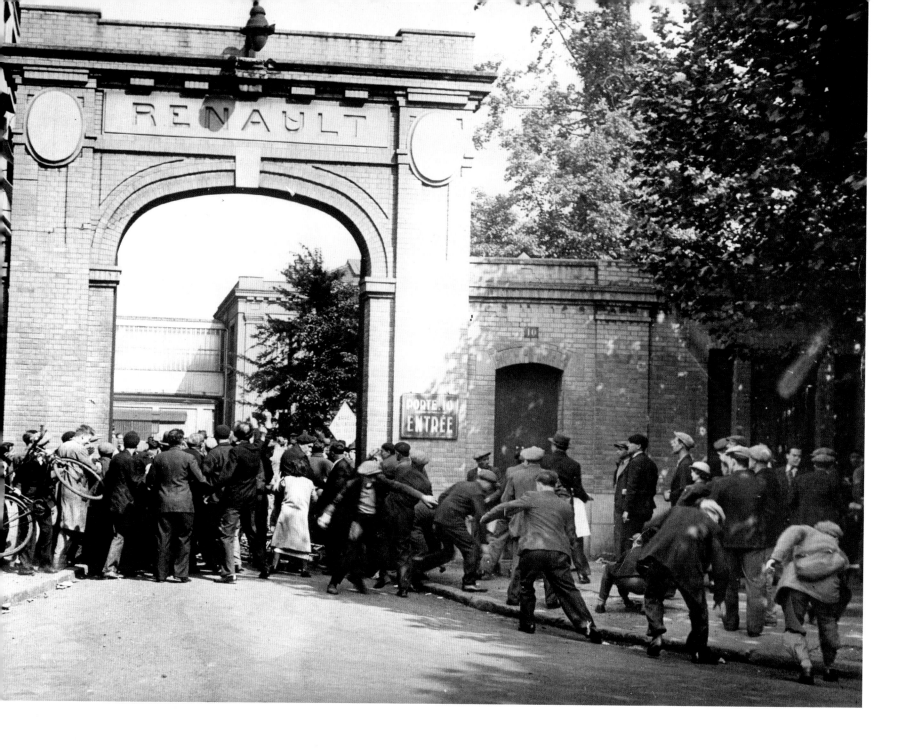

ABOVE: Conflict between striking workers and strike breakers at the gate of the Renault factory in Paris, May 1936.

RIGHT: Workers leave the Renault factory in the Boulogne-Billancourt district after the conclusion of a six-day strike under the leadership of Communist delegates, May 1936.

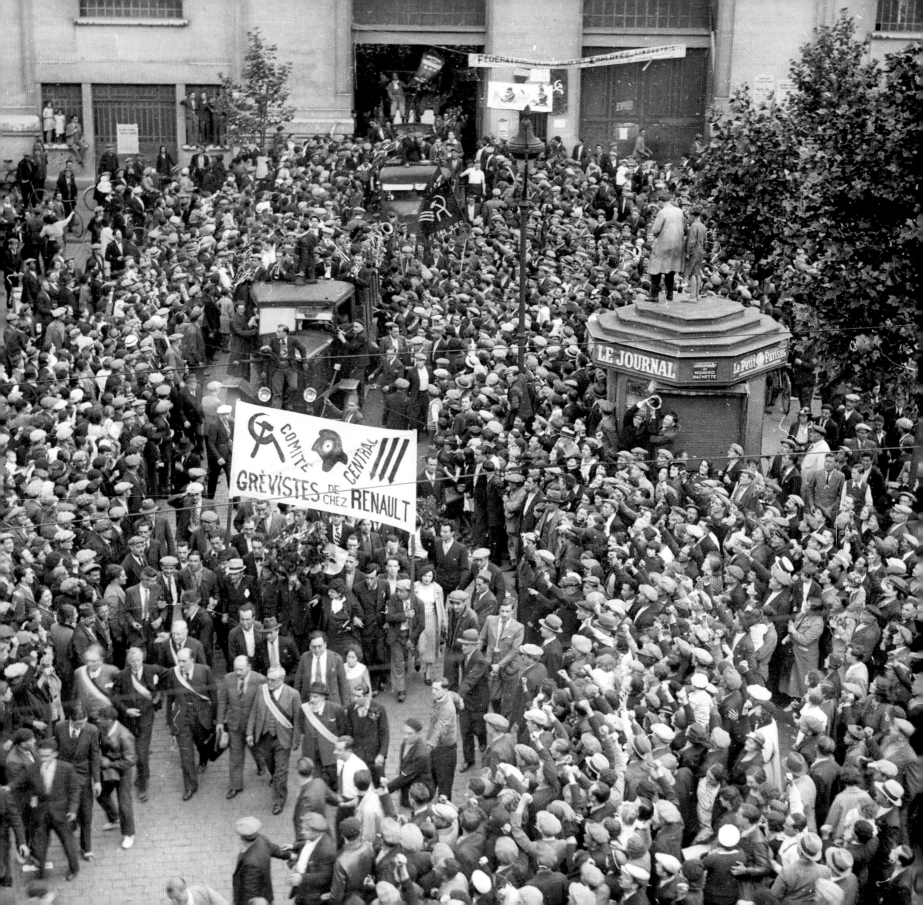

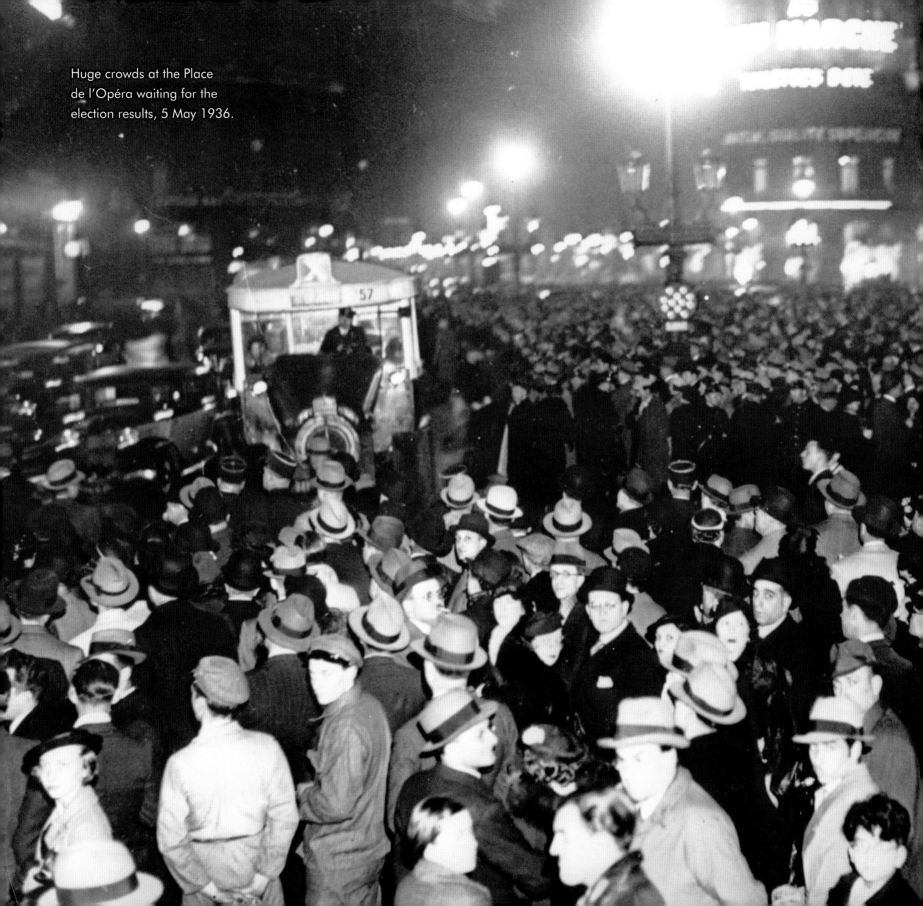

Huge crowds at the Place de l'Opéra waiting for the election results, 5 May 1936.

LE PETIT JOURNAL

HEBDOMADAIRE - 36ᵉ Année
61, rue Lafayette, Paris

ILLUSTRÉ

10 Mai 1925. - Nᵒ 1794
PRIX : 30 CENTIMES

UN ODIEUX ATTENTAT COMMUNISTE

ABOVE: Illustration of the Communists attacking a right-wing political meeting, May 1925.

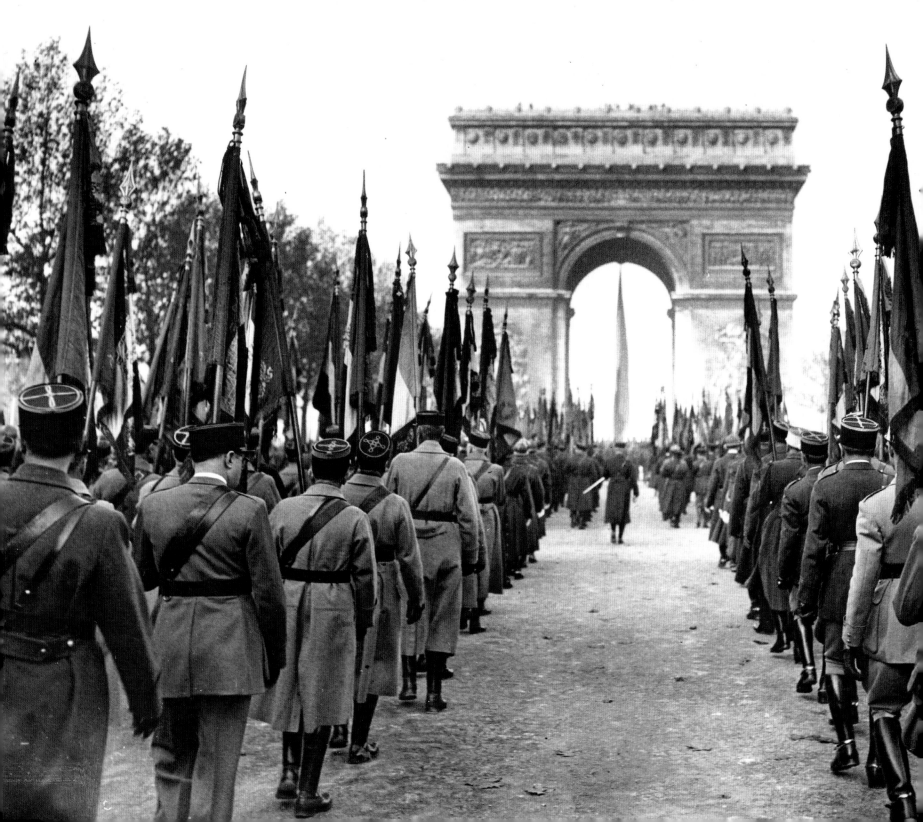

An impressive military display commemorating the twentieth anniversary of the Armistice at the Arc de Triomphe, 11 November 1938.

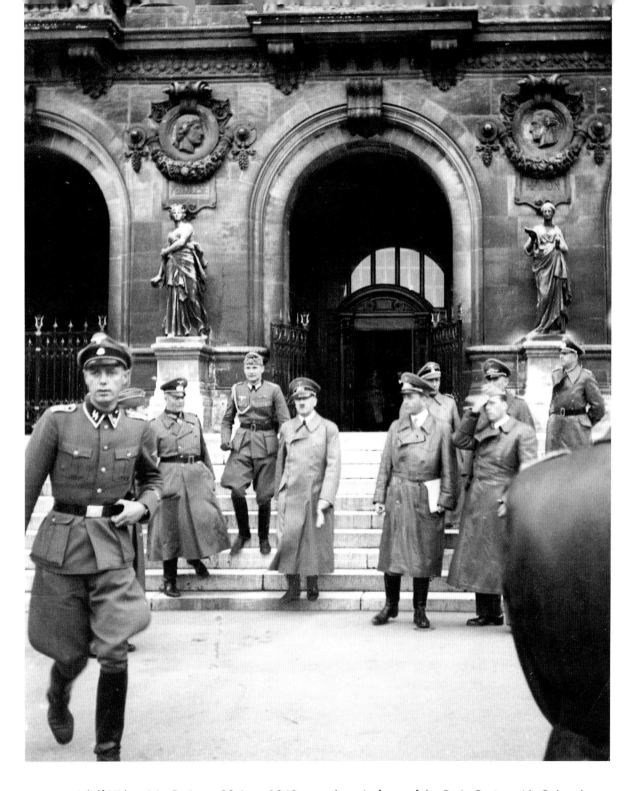

ABOVE: Adolf Hitler visits Paris on 23 June 1940, seen here in front of the Paris Opéra with Colonel-General Wilhelm Keitel (2nd from left), Professor Albert Speer (on Hitler's right) and Professor Hermann Giesler (with hand on forehead).

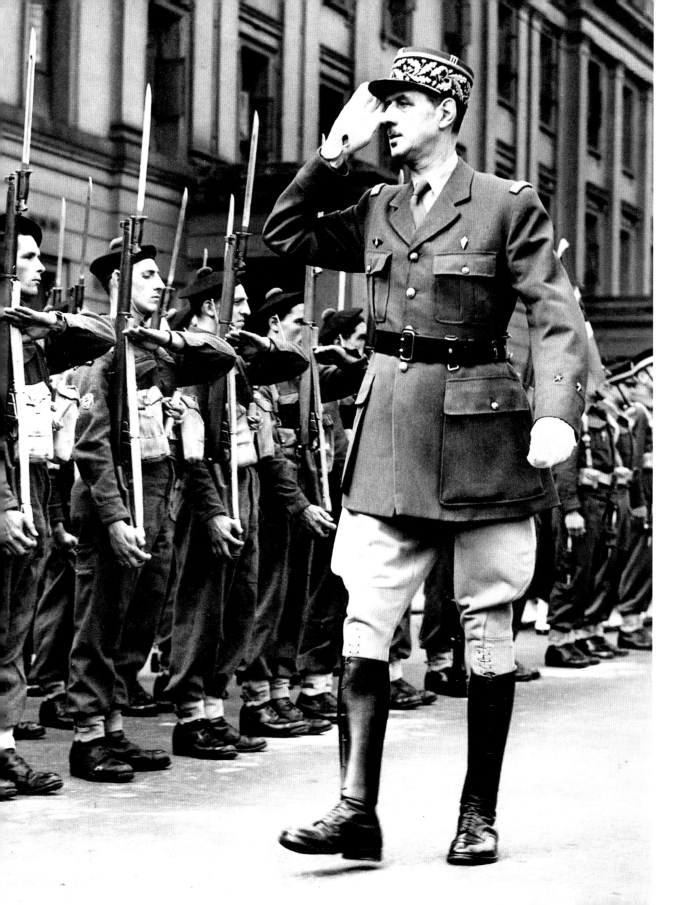

LEFT: General Charles de Gaulle and the Free French Forces, *Forces Françaises Libres*, in London, 14 July 1942. They were French fighters during World War II, who decided to continue fighting after the surrender of France and subsequent German occupation.

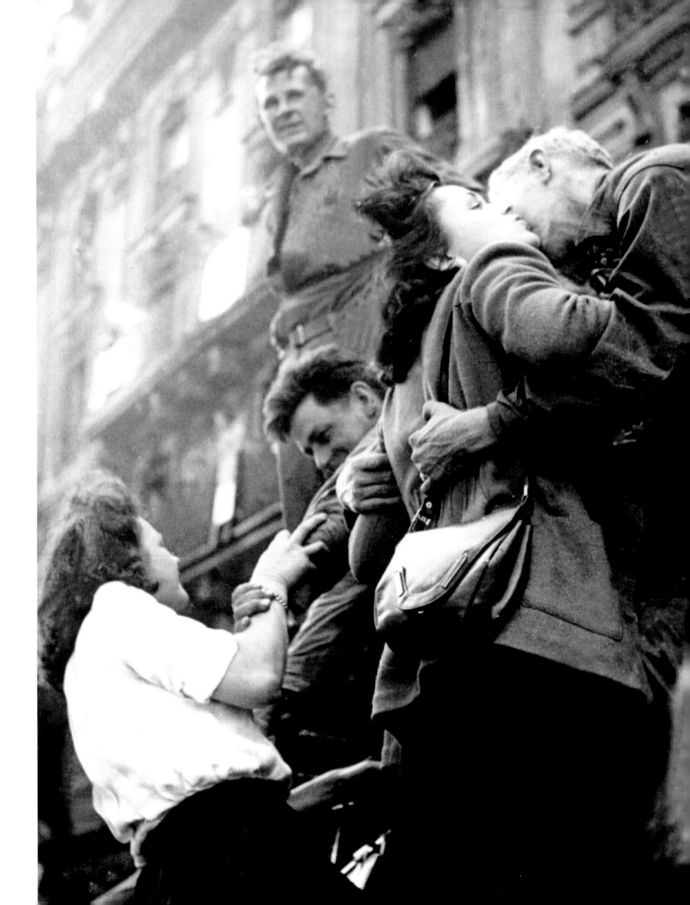

RIGHT: Parisians greet the American troops after the liberation of the city, 31 July 1944. German commander Dietrich von Choltitz had given the order to retreat or lay down arms, although Hitler had given instructions to hold on to Paris or turn it into an expanse of rubble. On the 25 of August 1944, von Choltitz signed the admission of defeat.

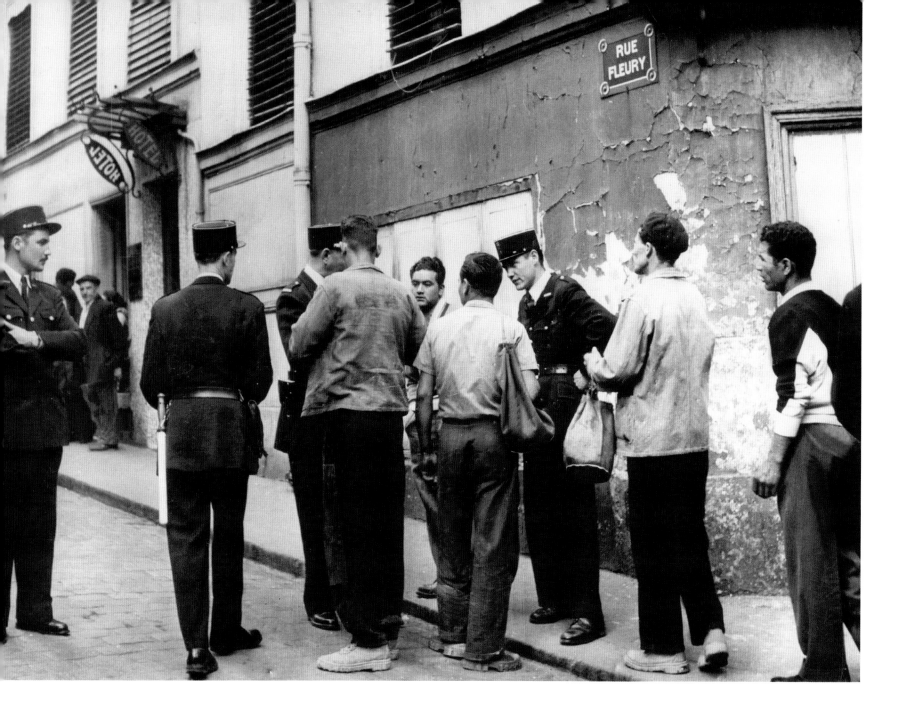

ABOVE: During the Algerian War of Independence (1954–1962), policemen check the identity of Algerian workers in Paris, August 1955.

RIGHT: Algerians celebrating the independence of their country in Paris with the Algerian nationalist flag, 5 July 1962.

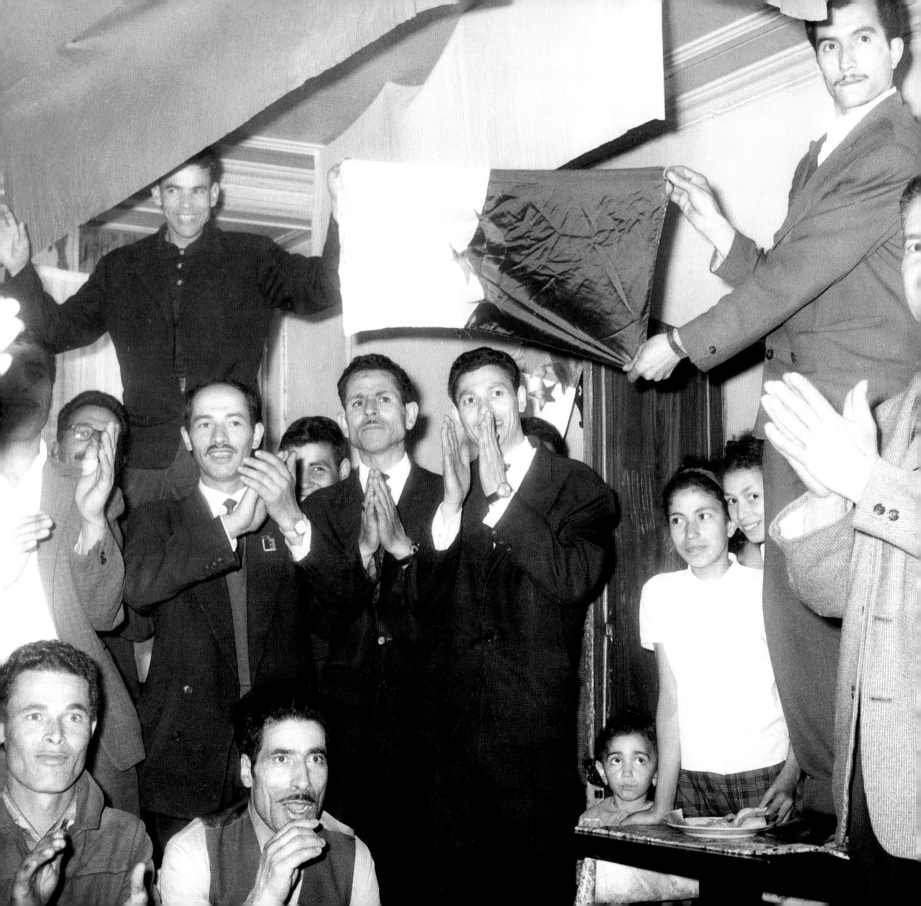

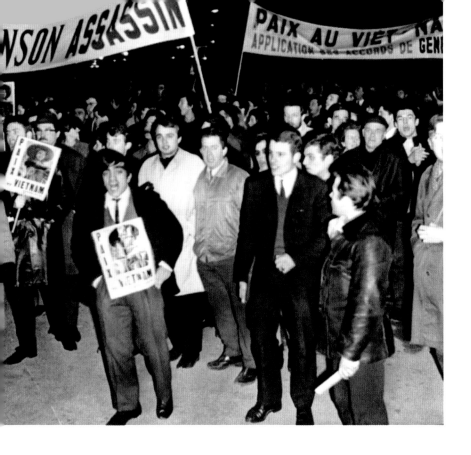

ABOVE LEFT: An anti-Vietnam war demonstration in Paris on 3 February 1966. Leftist demonstrators mass in the Place de la Concorde near the U.S. Embassy. Protesters carry signs reading 'Peace in Vietnam, 'Application of the Geneva Treaty' and 'Johnson Assassin'.

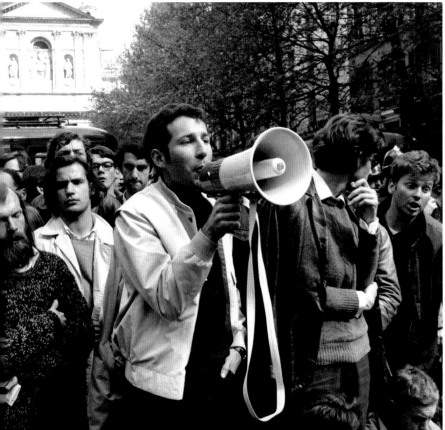

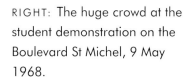

BELOW LEFT: Students march during a demonstration on the Boulevard St Michel in front of the Sorbonne, Paris, 9 May 1968.

RIGHT: The huge crowd at the student demonstration on the Boulevard St Michel, 9 May 1968.

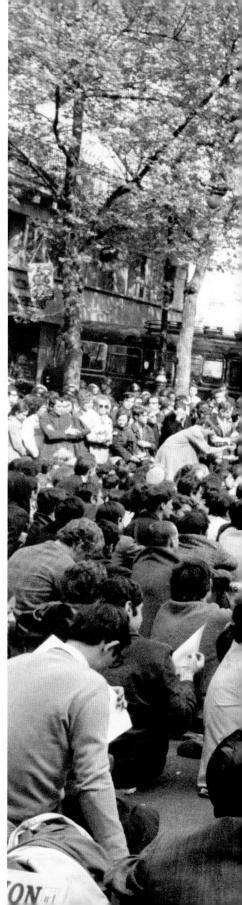

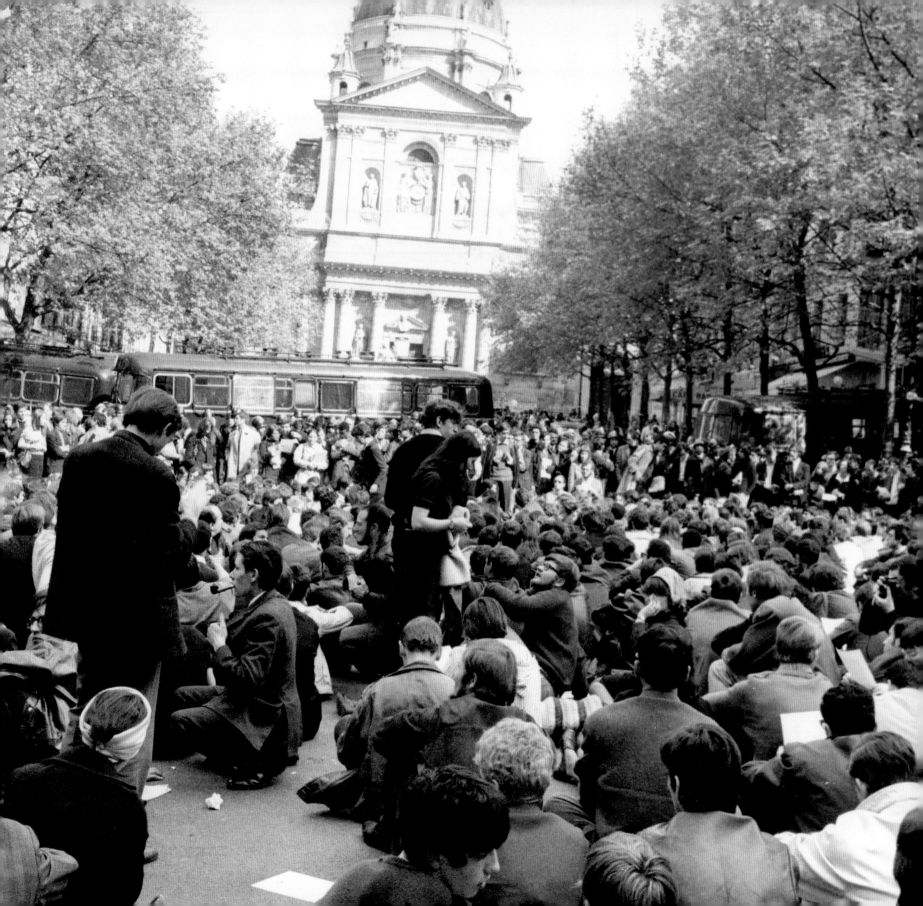

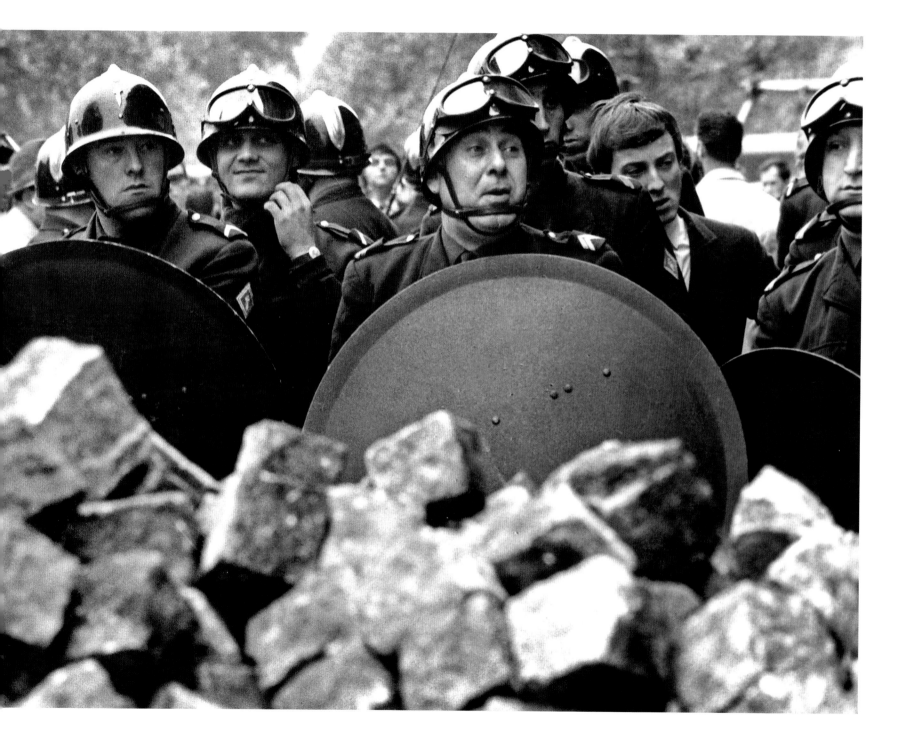

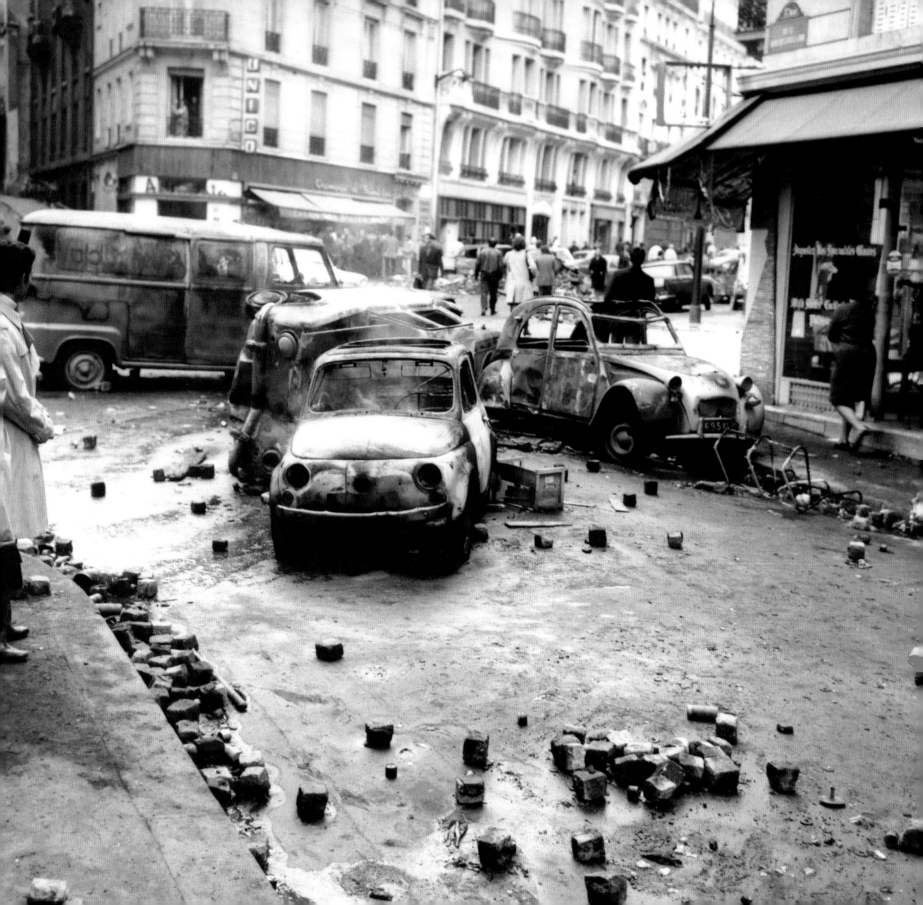

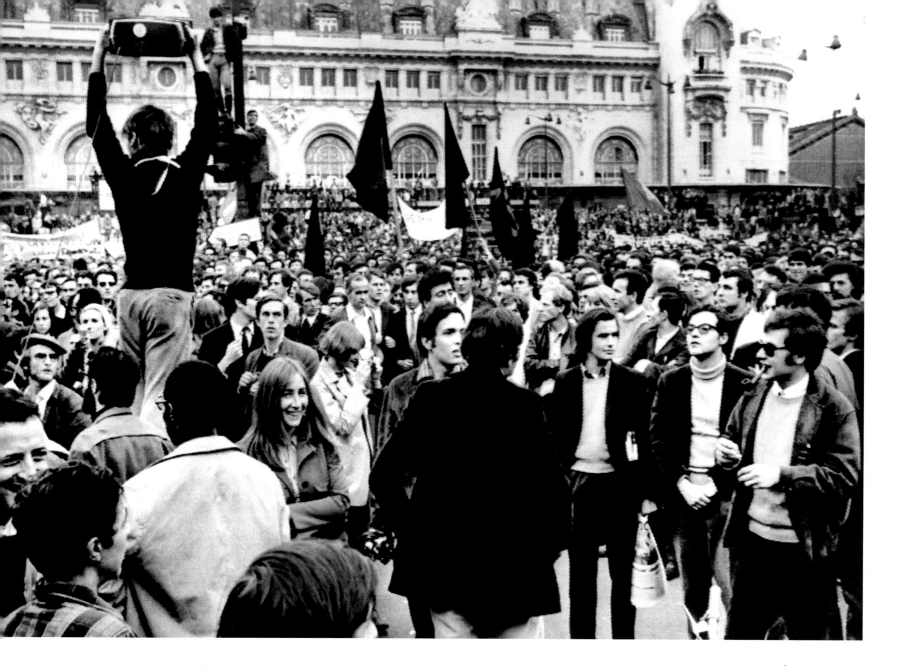

ABOVE: Demonstrators listen to the broadcast address by President Charles de Gaulle during a Paris general strike on 24 May 1968. De Gaulle called for a nationwide referendum to grant him dictatorial powers to avoid the threat of civil war in France. His request was refused and on 30 May, de Gaulle announced a new election on 23 June 23, 1968.

RIGHT: Thousands of demonstrators fill the Champs-Élysées on 30 May 1968 answering President Charles de Gaulle's call for support. After weeks of student riots and a general strike, de Gaulle fled to a French military base in Germany. He said we would not resign, but dissolved parliament and called for new elections. De Gaulle returned triumphant.

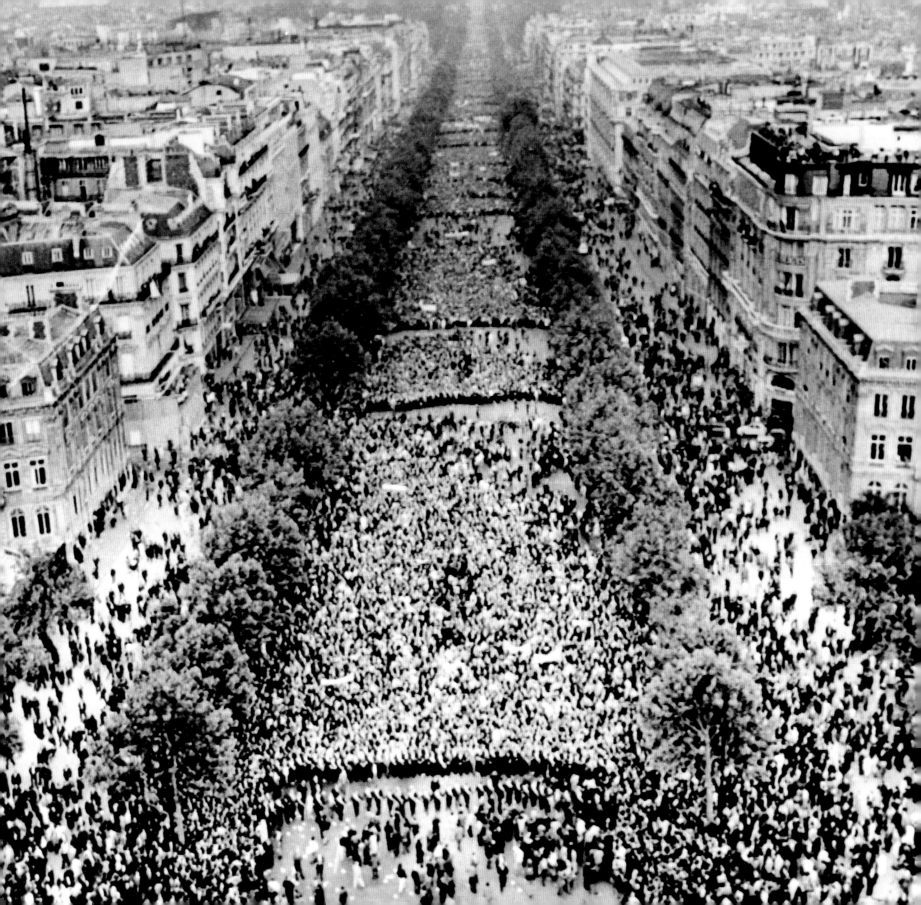

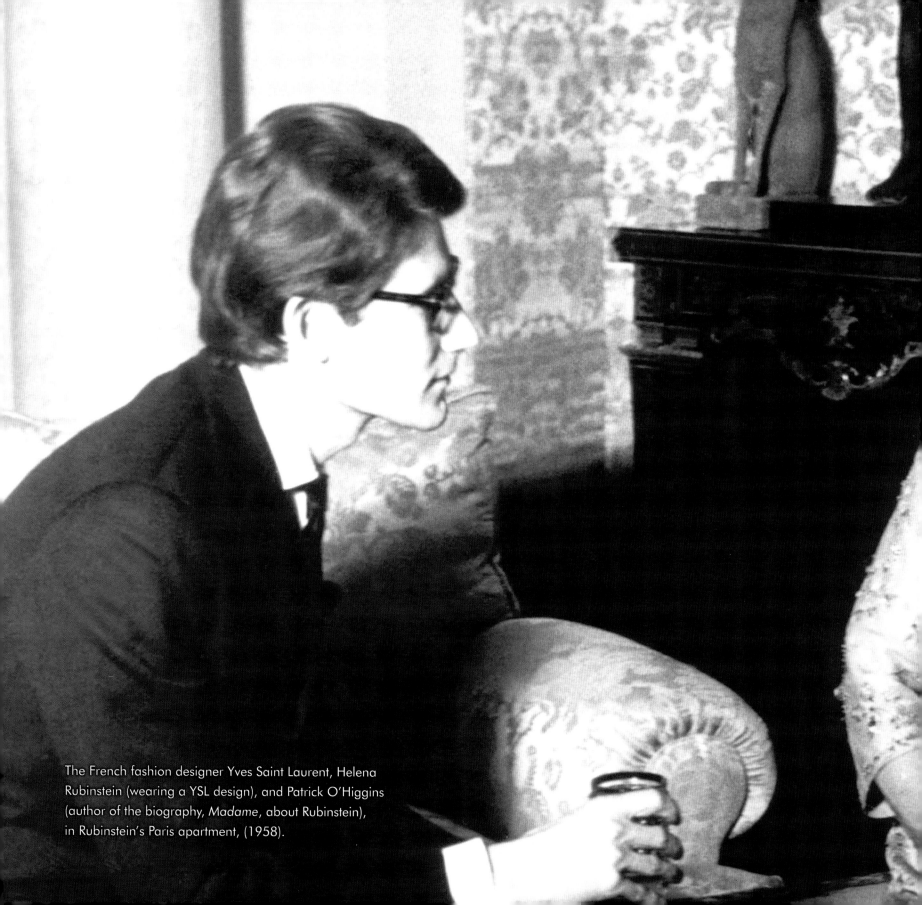

The French fashion designer Yves Saint Laurent, Helena Rubinstein (wearing a YSL design), and Patrick O'Higgins (author of the biography, *Madame*, about Rubinstein), in Rubinstein's Paris apartment, (1958).

FAMOUS IN PARIS

There have been numerous native-born French personalities and celebrities who have become Parisian icons, but equally there are also many foreigners who made Paris their home and gained the same status. There is especially a long list of Americans who took the city to their hearts and were adopted by Paris as her own. Of course, the list of famous people who made their mark in all walks of life is endless, from politicians and military leaders to artists, musicians, writers, performers, singers, fashion designers, business luminaries, film luminaries, royalty and sporting stars.

The French tennis player Suzanne Lenglen became a sporting legend, described as the 'Queen of the tennis court'. One of the first international female sporting stars, she won 31 championship titles between 1914 and 1926. She changed the perception of tennis, drawing new audiences and a greater interest from female observers.

Of all the British royals, none are more closely connected to Paris than the Duke and Duchess of Windsor. Following Edward VIII's abdication in December 1936, he married the American divorcee Wallis Simpson in France. After World War II – when the Duke was governor of the Bahamas – they made Paris their home and in 1953 moved into a grand villa on the edge of the Bois de Boulogne. Both died there in 1972 and 1986 respectively.

Despite the dominance of Hollywood, France has nurtured many film luminaries including directors such as Jean Renoir, Abel Glance, René Clair and actresses like Catherine Deneuve. But none resonate more than the screen goddess, Brigitte Bardot. The model, actress and singer was one of the best-known sex symbols of the 1950s and 60s. She starred in 47 films and become a strident animal rights activist.

Paris has provided a haven and inspiration for writers for centuries and in the 20th century was a vibrant centre for literary excellence from the delicate and humorous realism of writer, Colette to the existentialist movement exemplified by Jean-Paul Sartre, Albert Camus and Simone de Beauvoir. Sylvia Beach and her husband George Antheil (American avant-garde composer, pianist, author and inventor) founded the Shakespeare and Company bookshop in 1919 to sell English-speaking literature in Paris. It was the gathering place for the American expatriate community including Ernest Hemingway, Ezra Pound, Gertrude Stein, Alice B. Toklas and F. Scott Fitzgerald and the American journalist and writer Janet Flanner, who was the Paris correspondent of the *New Yorker* magazine for five decades from 1925 to1975, writing under the name, Genet.

Paris has, like any national capital city, produced some prominent and influential political figures but it was not until World War II that the first charismatic leader emerged with Charles de Gaulle, at first head of the Free French Forces in exile in London and then, on liberation in 1944, leader of the new French government. But successive crises brought numerous changes of government. The Algerian crisis in 1958 led to De Gaulle being elected President by a direct ballot. The student riots in 1968 were partly a reaction against the Gaullist regime but in 1969, Charles de Gaulle was followed by the Gaullist George Pompidou (1969–74). Next came the conservative Valéry Giscard d'Estaing (1974–81) before the socialist candidate, François Mitterand came to power for two terms (1981–95). Since then, France has had as president, the conservative Jacques Chirac (1995–2007), Nicolas Sarkozy (2007–12) and François Hollande (2012–current).

As well-known as the politicians in their day were the many industrialists and businessmen such as the car manufacturers André Citroën and Louis Renault and the newspaper magnate and perfumier, François Coty.

Throughout the 20th century Paris has maintained its position as the worldwide centre of couture. Its designers became world famous from the earliest artistic flair of Paul Poiret and Lucile to the genius of Coco

Gabrielle 'Coco' Chanel (1883–1971), French couturier (c.1960s).

Chanel, Yves Saint Laurent and Christian Dior.

Parisian entertainers have made France smile, gasp, laugh and cry and many developed an international appeal and admiration. Yvette Guilbert was one of the first recognisable stars of *chanson* and paved the way for others like Frehel and Yvonne George. Some of the male singers such as Charles Trenet and Yves Montand also rose to great heights. But, of all the Parisian singers, none is more widely admired than Édith Piaf or *La Môme Piaf* (The Little Sparrow) who became a symbol of French passion for her songs of love, loss and sorrow.

The Paris music hall has been home to so many major French and foreign performers. Gaby Deslys became the reigning queen of Paris entertainment on either side of World War I and made a huge impact in America and London. Regarded as the femme fatale of her era she had a seductive presence and was courted by King Manuel II of Portugal and Gordon Selfridge. Harry Pilcer became her dancing partner, forming an enduring partnership. His innovative and uniquely American style took Europe by storm. After the death of Deslys in 1920, he continued performing and became a celebrated cabaret host.

Described as the Queen of the Paris Music-Hall, Mistinguett or simply 'Miss', was the most dazzling of all Parisian entertainers. She was a lithe dancer who had a flair for style and glamour that gave her star quality. Her legs were reputedly insured for a million dollars.

The first black superstar, Josephine Baker rivalled Mistinguett as Queen of the Paris Music Hall following her arrival in Paris in 1925. Exotic, provocative, thrilling and charismatic, her performances and singing were legendary. On April 8, 1975, Baker starred in a revue, *Joséphine à Bobino 1975*, celebrating her 50 years in show business. Four days later, she was found lying peacefully in her bed (after suffering a cerebral haemorrhage) surrounded by newspapers with glowing reviews of her performance.

An institution not just in France, but all over the world, Maurice Chevalier was a major music hall entertainer, best known for his signature songs. He made good in Hollywood in the talkies during the 1930s but after participating in a Communist demonstration in Paris, he was not regarded favourably in America under the right-wing McCarthyism during the 1950s. There were dozens of other stars of theatre and music hall such as Sacha Guitry, regarded as the embodiment of the Parisian stage, the Russian ballet dancer Nijinsky, the glamorous American singers, the Dolly Sisters, the three Italian clowns known as the Fratellini brothers, the extraordinary aerial trapeze and drag artist, Barbette, the elegant star of the Comédie-Française, Cécile Sorel and the effervescent black American performer, Florence Mills who died prematurely in 1927.

Throughout the 20th century Paris had a major influence on the art world and following impressionism came even more innovative art styles: Fauvism, Cubism, Dadaism, Futurism, Surrealism and much later New Realism. Artists flocked to Paris from all over Europe and revolutionised our perception of modern art. Henri Matisse was a master of using colour. Marc Chagall created works in all artistic mediums and was adapt at fusing all the various art forms. The Spanish artist Salvador Dali was a leading exponent of surrealism. The American Man Ray was a visual artist best remembered for his photography. Marcel Duchamp was continually testing the boundaries of art; his work was unconventional in its use of media. Multi-talented Jean Cocteau was a poet, artist, actor, playwright and filmmaker. The Spanish artist Pablo Picasso, co-founder of the cubist movement, spent most of his adult life in France. Kiki (Alice Prin), nicknamed the Queen of Montparnasse, was an artists' model, singer, artist and actress who helped define Paris in the 1920s. The embodiment of the carefree and outspoken independent modern woman, she was also May Ray's muse.

Jean Cocteau, French writer, artist and filmmaker, reading in bed, (1941).

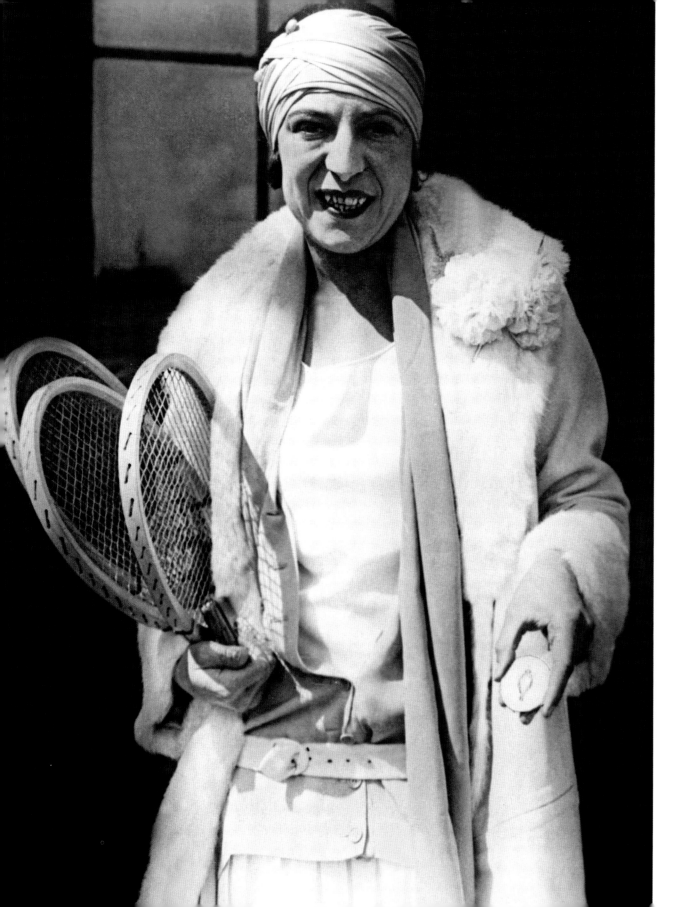

LEFT: The international tennis star Suzanne Lenglen at the height of her fame, (c.1920s). She died young after being diagnosed with leukemia in 1938.

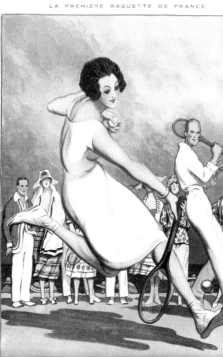

LA PREMIÈRE RAQUETTE DE FRANCE

SUZANNE AUX BAINS... DE MER

ABOVE: Illustration of the French tennis player, Suzanne Lenglen (1899–1938) in action, 30 July 1921. In addition to tennis, Lenglen was quite the trendsetter and one of the first advocates of sunbathing.

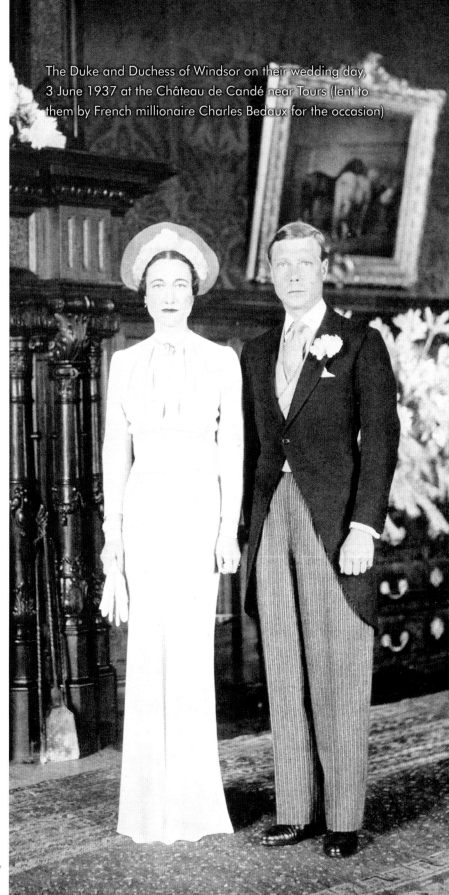

The Duke and Duchess of Windsor on their wedding day, 3 June 1937 at the Château de Candé near Tours (lent to them by French millionaire Charles Bedaux for the occasion)

ABOVE: Edward Duke of Windsor (formerly King Edward VIII) and his wife the Duchess of Windsor (Wallis Simpson) at Le Lido December 10 1959. The Duchess wears the bracelet diamond and onyx *Panthère de Cartier*.

BELOW: THE Duke and Duchess of Windsor leaving Maxim's restaurant in Paris (c.1971).

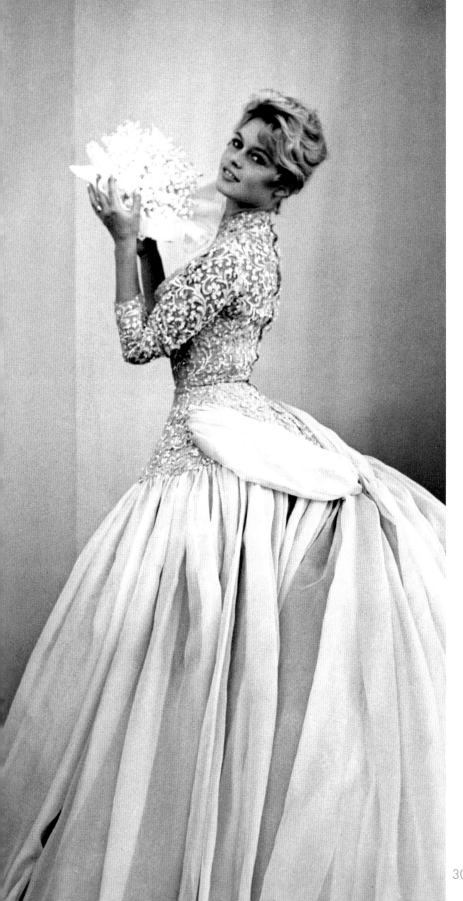

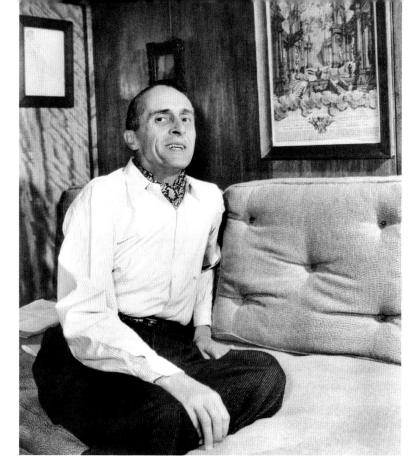

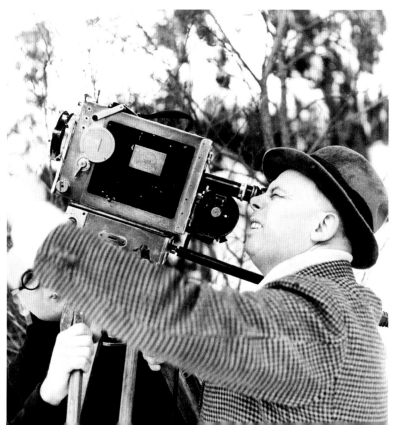

ABOVE: The film actress
Catherine Deneuve with the
French screenwriter Roger
Vadim, (1963).

ABOVE: French writer, Albert
Camus (1913–1960), at
the café, Les Deux Magots,
(1945).

FAR LEFT: The original sex
kitten, international movie star
Brigitte Bardot was described
by *Paris Match* (1958) as
'immoral, from head to toe'.
Here she is trying on a dress
by Balmain for the film, *La
Mariee est Trop Belle*, (1956).

ABOVE LEFT: René Clair
(1898–1981), in 1954.

BELOW LEFT: Film director
Jean Renoir filming the last
outdoors shot for the film *The
Grande Illusion* in Chamonix,
(1936).

LEFT: The American bookseller and publisher Sylvia Beach (1887–1962) applauds her husband, Georges Antheil as he climbs up to a window above their bookstore, Shakespeare and Company, (1923).

RIGHT: Simone de Beauvoir (1908–1986) and Jean-Paul Sartre (1905–1980) on 21 June 1977 at the Théâtre Récamier. The meeting, organised by Jean Paul Sartre, was to gather dissidents from Eastern countries. Beauvoir and Sartre are sitting opposite each other.

BELOW: Sidonie-Gabrielle Colette (1873–1954), French novelist and performer, with one of her cats at a desk, (1935).

CONTINUED

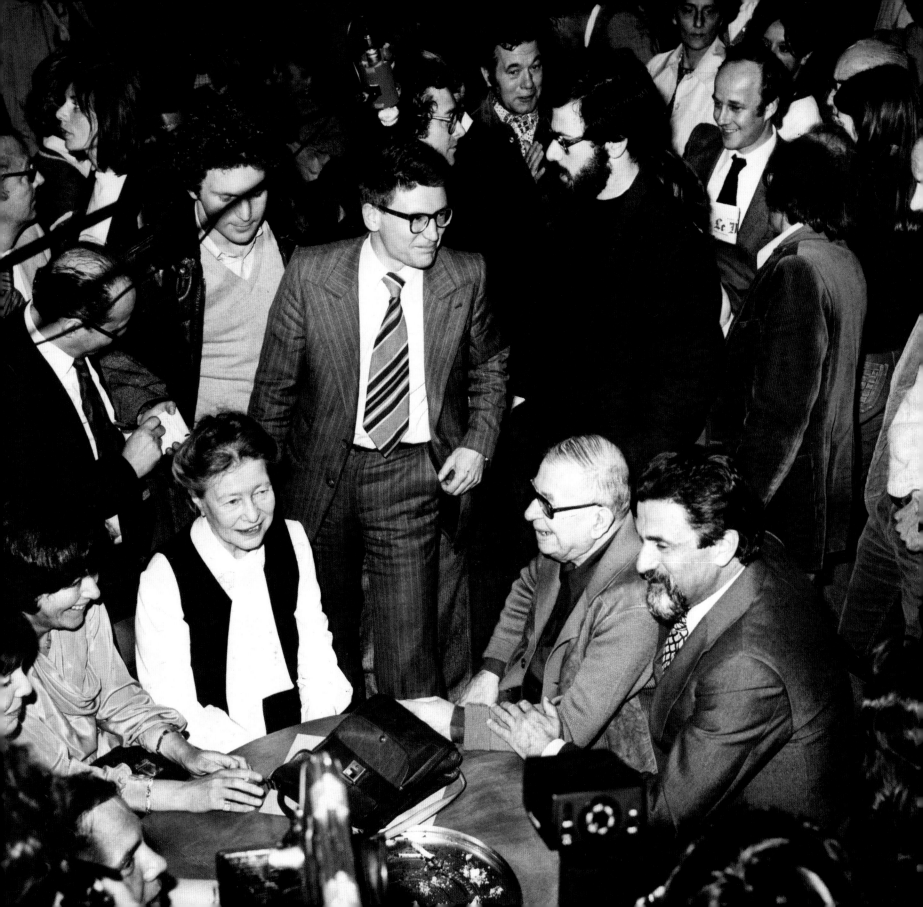

LEFT: Alice B. Toklas (1877–1967) at back, and Gertrude Stein (1874–1946). Stein first visited Paris in 1903 and, along with her partner Toklas, had a significant influence on both writers and artists in the early 20th century. Her salon at 27 Rue de Fleurus was a pilgrimage to many, (1937).

ABOVE: The writers Janet Flanner (1892–1978) and Ernest Hemingway (1899–1961) wearing war correspondent uniforms in Paris, (1944).

RIGHT: Ernest Hemingway, with Sylvia Beach (2nd from right) with friends outside Beach's Paris bookstore, Shakespeare & Company, a popular gathering spot for American writers, (c.1920s).

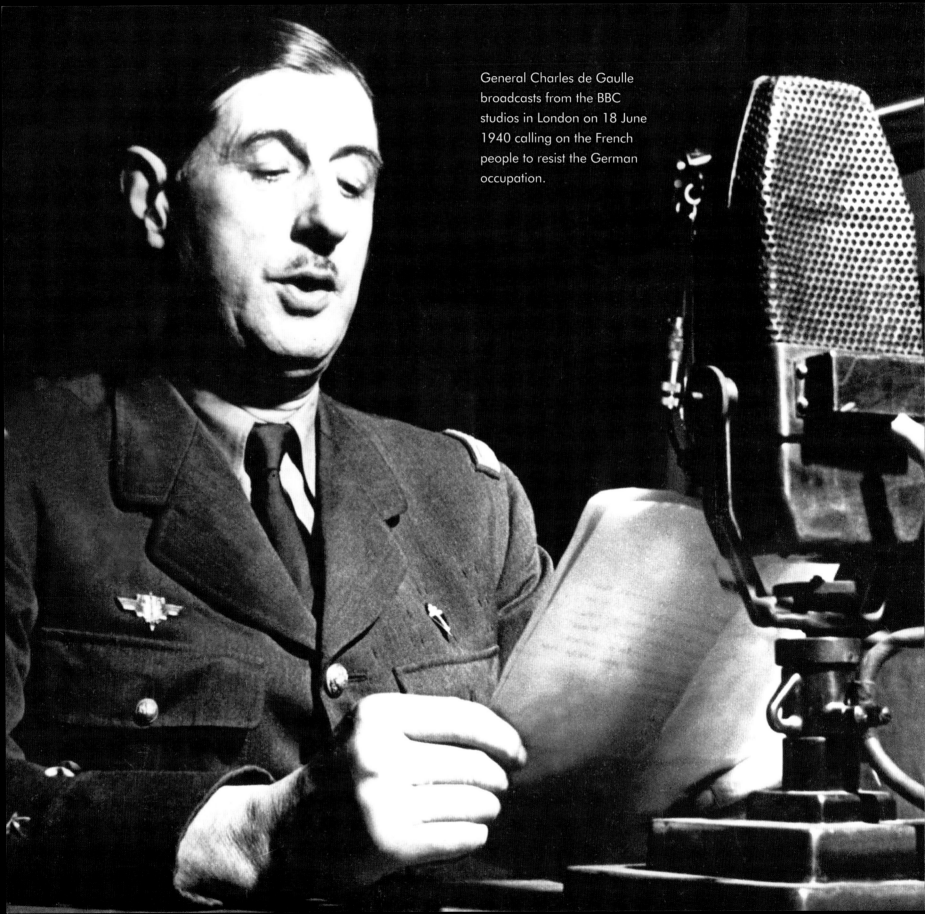

General Charles de Gaulle broadcasts from the BBC studios in London on 18 June 1940 calling on the French people to resist the German occupation.

RIGHT: French Prime Minister, Georges Pompidou announces the draft agreement between government, trade unions and employers known as *les accords de Grenelle* on 27 May 1968 in response to disturbances across the country. In the background is Jacques Chirac, Secretary of State for Social Affairs who was responsible for employment issues.

BELOW RIGHT: French politician, Jacques Chirac during a meeting of the RPR (*Rassemblement Pour la République*) right-wing political party, 20 December 1977.

BELOW: The French general and politican, Charles de Gaulle, (c.1960).

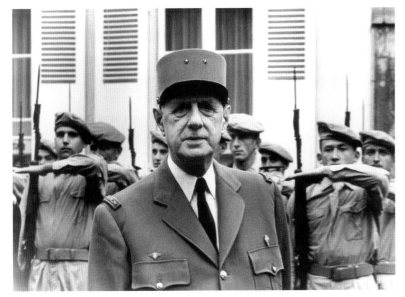

ABOVE: The French President visiting the French car salon of
Renault, 1930. Left to right: Albert Sarraut, First Lord of the
Admiralty; Louis Renault, founder of the company; French President
Albert Lebrun and Joseph Paganon.

ABOVE: André Citroën (1878–1935), French industrialist and car manufacturer, (c.1930s).

LEFT: Louis Renault (1877–1944), French engineer, industrialist and car manufacturer, (1925).

RIGHT: François Coty (1874–1934), French newspaper magnate and perfumery producer, (1932).

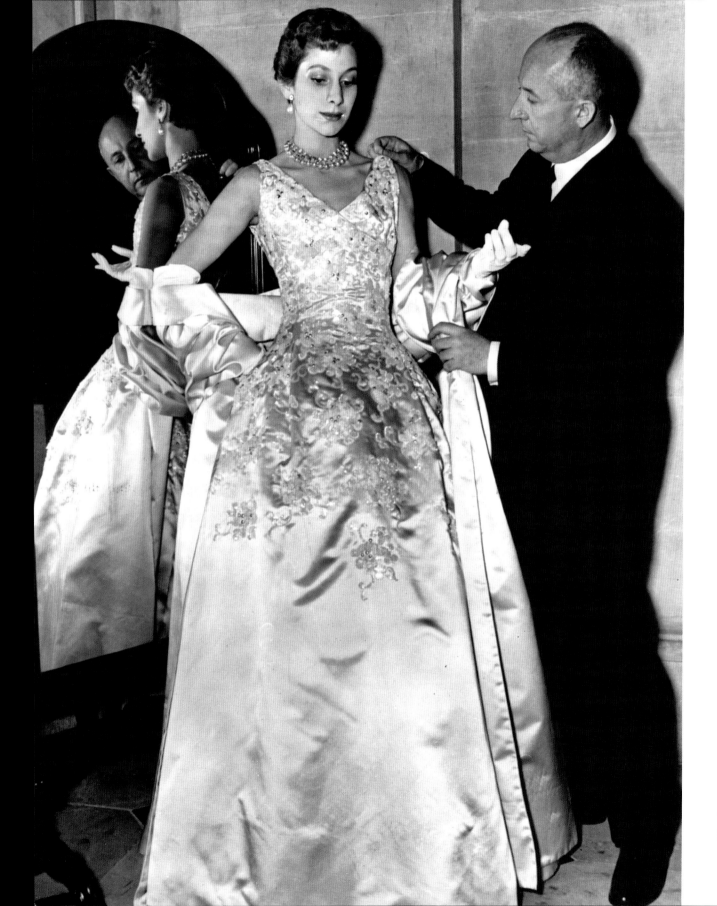

LEFT: French couturier Christian Dior with one of his models, October 1954.

RIGHT: Coco Chanel, watching her collection being presented in Paris, January 1969.

RIGHT: Yves Saint Laurent (1936–2008), French fashion designer, (1966).

FAR RIGHT: Yves Saint Laurent in front of his shop with one of his models, 26 September 1966.

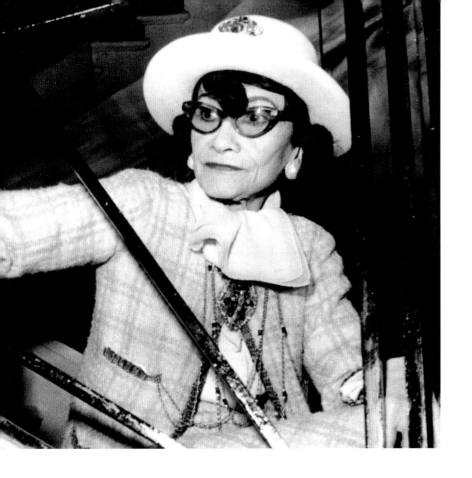

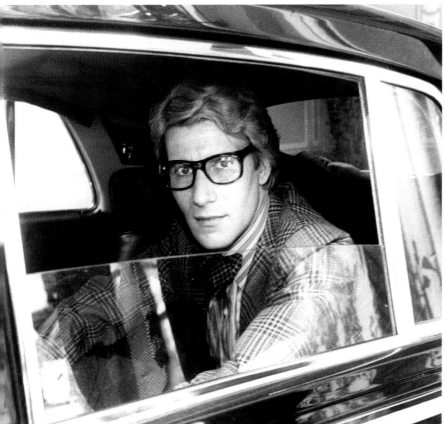

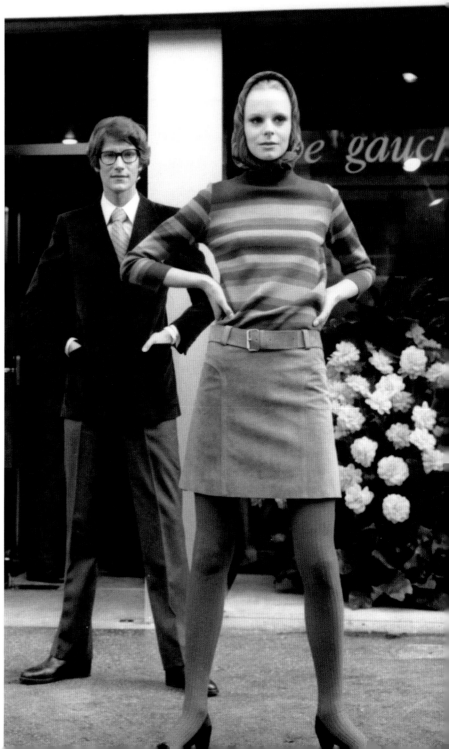

319

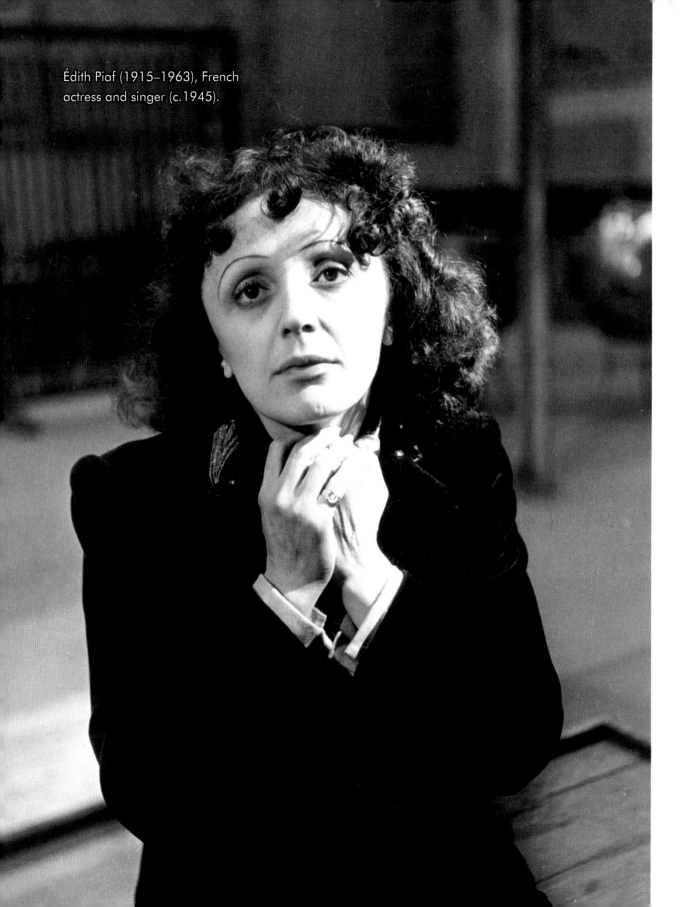

Édith Piaf (1915–1963), French actress and singer (c.1945).

ABOVE RIGHT: Fréhel (1889–1951), French singer, came from a humble background and was once described as an 'angel with a mouth like a sewer-worker', (c.1920).

FAR RIGHT: Yvonne George (1896–1930), a Belgian actress and singer, was described as the muse of Montmartre inspiring many of Robert Desnos' greatest poems. In the 1020s, she appeared at intellectual haunts such as the Boeuf sur le Toit and Chez Fysher, (1925).

BELOW RIGHT: The singer Yvette Guilbert (1867–1944) dusted her face white, coloured her hair Titian red and often wore a simple gown with long black gloves, (c.1929).

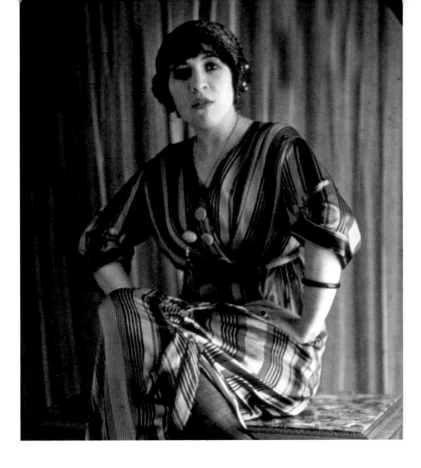

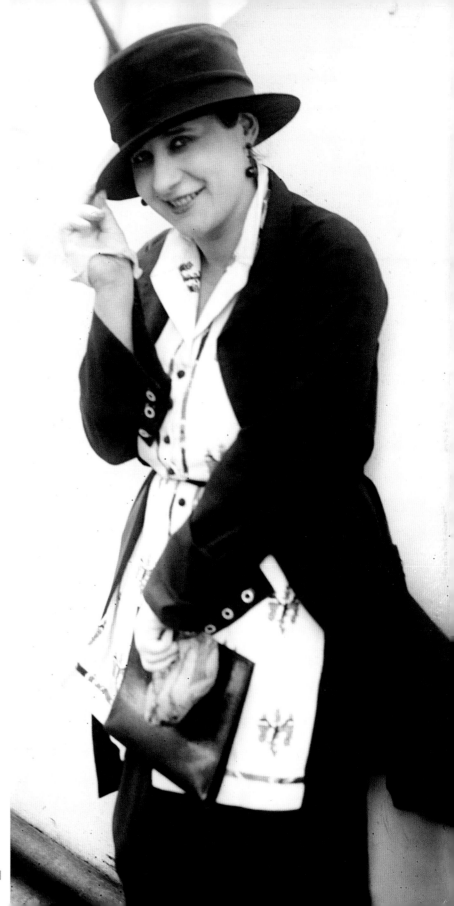

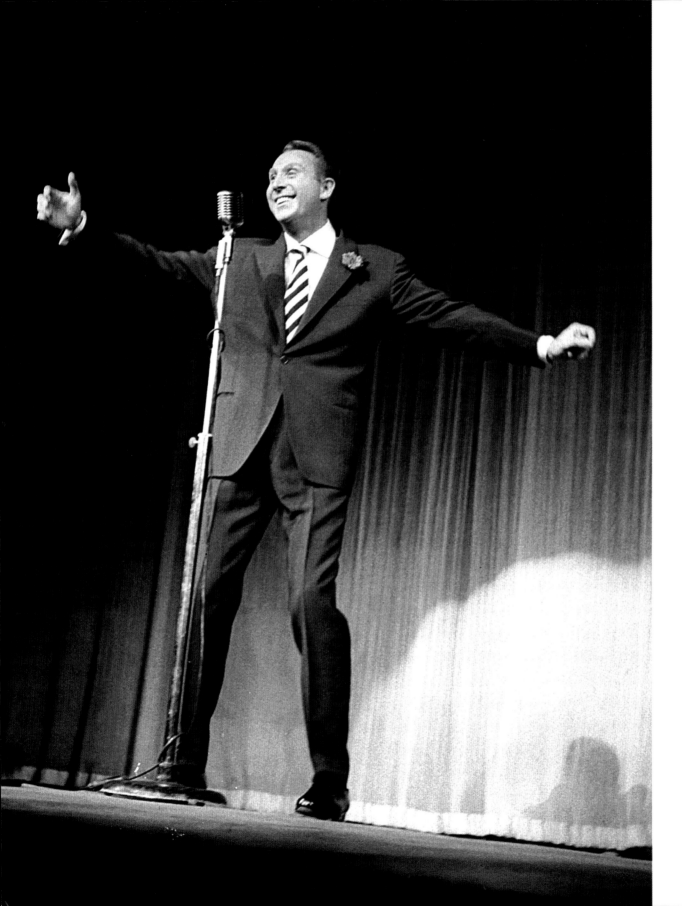

LEFT: French singer, Charles Trenet on stage in Paris, (1960).

BELOW: Yves Montand (1921–1991) in 1957.

RIGHT: Gaby Deslys and Harry Pilcer (c.1910s). Deslys was a major star of the Paris music hall in the first two decades of the 20th century. Her dancing partner, the American Harry Pilcer was every bit as beautiful as she was. She died in 1920 of complications from contracting influenza.

BELOW: Mistinguett (1873–1956) was a French dancer and cabaret singer, (1956).

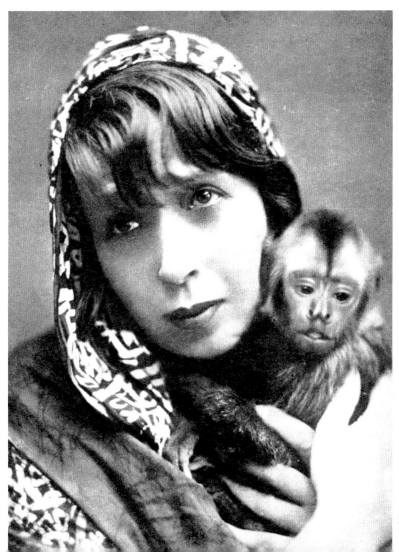

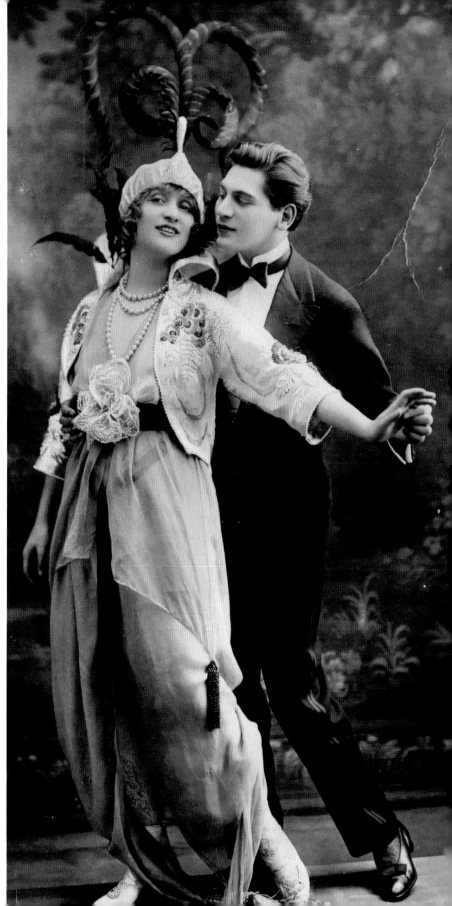

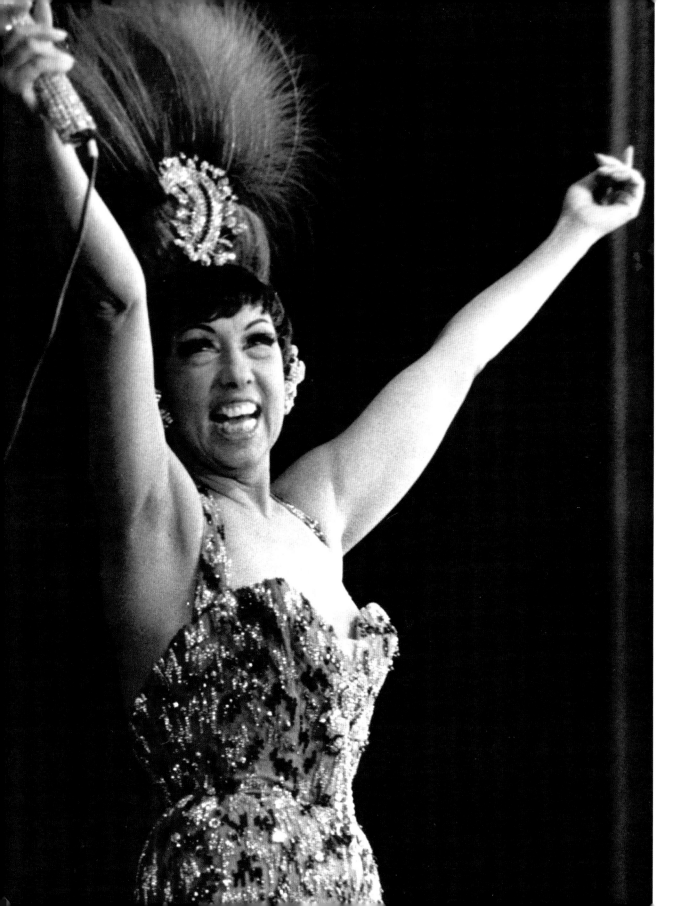

LEFT: American, Josephine Baker (1906–1975), was the first black woman to star in a major motion picture, *Zouzou* (1934). She is seen here on stage in Paris, (1964).

BELOW: Josephine Baker, who adopted numerous children known as her 'rainbow tribe', was a strident humanitarian. Here she distributes food to the population receiving a kiss from a grateful man in Montmartre, (1933).

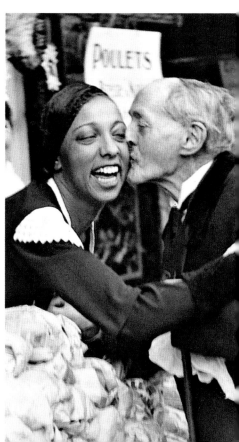

RIGHT: Josephine Baker in *La Folie Du Jour* at the Folies Bergère, 1926. Baker was renowned in her early days in Paris for her provocative costumes, daring dance routines and raw exotic beauty.

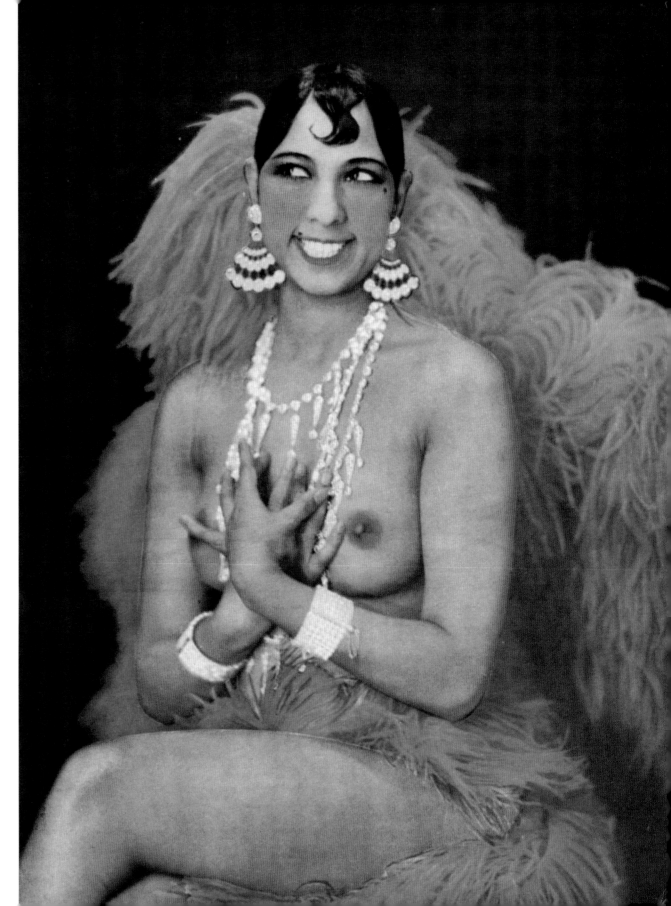

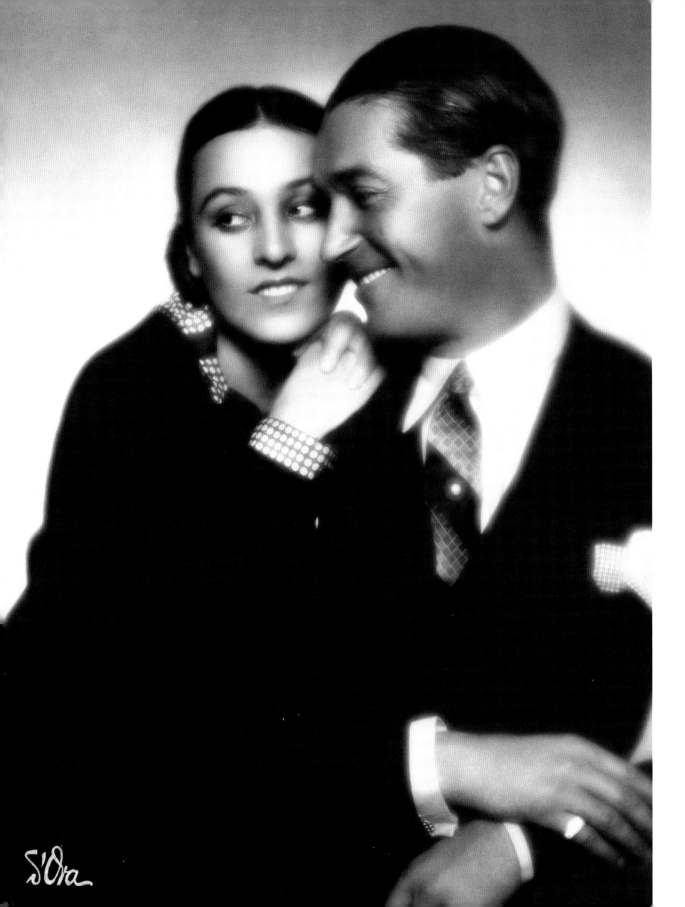

S'Ora

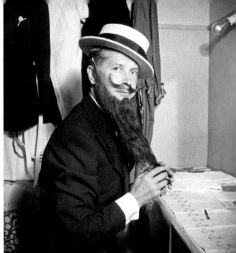

ABOVE: Maurice Chevalier in his dressing room before a performance during the German occupation, (1942).

LEFT: French actor-couple Maurice Chevalier and Yvonne Vallée, (1927).

BELOW: French singer Maurice Chevalier in the 1950s.

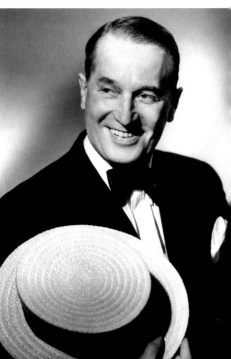

RIGHT: French actor and playwright, Sacha Guitry came from a Russian-born theatrical family. Seen here with his wife, Yvonne Printemps during a visit to London, (1929).

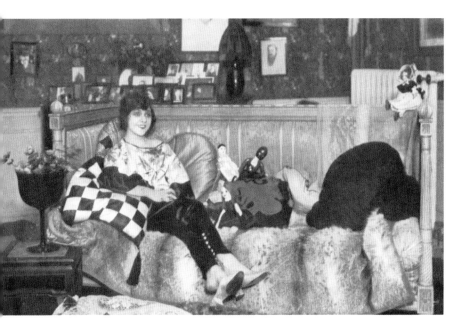

ABOVE: Yvonne Printemps, Madame Sacha Guitry, at home in her boudoir in Paris, 6 January 1921.

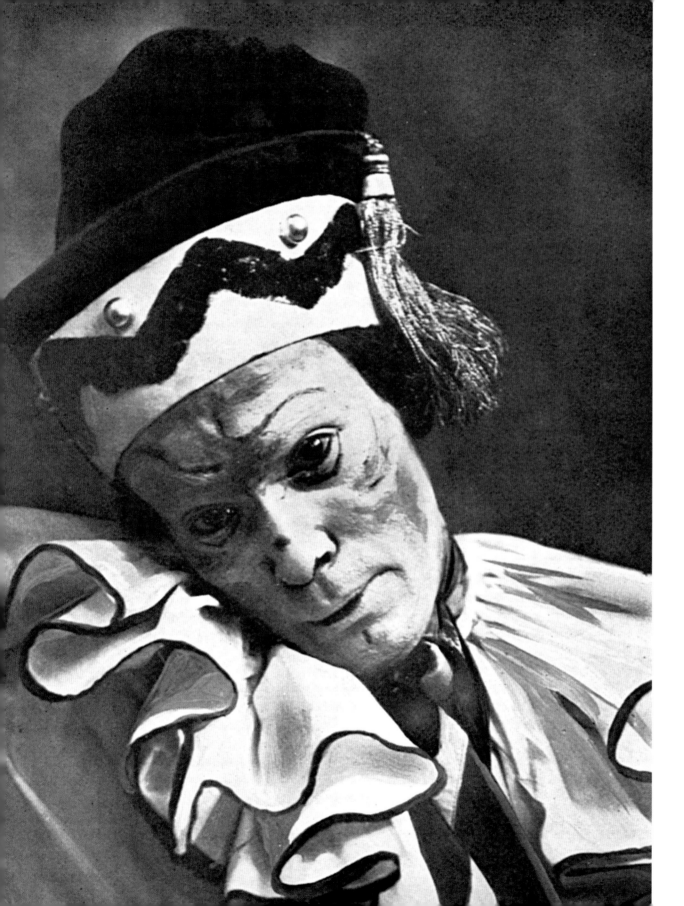

LEFT: The Russian ballet dancer and choreographer Vaslav Nijinsky (1890–1950), in the lead role of *Petrushka,* (c.1911). Regarded as the greatest male dancer of the early 20th century, Nijinsky was a member of the famed *Ballets Russes* and adored by the Parisian public.

BELOW: The tomb of Vaslav Nijinsky with the statue showing him as the puppet, Petroushka. Nijinsky was diagnosed with schizophrenia and hospitalised for the last 30 years of his life. Although he died in London, he was re-interred in the Montmartre cemetery in Paris.

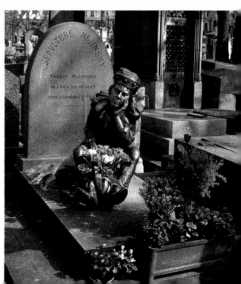

ABOVE: The Dolly Sisters and
Maurice Chevalier in *Paris
En Fleurs* in 1925. The Dolly
Sisters were described as
'marvellous birds of paradise'
and became legends on both
sides of the Atlantic but found
Paris to be their spiritual
home.

RIGHT: The Dolly Sisters in
their feather creations by
Patou, *Oh Les Belles Filles*
performing at the Théâtre
Le Palace, 1923. The Dollies
were continually in the news
for their extravagant living,
gambling, predilection for
jewellery and high profile
love affairs with the rich and
famous, as much as for their
talent as entertainers.

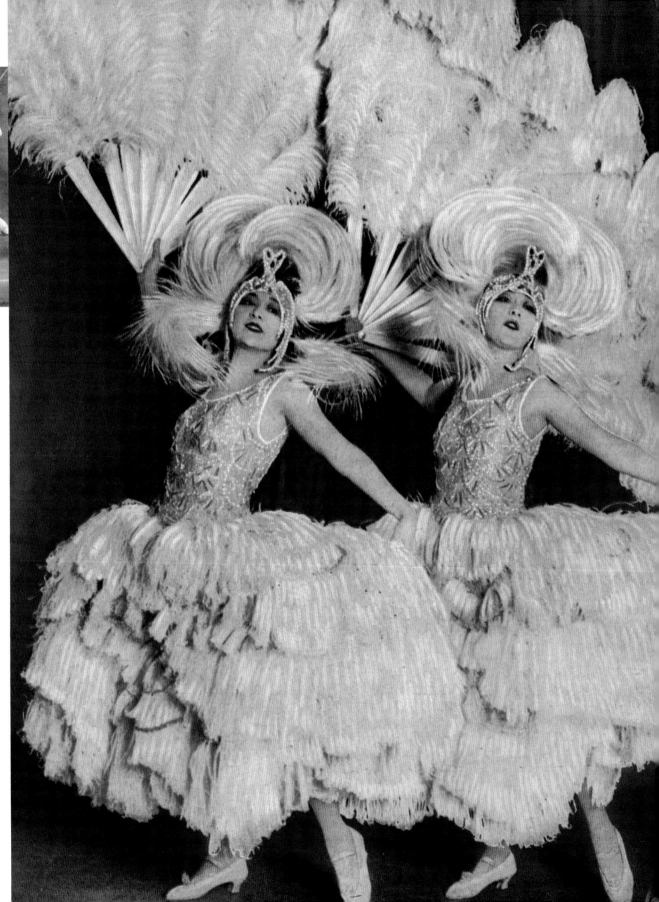

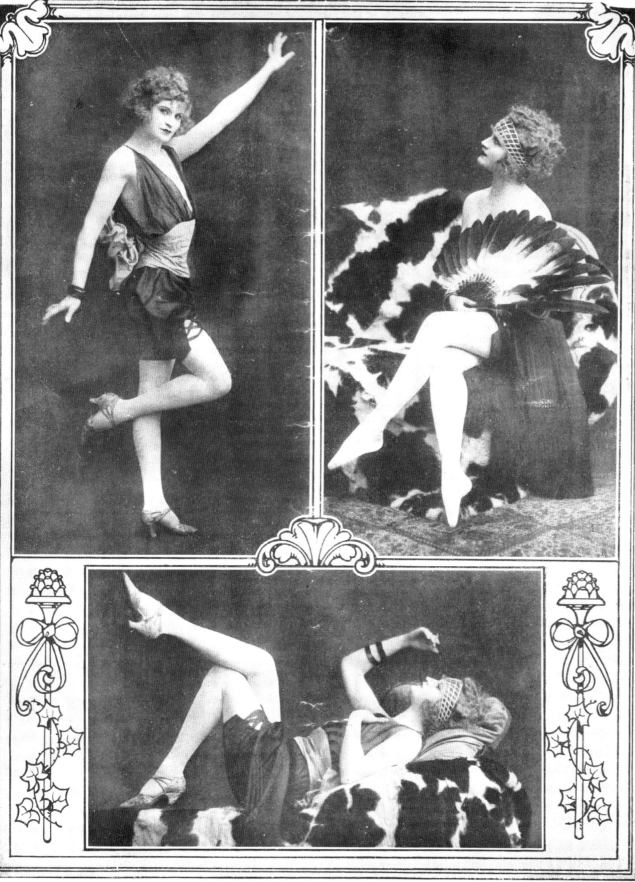

"Exquisite Barbette"??

Studio WALÉRY

LEFT: Barbette at the *Casino de Paris* in December 1923. The American-born, Vander Clyde was described as a 'jazz age Botticelli'. Barbette was a trapeze artist and illusionist who made Paris gasp as one of the most tasteful and convincing drag acts ever to take the stage.

BELOW: The clown Francois Fratellini celebrating his birthday (70) in Paris on 19 January 1949. Francois was one of the three Fratellini Brothers clown act.

RIGHT: The French actress Cécile Sorel (1873–1966) was a major star of the Comédie-Française but also appeared at the *Casino de Paris,* (1933). She starred in several movie, married and became the Comtesse de Ségur.
In 1950 she underwent a religious conversion and spent the rest of her life in prayer.

ABOVE: Florence Mills, the star of the show *Blackbirds* by Edmund Sayag captivated Paris. Staged at the Café des Ambassadeurs in1926, Florence tragically died a year later in 1927.

ABOVE: Jean Cocteau
(1889–1963) French painter,
artist and writer wearing a
mask, (1919).

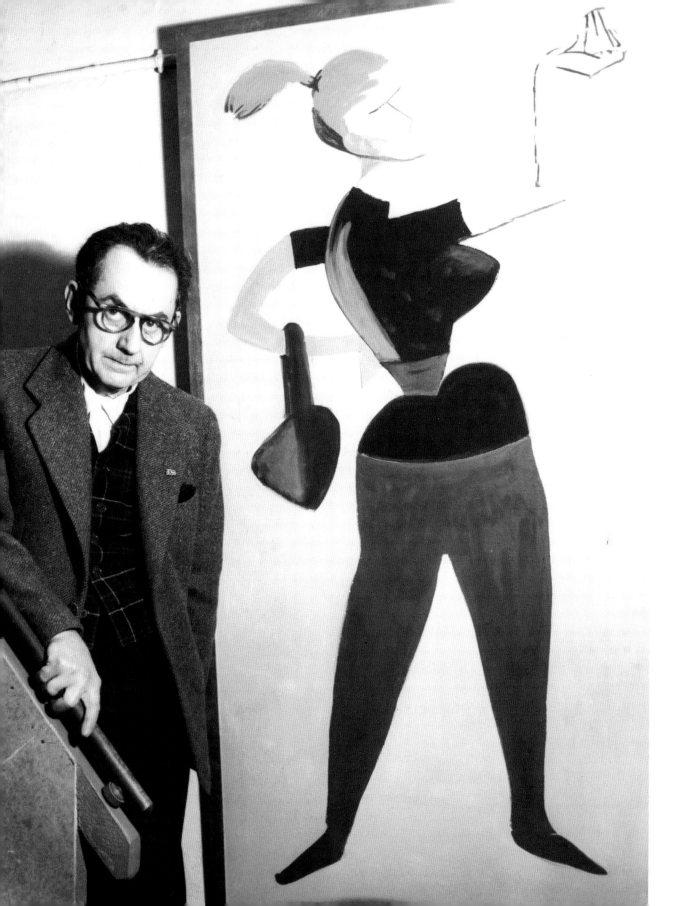

LEFT: American painter,
photographer and filmmaker,
Emmanuel Rudnitsky, known
as Man Ray (1890–1976),
photographed with one of
his paintings of a girl with a
ponytail, (1954).

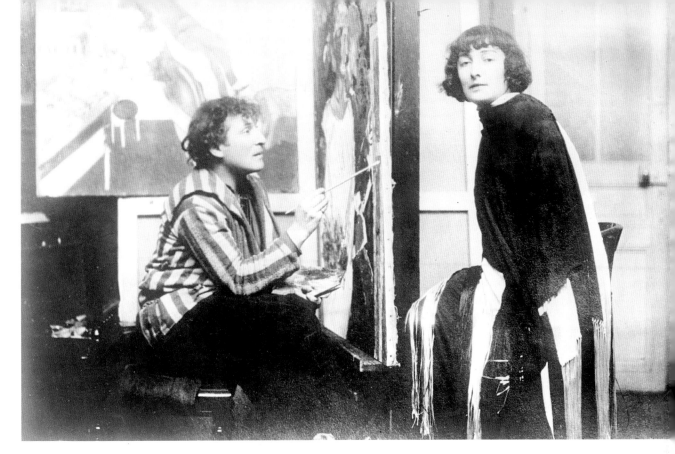

RIGHT: The Russian-French artist, Marc Chagall (1887–1985), with his first wife Bella (Berta) Rosenfeld in his studio in Paris, (1926).

RIGHT: The American painter and photographer Man Ray (on left) plays chess with the French artist Marcel Duchamp (1887–1968).

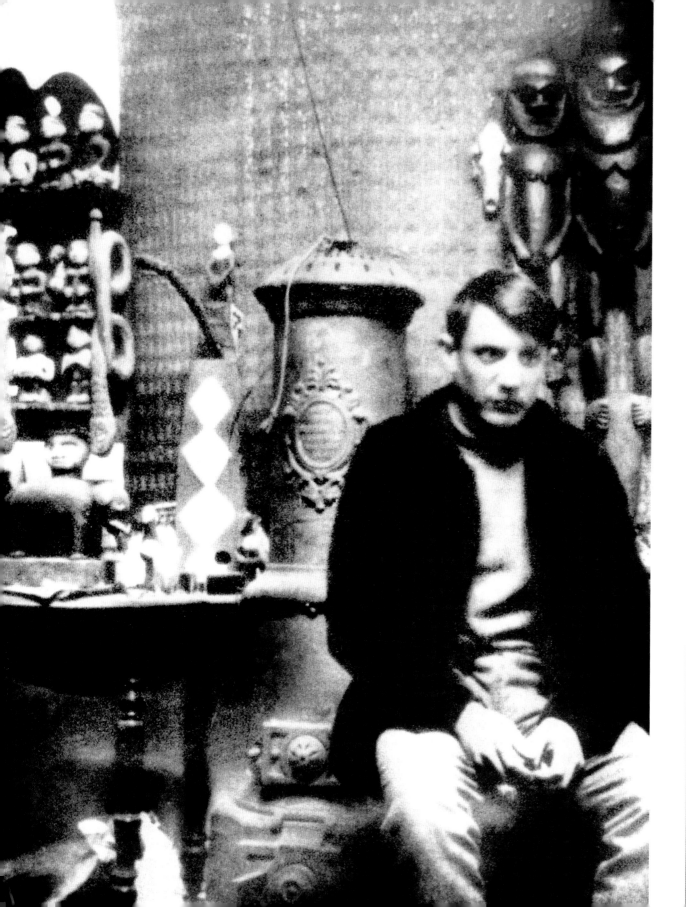
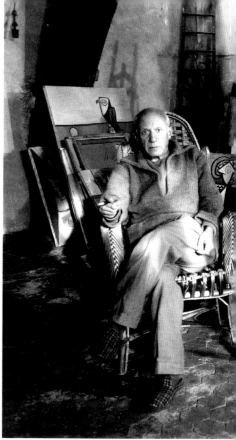
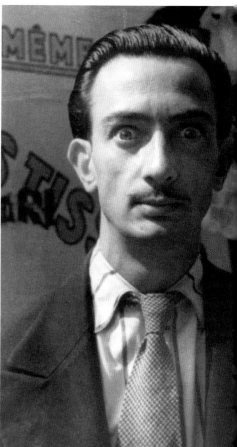

FAR LEFT: Spanish painter Pablo Picasso (1881–1973) during the summer of 1908 in his workshop in Montmartre.

ABOVE LEFT: Pablo Picasso in his workshop studio in Paris, (1947).

BELOW LEFT: Salvador Dali, and Man Ray in Paris, 16 June 1934.

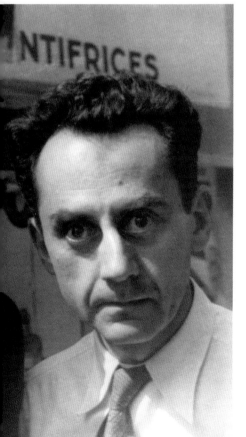

RIGHT: French painter, Henri Matisse (1869–1954), during an exhibition in Paris, September 1945.

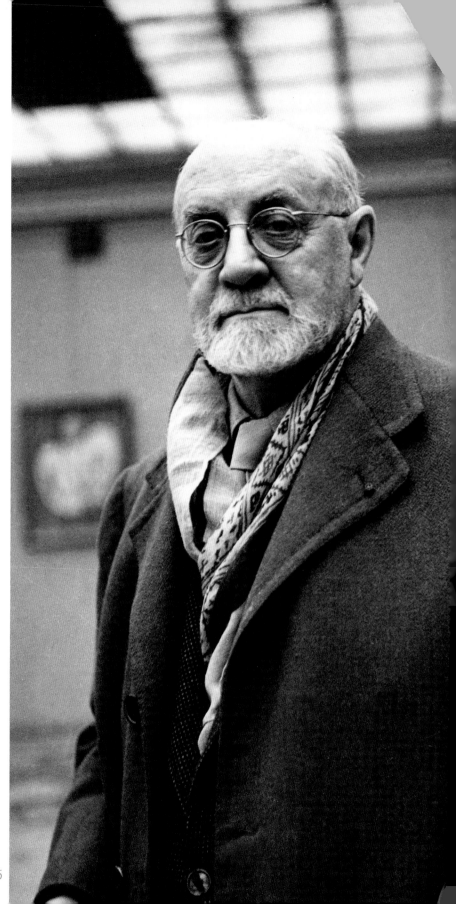

Picture Credits

BeBa/Iberfoto/Mary Evans: 254

Illustrated London News Ltd/
Mary Evans: 58, 115a, 115b,
122b, 127b, 172a, 184b, 188,
194, 195, 212–213, 244–245,
246–247, 249b, 262, 266b,
274, 276, 277, 289, 307c

Imperial War Museum/Robert
Hunt Library/Mary Evans: 62

Mary Evans/Andrew Besley: 27

Mary Evans/Bill Angove: 192

Mary Evans/Classicstock/
C.Ursillo: 90–91

Mary Evans/Classicstock/
H.Armstrong Roberts:
2, 210, 211

Mary Evans/Classicstock/May:
96, 101

Mary Evans/Grenville Collins
Postcard Collection: 38a, 94a,
105, 166–167, 180, 206, 212a,
213b, 219, 227, 265, 266a

Mary Evans/Ida Kar: 332a

Mary Evans/Jazz Age Club
Collection: 94b, 106a, 106b,
107a, 107b, 108a, 108b, 109a,
109b, 110a, 110b, 111, 113b,
114b, 122a, 126–27, 128–129,
132, 133, 134a, 134b, 134–
135, 136a, 136b, 137a, 137b,
138a, 138b, 139a, 139b, 140a,
140b, 141, 142, 143a, 143b,
147a, 147b, 148a, 148b, 149b,
149c, 150bg, 150c, 151a, 151b,
151c, 152, 157a, 157b, 172b,
176, 177a, 177b, 177c, 178,
179a, 179b, 181, 182, 323b,
325b, 329a, 329b, 330a, 331a

Mary Evans/John Massey Stewart
Collection: 328b

Mary Evans/Lionel Coates: 50

Mary Evans Picture Library: 5,
6, 7, 8, 9, 10–11, 12, 13, 14,
16, 17, 18, 21, 22, 23, 24,
26, 29, 32, 34a, 34–35, 36,
37, 38–39, 41, 44, 45, 49, 52,
60a, 60b, 61b, 63, 67, 82a, 98,
99, 100, 102, 103, 104, 116c,
117a, 117b, 120a, 121, 123a,
123c, 124, 125a, 125b, 130,
144a, 145b, 146c, 146d, 148a,
148b, 149a, 150a, 153a, 154,
155, 162–163, 164, 165, 168,
169, 170a, 170b, 171, 173a,
173b, 174, 175, 183a, 183b,
186, 187, 188, 189, 190, 191,
196, 197, 198, 199, 200–201,
202, 204, 205, 207, 218, 220,
221, 222, 225, 228c, 230, 231,
232a, 232b, 233, 236, 241b,
250, 252a, 252b, 255, 256,
257, 258, 259, 260, 261, 263,
217a, 271b, 272, 273, 275,
278–279, 280, 294, 295, 296a,
296b, 297, 298, 299, 300,
301, 302–303, 304, 305, 306b,
307a, 308a, 308b, 308c, 309a,
309b, 310a, 310b, 311, 312a,
312b, 313, 314, 315a, 315b,
315c, 316, 317a, 317b, 317c,
319a, 319b, 320, 321a, 321b,
324a, 326a, 326b, 326c, 327a,
327b, 328, 332b, 333b, 334a,
334–335a, 334–335b, 336.

Mary Evans/Pharcide: 19

Mary Evans/Roger Mayne: 214

Mary Evans/Roger Worsley
Archive: 252–253

Mary Evans/Shirley Baker: 223

Mary Evans/Sueddeutsche
Zeitung Photo: 25, 28, 30–31,

54–55, 57, 59, 76a, 76b, 81,
92, 98, 131, 208, 217, 229,
234a, 234–235, 235b, 264,
268, 269, 281, 282, 283, 285,
286, 287, 288, 333a

Mary Evans/SZ Photo/Scherl:
33, 42, 48, 53, 56, 62, 93,
95, 112, 113, 160, 161, 215a,
215b, 242, 251, 306a, 323a,
324–325, 331b

Mary Evans/Vanessa Wagstaff:
51

Mary Evans/Weimar Archive:
69, 72, 73, 75

Robert Hunt Library/Mary Evans:
61a, 66b, 68, 71, 77, 79, 82b,
83, 84, 87, 88, 89, 290, 291,
292, 293

Rue de Archives/Mary Evans:
15, 31b, 40, 43, 47, 64, 66a,
70, 74, 78, 80, 85, 86, 97,
116b, 116c, 118, 119, 120b,
123b, 144b, 144c, 145a, 146a,
146b, 153b, 156a, 156b, 158,
159, 184a, 185, 193, 203, 209,
224, 226, 228a, 228b, 237,
238, 239, 240–241, 243, 267,
270, 307b, 318, 319c, 321c,
322a, 322b, 330b

Spaarnestad Photo/Mary Evans:
216a

The Burton Family Collection/
Mary Evans: 46

The Royal Aeronautical Society
(National Aerospace Library)/
Mary Evans: 248–249

About the author

Gary Chapman has worked in
the book publishing industry for
over thirty years focused primarily
on non-fiction titles and in various
marketing capacities.

Gary has an enduring fascination
with the Jazz Age and has been
an avid collector of ephemera
from the inter-war years, focused
largely on fashion, cabaret,
silent film, music hall, dance,
theatre and costume design.
He has become an expert on
1920s culture and nightlife and
launched the Jazz Age Club
website dedicated to the 1920s.
He adores Paris and a large part
of his collection is connected with
Paris and the Paris music hall.

In 2006 he moved from
London to the Cotswolds and
his biography about the Dolly
Sisters was published. After
setting up Edditt Publishing
in 2012 he has republished
The Dolly Sisters and another
book, *London's Hollywood:
The Gainsborough Studio in
the Silent Years.*

Gary is currently working on
various other book projects all
with a 1920s theme.

A MONTM

92 Bd. DE CLI

ON SE R

Chez

US $35.00
UK £24.99